The Films of Wes Anderson

The Films of Wes Anderson

Critical Essays on an Indiewood Icon

Edited by Peter C. Kunze

THE FILMS OF WES ANDERSON
Copyright © Peter C. Kunze, 2014.

All rights reserved.

First published in 2014 by PALGRAVE MACMILLAN® in the United States—a division of St. Martin's Press LLC, 175 Fifth Avenue, New York, NY 10010.

Where this book is distributed in the UK, Europe, and the rest of the world, this is by Palgrave Macmillan, a division of Macmillan Publishers Limited, registered in England, company number 785998, of Houndmills, Basingstoke, Hampshire RG21 6XS.

Palgrave Macmillan is the global academic imprint of the above companies and has companies and representatives throughout the world.

Palgrave® and Macmillan® are registered trademarks in the United States, the United Kingdom, Europe and other countries.

ISBN: 978-1-137-40311-7

Library of Congress Cataloging-in-Publication Data

 The films of Wes Anderson : critical essays on an indiewood icon / edited by Peter C. Kunze.
 pages cm
 Includes bibliographical references and index.
 ISBN 978-1-137-40311-7 (alk. paper)
 1. Anderson, Wes, 1969—Criticism and interpretation. I. Kunze, Peter C. (Peter Christopher), editor of compilation.
PN1998.3.A526F57 2014
791.4302'33092—dc23

 2013045031

A catalogue record of the book is available from the British Library.

Design by Amnet.

First edition: May 2014

10 9 8 7 6 5 4 3 2 1

Contents

List of Illustrations vii

Introduction: The Wonderful Worlds of Wes Anderson 1
Peter C. Kunze

Part 1

1 The Short Films of Wes Anderson 13
Nicole Richter

2 Cast of Characters: Wes Anderson and Pure Cinematic Characterization 25
Kim Wilkins

3 The Jellyfish and the Moonlight: Imagining the Family in Wes Anderson's Films 39
Steven Rybin

4 "Max Fischer Presents": Wes Anderson and the Theatricality of Mourning 51
Rachel Joseph

5 "Who's to Say?": The Role of Pets in Wes Anderson's Films 65
C. Ryan Knight

6 "American Empirical" Time and Space: The (In) Visibility of Popular Culture in the Films of Wes Anderson 77
Jason Davids Scott

Part 2

7 From the Mixed-Up Films of Mr. Wesley W. Anderson: Children's Literature as Intertexts 91
Peter C. Kunze

8 A Shared Approach to Familial Dysfunction and Sound Design: Wes Anderson's Influence on the Films of Noah Baumbach 109
Jennifer O'Meara

9 Bill Murray and Wes Anderson, or the Curmudgeon as Muse 125
 Colleen Kennedy-Karpat

10 Life on Mars or Life on the Sea: Seu Jorge, David Bowie,
 and the Musical World in Wes Anderson's *The Life Aquatic
 with Steve Zissou* 139
 Lara Hrycaj

Part 3

11 The Andersonian, the Quirky, and "Innocence" 153
 James MacDowell

12 "I Always Wanted to Be a Tenenbaum": Class Mobility
 as Neoliberal Fantasy in Wes Anderson's *The Royal Tenenbaums* 171
 Jen Hedler Phillis

13 Objects/Desire/Oedipus: Wes Anderson as Late-Capitalist
 Auteur 181
 Joshua Gooch

14 Systems Thinking in *The Life Aquatic with Steve Zissou*
 and *Moonrise Kingdom* 199
 Laura Shackelford

Notes on Contributors 215

Index 219

List of Illustrations

Figure 11.1	*Bottle Rocket*: The Hurricanes "don't let defeat get them down."	163
Figure 11.2	*Bottle Rocket*: Dignan is "fuckin' innocent."	163
Figure 11.3	*Fantastic Mr. Fox*: Raised-first salutes.	165
Figure 13.1	*The Darjeeling Limited*: Adrien Brody outruns Bill Murray's metatextual paternal figure.	184
Figure 13.2	*The Darjeeling Limited*: Sons shed their paternal baggage.	184
Figure 13.3	*The Darjeeling Limited*: The paternal figure anchors a desiring chain of train cars.	185
Figure 13.4	*Moonrise Kingdom*: The an-Oedipal objects of Sam's costume.	192
Figure 13.5	*Moonrise Kingdom*: Sam's costume acts as an assemblage.	192
Figure 13.6	*Moonrise Kingdom*: Suzy's objects are largely those of passive consumption like this portable record player.	193
Figure 13.7	*Moonrise Kingdom*: As part of the film's thematics of policed desire, Sam swaps his Scouts uniform for that of his adopted father.	194
Figure 13.8	*Moonrise Kingdom*: In place of his earlier painting of adolescent desire, Sam substitutes a representation of its scene in the film's concluding sequence.	195

Figure 13.9	*Moonrise Kingdom*: To emphasize the connection between art, cinema, and the capture of desire, the film ends with a dissolve from Sam's painting to this shot of the beach.	196
Figure 14.1	*The Life Aquatic with Steve Zissou*: Communicating with cybernetic "albino dolphin scouts."	200
Figure 14.2	*The Life Aquatic with Steve Zissou*: Underwater in the *Deep Search*.	209

Introduction

The Wonderful Worlds of Wes Anderson

Peter C. Kunze

Are any film directors working today as polarizing as Wes Anderson? In less than 20 years and with seven feature films (an eighth, *The Grand Budapest Hotel*, is set for release in March 2014), he has established himself as a creative force to be reckoned with, inspiring overblown diatribes and excessive praise. Christopher Kelly of *Texas Monthly* claims Anderson's films prior to *Moonrise Kingdom* (2012) reveal that he "never seemed to understand real people" (97), while Jonah Weiner contends, "In every film he's made, even the best ones, there's been something kind of obnoxious about Wes Anderson." A. O. Scott, of *The New York Times*, remarks that *The Royal Tenenbaums* (2001) "finally elicits an exasperated admiration. Yes, yes, you're charming, you're brilliant. Now say good night and go to bed." In his review of *The Life Aquatic with Steve Zissou* (2004), Roger Ebert ambivalently concludes, "I can't recommend it, but I would not for one second discourage you from seeing it." On the other side, Elbert Ventura, of *Slate*, and Steven Hyden, Noel Murray, Keith Phipps, Nathan Rabin, and Scott Tobias, of *A.V. Club*, have credited Anderson with inspiring a stream of recent indie films, including *Garden State* (Braff, 2004), *Napoleon Dynamite* (Hess, 2004), *Juno* (Reitman, 2007), and *Charlie Bartlett* (Poll, 2007). In *Wes Anderson: Why His Movies Matter*, Mark Browning claims, "The only movies Wes Anderson films look like are other Wes Anderson films" (ix). On October 26, 2013, *Saturday Night Live* featured a mock trailer for a Wes Anderson horror film entitled *The Midnight Coterie of Sinister Intruders*, starring *The Royal Tenenbaums*'s narrator, Alec Baldwin, as the narrator and *Moonrise Kingdom*'s Edward Norton as frequent

Anderson collaborator Owen Wilson. The sketch volleyed between parody and homage, yet implicitly it solidified the impression that Anderson's style was noteworthy, recognizable, and influential. What remains clear is that Anderson and his films inspire heated conversations, full of hyperbole and generalities, between devotees who see him as nearly infallible and detractors who apparently find little to no redeeming quality in his body of work whatsoever. Perhaps herein lies his success as an artist: not only does Anderson create, but he provokes, amuses, inspires, delights, irks, challenges, charms, and angers his audiences.

One source of this adoration and denunciation of Wes Anderson's films appears to be the director's visual style. In an 1807 letter to Lady Beaumont, William Wordsworth recalled a sentiment Samuel Taylor Coleridge had expressed to her when he wrote, "Every great and original writer, in proportion as he is great or original, must himself create the taste by which he is to be relished; he must teach the art by which he is to be seen" (150). Yet, like every artist, Wes Anderson is derivative and collaborative; his genius lies in his ability to make something new from the wealth of sources he draws from in each film, as well as the numerous associates with whom he has ongoing personal and professional relationships, both onscreen and behind the camera. Attentive eyes and ears will recognize *Bonnie and Clyde* (Penn, 1967) and Jacques Cousteau, the Rolling Stones and *The Catcher in the Rye*, the films of François Truffaut and the music of Benjamin Britten. But despite all of this deliberate allusiveness, Anderson's films have developed into easily identifiable productions through their use of bold colors, popular music, deadpan expressiveness, and devastating one-liners that, like poetry, find their power in their concentration. No critic can satisfactorily lasso Anderson's oeuvre under one generalization because each film shows development and an expected amount of experimentation and risk-taking, yet there are various traits that seem to echo through several, though usually not all, of his films.

A comprehensive list of the defining characteristics of Anderson's aesthetic would be understandably extensive—far beyond what I can or wish to offer here—but I would like to outline some key features that make Anderson's films so charming and infuriating, distinctive and derivative, pleasing and exasperating. Perhaps the most immediately detectable traits are the dry delivery of the dialogue, echoing a coolness and nonchalance that some connect with a pervasive melancholy in his work; the striking use of primary colors that seem to integrate a 1960s and 1970s style into the hard-to-pin-down present; and bird's-eye shots of hands, letters, and other everyday objects that contribute to both the progression of the plot and the development of the characters. Yet these commonly identified features only scrape the surface of Anderson's aesthetic.

His lead male characters—Max Fischer (Jason Schwartzman), Royal Tenenbaum (Gene Hackman), Steve Zissou (Bill Murray), Mr. Fox (George Clooney)—are often self-centered and hubristic, though plagued by doubt, depression, and angst. Usually they are fathers, inept in their fulfillment of this social role, though their haphazard efforts at redemption eventually appear to be somewhat effective. On the other hand, his lead female characters—Etheline Tenenbaum (Anjelica Huston), Felicity Fox (Meryl Streep), and Laura Bishop (Frances McDormand)—are often calm and collected, grounding the more dynamic and more dangerous male characters. They hold the family together, and their own problems are often treated as minute or consciously concealed from others. The traditional nuclear family units break down through infidelity, divorce, and death, and surrogate units arise in their place, be it a group of friends, coworkers, or a scout troop. While the characters may be broken, they are not beyond repair.

The tone of the films often alternates between an ironic mode that is detached and seemingly disinterested and a sincere mode that seeks connection, redemption, and affection. Child figures and childhood provide a foil for understanding adult ineptitude and inadequacy, framing the existential concerns that linger throughout the films and often manifest themselves in the characters' blank stares and dispassionate utterances. The betrayal, failure, and anxiety that plagues the characters at the outset are somewhat ameliorated by the narrative's end, and the disparate cast of characters is happily united (and unified), as revealed by a slow tracking shot. The reunion is the resolution, which may lead to dancing (*Rushmore* (1998) or *Fantastic Mr. Fox* (2009)) or a collective exit in good spirits (*The Royal Tenenbaums* and *The Life Aquatic with Steve Zissou*)—moments often captured with slow motion cinematography.

Despite these shared characteristics, the focus on Anderson as the sole responsible party remains problematically persistent. Such a presumption perpetuates Wordsworth's Romantic conception of the artist while minimizing the considerable impact of the collaborators who populate both his movie sets and his filmic worlds. Devin Orgeron has convincingly demonstrated how Anderson deliberately perpetuates this notion, and recently, Matt Zoller Seitz has tried to counter this popular image of Anderson.[1] Film studies, both popular and academic, has long challenged the persistence of the auteurist approach, from film critics Pauline Kael and Richard Corliss, who both advocated the role of the screenwriter, to scholars Thomas Schatz and Jerome Christensen, who rightfully turn our attention to the studio system and corporate Hollywood, respectively, as an undeniable authorial force. Criticism of all directors, Anderson especially, needs to more carefully consider the role of partnerships and collectives in the production of what is an inherently collaborative art form.

Owen Wilson, Noah Baumbach, and Roman Coppola alternately have cowritten the scripts to all of Anderson's films, while Robert Yeoman's cinematography has immeasurably impacted the visual style we too often credit to Anderson alone. The film's music, a combination of unearthed classics and new compositions, can be credited to composers, such as Mark Mothersbaugh and Alexandre Desplat, and music supervisor Randall Poster. Indeed, "Wes Anderson" may best operate as a metonymic term for the team of technicians and artists whose efforts behind and in front of the camera yield such highly imaginative and technically impressive films. Just as family units form the core of Anderson's film narratives, the production-team "family" may be the best model for appreciating "his" work.

These traits testify to Wes Anderson's and his collaborators' personal interests and obsessions, flavoring their films in a way that make them easily recognizable. Love him or hate him, Anderson has clearly emerged as one of the preeminent filmmakers in recent Hollywood cinema, a fact reinforced by *Moonrise Kingdom*'s selection as the opening film of the 2012 Cannes Film Festival. If, as Warren Buckland contends, Wes Anderson's films capture "the structure of feeling of the present moment" (4), we should continue to give serious treatment to his growing body of work. The present collection seeks to perform such critical work by continuing the active discussion around Wes Anderson, his collaborators, and their films, as well as his influence on contemporary film culture.

The Films of Wes Anderson is the first edited collection to examine Wes Anderson's film work in its entirety, including his most recently released film (as of November 2013), *Moonrise Kingdom* (2012). It builds upon an already impressively extensive amount of criticism on Wes Anderson, from film reviews in the popular media to blogs to journal articles in some of the leading film studies journals. The essays that follow come from a variety of perspectives that consider how Anderson's distinctive form and content work together to create films that are simultaneously reverent toward their sources and original in their execution. These new interpretations aim not only to read Wes Anderson through a practical and theoretical lens, but also to address and explain the recurring stylistic techniques, motifs, and themes that dominate Anderson's films. Critics have claimed Wes Anderson creates his own world, but more accurately, he creates his own *worlds*. From the idyllic prep school in *Rushmore* to the mythical New York City of *The Royal Tenenbaums* to the English countryside of *Fantastic Mr. Fox*, each film drastically shifts its setting from the world that preceded it in the last film. His characters are a bit more consistent: Anderson admitted to Arnaud Desplechin, "I do feel a bit like my characters from one movie could walk into another one of my movies and it would make sense." Deadbeat dads, tough mothers, lost souls, precocious children, charismatic

schemers, impractical dreamers—these figures populate the worlds of Wes Anderson. What brings them together is not a common interest, setting, or concern, but a sense of wonder. That is what they find in their worlds, and that is often what we see when we watch Anderson's films: a visual spectacle that creates an alternate, artificial universe where characters nevertheless have real problems and search for honesty, redemption, and community.

The following essays represent 14 new perspectives on Wes Anderson, his films, and their contribution to cinema and popular culture at large. Informed by both the growing corpus of Anderson criticism as well as contemporary theoretical trends in film and cultural studies, the essays seek to extend our understanding of Anderson while also challenging existing prejudices and presumptions in how we discuss this seemingly unique and undeniably influential American filmmaker. While the contributors share a fascination, even admiration, for Anderson, they diverge entirely in their discussions of his importance on various fronts: artistically, politically, culturally. The end result, hopefully, will inspire curiosity, conversation, and criticism.

The Films of Wes Anderson is separated into three clusters, though this loose arrangement aims to put the pieces into conversation with one another, rather than suggesting they are wholly insular or unconcerned with issues beyond their part of the book. Indeed, issues of style inform collaboration and engagement, so one could understandably argue such delineations are arbitrary. Nevertheless, the goal is to draw attention to ongoing concerns within Anderson criticism and often film studies at large, including the development of style and establishment of authorship, the inherent collaborative nature of filmmaking and its implicit challenge to auteurist approaches to film history and criticism, and the political nature and import of film in this sociocultural moment.

The first cluster features six essays examining the development of Anderson's aesthetic, addressing issues surrounding form, characterization, and intertextuality. In the lead essay, Nicole Richter considers how a focus on Wes Anderson as a feature filmmaker has skewed critical discussions of his artistry. Drawing on theoretical work by Richard Raskin, she develops the understanding of Anderson as a storyteller through close attention to the important, though often underappreciated, cinematic form of the short film. Kim Wilkins shifts our focus to characterization in Anderson's films, arguing that there is a fundamental disconnect between his characters and real people. While the characters may be empathetic, this trait is relegated to within the film narrative and does not continue after the film's conclusion. They are, in effect, "pure cinematic" creations. Steven Rybin's chapter develops the discussion of Anderson's characters through an analysis of the fragmented family unit within his films. The narrative work of the films is therefore to reunite these families through the careful construction

of images and selection of emotionally evocative music. The role of melancholy and loss in Wes Anderson's work is of equal concern to Rachel Joseph, who contends staging within the films' narratives echoes the function of theatricality as a form of mourning. Through staged productions, Max Fischer (Jason Schwartzman) of *Rushmore* and Sam Shakusky (Jared Gilman) and Suzy Bishop (Kara Hayward) of *Moonrise Kingdom* perform love and capture the emotional moment within an artistic medium.

The cluster rounds out with two essays that examine two noticeable components of Anderson's style: animals and allusions. In a 2012 *New Yorker* blog post following the release of *Moonrise Kingdom*, Ian Crouch mused, "Does Wes Anderson hate dogs?" C. Ryan Knight's contribution to this collection takes up this issue, among others, in his discussion of the role of pets in Anderson's films. Drawing on work from posthumanist theory, including animal studies, Knight builds on strains in Rybin's and Joseph's chapters to demonstrate how pets allow the human characters to build community while coping with loss. Finally, Jason Davids Scott interrogates the use and function of popular culture within Anderson's films, both in establishing the setting and building character. In his films' fundamental altering of time and space, Anderson creates a distinctively new product from the old while emphasizing the characteristic outsider sensibility of the subjects of his films. This manipulative allusiveness segues into the second cluster, which examines not only sources in Anderson's films, but the integral role of collaboration in the creation of these distinctive cinematic narratives.

The question of influence informs the second cluster, as the various critics closely consider both the source material and the impact of collaborators on Anderson's oeuvre. Peter C. Kunze's chapter extends the role of popular culture in Anderson's work to consider an often overlooked source for his aesthetic and stories: children's literature. Through a discussion of how children's literature alternatively serves as inspiration, source text, and prop, Kunze argues that Anderson's indebtedness to children's literature informs his ongoing deconstruction of the child/adult binary that organizes interpersonal relationships between the two groups in his films and within society at large. The remaining three chapters illustrate the impact of a collaborator on the flavor many see to be characteristic of Anderson's films. Jennifer O'Meara's chapter draws upon David Kipen's "Schreiber theory" to delineate the role of coscreenwriter Noah Baumbach's work on Anderson's films and, in turn, Anderson's influence on Baumbach's own films, including *Margot at the Wedding* (2007) and *Greenberg* (2010). By first establishing commonalities between the filmmakers' works, O'Meara is able to trace the key differences that allow each to hone their individual cinematic voices. Colleen Kennedy-Karpat turns our attention to the impact of a star

and his persona on the creation of a film by examining the career of, arguably, Anderson's most popular recurring star, Bill Murray. From his initial success in broad comedies to his later work with Sofia Coppola and Jim Jarmusch, Bill Murray's onscreen comic persona has matured and transformed significantly, due in large part to his work with Anderson, beginning with the 1998 film *Rushmore*. Lara Hrycaj wraps up the section with a compelling study of Seu Jorge, the actor and musician who, as the crew's safety expert, Pelé dos Santos, performs charming Portuguese renditions of David Bowie that help to create the mood of Anderson's *The Life Aquatic with Steve Zissou*. Since Jorge took some liberties with the translations—to an extent of which Anderson was unaware—Hrycaj contends that the songs both contribute to Anderson's attempt to impose an auteur identity and implicitly challenge the implied singularity of such a designation. Collectively, these chapters unsettle the prevailing romantic tendency to view Wes Anderson as a singular genius. Instead, what emerges is an impressive team of behind-the-camera and onscreen collaborators, led by Anderson, who manage to create a unique world within each film that is nevertheless united throughout Anderson's oeuvre by a similar sensibility, sense of humor, and style.

In the final part, critics offer theoretically rigorous chapters that examine the extent to which Anderson's films are politically and socially engaged. While many fans and critics alike celebrate Anderson's films for their considerable charm and nostalgic whimsy, a noticeable contingent decries this feature as nauseating and repetitive. In the same vein, some detractors have extended this critique to deem the films self-indulgent, ostentatious, and apolitical. Informed by theorists as diverse and divergent as Slavoj Žižek, Gilles Deleuze, Felix Guattari, and Pierre Bourdieu, these chapters reconsider Anderson's film poetics and politics with keen insight and intellectual rigor. At the outset, James MacDowell expands on his ongoing theorization of the "quirky" sensibility by challenging critical assumptions that Anderson's thematic examination of innocence is conservative, even reactionary. In its desire for commitment, innocence in Anderson's work, MacDowell argues, rebuffs the perceived regressive nature of nostalgia. Jen Hedler Phillis, on the other hand, engages politics via the question of what being a Tenenbaum entails, playing upon the names of ensemble characters Royal Tenenbaum and Eli Cash. Rejecting lineage and finances in favor of taste, Phillis's chapter traces a turn toward neoliberalism in American society and culture while emphasizing how *The Royal Tenenbaums* ultimately underscores neoliberalism's fictionality.

Joshua Gooch's concern over objects and the desire imposed upon them leads to a compelling analysis of Anderson's oeuvre through the work of Deleuze and Guattari. Such an analysis, Gooch contends, reveals the films'

dependence on a tension between personal investment of one's desire onto objects and commodity fetishism. Understanding these oedipal connections poses consequences for both the resolution of the narrative and the popular consumption of Anderson's work. Laura Shackelford, drawing on cybernetics and systems thinking, concludes the cluster and the book with an examination of how Anderson's work negotiates the relationship between the characters, nonhuman animals, and the material world. This analysis reveals not only how world building occurs within the narratives of *The Life Aquatic with Steve Zissou* and *Moonrise Kingdom*, but how the subject and society itself are constituted. Taken together, these chapters embody an impressive reimagining of Anderson's art, both within the worlds he creates and in their connections to the society from which they emerge. Consequently, these writers complicate the broad generalizations that characterize popular opinion of Anderson and, to a degree, many of the academic arguments made about his work as well.

The essays are wide in their considerations and methodologies, and they share a personal intellectual interest in Anderson's work. While they enjoy the worlds Anderson creates on the screen, the scholars herein are equally intrigued by how it works and what it reveals about Anderson, film, and our culture at large. What follows is an attempt to understand those worlds, to capture them, to interpret them, to explain them—to revel, like his characters, in the wonders of Wes Anderson's filmic worlds and, by extension, the world of cinema itself.

Note

1. In an interview to promote his book, *The Wes Anderson Collection*, Matt Zoller Seitz comments, "The biggest surprise in spending all of these hours interviewing Wes was learning that he's not really as much of a control freak as his movies suggest."

Works Cited

Anderson, Wes. Interview with Arnaud Desplechin. *Interview*, October/November 2009. Web. March 3, 2013.
Buckland, Warren. "Wes Anderson: A 'Smart' Director of the New Sincerity?" *New Review of Film and Television Studies* 10.1 (2012): 1–5. Print.
Christensen, Jerome. *America's Corporate Art: The Studio Authorship of Hollywood Motion Pictures*. Stanford, CA: Stanford UP, 2012. Print.
Corliss, Richard. *Talking Pictures: Screenwriters in the American Cinema, 1927–1973*. Woodstock, NY: Overlook Press, 1974. Print.
Crouch, Ian. "Does Wes Anderson Hate Dogs?" *Culture Desk* (blog). *The New Yorker*, June 22, 2012. Web.

Ebert, Roger. Review of *The Life Aquatic with Steve Zissou*. RogerEbert.com, December 23, 2004. Web.

Hyden, Steven, Noel Murray, Keith Phipps, Nathan Rabin, and Scott Tobias. "10 Films That Couldn't Have Happened without Wes Anderson." *The A. V. Club*, October 9, 2007. Web.

Kael, Pauline. *The Citizen Kane Book*. Boston: Little, Brown, 1971. Print.

Kelly, Christopher. "Wes Is More; or, How I Learned to Stop Hating the Director of *Rushmore* and Love *Moonrise Kingdom*." *Texas Monthly* 40.11 (November 2012): 96–97, 106. Print.

Orgeron, Devin. "La Camera-Crayola: Authorship Comes of Age in the Cinema of Wes Anderson." *Cinema Journal* 46.2 (Winter 2007): 40–65. Print.

Schatz, Thomas. *The Genius of the System: Hollywood Filmmaking in the Studio Era*. New York: Pantheon, 1988. Print.

Scott, A. O. "Brought Up to Be Prodigies, Three Siblings Share a Melancholy Oddness." Review of *The Royal Tenenbaums*. *New York Times*, October 5, 2001. Web.

Seitz, Matt Zoller. "Matt Zoller Seitz Talks His Book *The Wes Anderson Collection*." Interview by Ross Scarano. *Complex*, October 8, 2013. Web.

Ventura, Elbert. "The Ubiquitous Anderson." *Slate*, May 21, 2009. Web.

Weiner, Jonah. "Unbearable Whiteness." *Slate*, September 27, 2007. Web.

Wordsworth, William. "Letter to Lady Beaumont. 21 May 1807." In *The Letters of William and Dorothy Wordsworth*, 2nd ed., Vol. 2., edited by Ernest de Selincourt, 145–51. Oxford: Clarendon, 1969. Print.

Part I

The Short Films of Wes Anderson

Nicole Richter

Wes Anderson's feature-length filmmaking has largely been met with critical acclaim, with widespread consensus among critics that, at the very least, Anderson is a modern-day auteur with a distinct directorial style.[1] Critical studies of Anderson's work range from large-authorship analyses, like Mark Browning's 2011 book-length work, *Wes Anderson: Why His Movies Matter*, Tod Lippy's "Wes Anderson," or Devin Orgeron's director study, to scholarship about more specific themes in Anderson's filmmaking, such as Cynthia Felando's work on women and aging, James MacDowell's essay on tone and quirky sensibility, or Joshua Gooch's discussion of fatherhood. While these works each have something important to offer readers, what is missing from the current scholarship surrounding Anderson is an analysis of his short films.

Criticism about Anderson's work is heavily skewed toward his feature filmmaking. At first glance this may seem appropriate, but even a cursory numerical accounting of Anderson's films shows a blind spot in Anderson scholarship. To date Anderson has directed seven feature films and three (arguably four) short films. This problem with scholarship is not unique in relation to Anderson's work, specifically, but rather reflects a critical bias against the short film in general. Richard Raskin, in his pioneering book, *The Art of the Short Fiction Film*, argues that short fiction films have "received little attention within the university community with regard to teaching and research . . . At many film schools today, students are implicitly encouraged to think of [them] . . . as though they were miniature feature films, rather than as works belonging to an art form in its own right" (1). In his analysis of the short-fiction form, "The Art of Reduction," Matthias Brütsch agrees with Raskin, explaining that, although short films

are popular, "film studies has displayed a persistent lack of interest for the short format," which is often marginalized because short films are thought of "only as an exercise for beginners, as a 'calling card' that may help on the path towards making 'real,' i.e. feature films" (1).

Consistent with the continual lack of attention paid to the short-film genre by critics, Anderson's short films—*Bottle Rocket* (1994), *Hotel Chevalier* (2007), *Cousin Ben Troop Screening with Jason Schwartzman* (2012), and *Moonrise Kingdom Animated Short* (2012)—have had relatively little written about them. Anderson's continued engagement with the short-film format points to his alternative perspective on the form. His choice to release his features films alongside related shorts separates him from traditional approaches to filmmaking. An analysis of Anderson's short films expands our understanding of his worldview because his short-film work approaches narrative and pacing differently than his feature work.

Based on Raskin's criteria, I argue that *Hotel Chevalier* belongs in the pantheon of the history of great short films—alongside Jean Rouch's *Gare du Nord* (1964), Jean-Luc Godard's *Montparnasse et Levallois* (1965), Tom Tykwer's *Faubourg Saint-Denis* (2006), and Jim Jarmusch's *Coffee and Cigarettes* (1986). *Hotel Chevalier* stands alone on its own merits and is as successful as, if not more than, the feature it was released as a prologue to, *The Darjeeling Limited* (2007). In applying Raskin's conceptual short-film model to Anderson's shorts, I attempt to explain how Anderson's storytelling in the short film differs from his feature-length presentations. The format of the short film allows stories to be told differently, and Anderson's *Hotel Chevalier* breaks new ground in narrative possibilities, while *Bottle Rocket* is only partially successful as a short. The two shorts released with *Moonrise Kingdom* are consistent with Anderson's feature-filmmaking approach whereby "the concept of 'story' and 'storytelling' is self-consciously foregrounded in Anderson's work" (Thomas 104). However, it is with *Hotel Chevalier* that we come to know Anderson more intimately as a filmmaker, as the emotional core of his art comes through with full force.

While most academics writing about Anderson's work avoid a discussion of his short films altogether, there are a few critics who at least give passing acknowledgment to his shorts. Joseph Aisenberg assesses Anderson's career as a whole, with only two passing references to *Hotel Chevalier* and no references to *Bottle Rocket*. Aisenberg references *Hotel Chevalier* as "the short film pre-ambulating *Darjeeling*," and later in the article he mentions his disgust at the thinness of Natalie Portman's body in the short. This terse reference to *Hotel Chevalier* can hardly be called a review of the film. In Aisenberg's study, the film exists, but it does not deserve space for serious analysis in his assessment of the director. Mark Browning commits several pages of his book *Wes Anderson: Why His Movies Matter* to analysis

of Anderson's short film *Bottle Rocket* (1994). Browning's main arguments about the 16 mm short revolve around a comparison between the short and the feature film based on it. Browning does little more than explain what is lacking in the short that makes its way into the feature. Browning's criticism is inevitable, of course, since the short is a short and not a feature. Browning, however, does observe, "Although radically shorter than the feature, there is a tenser dynamic at work here between the three leading roles" (3).

Browning's analysis of *Hotel Chevalier* is slightly more detailed than his review of *Bottle Rocket*, but it reinforces the marginalization of short film. Browning calls *Hotel Chevalier* "an appetizer, a short before the main feature" that has "the feel of a very extravagant DVD extra or trailer for the longer film" (76). Claiming the short is "dispensable," Browning questions whether it just "seems self-indulgent" (76). It is more useful to approach the film as a self-contained text that bears a relationship to *The Darjeeling Limited* but functions independently of it. Browning frames the short as a teaser to the longer film, implying the feature film is of primary importance and the short unnecessary, since *The Darjeeling Limited* can be viewed on its own terms. Seeing this short as self-indulgent misses the point—Anderson has released two films that should be valued on the same level (length should not determine quality), and viewers are able to access two films for the price of one.

The dynamics of storytelling in the short-fiction-film form are substantially different than those in the feature film. In the feature film, the two most common approaches to narrative are the three-act structure and the monomyth. Syd Field, the most well-known advocate of the three-act structure in screenwriting, argues that screenplays can be divided into three parts: setup, confrontation, and resolution. Other screenwriters use Joseph Campbell's narrative pattern of the monomyth, or "The Hero's Journey," which is broken down into 17 distinct stages the hero goes through on his or her journey. Neither theoretical approach to the study of narrative applies adequately to narrative dynamics in the short fiction form. Recognizing that while "such models may be useful in working with feature films, the greater freedom of the short fiction film requires a more flexible approach" (2), Richard Raskin proposes a conceptual framework for the short film, consisting of seven parameters that, when balanced, exploit the storytelling potential of the short-film format. The parameters are as follows:

1. Character-Focus vs. Character-Interaction
2. Causality vs. Choice
3. Consistency vs. Surprise

4. Image vs. Sound
5. Character vs. Object and Décor
6. Simplicity vs. Depth
7. Economy vs. Wholeness

While each parameter need not be present in every successful short, balance in two or three areas is likely to make a great short.

Bottle Rocket

Bottle Rocket (1994) premiered as a 13-minute short at Sundance, and it made quite an impression on producer James L. Brooks, who commented:

> When I first saw the thirteen-minute video I was dazzled—the language and rhythms of the piece made it clear Wes and Owen were genuine voices. The possession of a real voice is always a marvel, an almost religious thing. When you have one, it not only means you see things from a slightly different perspective than the billions of other ants on the hill, but that you also necessarily possess such equally rare qualities as integrity and humility.

The strength of the film lies in the fact that it does establish Anderson as a unique voice in filmmaking through its witty screenwriting and strange characterization, and it introduces audiences to the ironic tone and offbeat mood of an Anderson film. The short makes strong use of the fifth of Raskin's parameters (character versus object and décor), most notably in a close-up shot of a carefully arranged marching band on the dresser of a room that is being stolen from and the close-ups of various significant objects in Dignan's escape plan.

The film, while containing many thematic and stylistic aspects that Anderson returns to in his feature filmmaking, does not make use of the strengths of the short-film format. Instead, it functions like a screen test for the feature of the same name that Anderson goes on to make. The short is unbalanced in several ways, most notably in character focus versus character interaction. There is no character focus in the short since the film presents two characters, Dignan (Owen Wilson) and Anthony (Luke Wilson), to us simultaneously, emphasizing character interaction instead. The empathetic attachment to characters found in *Hotel Chevalier*, for example, is not present. The feature film makes more of an impact since it centers on Dignan as the main character. The conversation that takes place between Dignan, Anthony, and Bob (Robert Musgrave) in the diner is reminiscent of Jim Jarmusch's *Coffee and Cigarettes*. *Coffee and Cigarettes* succeeds in being a great short film because it is simplified down to one conversation

between Roberto Benigni and Steven Wright. In the short-film form, there is less time to develop complexity, and this lack of development is why *Bottle Rocket* feels more like a shortened version of a feature than a short film in its own right. Character development is limited because so much of the short is focused on the action of the robbery that no single strength breaks through the complexity of the narrative. Anderson was thinking of the feature film while making the short, and the script was feature length before the short was even made. Anderson explains, "That short was supposed to be just an installment of the feature" (Murray 2008). Early in his career, Anderson privileged feature filmmaking, seeing the short as secondary. He overcomes this problematic way of thinking by the time he begins working on *Hotel Chevalier* and exploits the inherent strengths of the short-film format to explore the emotional complexity of love.

Narrative Construction in *Hotel Chevalier*

Several critics have discussed their disappointment with *The Darjeeling Limited*. Aisenberg argues that *The Darjeeling Limited* "remains abstractedly adrift throughout, a special feature of almost all of Anderson's films, I suppose, but here lacking any zest." Browning claims that Anderson's attempt to make a movie about India can "only be viewed as a failure" (87). While I agree that *The Darjeeling Limited* is one of Anderson's weaker films (but still a strong film when evaluated on its own), *Hotel Chevalier* was a revelation; it is a superior film to *The Darjeeling Limited* and provides an ideal opportunity to discuss the strengths of the short form over the feature. It also demonstrates why Anderson continues to work in the short form, despite being a successful feature director. *Hotel Chevalier* is usually described as a prologue to *The Darjeeling Limited*, and while it certainly is this, it is so much more. To understand it merely as a prologue, positions it as a precursor to the "real story" as told in the feature. Anderson financed the film himself and originally intended for it to be a standalone piece, but he had trouble figuring out how to release the film to audiences. Anderson explains in an interview with the *Boston Phoenix*, "When it was all done, I didn't want to incorporate the short into the movie. But I couldn't decide how I wanted it to go. I wanted to play the short in front of the movie, but not always. Sometimes I preferred to watch the movie without the short. It became a puzzle to me. So in the end I decided that I would like to have the movie open in America without the short, but I would like people to have access to it if they want to see it first." The difficulty Anderson had with placing the short speaks to the structural exclusion of the short film from channels of distribution. In essence, *Hotel Chevalier* and *The Darjeeling Limited* are two separate films, each deserving their own

audience response. Anderson's decision to release them separately emphasizes the idea that *Hotel Chevalier* is a narrative universe in and of itself.

Hotel Chevalier's strength as a short film lies in its narrative construction, which utilizes several of the parameters present in Raskin's model. The parameters most present in the short are character-focus versus character-interaction, character versus, object and décor, and image versus sound. Character-focus is established immediately in *Hotel Chevalier*, which opens with a scene of Jason Schwartzman attempting to order grilled cheese in French from the front desk of his hotel. He is alone and it is clear that he is the main character of the short. The intensity of the film is subdued in the beginning because the first minute of the film shows Schwartzman alone in his hotel room, but character-interaction in the short keeps our interest engaged. When Natalie Portman's character calls on the phone, announcing her surprise visit to his hotel room, the narrative direction of the short is initiated, and with Portman's arrival, the intensity of the short escalates. Brannon M. Hancock argues that a central quality of Anderson's character narrative development lies in the relationality between self and other. He claims Anderson's approach to personhood depends on "characters' *recognition that authentic being or personhood is found only in communion*, which is to say in radical inter-relationship with others through participation in a particular community of character(s)." Hancock's analysis helps explain why Portman's character tracks down Schwartzman, in order to reconnect despite her knowledge it won't work out. Portman is acknowledged as a self through Schwartzman's deep knowledge of her as a person—he knows her in a way no one else does (he knows, for example, to hand her a toothpick at a particular moment). They become full selves through their mutual recognition of one another, so that "being is actually *becoming*, for it is a participatory process of discovering the Self in the Other and the One in the Many that leads out of isolated individuality and into personhood" (Hancock). This singular moment of becoming, together in the hotel room, is the point of the encounter; they both move out of alienated individuality toward a communion with one another. In this encounter, they become fully present in the moment, and the encounter need not lead to anything more than this. The fact that the audience doesn't know the full story elevates this particular story to a universal one—this film is about relationships in general and speaks to how all human beings more fully become themselves when they are face-to-face with another being that acknowledges who they really are. The interaction between Portman and Schwartzman in the film is the primary strength of the narrative.

Anderson's films are renowned for their detailed attention to set construction, but in the short film this Anderson trademark becomes even more necessary. The interaction between characters and object and décor

in *Hotel Chevalier* conveys a wealth of information quickly, providing depth to each character in a limited amount of time. A considerable amount of the film is spent positioning and repositioning objects in the hotel space: firstly by Schwartzman as he prepares for Portman's arrival, and secondly by Portman as she discovers Schwartzman's space. The interactions with objects inform character interactions in the film since very little verbal communication occurs. After Schwartzman receives the phone call, he spends almost 2 full minutes of the film (substantial since the short is only 13 minutes) picking up clothes in his hotel room, pouring a bath and putting in bubble bath, changing the lighting, turning off the TV, pulling a figurine out of storage and setting it on the table, setting his iPod to the perfect song, and changing into a suit. Portman knocks, and instead of answering the door immediately, he turns on his iPod, setting the mood for Portman's arrival into the space. As he opens the door, she is on her cell phone, the object mediating their first interaction; she only says, "What's this music?" and proceeds to hand him flowers as they embrace. She is chewing on a toothpick when she arrives, and she wanders around the space: first attending to a small altar of figurines and pictures, then to a second setting of candles and a butterfly mounting while she plays a miniature music box, and then to a desk of his paintings and paints. She walks into the bedroom, opens a trunk, and puts something inside it; she then walks to the bathroom, grabs his toothbrush, and brushes her teeth. This series of interactions with objects in the space takes up a minute of the film and constructs the ambiguous mood and the dense atmosphere of the film. The silences between the couple are filled in with the décor of the space. After all, as Stefano Baschiera claims, "The cinema of Wes Anderson is a cinema of objects . . . Objects are not a mere element of décor in his films; they are central to the development of the narrative, and, consequently, to the meaning of the film, to the extent that the cinema of Wes Anderson overcomes the separation between subjects and objects" (118). Often he uses objects in the home to develop the narrative (as in *The Royal Tenenbaums*), but this location is importantly not a home but a hotel room, a transient space, which makes the objects all the more meaningful, as they in some way transform it into a home. While symbolically charged, the objects have no specific meaning in themselves; all initiate a chain of signification that is never fully resolved. The last minute of the film centers around the two characters interacting in the space: a slow motion movement of Schwartzman putting a robe on Portman as the two of them walk outside to the balcony to see the view of Paris. Schwartzman hands her a toothpick, solidifying their special understanding of one another. The toothpick stands in for a shared sense of mutual understanding and provides the resolution to the film—simply that he knows her, and she knows that he knows her. No other resolution is provided.

The third parameter that *Hotel Chevalier* is particularly strong in is image versus sound. Image and sound interact in the film in a beautiful way, especially through the use of music. The music in the short metaphorically comments on the action and adds meaning and expression to the characters' private thoughts. The sound advances character development by articulating the "meta" idea of the piece through the use of Peter Sarstedt's 1969 song "Where Do You Go To (My Lovely)?" The song reinforces the importance of objects in Anderson's work, with lyrics such as "There's diamonds and pearls in your hair" and "Your clothes are all made by Balmain." The song lyrics are about clothing, collections, and settings. The music acknowledges the importance of detail—what people wear and what they collect is not superficial. In Anderson's view they provide individual meaning in people's lives and help define the context of our being. Anderson's work as a whole emphasizes the importance of surroundings in living one's life, and the song comments on the mise-en-scène of *Hotel Chevalier* as well as Anderson's approach to filmmaking more generally.

Hotel Chevalier and Popular Culture

Hotel Chevalier is intimately related to French New Wave short filmmaking, specifically the French anthology film *Paris vu par . . . (Six in Paris,* 1965). *Six in Paris* features vignettes of different locations in Paris, from six New Wave directors, including Éric Rohmer, Claude Chabrol, and Jean Douchet, but the two vignettes that share the most resemblance with *Hotel Chevalier* are Jean Rouch's *Gare du Nord* and Jean-Luc Godard's *Montparnasse et Levallois*. The central theme of *Gare du Nord* is the communication, or failure of communication, between a married couple. The woman desires to lead an adventurous life, and the man is content with mediocrity; the two argue over their vision of an ideal life. Upon leaving the apartment after the quarrel, the woman meets a man who embodies all she claims to desire in a partner, and upon refusing his invitation to join him in adventure, the man jumps to his death. *Hotel Chevalier* seems to begin where *Gare du Nord* leaves off—what happens when the woman returns to the man she rejected for being dull?

It is slowly revealed in *Hotel Chevalier* that Natalie Portman's character has run away from Jason Schwartzman's character in the past, and it is implied through the way the two interact—Portman, adventurous and very much in command; Schwartzman, detached and passive—that Schwartzman wasn't audacious enough for her. It is made clear that Portman has slept with other men since their break-up, while simultaneously being made clear that Schwartzman has not slept with other women. And Portman's return signals a failure to find in her relationships with other

men the thing she is seeking. She finds something in Schwartzman that she wants to return to, yet he isn't enough for her to stay with permanently. The beauty of the film lies in this very paradox: the desire for part of the other but not the whole thing. The transience of the space (the hotel room) and the temporariness of the moment (she is leaving tomorrow) construct a momentary zone of freedom and love that does not demand a further commitment. The structure of the short film is particularly well suited to explore this paradox since it allows narrative to develop without exposition or closure—we begin in the middle and end in the middle of the story. The middle becomes primary, a rarity in feature-film narrative, which generally prioritizes the ending (or Act 3). Brütsch explains, "Longer films, especially features obeying classical rules of storytelling, usually try to make sure that in the end all questions raised are adequately answered. Short films . . . more often leave issues open, in suspense, undecided . . . The best examples . . . [achieve] an intriguing ambiguity, surprising given their limited duration" (7). The subject of the film, like the shorts in *Six in Paris*, is a specific location in Paris that enables the creation of a specific type of experience—as long as they are in the Hotel Chevalier, Portman and Schwartzman can delay dealing with the problems in their relationship and enjoy one another without precondition or future commitments.

Anderson's way of writing the dialogue—and slowly allowing the conversation to unfold in a naturalistic way—is very reminiscent of the way Jean-Luc Godard filmed intimate conversations between couples. The extended apartment scenes in *Contempt* (1963) and *Breathless* (1960) work virtually in the same way as Anderson's short. Anderson builds an entire film around one of the scenes—one location, one couple, one conversation—and approaches Godardian themes, such as the impossibility of communication between men and women, and the incompatible desire of man and woman in a purified form. Godard's short *Montparnasse et Levallois* is Godard's attempt to explore these "modes of discourse" in the shortened form (Monaco 146). Godard explains that when watching the film you are "able to feel existence like physical matter: it is not the people who are important, but the atmosphere between them" (211–12). Anderson approaches the two characters in *Hotel Chevalier* in the same way: what matters is not each character individually but the atmosphere between them. The eroticism of the film is derived from the space shared between Portman and Schwartzman.

The atmosphere between them is heightened by the delay of narrative development. There is no exposition that explains how the characters got to where they are or what they are doing there. One critic, in discussing Godard's use of narrative delays, claims, "One of his narrative strategies is to seemingly do any and everything possible to avoid that proverbial 'cut to the chase'" (Carr). The dramatic tension in *Hotel Chevalier* is

narratively derived in the same way since Portman and Schwartzman (and, at a deeper level, Anderson) refuse to say what they are really feeling, both of them failing to "cut to the chase." Most of the film is spent disavowing, ignoring, suppressing, and repressing the truth of the matter. Small details emerge over time, but the film never does fully speak the truth into existence; rather, the film is about the ways in which human beings are incapable of getting to the point and incapable of being direct. Anderson reinforces this idea through the mise-en-scène of the film, the chain of meaning (mentioned previously) initiated by objects in the space that is never resolved. The lack of resolution is reinforced by the short's structural relationship to *The Darjeeling Limited*. They are related in one way; that is to say, they share a resemblance and overlap. But one does not structurally define or determine the other. *Hotel Chevalier* is intertextually referenced in *The Darjeeling Limited*, but the reference itself is the meaning—one film does not elucidate the other. The same is true of Godard's *Montparnasse et Levallois*—the story related in the short is the same as the story Jean-Paul Belmondo reads to Anna Karina in the feature *Une femme est une femme* (1961).

Hotel Chevalier should also be analyzed alongside *Paris, je t'aime*, a 2006 anthology of short films, each set in a different district of Paris. *Paris, je t'aime* is made in the spirit of *Six in Paris*, the primary difference being that the directors involved in the anthology come from diverse national backgrounds, instead of being only French. While there are several strong works in the anthology, *Faubourg Saint-Denis* is of primary interest here because it stars Natalie Portman and preceded *Hotel Chevalier* by merely a year. Directed by Tom Tykwer, the film centers on a moment of miscommunication between a couple: Natalie Portman, playing an American actress in Paris, and Melchior Beslon, playing her blind boyfriend. Most of the film is told through montage, showing the repetitive actions taken by each person in the relationship and eventually leading to a breakdown in passion. Like *Hotel Chevalier* the woman desires more, while the man desires the same. One could imagine Anderson making *Hotel Chevalier* in this fashion, since one of the four main stylistic traits of Anderson's films mentioned earlier is the use of montage. *Hotel Chevalier*, in rejecting the use of montage, actually maintains more of the impossibility of communication between the couple since it fails to explain how or why the break-up in the couple occurred in the first place.

Faubourg Saint-Denis is also related to the film through Natalie Portman's star persona, bringing her previous short film work into her *Hotel Chevalier* performance, but Anderson pushes the themes Tykwer is working with into a more subtle and mysterious direction. Portman's lover in *Faubourg Saint-Denis* literally can't see her and fails to understand who she

really is until a moment of insight gleaned from a false performance initiated by Portman enables him to fully see her metaphysically. "I see you," says Thomas at the end of the film. *Hotel Chevalier* is less optimistic and hopeful—the couple doesn't acquire any new knowledge from their temporary meeting—yet Anderson finds it meaningful enough that they meet and share time together. Impermanence and open-endedness are all there is here, and this ambiguity plays well into the short-film format, which "[has] more to do with allusion, paradox, ambiguity, simplicity and playfulness than with epic grandeur, complete fictional immersion and intricate plot development" (Brütsch 9).

Matthias Brütsch proposes the idea that shortness is an opportunity, not an obstacle; he asks the question, "What is possible *not despite but because of the limitation in time?*" Wes Anderson answers this question with *Hotel Chevalier*. Anderson is freed in *Hotel Chevalier* to focus intensely on one idea, to reduce the experience of a romantic relationship to a minimalist moment in time, thereby simplifying his idea to its bare necessity. For this reason the film feels intensely erotic and filled with longing. The lack of closure at the end of the film reinforces this intensity by leaving the future of the couple unresolved.

Anderson's experimentation with the short-film format distinguishes him from his contemporaries and enables him to explore different facets of himself instead of being confined to one structure. Anderson's short-film work is in conversation with the rich history of French New Wave short filmmaking and incorporates elements of art cinema, produced outside of the dominant Hollywood paradigm of the feature. His ongoing commitment to making shorts, an art form marginalized by commercial production, reflects the aspirations of his unusual film characters—he refuses to accept the traditional structure of filmmaking and breaks free from convention by making art for Wes's sake.

Note

1. Consult Aisenberg, Browning, MacDowell, and Orgeron.

Works Cited

Aisenberg, Joseph. "Wes's World: Riding Wes Anderson's Vision Limited." *Bright Lights Film Journal* 59 (February 2008): n.p. Web.

Baschiera, Stefano. "Nostalgically Man Dwells on This Earth: Objects and Domestic Space in *The Royal Tenenbaums* and *The Darjeeling Ltd.*" *New Review of Film and Television Studies* 10.1 (March 2012): 118–31. Print.

Brooks, James L. "*Bottle Rocket.*" *Current*, November 2008, n.p. Web.
Browning, Mark. *Wes Anderson: Why His Movies Matter*. Santa Barbara, CA: Praeger, 2011. Print.
Brütsch, Matthias. "The Art of Reduction: Notes on the Dramaturgy of the Short Fiction Film." *In Short: The Journal of Small Screen Studies* 1 (2008): 1–9. Print.
Buckland, Warren. "Wes Anderson: A 'Smart' Director of New Sincerity?" *New Review of Film and Television Studies* 10.1 (March 2012): 1–5. Print.
Carr, Jeremy. "Jean-Luc Godard: Audience Detachment through Narrative Delay." *Studies in Cinema*, February 2010, n.p. Web.
Felando, Cynthia. "A Certain Age: Wes Anderson, Anjelica Huston and Modern Femininity." *New Review of Film and Television Studies* 10.1 (March 2012): 68–82. Print.
Godard, Jean-Luc. *Godard on Godard: Critical Writings by Jean-Luc Godard*. New York: Da Capo Press, 1972. Print.
Gooch, Joshua. "Making a Go of It: Paternity and Prohibition in the Films of Wes Anderson." *Cinema Journal* 47.1 (Autumn 2007): 26–48. Print.
Hancock, Brannon M. "A Community of Characters: The Narrative Self in the Films of Wes Anderson." *The Journal of Religion and Film* 9.2 (October 2005): n.p. Web.
Lippy, Tod. "Wes Anderson." *New York Film-makers on New York Film-making*. London: Faber & Faber, 2000. Print.
MacDowell, James. "Wes Anderson, Tone and the Quirky Sensibility." *New Review of Film and Television Studies* 10.1 (March 2012): 6–27. Print.
Murray, Noel. "Wes Anderson." *The A.V. Club*, December 2008, n.p. Web.
Orgeron, Devin. "La Camera-Crayola: Authorship Comes of Age in the Cinema of Wes Anderson." *Cinema Journal* 46.2 (Winter 2007): 40–65. Print.
Susman, Gary. "Darjeeling Unlimited." *Boston Phoenix*, October 2007, n.p. Web.
Thomas, Deborah J. "Framing the Melancomic: Character, Aesthetics and Affect in Wes Anderson's *Rushmore*." *New Review of Film and Television Studies* 10.1 (March 2012): 97–117. Print.

2

Cast of Characters: Wes Anderson and Pure Cinematic Characterization

Kim Wilkins

Ned Plimpton (Owen Wilson) hangs from the side of Steve Zissou's (Bill Murray) boat, the *Belafonte*, by one arm. The flickering of a projector is heard beneath Mark Mothersbaugh's score. The use of Ektachrome film stock creates bright and overblown colors, forming saturated, flat blocks of ocean and sky, as though filmed on 16 mm. Steve Zissou narrates: "Kingsley Ned Zissou. 29. Junior grade diving tech, executive producer. Energetic, spirited, youthful." The projector stops as the camera cuts from the film within a film to the film we are watching, Wes Anderson's *The Life Aquatic with Steve Zissou* (2004). As they sit in the editing room, Steve suggests to "probably [his] son," Ned, "This is what I'm talking about. A relationship subplot. There's chemistry between us, you know?" The chemistry Steve refers to is not the relationship between a prospective father and son, but an affinity that will appear appealing *onscreen*. In this sequence, Anderson notes the necessity of character alignment in both documentary and narrative film. He reminds the audience of the constructed nature of character identification in cinema as a medium.[1]

Wes Anderson creates pure cinematic characters that are distinctive, yet unidentifiable as representations of real people. Pure cinematic characters do not directly relate to authentic lived experiences, but rather are presented as cinematically constructed figures whose improbable experiences and reflexivity are facilitated by, and imaginatively confined to, one particular film. Yet, despite their recognizably cinematic nature, the audience can empathize with the constructed characters within the boundaries of

cinematic screen time. The awareness of the constructed nature of these idiosyncratic characters (pure cinematic character) does not preclude identification/alignment, but promotes temporary emotional investment that concludes with the closing credits.

The plights of Andersonian characters center on genuine existential issues. *Bottle Rocket*'s (1996) Dignan (Owen Wilson) seeks to construct an identity as an outlaw, based only on knowledge from American Western mythology and popular culture. *Rushmore*'s (1998) Max Fischer (Jason Schwartzman) actively avoids pursuing a future beyond his schooling years. Steve Zissou is plagued by filial obligation and authenticity. In *The Royal Tenenbaums* (2001), Royal (Gene Hackman) acts beyond ethical norms in order to maintain his position and relevance within the family institution. *The Darjeeling Limited*'s (2007) Whitman brothers (Owen Wilson, Adrien Brody, Jason Schwartzman) embark on an existential journey in order to regain something individually and collectively lost, and *Moonrise Kingdom*'s (2012) Sam Shakusky (Jared Gilman) and Suzy Bishop (Kara Hayward) unite against the inequities of mainstream society in favor of a limited existence beyond its boundaries. Despite the severity of two 12-year-olds rejecting society, *Moonrise Kingdom*'s Sam and Suzy have been read as amusing and odd, but ultimately benign—as though their discontent will pass with age (McCarthy 58–59, Lally 96, Davies 70, Wallace). However, the causes of Sam's and Suzy's behavior (he is an orphan whose disturbing behavior has resulted in his removal from foster care to become a permanent ward of the state, while she is an emotionally troubled girl who experiences uncontrollable spurts of aggression that alienate her from her family and peers) are an instrumental component of their rejection of society, rather than a product of preteen confusion—after all, Wes Anderson rarely presents adulthood as a component of maturity or emotional equilibrium. *Moonrise Kingdom* is not, as Todd McCarthy claims "a portrait of young love" (McCarthy 58), nor is it primarily concerned with the "obsessive love of two 12-year-old outcasts" (Lally 96). The primary thematic concern of *Moonrise Kingdom* is a profound existential anxiety, and the inability to articulate anxiety for both children and adults. Yet, despite the seriousness of their troubling behavior, Sam and Suzy have not been read as reflections of the increasing recognition of mental illness in children (Goldman and Grob 737–49, Leibenluft et al. 201–18, Stein and McNairn 443–61), nor as the outcome of emotional alienation in a contemporary society in which the virtual experience has largely replaced the physical. *Rushmore*'s Max Fischer has been described as "one strange kid ... monomaniacal enough to make people uncomfortable" (Turan 9) rather than a teenager deliberately avoiding adulthood, and Steve Zissou, as performing a "paterfamilias/jerk role" (Agger 74) rather than a childlike man emotionally stunted in adulthood. Although Andersonian

characters display sincere anxieties, the audience reception of these characters suggests a different mode of viewing and interaction to conventionally conceived characters. Anderson positions the "cinematic" character at a distance that is facilitated by, and confined to, a particular film's diegesis. Rather than a *reflection*, the purely cinematic character is a *refraction* of contemporary existential anxiety mediated through Anderson's idiosyncratic cinematic aesthetic.

In recent years much attention has been devoted Anderson's distinctive visual style in accordance with Jeffrey Sconce's "smart" cinema aesthetic. The "smart" aesthetic employs five defined elements: "1) the cultivation of a 'blank' style and incongruous narration; 2) a fascination with 'synchronicity' as a principle of narrative organization; 3) a related thematic interest in random fate; 4) a focus on the white middle-class family as a crucible of miscommunication and emotional dysfunction; 5) a recurring interest in the politics of taste, consumerism and identity" (358).

Sconce notes that the smart cinema aesthetic focuses on a subversively ironic, or nihilistic, tone in the place of formal, narrative experimentation that performs a deliberate separation of the audience into those that "get it" and those that do not (352). While Anderson's films focus on white, middle-class (although perhaps more narrowly, upper-middle-class) issues, his inclusion in Sconce's smart aesthetic is contentious. Anderson's use of irony does not function to include or exclude viewers. Rather, Anderson employs irony with sincerity in a manner that fluctuates between the two modes of expression but never completely divorces itself from either position, as analyzed by James MacDowell in his discussion of the "quirky" aesthetic. MacDowell writes that the quirky aesthetic is "a visual style that courts a fastidious 'artificiality,' a thematic interest in childhood and innocence, and—most pervasively—a tone which balances ironic detachment with sincere engagement" (6). The mixture of comic registers allows the audience to "simultaneously regard a film's fictional world as partly unbelievable, laugh at its flat treatment of melodramatic situations and still be moved by characters' misadventures" (9). In his formulation, MacDowell aligns the quirky aesthetic with a new structure of feeling that builds on Jim Collins's "New Sincerity"[2] and Timotheus Vermeulen and Robin van den Akker's metamodernism. This structure of feeling moves away from the dominant postmodern mode of ironic and cynical expression, represented by Sconce's smart aesthetic, and toward the coexistence of irony and sincerity. In Anderson's films, meaning is revealed in the tensions between irony and sincerity, and complicated by inconsistently shifting the balance between the two. These inconsistent fluctuations promote and destabilize character alignment as genuine empathies emerge and are distanced (unevenly) during the course of any one film.

Conventionally conceived characters present the audience with individuals whose aim within a film is to overcome specific problems or attain certain goals. David Bordwell describes the dominant classical Hollywood character model as "a discriminated individual endowed with a consistent batch of evident traits, qualities, and behaviors" (157). The consistency of these character-based attributes enables the audience to create logical and discernible links between a character's actions and reactions within the film, which in turn aids the film's internal coherence and verisimilitude and promotes character alignment and identification. The absence of consistent behaviors, traits, and qualities in Wes Anderson's characters restricts the formulation of logical action/reaction linkages. Rather, the audience is compelled to allow actions and reactions to occur without preformulated or logical expectations. Anderson's subversion of expectation creates a mode of viewing in which characters undergo constant reassessment by the spectator, as an Andersonian character's actions, while not inconceivable in hindsight, can rarely be predicted in advance. Through this constant reassessment, Anderson denies his audience the sense of verisimilitude afforded by more conventional cinema. Rather, Anderson creates two intersecting fields of performance—normative believability and eccentric possibility—between which his characters fluctuate without prior indication. This fluctuation is evident in the sequence in which Royal Tenenbaum attempts to "brew some recklessness" in his grandsons against the will of their widowed, vigilant father, Chas (Ben Stiller). A montage sequence, played to Paul Simon's "Me and Julio Down by the Schoolyard," whimsically displays a range of rebellious juvenile behaviors that oscillate between normative believability (leaping off furniture into a pool, jaywalking, go-karting) and eccentric possibility (dogfights, petty theft, riding on the back of a garbage truck). Chas, incensed at this discovery, corners his father in a walk-in closet in the Tenenbaum house, surrounded by board games. Rather than responding to Chas's castigation, Royal engages in a moment of nostalgia as he exclaims, "My God, I haven't been in here in years!" Royal's reaction (amused by his surroundings rather than concerned for his son) is believable and concordant with the audience's prior knowledge of him as a man who has purposely misinformed his family that he has cancer, for his own personal gain. However, Royal's expected disengagement is abruptly reversed as he responds to Chas's shouted question "Are you listening to me?" with an observant and sensitive (albeit yelled), "Yes, I am! I think you are having a nervous breakdown! I don't think you recovered from Rachael's death." This response is unpredictable prior to its occurrence as Royal has hitherto expressed little knowledge of his children's lives during his extended absence from the family. (Earlier in the film, Royal appeared ignorant of Chas's deceased wife's name and referred to her as "another

body" in the cemetery.) However, Anderson swiftly undermines Royal's momentary concern for Chas when, rather than pursue his distressed son, he remains in the closet, admiring his prized mounted javelina's head.

Despite the limitations Anderson's pure cinematic characterization places on alignment and identification, he has created some of the most memorable protagonists in contemporary American cinema. Sam Davies writes, "He doesn't do characterization so much as character design" (68)—indeed, Andersonian characters are recognizable products of his films.[3] Wes Anderson creates a brand-like consistency through the recurrent casting of Bill Murray, Owen Wilson, Jason Schwartzman, Kumar Pallana, Anjelica Huston, Luke Wilson, Seymour Cassel, and Andrew Wilson. In keeping with Anderson's carefully constructed set designs, clothes are intrinsically bound with identity—Dignan's yellow jumpsuit, Max's Rushmore blazer, the consistent Tenenbaum outfits, Team Zissou's uniforms, the Whitman brothers' bespoke lounge suits, Sam's Khaki Scout uniform, and Suzy's shift dress—which establishes a theatrical, stage-like quality. Indeed, the clothes worn by Anderson's characters more than visually individualize them—they are elementally constructed into the characters' identity such that their absence or alteration would result in an absolute reshaping and reevaluation of the character (Baschiera 123, Browning 33–35, 97–98).

In addition to their stage-like appearance, Anderson's purely cinematic characters do not directly relate to the authentic lived experiences of his audience. Anderson's characters are regularly driven toward unconventional ambitions—committing burglaries, remaining in a high school despite being an outsider, exacting revenge on a fictional sea creature. As Anderson's characters are invariably wealthy,[4] there is no financial necessity or material drive toward these unusual ambitions. Rather, these characters *perform* these unconventional ambitions through an ironic amalgamation of expectations of compiled pop-culture references. This performance produces a simulacral form of audience identification in which a *cinematic* experience substitutes for direct recognition and a shared *lived* experience that more conventional characters provide. *Bottle Rocket* begins with Anthony (Luke Wilson) performing an escape from a voluntary mental hospital (by a makeshift rope consisting of sheets tied together) for Dignan's benefit, evoking Huck and Tom's "rescue" of Jim from the Phelpses' shed in Mark Twain's *Huckleberry Finn* (1884). Dignan and Anthony's first—and only—successful act is to rob Anthony's family home, not for financial gain, but for practice because he can afford it. Dignan and his team of robbers are not only odd and inefficient, but essentially inept (Browning 4–5). Dignan's knowledge of criminal activity is primarily informed by heist films like *The Sting* (Hill, 1973). Similarly, in *Darjeeling*, Francis's (Owen Wilson) explanation of the purpose of the

brothers' cross-country journey—"A: I want us to be brothers like we used to be and to find ourselves and bond with each other. B: I want to make this trip a spiritual journey where each of us seeks the unknown, and we learn about it. C: I want us to be completely open and say yes to everything, even if it's shocking and painful."—is delivered to Peter (Adrien Brody) and Jack (Jason Schwartzman) while facing the camera, and thus the audience. Through this performative gesture, Anderson ironically acknowledges the audience's genre expectations of the road film. Yet, he simultaneously situates Francis as a self-referential character performing these expectations while remaining genuinely invested in the pursuit of their emotional fulfillment within the film's diegesis. As MacDowell suggests, camera recognition is a recurring Andersonian trait: "Anderson exemplifies one extreme of the sensibility's visual style . . . a static, flat-looking, medium-long or long 'planimetric' shot that appears nearly geometrically even, depicting carefully arranged characters, often facing directly forward, who are made to look faintly ridiculous by virtue of a composition's rigidity . . . Partly because of their presentational neatness, there is a degree of 'self-consciousness' to such shots" (8). In addition to self-conscious performance, Anderson's characters deliver dialogue in off-kilter, straight tones and unexpected expressions. Following Sconce's discussion of Anderson within the smart aesthetic, this mode of delivery has frequently been described as "deadpan" (Sconce 349–69). Indeed, Anderson often frames his actors in close-up, static shots, with focus on the characters' motionless faces (Peberdy 56). However, as Donna Peberdy notes, deadpan performance does not equate "motionless" with "emotionless" in the Andersonian context, but rather the blocking of emotion. As Anderson lingers on deadpan expressions, the minute details of the characters' faces become amplified in the absence of more distinct visual representations of emotion (Peberdy 56–59). This is evident in *Rushmore* when Herman Blume, seated beside Max Fischer at a wrestling match of his twin sons, states with deadpan intonation, "Never in my wildest imagination did I ever dream I'd have sons like these." The camera holds on a two-shot of Herman and Max, as the gradual clouding of Herman's eyes, infinitesimal trembling of the downturned corners of his mouth, and faint quiver of downward slanting eyebrows subtly suggest the sincere filial and masculine anxieties beneath his motionless exterior. Peberdy writes:

> The deadpan performance mode is thus an illusion of blankness, functioning as a mask that both disguises and protects. Deadpan is not a simple case of emptiness, as Randall Knoper has pointed out, deadpan takes on a 'doubleness . . . between an intentionally blank face and idiocy, or between cunning and naïveté.' This definition is particularly appropriate in thinking about the

deadpan on display in Anderson's films where the character's interactions are often as much about the incapacity of expression as they are the result of ignorance regarding an appropriate response. (59)

While the term *deadpan* accurately describes the delivery of dialogue by Anderson's characters (particularly those played by Bill Murray), the written dialogue is distinctively Andersonian in that it acknowledges the presence of a composed, formal script through the use of self-referential statements ("You don't know me; you don't want to know me . . . I'm just a character in your stupid film." [Ned, *The Life Aquatic*]), unexpected expression ("I'm very sorry for your loss. Your mother was a terribly attractive woman." [Royal, *The Royal Tenenbaums*]), and deliberately repeated lines ("Let's go get a drink and smoke a cigarette." [Francis, *The Darjeeling Limited*]). More than ironic dialogue with a deadpan mode of delivery, Anderson employs what I refer to as *hyperdialogue*—that is, the intensified, unevenly fluctuating, and often ironically inflected delivery of dialogue in the place of action. In conversation with Jean Baudrillard's concept of the hyperreal, hyperdialogue is *more than dialogue*—dialogue that blends real or sincere anxiety and its slippery, referential articulation.

Hyperdialogue, as action or gesture, stems from the presence of a deep, unspoken anxiety, as when Suzy's explanation for her constant use of binoculars—"It helps me see things closer. Even if they're not very far away. I pretend it's my magic power."—elicits this response from Sam: "That sounds like poetry. Poems don't always have to rhyme, you know. They're just supposed to be creative." Rather than inquire into Suzy's obsessive investigation of external and internal worlds she cannot comprehend, Sam provides the audience with a moment of hyperdialogue—he distances the anxiety of the exchange by ironically reciting a piece of information in a deadpan manner. The constructed nature of dialogue is consistent with Anderson's created cinematic milieus. The characters, in effect, recognize the presence of a world constructed by a screenplay. Yet the recognizability of an Anderson character's use of dialogue, costume, motivation, and casting is not wholly congruent with Sam Davies's notion of "character design," since the concept of design implies a degree of superficiality, as though these characters are variations in shape cut from the same signature motif. While there is an undeniable intertextual dialogue across the Anderson oeuvre,[5] it speaks only to the knowing Anderson audience in terms of subverting or affirming character expectations.

The performative nature of the cinematic medium is recognized by Anderson in the recurring use of theater, film, and literature, both diegetically and formally. Max Fischer and Margot Tenenbaum (Gwyneth Paltrow) are playwrights, Steve Zissou is a film director, and Jack Whitman

writes thinly veiled autobiographical short stories. Max's interest in the theater is formally reflected in *Rushmore* as the narrative is propelled by grand drapes displaying intertitles that delineate the passing of time. *The Life Aquatic* begins and concludes inside the Teatro di San Carlo at a film-festival screening of Zissou's documentaries, *The Jaguar Shark Part 1* and *The Jaguar Shark Part 2*, respectively. *The Royal Tenenbaums* is narrated by Alec Baldwin, off-screen, in book chapters from "a novel by the same name," and *Moonrise Kingdom* features an on-screen narrator (Bob Balaban) who interacts with both the characters and audience. Additionally, Anderson twice incorporates animated "still" photographs to reveal specific details about certain characters. In *Rushmore*, after Dr. Guggenheim (Brian Cox) declares that Max Fischer is "one of the worst students" at the academy, the camera cuts to an aerial shot of a school yearbook. The yearbook opens, and a montage of Max's extracurricular activities with explanatory intertitles is played to Creation's "Making Time." Similarly, in *The Royal Tenenbaums*, Margot's colorful secret history is revealed through a private detective's file. Again, an aerial shot shows the file opening, and a montage sequence of animated photographs displays Margot's sexual exploits as the Ramones's "Judy Is a Punk" plays. The montage sequences not only deliver background information, but function outside narrative time. Both montages end by abruptly cutting the accompanying music as the action returns to the narrative time of the film (Boschi and McNelis 33–34). However, this notion of montage technique as a form of construction can be taken further. In both of these sequences, Anderson uses the montage to provide access to the character that Max has created for himself at Rushmore and the character that Margot has concealed from her family by performance.

The most distinct example of Anderson's use of formal techniques to highlight cinematic performance is the introductory "Cast of Characters" sequence in *The Royal Tenenbaums*. The sequence introduces the major players in medium close-up, facing the camera (in the position of a mirror), as they carry out a variety of tasks expressive of each character's personality. The actors/characters face forward as opening credits appear, stating characters by name and the stars portraying them: "Gwyneth Paltrow as Margot Tenenbaum," "Gene Hackman as Royal Tenenbaum," and so forth (Peberdy 48). As this sequence appears after the film's prologue, which outlines the narrative background of the film, it destabilizes conventional character alignment by encouraging the audience to recognize the role of the actors in their portrayal of the characters. Margot Tenenbaum is at once a fictional character created by Wes Anderson *and* a role played by Gwyneth Paltrow. Yet, while Anderson reminds the audience that Margot Tenenbaum is a figure to be negotiated within *The Royal Tenenbaums* and a

character portrayed by Paltrow, beyond the "Cast of Characters" sequence Paltrow does not bring the intertextual dialogue of her past roles to the character, as Margot Tenenbaum is her first Andersonian role. The appearance of a recurring actor within an Anderson film, on the other hand, creates an intertextuality that is separate from the actor's complete body of work. Thus, due to his previous roles as Herman Blume, Steve Zissou, and Raleigh St. Clair, the appearance of Bill Murray at the opening of *The Darjeeling Limited* leads the knowing Anderson audience to suppose that he will figure as a problematic biological or surrogate father. Therefore, it is unexpected when Murray is revealed as peripheral to the central storyline. This subversion of Murray's Andersonian persona performs a subtle dramatic function within the film. Murray is notably absent, which shadows the thematic presence of the Whitmans' deceased father. Murray's multifarious Andersonian paternal role is subsequently reinstated in *Moonrise Kingdom* as Suzy's father, Walt Bishop, and thus speaks to his absence in *Darjeeling*.

The presence of Murray in an Andersonian context creates different expectations from that created in *Stripes* (Reitman, 1981) or the *Ghostbusters* films (Reitman, 1984; Reitman, 1989)[6]. Likewise, Owen Wilson, as an Andersonian figure, is distinct from his characters in *Meet the Parents* (Roach, 2000) or *Zoolander* (Stiller, 2001). This character's intertextuality is not the "thespian intertext formed by the totality of antecedent roles" (60) described by Robert Stam, but rather a thespian sub-intertext formed by the totality of antecedent *Andersonian* roles. This distinction is in part due to the variation in performance elicited by the Andersonian character. The deviation from conventional characterization alters the delivery of performance. Unlike conventional characters, Anderson's actors do not attempt to consistently elicit a specifically identified emotion or audience reaction, or to necessarily communicate a distinct motivation or interiority. Rather, the integration of ironic representation (within the Andersonian formula) promotes distance in alignment as the aesthetics of ironic expression highlight fictitiousness, artifice, and a mode of performance that complicates the affective response of the audience. As Anderson provides his audience with moments of sincere identification and genuine pathos between self-referential or parodic sequences, he is able to produce an overall tone of bittersweet whimsy, despite the existential anxiety of his central characters. The shifting representations of characters adhere to Vermeulen and van den Akker's formulation of metamodernism as a mode that oscillates between modern sincerity and postmodern irony. Metamodernism negotiates both modes of representation but rests on neither. It is not configured "as a balance ... rather, [a]s a pendulum swinging between 2, 3, 5, 10, innumerable poles. Each time the metamodern enthusiasm swings toward fanaticism, gravity

pulls it back toward irony; the moment its irony sways toward apathy, gravity pulls it back toward enthusiasm" (Vermeulen and van den Akker).

The fluctuation between sincere identification and ironic distancing is exemplified in the reconciliation sequence in *Rushmore*. The camera focuses on Herman's distraught face, his reddened eyes indicative of exhaustion. Upon discovering that Max is the son of a modest, convivial barber (Seymour Cassel) rather than (as previously claimed) a renowned neurosurgeon, Herman's face tiredly shifts to a resigned sigh of comprehension that the Max he has known has been a performance contrived by Max. In revealing himself to Herman, Max offers a moment of complete sincerity within the film. Herman swivels in the barber's chair to face the mirror, and camera. The viewer is placed in a moment of genuine identification as Herman recognizes himself in sincere crisis. Herman has been driven by single sequential motivations—building his business, the courtship of Rosemary Cross (Olivia Williams), revenge on Max Fischer. Without distinct motivation, he lacks identity. Within the idiosyncratic Andersonian aesthetic, this scene is poignant in its careful articulation of reconciliation and bereavement. The camera cuts to a refreshed Herman, as Max casually inquires, "How much are you worth, by the way?" With Max restored to his Rushmore self, this inquiry immediately suggests an elaborate plan. This suggestion is reinforced as Max continues, "We're going to need all of it." The two men exit the frame to a crescendo of John Lennon's "Oh Yoko!" Anderson cuts to a montage of the reconciled men performing choreographed dance sequences in Blume's steelworks, riding bicycles (albeit while smoking), and planning their next enterprise. The montage evokes the training sequence in *Rocky* (Avildsen, 1976), yet, due to Lennon's jaunty love song, it appears here in lieu of a "falling in love" montage.[7] The montage resituates the characters within the milieu of the Anderson world—the sincere pathos and emotional distress of the previous sequence are whimsically reframed.

Despite their eccentric fluctuations, Anderson's characters are not incongruous within their cinematic contexts. The characters are isolated from external interaction, as Anderson focuses on small families (biological or constructed) of characters in confined, insular environments. These environments are cinematic worlds that are both familiar and inauthentic representations of reality. The New York of *The Royal Tenenbaums* is not a recognizable contemporary reality, but an imagined space informed by the literature of J. D. Salinger (the Glass family stories) and the films of Orson Welles (*The Magnificent Ambersons* [1942]) for the purpose of facilitating the narrative (Kredell 95, Perkins 90).[8] The *Belafonte* and its surroundings in *The Life Aquatic* are not reflections of natural wonders, but the melding of spectacular artifice, metacinematic documentary, and melodrama

informed by the films of Jacques Cousteau. Similarly, *Darjeeling*'s India is not presented as a real country, but as a foreign place accessed through Jean Renoir's *The River* (1951), Louis Malle's documentaries, and the films of Satyajit Ray. The aesthetics of these settings—the sandstone walls of the Rushmore academy, the monolithic Tenenbaum house, the aesthetic (yet largely impractical) "long-range sub hunter from WWII" (the *Belafonte*), a first-class compartment on the luxury Darjeeling Limited, and the large seaside Bishop house—denote upper-middle-class nostalgia. Yet while the locations suggest a past bourgeois era, the films' soundtracks are dominated (diegetically and nondiegetically) by a combination of songs from the British Invasion, and the characters are decidedly contemporary. In *Darjeeling*, when Jack Whitman attempts to seduce Rita (Amara Karan) while on board the Darjeeling Limited, he selects Peter Sarstedt's "Where Do You Go To (My Lovely)?" (1969) on his iPod. The fusion of a contemporary technology, a sixties narrative pop song, and the train's dated interior inspired by the 20th Century Limited[9] creates a curious interaction between the present time and various pasts. The merging of diffuse historical and contemporary contexts promotes identification and nostalgia that is unable to be located in a wholly contemporary or retrospective chronological context. The films occupy a chronological space imagined only by Anderson.

The audience's emotional participation with Andersonian characters is limited by an inescapable awareness of their cinematic construction, even as their sincerity promotes it. While Andersonian characters are largely unfathomable outside of the film's diegesis, they slide between an empathetic identification that is not forced on an audience, but encouraged and desired, and a semiabsurdity in which the viewer is reminded of the place and role of the cinematic construction of character within the film. The audience cannot infiltrate the constructed cinematic world created by Anderson, nor are the purely cinematic characters able to transcend their specific cinematic representations. Anderson's signature use of a concluding slow motion sequence draws attention to the film construct: it signals the end of the narrative and the characters within it. While the audience may have been moved by the narrative and characters, the closing credits ensure that both are irretrievably complete.

Notes

1. Donna Peberdy offers a detailed reading of the father-son relationship between Ned and Steve in her article "'I'm Just a Character in Your Film': Acting and Performance from Autism to Zissou."
2. Collins's "New Sincerity" refers to works that reject irony in favor of sincerity. Wes Anderson does not reject irony, or postmodern techniques, but rather

incoporates them into his expression of sincerity in a new, contemporary mode.
3. The luggage featured in *The Darjeeling Limited* was designed by Marc Jacobs for Louis Vuitton.
4. Those who are not wealthy (e.g., Max Fischer and Steve Zissou) have access to wealth that they claim as their own (Herman Blume and Eleanor Zissou, respectively).
5. Francis's laminated itineraries for the brothers' spiritual journey in *The Darjeeling Limited* is a somewhat "matured" version of Dignan's handwritten life plan in *Bottle Rocket*.
6. Peberdy notes that Anderson has helped launch or revitalize a number of actors' careers. Peberdy writes, "*Rushmore*, for example, provided the opportunity for Murray to move away from his 1980s goofy comedic characters of *Stripes* (1981) and *Ghostbusters* (1984), demonstrating a shift in acting style for Murray that he would later cement in *Lost in Translation* (2003) and *Broken Flowers* (2005) to become a firm 'Indiewood' favourite" (54).
7. For examples of the falling-in-love montage trope, see John Stockwell's *Crazy/Beautiful* (2001) and David Zucker's *The Naked Gun* (1988).
8. Perkins writes that the "house on Archer Avenue" is described in the film's prologue purely in terms of the activities of it child-genius inhabitants, with every bedroom "set up as a shrine to its occupant's discipline" (90). Perkins also notes that the house functions as the logical space for all events past and present.
9. The 20th Century Limited was a passenger train that ran between New York and Chicago between 1902 and 1967. This was, incidentally, also the venue for Howard Hawks's screwball comedy *Twentieth Century* (1934).

Works Cited

Agger, Michael. Review of *The Life Aquatic with Steve Zissou*. Film Comment 41.1 (2005): 73–74. Print.
Baschiera, Stefano. "Nostalgically Man Dwells on This Earth: Objects and Domestic Space in *The Royal Tenenbaums* and *The Darjeeling Ltd.*" New Review of Film and Television Studies 10.1 (2011): 118–31. Print.
Baudrillard, Jean. *Simulacra and Simulation*. Translated by Sheila Faria Glaser. Ann Arbor, MI: University of Michigan Press, 1995. Print.
Bordwell, David. *Narration in the Fiction Film*. London: Methuen, 1985. Print.
Boschi, Elena, and Tim McNelis. "'Same Old Song': On Audio-Visual Style in the Films of Wes Anderson." New Review of Film and Television Studies 10.1 (2011): 28–45. Print.
Browning, Mark. *Wes Anderson: Why His Movies Matter*. Santa Barbara, CA: Praeger, 2011. Print.
Collins, Jim. "Genericity in the Nineties: Eclectic Irony and the New Sincerity." In *Film Theory Goes to the Movies*, edited by Jim Collins, Hilary Radner, and Ava Preacher Collins, 242–63. New York: Routledge, 1993. Print.

Davies, Sam. Review of *Moonrise Kingdom*. *Sight and Sound* 22.7 (July 2012\): 68–70. Print.

Goldman, Howard H., and Gerald N. Grob. "Defining 'Mental Illness' in Mental Health Policy." *Health Affairs* 25.3 (2006): 737–49. Print.

Kredell, Brendan. "Wes Anderson and the City Spaces of Indie Cinema." *New Review of Film and Television Studies* 10.1 (2011): 83–96. Print.

Lally, Kevin. Review of *Moonrise Kingdom*. *Film Journal International* 115.7 (2012): 96. Web.

Leibenluft, Ellen, R. James R. Blair, Dennis S. Charney, and Daniel S. Pine. Daniel S. "Irritability in Pediatric Mania and Other Childhood Psychopathology." *Annals of the New York Academy of Sciences* 1008.1 (2003): 201–18. Print.

MacDowell, James. "Wes Anderson, Tone and the Quirky Sensibility." *New Review of Film and Television Studies* 10.1 (2011): 6–27. Print.

McCarthy, Todd. Review of *Moonrise Kingdom*. *Hollywood Reporter* 418 (2012): 58–59. Print.

Peberdy, Donna. "'I'm Just a Character in Your Film': Acting and Performance from Autism to Zissou." *New Review of Film and Television Studies* 10.1 (2011): 46–67. Print.

Perkins, Claire. *American Smart Cinema*. Edinburgh: Edinburgh UP, 2012. Print.

Sconce, Jeffrey. "Irony, Nihilism and the New American 'Smart' Film." *Screen* 43.4 (2002): 349–69. Print.

Stam, Robert. "Beyond Fidelity: The Dialogics of Adaptation." In *Film Adaptation*, edited by James Naremore, 54–76. London: Athlone, 2000. Print.

Stein, Steven J., and Cynthia McNairn. "The Changing Nature of Diagnosis in an Inpatient Service over 20 Years." *Journal of Abnormal Child Psychology* 11.3 (1983): 443–61. Print.

Turan, Kenneth. "Pest-as-Hero Theme in Mountain of Eccentricity." Review of *Rushmore*. *Los Angeles Times* 1998: 9. Print.

Vermeulen, Timotheus, and Robin van den Akker. "Notes on Metamodernism." *Journal of Aesthetics & Culture* 2 (2010): 1–14. Web.

Wallace, Lisa. Review of *Moonrise Kingdom*. *NMMU Life*, November 28, 2012. Web.

3

The Jellyfish and the Moonlight: Imagining the Family in Wes Anderson's Films

Steven Rybin

In an early scene in Wes Anderson's *The Life Aquatic with Steve Zissou*, the oceanographic filmmaker of the title (Bill Murray) is busy at work on his latest feature. As his camera operator, Klaus (Willem Dafoe), films him, Zissou lectures about a swarm of electric jellyfish washed to shore, glowing on the sand in the dark of evening. Ned (Owen Wilson), meanwhile, a young aviator who may or may not be Zissou's long-lost son, operates the boom mic. Although he knows little about filmmaking, Ned nevertheless attempts to earn his stripes as part of Zissou's crew by ad-libbing a question for the camera. He asks Zissou about the cause of the jellyfish's illumination, wondering whether their glow is produced by a special kind of chemical. Zissou—taken aback by this improvisation in his carefully staged "documentary"—tells Ned that the jellyfish are not lit from within, but rather glow because of the reflection of the moonlight on their outer membranes. Recognizing the creativity of Ned's contribution to the scene, Zissou then asks Ned if he might like to "officially" join the Team Zissou filmmaking crew.

This moment from *The Life Aquatic* offers an example of Anderson's approach to the theme of family. It lets us understand how Anderson's characters are themselves the creators of artistic events that enable the discovery of new forms of family and community. Anderson is often regarded by critics as a fussy, excessively precise filmmaker who overdetermines the visual placement of his characters, treating them as if they were a child's playthings in a cinematic diorama (Edelstein). But Anderson's characters,

I contend, are not stuck in their place. Instead, Ned's improvisation and Zissou's response to it are exemplary of their desire to actively create alternative formations of collectivity that might heal past pain. Anderson's style is sensitive to the small details that bring his characters together; his mise-en-scène draws our attention to the colorful illumination of the jellyfish, and the découpage of the scene, through gradually closer shots, links Ned to Zissou. But Anderson is equally concerned with his characters' own stylish ways of forging bonds. As Zissou's relationship with his possible son reaches a dramatic moment through Ned's improvisation, Anderson draws our attention to the creative way his movie people use their chosen medium (for Zissou, the cinema itself) to find privileged moments through which to connect with others.

In Anderson's cinema, the formation of family is thus an aesthetic event, a stylish coming-together. Indeed, the various ways his characters, themselves sensitively guarded artists and expert imaginers, create the conditions for these various comings-together are what the films are about. Zissou's line about the moonlight and the jellyfish reminds us that, for Anderson, families, like these creatures, are potentially beautiful not because of any intrinsic biological or chemical property but because of a luminous relationship between earth and sky, a drawing together through a play of light. Families in his films are like the jellyfish, always very carefully arranged cinematic assemblages perpetually reformed and restaged through the creative acts of the characters. For just as Zissou demonstrates a principle about the family of fish behind him, in his own mise-en-scène, his filmmaking enables the discovery of a new bond with his potential son. As their cinematic collaboration teaches us, Anderson's families take shape not only through the director's own creative efforts as auteur, but through the creativity of the characters themselves, whose works of art and performance open up the space for new familial forms to emerge. These efforts at making art within the narrative worlds of Anderson's films—which, notably, do not always succeed and, at times, especially in the later films, tend to happen in private spaces away from prying eyes—are attempts to form alternative unities that depart from the normative definitions of family that cause so much angst.

That family is continually restaged through the making of art in Anderson's stories is a sign that the director himself regards the family not as a fact of nature, but as a system of cultural relations contingent, for its unity, on playfully creative reaffirmations and reformations.[1] Of course, as Murray Pomerance argues, the family is one of the cinema's ongoing dramaturgical challenges, one of its key "presentational problems" (295). As Pomerance writes, "The performance of family bonds onscreen is a complex of arrangements and actions"—and it could not help but be so, given that the

actors playing "related" characters in films are, of course, most often not really related (299). In other words, "relation" in the cinema, biological or otherwise, must always be performed; it can never be assumed or taken in at one glance. Even in the rare case when Anderson does use actors who are related to, or look like, one another, he defuses the biological relationships inherent to them—as in *Bottle Rocket*, where real-life brothers Owen and Luke Wilson are cast not as kin but as childhood friends. Further, in Anderson's films the characters themselves sense that something is not quite right with their biological relations; they intuit the possibility of staging a more satisfying form of collectivity even as biology lays claim to a preexisting idea of family they must negotiate. In *The Royal Tenenbaums*, particularly, Pomerance finds in Anderson's family a quarrelsome coldness that might freeze old familial relations in the hopes of warming new ones: "What allows us to see the betrayal and sneakiness between members of this family as funny rather than metaphorical or indexical of real life is the startlingly cerebral quality of the interaction, quite as though no bond of blood existed to warm the feelings of the participants" (302).

As Pomerance divines, Anderson's slightly detached comedy, although not devoid of emotional warmth at key moments, is nevertheless austere in its attachment to the family unit as *presently* formulated. Although Anderson's work embodies feelings of nostalgia regarding the ephemera of popular culture and film (such as the pop music his characters listen to and the previous movies his works reference), they do not remain in a permanent state of nostalgia for the past of the family itself, which is often a locus of lingering emotional pain rather than fond remembrance.[2] In *Rushmore*, Max may pine after his dead mother, but his emotions—and the way they are projected on the schoolteacher—productively guide him to a new formation, the creation of a stage play that results in a new kind of community. Further, Anderson's treatment of family, as Pomerance writes of *The Royal Tenenbaums*, also exhibits *smarts*: a knowing intelligence that allows us to understand the family as mediated by ideas that at any moment might pull them into a different direction, toward a new construction that leaves the old one behind. It is, after all, the intellectual coldness with which Margot (Gwyneth Paltrow) regards Raleigh St. Clair (Bill Murray) that opens the door for her leaving him and returning to live with her mother (Anjelica Huston), a relationship itself qualified by a certain knowing regard felt not only in the playing of the principal leads but also in Anderson's framing of objects (such as an old television set propped on top of a bathtub in between mother and daughter during an early conversation) that often intervene oddly in the space between family members in his films.

Pomerance's discussion of the Tenenbaum family as both constructed and cerebral, of course, is in keeping with the wider academic reception of

Anderson's cinema. Jeffrey Sconce initially identified Anderson in a survey of what he called "smart films," works that "share an 'aura' of intelligence that distinguishes them (and their audiences) from the perceived 'dross' (and 'rabble') of the mainstream multiplex" (351). Later scholars have built upon Sconce's ideas, which are mostly concerned with the circulation of cultural capital among cinema audiences, by looking more closely at the work Anderson's films themselves do—that is, precisely *how* they put their smarts into play to achieve a significance not there before. In contrast to Sconce, who emphasizes the irony and individualistic cynicism in the "smart films," these later scholars, including Warren Buckland, have found a sincere heart beating in Anderson's work and have placed him in a larger movement dubbed "New Sincerity" dialectically combining a slightly detached position of irony with earnest expressions of feeling. Buckland notes how recent critics have examined "how [Anderson's] irony distances spectators from characters but also how moments of affect encourage allegiance towards them" (2). And Devin Orgeron has found these sincere smarts at play in Anderson's characters, who are often authors and artists delicately balanced on the edge of self-involved narcissism and communal engagement: "Populating his films with flawed but ultimately redeemable auteurs who, in the end, orchestrate their elaborate fictions in the name of a community that requires their particular intervention, Anderson's films imagine the author as an almost inscrutable entity" (41).

The value of Orgeron's position, for my present argument, is its understanding of Anderson's characters as artists and authors who enable new formations of everyday life. Here, the value of Anderson's smart cinema is found not only in the director's own aesthetic precision—a key marker of his status as a "smart" auteur—but also through his insight that distinctive creative impulses can prepare the way for those flashes of emotional engagement (between characters, and between audiences and Anderson's cinema) that are the beginnings of an alternative community, a new kind of social bond.[3]

Thus, one key thematic element in these surrogate auteurs' artistic achievements *is* open for scrutiny: the various ways they create artistic events, and the ways in which these events prepare the way for those moments of emotional expressivity that form the beginnings of new forms of familial bonding. Anderson's characters, through various forms of art and play—staged robberies in *Bottle Rocket*, amateur theater in *Rushmore*, literature, painting, and music in *The Royal Tenenbaums*, cinema in *Zissou*, and various forms of writing, acting, and entrepreneurship in the later films—imagine these new communities (call them alternative families) through various artistic events. If their smarts achieve these events through aesthetic cleverness, their hearts use these events as affective openings

through which these usually quite private characters will discover new kinds of social bonds. Crucial to *our* understanding of these artistically achieved communities is the tonal pitch Anderson himself strikes in his depictions of these various comings-together, resulting in a double-layered aesthetic presentation—by both character and by Anderson, as auteur—of the family as it undergoes its artistic reformation.

In *Bottle Rocket*, Owen Wilson's Dignan, with the help of his friend Anthony (Luke Wilson), executes comically inept robberies. These heists, it turns out, are part of Dignan's larger "five-year plan," a whimsically conceived structure for personal fulfillment that is fully documented in a color-coded notebook. Early in the film, as Dignan and Anthony make an absurd "escape" from a voluntary mental health institution, Anderson frequently frames the duo in a medium two-shot, keeping our focus on their partnership while also drawing our attention to the various external elements that might at any moment throw Dignan's carefully laid plans into comic disarray. What is significant is that these external elements are the previously existing families from which our bungling heroes attempt to extricate themselves. Anthony, for example, is estranged from his sister, Grace (Shea Fowler), who holds her brother in low esteem for his inability to hold a job. Meanwhile, Anthony and Dignan's partner in crime, Bob Mapplethorpe (Robert Musgrave), has his own trouble with his bullying brother, Future Man (Andrew Wilson). In these depictions of familial conflicts, however, the tonal pitch of the scenes prevents Anderson's viewers from indulging in familial nostalgia, emphasizing instead the family at a moment in its transformation. Grace is presented as a precocious, wise-beyond-her-years figure (the first of many such children in Anderson films); worried about her brother's future, she treats Anthony with an almost maternal sense of protectiveness. Yet she is never seen again in the film after an early sequence, as both Anthony and *Bottle Rocket* abandon biological connection and instead emphasize Anthony's relationship with a housekeeper named Inez (Lumi Cavazos) as the possible beginning of a new familial formation. The sounds of Future Man beating up Bob off-screen, meanwhile, reduce familial conflict to an off-screen sound; Anderson plays it for wryly distanced comedy, placing his visual emphasis instead on the two friends whose bungled burglaries will lead to a new, ideal, nonbiological formation of the family.

Bottle Rocket is a heist picture, so the family is again reformulated in the gang's comical robbery of a cold-storage facility. Dignan is performing this heist as a service to his boss, the owner of a landscaping company (which serves as a front for criminal activities), Mr. Henry (James Caan). Throughout the film, Dignan has carried a photograph of himself standing with Henry and two of his associates, proudly displaying it to Anthony as

a sign that his "five-year plan" might be achieved through the successful execution of robberies. As it turns out, however, the heist itself is a mere distraction while Mr. Henry robs Bob's (unseen) wealthy family; Dignan's ideal alternative family unit dissolves before it has a chance to form itself. Cinematically, Anderson finds emotional resonance in Dignan's bungle, using slow motion cinematography, during the film's penultimate and concluding sequences, to indicate an emotional gravitas that goes beyond the playful surface of the film. *Bottle Rocket* ends not with the double-cross, but with Dignan's assertion that he remains committed to his partners even after their betrayal and his arrest for the crime. (He instructs Anthony and Bob to give Henry and his crew the belts he has made in prison as a gift.) Dignan remains convinced that he might still stage an event that will lead to the formation of a new family unit. The film, then, ends not with the formation itself but with the persistence of the desire to achieve it.

If *Bottle Rocket* is colored by our knowledge that the friends in the films are played by two real-life, off-screen brothers, Luke and Owen Wilson, Anderson's next film, *Rushmore*, asks us to comprehend very different actors—Bill Murray, Olivia Williams, Jason Schwartzman, and a host of supporting players—as a makeshift collective unit. In *Bottle Rocket*, the familial pasts of Dignan and Anthony are only hazily defined, but in *Rushmore* the friendship between the precociously intelligent (but academically stunted) Max Fischer (Schwartzman) and the grade-school teacher, Miss Rosemary Cross (Williams), is formed through their shared losses of loved ones: Max's mother died when he was seven; Miss Cross's husband, a year before the film's story begins. Fischer would seem to possess all the requisite creative skills to leave this past behind and imagine a new future family. His overactive imagination and extracurricular enthusiasm inspire him to found and participate in many Rushmore clubs (a roll call of which is given in an early montage sequence in the film), and he is a noted amateur playwright in the community. However, many of Fischer's achievements are rooted in the past: his position as president of the Rushmore Beekeepers was previously held by Miss Cross's late husband, Edward Appleby (who founded the club), and the first stage play we see him direct is a high-school adaptation of *Serpico* (Lumet, 1973). Even his crush on Miss Cross is tied to the loss of his mother; and although Miss Cross herself would like to dissuade the too-young Max from developing inappropriate romantic thoughts about her, she cannot resist telling him that he reminds her of Edward, a guarantee that both characters will have difficulty moving beyond earlier families to discover the formation of new ones.

Max's breakthrough is an amateur stage play—a vividly imagined, low-tech rendering of the Vietnam War entitled *Heaven & Hell*. Its subject matter may be rooted in a past event, but what matters now is the way Max

stages the play as both a social and aesthetic gesture bringing together friends and family in a new community. Earlier in the film, Herman Blume (Murray), one of Rushmore Academy's benefactors, has revealed to Max his past in Vietnam. (Like many revelations of the private self that linger behind characters in Anderson movies, this information is delivered quickly, its emotional importance to the character in inverse proportion to the amount of screen time the mention receives.) The Vietnam War is only one of the many indications of Blume's tortured inner life: embroiled in an expensive divorce with his wife, his relationship with Miss Cross has also fallen apart after her discovery of the various cruel practical jokes Max and Blume have played upon one another (acts perpetrated as a result of Max's discovery of Blume's own love for the schoolteacher). For Blume, though, Max is nevertheless like a surrogate son—what he perhaps once was or imagines himself to have been—and when Max stages *Heaven & Hell* for his audience, he makes sure to seat Blume and Miss Cross together. As a piece of mise-en-scène presented to his friends, the play is intended not only as a precocious piece of theatricality, but as a social gesture that unites the two most important adults in his life off the stage (*and* serves to bring Max together with his new girlfriend, Margaret Yang (Sara Tanaka), who will lead him beyond his fixation on Miss Cross). In this sense, Max's gambit is more successful than Dignan's failed attempt at forming a new family in *Bottle Rocket*. Anderson's own style serves as a capstone to this beautiful sequence: his film ends with a slow motion shot of Miss Cross and Max dancing to "Ooh La La," by The Faces, a song that not only serves as a nostalgic punctuation mark to their shared pasts but also as a sign that these two reconciled friends will continue to live creatively with one another in the future.

There is perhaps no other film in Anderson's career that grapples with the emotional complexity of family as deeply as *The Royal Tenenbaums*. In contrast to *Rushmore*, the Tenenbaums' creative attempt to form a new family is a failure to engage with public space and a retreat into the private. The three Tenenbaum children have remarkable, but mostly unrealized, potential: Margot (Gwyneth Paltrow) is a struggling playwright; Richie (Luke Wilson) is a fading tennis star; and Chas (Ben Stiller) is an entrepreneur. Richie and Margot, in particular, share an important bond. In earlier Anderson films, new bonds are enabled by publicly presented creative endeavors that intervene in social life—such as Max's stage play or Dignan's robberies. By contrast, the connection between Margot and Richie is exceedingly private. Early in the film, Anderson gives us indications that Richie and his adopted sister have shared poignant moments in the past: the opening prologue spies an image of the two characters absconding from school at the natural history museum; and when Richie,

as an adult, meets Margot at the pier later in the film, her arrival is scored to the lilting rhythms of Nico's "These Days." In the latter example, Anderson films Margot's reentrance into Richie's life as an aesthetic event. As the song plays, all other sounds in the story world fade away, and the song carves out a private space within a larger public world. What is more, the public world itself seems to adjust its very movements to the rekindling of the psychological bond between these adoptive siblings: the mise-en-scène behind Richie recomposes itself in response to the siblings' emotions, as a team of ship captains walks, in prearranged coordination, from left to right in slow motion as Anderson films Richie gazing at his childhood sweetheart.

These two characters, then, are not creating a publicly viewable event; this is a purely private moment, one that, *to us*, seems to change the cinematic space around them, but which occurs away from the prying eyes of their mother, father, and friends. That it is Anderson himself, and not these two characters, creating this aesthetic event (through arrangement of mise-en-scène, through the Nico song, and through slow motion cinematography) is significant. Margot and Richie, after all, struggle with bringing their relationship, which flirts with incest, to a public eye. Margot, from the beginning, is a recurring motif in Richie's life—he paints a series of pictures of her as a child and throws his tennis career away once he learns of her marriage—yet the pattern she forms in his mind is hidden away from a public and a family that would not understand. ("What's he feeling right now?" asks one of the tennis commentators as Richie breaks down during a match; and the point is that a television broadcast of a tennis match can't possibly tell us.) A series of narrative objects—the paintings; Richie's letter to Eli (Owen Wilson), confessing his love for Margot to him; Margot's cigarettes, which she hides away from her family—contain psychological significance but are hidden from others. And to be sure, public revelation can be psychologically dangerous: after Richie learns of Margot's love affairs through a private investigator, he attempts suicide, an act that is clearly meant as an expression of painfully private feelings that cannot take socially discursive shape. In *Tenenbaums*, there is no stage play that works to publicly express inner pain and forge a new way; Richie's paintings of Margot, like his suicide, are deeply private works.

This retreat into a private space in *Tenenbaums* contains a certain kind of creativity, of course; just as Anderson, earlier, scored Margot's arrival at the pier to the Nico song, Margot and Richie, in their childhood tent, listen to the Rolling Stones' "She Smiled Sweetly" on a record player while confessing their love for one another. This private space, however, is where the relationship remains; as Margot tells Richie as she leaves the tent a moment later, their renewed bond is too fragile to survive the prying eyes of their family and the public. At the end of the film, as the pair sit on the

Tenenbaum rooftop, Margot lights two cigarettes—those objects that have throughout the film indicated the emotions she keeps buried away, inexpressible—but, this time, she *shares* one with Richie. Now, another song (Nico's "Fairest of the Seasons") is cued on the soundtrack—this time, however, by Anderson, and not by his characters—a sign once again that in *The Royal Tenenbaums*, it is Anderson, not Richie or Margot, who is in a better position to create aesthetic events that might forge new ideas of family. As Margot and Richie share the cigarette against Anderson's fabricated New York City skyline, they assert a deeply private bond that is itself an alternative to the more publicly achieved formations of community at the conclusions of *Bottle Rocket* and *Rushmore*.

As discussed in the first paragraph, in *The Life Aquatic*, Anderson's characters use filmmaking as a means to come together, and the movie ends with the reformation of Zissou's film crew, a kind of alternative family that specializes in the production of aesthetic works (Zissou's films). If this conclusion suggests a way out of Margot and Richie's private impasse in *Tenenbaums*, later Anderson films restage the tension between public expressions of new familial forms (as in *Rushmore*) and cautious retreats into protective private spaces. In *The Darjeeling Limited*, three estranged brothers—Francis (Owen Wilson), Peter (Adrien Brody), and Jack (Jason Schwartzman)—reunite on a railroad tour of India in the hope of moving beyond the memory of their dead father and reuniting with their mother (Anjelica Huston), who has taken up a new life as a missionary after the patriarch's death. Jack, a short-story writer, takes pen to paper to deal with these memories, yet it is not clear that he has much of a public audience for his fiction; whereas Max's *Heaven & Hell* was performed for a large community in *Rushmore*, no audience besides his two brothers reads Jack's story. Anderson himself signifies the weight of family memory through the luggage, an inheritance from their father, which burdens the three brothers throughout their journey and which they finally discard as they board the train for the final time near the end of the film. In *Darjeeling*, though, does this relinquishment of the father's luggage achieve a new form of family for the characters? Near the end of the film, Anderson shows us a series of pans across various train cars, each containing a different character who has figured, in one way or another, in the film: Peter's pregnant wife (Camilla Rutherford), Jack's ex-girlfriend (Natalie Portman), a businessman (played by Bill Murray) who we see miss the train in the prologue to the film, and even a Bengali tiger, glimpsed earlier during its prowl around the mission where the brothers find their mother. However, this string of train cars is not viewable within the diegetic space of the film; this imagined family exists only through Anderson's montage. The brothers themselves, in other words, do not glimpse this imagined new family.

Anderson's recent films suggest that the theme of the family and its potential for aesthetic reformation is itself in suspension, awaiting reconfiguration in his future work. With *Fantastic Mr. Fox*, the director turns to animated, stop-motion figures to create a nonhuman world that functions as a glorious alternative to the forms of adult companionship in Anderson's live-action movies. *Fantastic Mr. Fox* is the kind of playful film the two sad children in Anderson's most recent work, *Moonrise Kingdom*, might like to see, for they are both stuck in what is perhaps the most melancholy adult world Anderson has yet to stage. Just like Margot and Richie, Sam (Jared Gilman) and Suzy (Kara Hayward) come from broken homes, and the various alternative communities in which we initially find them—Sam, in the Khaki Scouts, and Suzie, with a group of young actors in a grade-school theater production—suggest that the social, communal solutions of *Rushmore* and *Zissou* are now unsatisfactory. Instead of forming yet another new group, Sam and Suzy abscond into the wilderness of New England. Sam uses his scouting skills to build a camp; Suzy's interest in art leads her to read her library books aloud to Sam. The kids' eventual curiosity about their preadolescent sexuality might suggest a conservative solution to the problem of family in Anderson's world, the simple regeneration of family through procreative coupling. But Sam and Suzy's wistful adolescent desire, itself a rebuttal against conventional attitudes about what is acceptable in the expression of sexuality, will soon brush up against the forces of history: the film, set in the midsixties, takes place during the midst of the Vietnam War, the tail end of which will almost certainly claim Sam as one of its draftees.

Yet there is a certain tone of hopeful melancholy at the end of *Moonrise Kingdom*, for Sam and Suzy still manage to escape the purely private space into which Margot and Richie retreat at the end of *Tenenbaums* through an aesthetic gesture that publicly signals a desire for something other than the traditional family. In the film's final shot, taken from an extremely high angle, we see Sam and Suzy's campsite, with stones arranged to spell out the film's title. However, there is no audience in the world of the film that will see these words. With the notable exception of the film's narrator, none of the adults understand—none can even see—the beauty of what the kids have created; Sam's scout leader, Ward (Edward Norton), compliments Sam on the efficiency of his camp and the skill with which it has been erected, but even he misses the emotional yearning buried within the secret campsite, glimpsed only in our privileged view from a high-angle shot. The film thus ends on a bittersweet note: Sam and Suzy have not found another family, and they cannot be with each other. Only the cinephiles who view Anderson's film will witness the desire for a new kingdom spelled out in the stones on the ground; perhaps they might finally form the kind of alternative family Anderson's characters search for but often do not find.[4]

Notes

1. This point helps develop an assertion voiced in Devin Orgeron's essay "La Camera-Crayola." Orgeron argues that the communities forming around appreciations of Anderson's films offer a counterpoint to the narcissistic forms of authorship that his characters enact (41). These fan communities, I contend, are the real-life, utopic parallels to the ideal, alternative families that take shape in Anderson's narratives.
2. For discussion of the interlinked themes of family and nostalgia in Anderson, see Turner.
3. As Orgeron points out, the communities in various states of evolution in Anderson's films have their parallels with the extradiegetic fan communities that develop on fan sites on the Internet. See Orgeron 42.
4. While reinforcing the claim that the kinds of communities the narcissistic authors in Anderson's films often do not find are instead found in the various fan communities formed out of enthusiasm for Anderson's films, the frustrated desire for community and collective creativity remains an important theme in the films themselves and cannot be resolved solely in terms of reception, as the final image of *Moonrise Kingdom* implies.

Works Cited

Buckland, Warren. "Wes Anderson: A 'Smart' Director of the New Sincerity?" *New Review of Film and Television Studies* 10.1 (2012): 1–5. Print.

Edelstein, David. "A Wes Anderson 'Kingdom' Full of Beautiful Imagery." NPR.org. May 25, 2012. http://www.npr.org/2012/05/25/153696198/a-wes-anderson-kingdom-full-of-beautiful-imagery (accessed February 19, 2013). Web.

Orgeron, Devin. "La Camera-Crayola: Authorship Comes of Age in the Cinema of Wes Anderson." *Cinema Journal* 46.2 (Winter 2007): 40–65. Print.

Pomerance, Murray. "The Look of Love: Cinema and the Dramaturgy of Kinship." In *A Family Affair: Cinema Calls Home*, edited by Murray Pomerance, 293–303. London and New York: Wallflower Press, 2008. Print.

Sconce, Jeffrey. "Irony, Nihilism, and the New American 'Smart' Film." *Screen* 43.4 (2002): 349–69. Print.

Turner, Daniel Cross. "The American Family (Film) in Retro: Nostalgia as Mode in Wes Anderson's *The Royal Tenenbaums*." In *Violating Time: History, Memory, and Nostalgia in Cinema*, edited by Christina Lee, 159–76. New York and London: Continuum, 2008. Print.

4

"Max Fischer Presents": Wes Anderson and the Theatricality of Mourning

Rachel Joseph

This chapter will explore the relationship between theatricality, screened stages, and mourning in the work of Wes Anderson with a focus on *Rushmore* (1998) and *Moonrise Kingdom* (2012). *Screened stages* refer to instances when the stage appears within a film, creating a moment of "liveness" within the cinematic. The screened stages within Anderson's films create miniaturizations of the mourning process and a working through and communal witnessing of the relinquishment of the mourned-for lost object. The stage within the screen frames both an absent present and love (in combination with grief) for that which has disappeared. Each framed moment in Anderson's films presents itself like a miniature stage pressed under glass and preserved as if it were some kind of childhood butterfly collection.

Anderson's *Rushmore* features the Max Fischer Players, a precocious acting troupe at the private school Rushmore under the direction of the endlessly clever, heartsick, and melancholic Max Fischer (Jason Schwartzman), who is perpetually in mourning from the loss of his mother. The players make their mark primarily by recreating famous films for the stage, films that the players are much too young to play without looking like some kind of miniaturized adults. In fact, the adults in *Rushmore* also look (and act) like children. Like Max, they are heartsick and in mourning. Tellingly, the film opens with curtains that instantly attract attention to its theatrical construct. Everyone in *Rushmore* is playing at being a grown-up; in reality, they are grieving children.

This playing at being grown-up is complicated in Anderson's worlds. Children's precociousness and the adults' stuntedness circle around questions of loss and grieving. Each character tries to hold on and simultaneously let go of moments of hurt and heartbreak. These losses tend to replicate throughout the films through both material and theatrical means that cumulate in a display of a kind of collective grief. At the heart of *Rushmore*, *Moonrise Kingdom*, and, I will suggest, all of Anderson's films, is a question of mourning.

The *presenting* in the "Max Fischer Presents" of the title of this chapter suggests that Anderson shoots all of his films framed flat front, as if onstage, hearkening back to the origins of film and the "cinema of attractions." At the birth of cinema, theater and film were tightly merged. Tom Gunning's definition of the "cinema of attractions" refers to the characteristic of non-narrative films of this time beckoning to a spectator's attention by directly addressing them from the screen as if an actor breaking the fourth wall. Although Anderson's films include a strong narrative (unlike the original cinema of attractions), he brings back the attraction aspect of the tradition by staging many of his shots as if presented to a theater audience. This use of the camera gives the effect of a highly stylized and theatrical world. This theatricality, I suggest, parallels the grieving process of reenacting and repeating the traumatic. At the heart of this staging is bringing the past into the present. The screened stage is the perfect site for this act because the stage represents a kind of longing for presence that cinema ultimately can only represent.

How does one say a final good-bye to a lost object while at the same time refusing to let go? Bringing back the dead onstage or through the medium of a small object (standing in, of course, for the true lost object) gripped in the hand or pressed in a book allows Anderson's collection of characters to forestall final good-byes, all the while "working through" grief (in Freud's sense of the term) toward a fragile completion. Michael Chabon's "Wes Anderson's Worlds" explores the objects and worlds of Anderson by pointing to the fact that "everyone, sooner or later, gets a thorough schooling in brokenness." The characteristic Anderson collection of objects and neat organization of those objects on-screen suggest a kind of memorialization of the experience of Chabon's "brokenness." Anderson's theatrical style creates a miniaturization and display of the grieving process. The fact that Anderson's characters are figures grappling with loss connects this style with the narrative substance of Anderson's worlds.

Chris Robé's "Wes Anderson, Entitled Masculinity, and the 'Crisis' of the Patriarch" alludes to the fact that the male figure's performances of masculinity in Anderson's films "serve as hyperbolic compensatory acts for the loss of a significant loved one they are unable to mourn" (105). Robé

goes on to cite Freud's claim that mourning can only occur when each of the memories associated with the object mourned has been brought up and examined (105–6). "Anderson's films stylistically emulate the very repression of loss that their protagonists feel," he argues; the films "embody a melancholic structure whereby loss serves as an absent presence" (107). This "absent presence" is manifest in, as Robé notes, the theatrical curtains dividing each scene in *Rushmore* and Max's performance of "adulthood" (107). I would add that it is the embedded stages and theatricality in the very texture of the film that both reveal the mourning process and perform Freud's theory of the lost object, as he outlines in "Mourning and Melancholia," in which the subject only completes the mourning process when the old love object (the lost loved one and focus of the mourning) has been replaced with a new love object being held and interrogated in the process of working through the mourning process. It is "onstage" in Anderson's films that this enactment is performed.

There are several ways this tendency is manifest, but perhaps the most searing examples of this working through and forestalling comes from a mourning process that is most noticeable through, as Samuel Weber has theorized, an "installation" of the medium of theatricality within film. What distinguishes Anderson's version of theatricality is its quality of both something bigger than the narrative of the films and at the same time being that which could be held as if it were a small object. Chabon's comparison of Anderson to the artist Joseph Cornell brilliantly connects the materiality of Anderson's work with the equally deep strain of nostalgia that surrounds the display of his objects on-screen. The relationship of mourning to objects becomes one that is somewhat of a magic trick in which grief is transformed into a precious thing: "'For my next trick,' says Joseph Cornell, or Vladimir Nabokov, or Wes Anderson, 'I have put the world into a box.' And when he opens the box, you see something dark and glittering, an orderly mess of shards, refuse, bits of junk and feather and butterfly wing, tokens and totems of memory, maps of exile, documentation of loss. And you say, leaning in, 'The world!'" Chabon's connection of Anderson's work transforming the world into a box points to the miniaturization of the worlds housed within his films. I suggest that these worlds are, importantly, also framed by stages. *Rushmore* and *Moonrise Kingdom*, for example, are characterized by a miniaturized theatricality that could be perhaps the singular hallmark of almost all of Anderson's films. Alongside this is another hallmark of Anderson's films: characters haunted, indeed stunted, by mourning. They mourn for dead mothers, fathers, wives, husbands, loves, and dreams that have passed them by.

In the recent *Moonrise Kingdom*, the bittersweetness of first love is initially encountered backstage in a dressing room before a performance.

The glimpses of the performance in the film stages contain the kernel of love itself. Love becomes a play. Yet, in all of Anderson's endeavors, love is something that is already to be mourned and, as such, must have a kind of theatricality accompanying it because theatricality, I will claim, is a form of mourning and mourning is a form of theatricality. Being theatrical, presenting oneself as if onstage and in front of an audience, is a form of mourning, in that theatre and performance always, as Peggy Phelan has theorized, "respond to a psychic need to rehearse for loss, and especially for death" (3). The act of performing necessarily is an act of disappearance. Alternatively, mourning uses theatricality to attempt to reanimate the lost object and to replay the trauma of the loss itself. The loss becomes restaged over and over again unconsciously by the subject until he or she has worked through the grief of the loved one's absence. Theatricality, I will claim, is a form of mourning itself. Loss in the world of Anderson is present from love's first inception, and the form that this loss takes demands to be staged, housed, and miniaturized as if in a collection of sorrowful treasures. Anderson's occupies a unique space in cinema by creating narratives centered in grief and grieving and then doubling this effect by creating a self-referential theatricality that heightens, displays, and miniaturizes this process. The narrative, through moments like the Max Fischer Players presenting their plays, becomes mirrored onstage, allowing the characters to witness themselves and their traumas as if displayed in a collection and therefore, as Chabon has claimed, magically put "the world in a box."

Trauma as Collection

In *Beyond the Pleasure Principle*, Freud famously noted the repetition inherent in trauma. The traumatic event is missed and therefore must be restaged, replayed over and over again. Susan Stewart, in her book *On Longing: Narratives of the Miniature, Gigantic, Souvenir, the Collection*, argues for a theory of objects that play with our sense of scale and longing. Using her work alongside selected ideas within trauma studies, I will position the theatricality and stages within Anderson's work under a larger project he has of staging the mourning process in such a way that we can nearly hold the trauma in our hands for a time (or at least witness this act). This enactment of mourning is brilliantly theatrical. The stage houses the heartbreaks collected in Anderson's films where the theatrical is neatly put away after the show and treasured.

If trauma, as theorist Cathy Caruth describes it in her paraphrase of Freud, consists of the "peculiar and sometimes uncanny way in which catastrophic events seem to repeat themselves for those who have passed through them," we might begin to imagine Wes Anderson's work through

the prism of trauma (1). Caruth points to the double wounding of the trauma by referring to the myth of Tancred, who unknowingly wounds his love for a second time. This unknowing repetition is the hallmark of trauma and one that we can see replayed not only in the narratives of Anderson's films, where characters often unknowingly psychically injure one another, but also in the stage within the film that offers a moment of absent presence that gestures to the traumatic moment's theatricality in its repetitions and reenactments. Caruth, however, also reminds us that "trauma is not only the repetition of the missed encounter with death, but the missed encounter of one's own survival. It is the incomprehensible act of surviving—of waking into life—that repeats and bears witness to what remains ungrasped within the encounter with death" (2–3). This missed encounter grapples with both loss and the need to continue in spite of that loss. After all, as Ruth Leys has observed, "Trauma was originally the term for a surgical wound, conceived on the model of a rupture of the skin or protective envelope of the body resulting in a catastrophic global reaction in the entire organism" (19). The aftereffects of such a wound reverberate throughout the present in order to deal with the "rupture" ungrasped by the past. The need to move forward and let go of the past drives the loop of traumatic repetition. The character knows the beloved is gone but somehow collects and clutches objects and memories to hold as a stand-in for the love lost and the event that one is unable to change or truly experience. This mourning process leads to characters in need of another to restage the trauma with a witness who can narrate its secret language.

This need to make an absence present resonates with the use of the stage within cinema in that the meeting of reproducibility and "liveness" mirrors the encounter with trauma (the past) being reenacted (the present). Anderson's theatricality beckons to the viewer, much like the gesturing magicians that make up the world of the "cinema of attractions," offering a spectacle to be looked at, luring the viewer's eye inward. The frame of the stage offers a kind of depth to the screen that perhaps stands in for the interiority of characters that are, in their grief, left treading the surface of the world, gripping their collections of memories and objects in order to create a smooth and screened appearance of surviving the lost object.

Freud's description of a father's dream that occurs just after the death of his son tells an important story about trauma. The son appears to the father in the dream and asks reproachfully: "Father, don't you see I'm burning?" At the same time the dream is occurring, a candle has fallen over in the next room and burns the corpse of the child (547–50). Caruth points to "a sleeping father, unconscious to this burning in the next room, who hears in his dream the voice of his dead child pleading for him to see the fire by whispering the words, 'Father, don't you

see I'm burning?' It is this plea by an other who is asking to be seen and heard, this call by which the other commands us to awaken (to awaken, indeed, to a burning), that resonates in different ways" (9). This need to reawaken is the command to Anderson's characters as they move stunted through life, held back by a past heavy with memory, regret, and collections of souvenirs that they cannot let go of. Stewart suggests, "We need and desire souvenirs of events that are reportable, events whose materiality has escaped us" (135). This clutching the objects and memories of the past lends the dense materiality that is present in Anderson's films. The screen is filled to the brim with souvenirs that ghost the lost objects that characters cannot and will not move past. As Dominick LaCapra has noted, "When loss is converted into (or encrypted in an indiscriminately generalized rhetoric of) absence, one faces the impasse of endless melancholy, impossible mourning and interminable aporia in which any process of working through the past and its historical losses is foreclosed or prematurely aborted" (698). Anderson's theatricality lifts the traumatic from "rhetoric of absence" and replaces it with an enactment that gradually loosens the impossibility of mourning and its objects and replaces it with the possibility of something other.

The possibility of finding a way through trauma in theatricality places Anderson's cinema in close dialogue between languages of reproducibility and presence. E. Ann Kaplan points to trauma studies' connection of trauma to modernity (24), and Kevin Newmark links trauma to Walter Benjamin's focus on the shock of the modern (238). Kaplan, in turn, links trauma to the "shock" of the new medium of cinema. She writes, "Among art forms, cinema is singled out by scholars like Tom Gunning, Wolfgang Schivelbusch, and Lynne Kirby as involving a special relationship to trauma in the 'shock' experience of modernity, especially as cinema disoriented traditional, primarily literary cultures" (24). This shock disrupts experience and involves the loss of the aura representing the singular experience and replaces it with the reproducible. Anderson's focus on objects and collections shows us characters grappling with an attempt to come to terms with trauma and reclaim the aura of authentic experience, now past and unable to be recovered fully as anything but a reproduced approximation, through theatricality.

How does this shock of the reproducible relate to Anderson's cinematic form? Although the very ontology of reproducibility requires repetition of the event, what occurs when mortality meets the frame? Anderson answers with his collections of objects within his films.[1] Stewart distinguishes between the object of the souvenir and the collection, pointing out that "the space of the collection is a complex interplay of exposure and hiding, organization and the chaos of infinity" (156–57). This interplay between

organization and infinity, memory and miniaturization of experience to that which one can hold, oscillates rapidly in Anderson's work and is anchored by an insistent theatricality. This theatricality performs meaning and translates these objects into a narrative of materiality that gives weight to the screened stage as a space of mourning wherein the past becomes present and the "attraction" (the trauma) is transformed into a spectacle that lures the spectator into unfathomable depths that on the surface look like a neatly framed collection.

Each of Anderson's films leads its characters through a process of mourning, love, and working through with a slightly different emphasis. From Max's lost mother and Rosemary's lost husband in *Rushmore* to the orphaned Sam Shakusky (Jared Gilman) grieving for his lost parents, each character deals with the absence by attempting to find a new love object that can replace or at least soften the loss of the beloved. In *Rushmore*, Max's plays are his attempt to work through his grief, just as Suzy's performance in *Moonrise Kingdom* is also a way of working through a troubled relationship with her parents. Seen as a totality, they begin to present a prism of grief and love framed by the screened stage. By looking at each of these films from different periods of Anderson's career, we can begin to see the importance of both the theatricality (the installation of the stage upon the screen) and performance of mourning (the enactment and working through of loss and grief) and how the stage houses these traumatic repetitions as miniaturized replications of the mourning process.

"I Was in the Shit"

Rushmore's Max Fischer is mourning for his mother. His relationship to school and his endless list of extracurricular activities are related to this grieving. His strivings and yet poor performance in school show a child attempting to move past his grief, but at the same time unable to let go. The film's opening pointedly is framed with curtains parting as if the audience is looking at a stage. This mirrors the structural punctuation of Max's productions with the Max Fischer Players within the narrative of the film. The plays that Max chooses are all adaptations of famous films with subject matters and characters inappropriately mature for the age of his actors. At the end of the film, Max writes his own play that confidently integrates Hollywood genres (such as the war film, *Heaven and Hell*, a Vietnam drama) and requires a great spectacle (again, inappropriate for the school stage). The violent subjects of the films (crime and the Vietnam War) speak to the inner life of Max and externalize that which he is unable to articulate. The very title of his Vietnam drama, *Heaven and Hell*, suggests the confusion with which Max is greeting both his love of Rosemary (Olivia

Williams)—clearly, as Robé also points to, a substitution of love for his dead mother (107)—and the flipside of that love, the loss of his mother. His experience is one of ambivalence, both heaven and hell, emotions that need witnesses to their violent and frightening intensity. Indeed, the gathering of the characters of the film to view *Heaven and Hell* serves as Max's enactment of his interior life and bringing that life to the surface with all of its violence and contradictions in plain view for all to witness and transform into something other than a repetition of loss and grasping for the lost object.

Herman Blume (Bill Murray), a wealthy industrialist with a stagnant marriage, and the recently widowed teacher Rosemary Cross, who comes to work at her dead husband's alma mater, form a triangle to Max's increasingly erratic mourning process. He focuses his attention on winning Rosemary's affections (all the while Herman and Rosemary realize they have an attraction to one another) and attempts chivalrously to build an aquarium with Blume's money, because of Rosemary's love of fish (which, in actuality, is just a mirroring of her dead husband's love of fish and ghostly annotations he made in a library book as a student at Rushmore).

Max's unrealistic love for Rosemary and unusual friendship with Herman Blume mirror the adults' need to return somehow to childhood, settle scores, and mourn the inescapable and traumatic losses of adulthood. Max's grief and the adults' grief play off of one another; each watches the grieving processes of the other as if it were a play being performed with slight bemusement and deadpan earnestness. This seriousness with which the adults treat Max and Max treats the adults creates a world where it is hard to know where childhood and adulthood begin and end. Trauma erases the divide between adult and child, offering instead a rare moment where generations can be present for one another without the separation age produces. This generates a liminal space for characters to interact with great empathy and understanding.

At the end of the film, before the premiere of *Heaven and Hell* at his new high school (after being expelled from *Rushmore*), Max asks Blume, who served in Vietnam, "Were you in the shit?" Blume replies (deadpan), "I was in the shit." This simple exchange encapsulates the situation for all of the characters in the film—they are all "in the shit," trying to find their ways home. *Rushmore* tells the tale of what happens when you are in the shit and need to find a way out. The child and the adult equally mourn and as such are positioned to help one another enact and work through traumatic repetition. The end result is that Max is returned to being a precocious adolescent and Blume and Rosemary begin a relationship again, this time freed of their stunted place in life and ready to move forward.

Theater within *Rushmore* becomes the place where adults and children alike join to watch and perform and begin to see their own dilemma and, perhaps, a way through to something past mourning. The film being framed as a play gives each moment a theatricality that "performs" each moment as if onstage. This performing is the state that the characters find themselves in. They perform the past in the present and loop between mourning and memory, seemingly without end. Theatricality installs itself onto situations that need repetition and witnessing. This connects the theatrical to mourning in that each offers sight of, within a site of restaging, that which was missed—the moment of the traumatic event, impossible to experience and destined to repeat.

Max Fischer's failures, foibles, and eventual success at not only surviving his mother's death, but boldly leading others through their own "shit," offers the stage as a place of connection and community that unites others in screening the possibility of survival in a frightening world. The miniaturizations of the crime drama *Serpico* and the Vietnam War make the frightening small and viewable. These traumatic and violent experiences mimic the emotional intensity felt by Max. By gathering all the characters into the theater at the end of *Rushmore*, Max stages an explosive catharsis and gives both an ending and new beginning to his community and ultimately to himself. As Devin Orgeron has pointed out in his essay "La Camera-Crayola: Authorship Comes of Age in the Cinema of Wes Anderson,"

> Max's authorship, in other words, has moved beyond the veneer of plagiarism and pyrotechnics and has affected the formation of real communities. The celebration after the play—the "Heaven and Hell Cotillion," as it is dubbed—is Max's real communal work, and Anderson slows the images down as the film draws to its conclusion; once again elongating the moment, the camera tracks slowly back, framing this newly discovered extended family and creating of the group a varied and redemptive version of the family portrait. (49)

This "family portrait" offers a life beyond heaven and hell, something that is in between the highs and lows of fervent love and loss. As Orgeron's article clearly shows, Anderson walks a tightrope between the genius auteur and a celebration of communal authorship taken on by the lives and narrations of his creations. This vacillation between singularity and community mirrors the relationship between spectator and performer that is enacted in Anderson's screened stages that in turn mirrors the relationship between presence and absence that the stage within the screen necessarily brings forth.[2] Max's *Heaven and Hell* makes present (through a medium of presence) his mother's absence. The absence that is ontologically at the heart of

narrative film is framed and made present through the invocation of liveness within reproducibility. This is in line with Gunning's theory that the cinema of attractions operates as "sudden bursts of presence" ("Now You See It" 45). These sudden "bursts" operate as portals of love and mourning, summoning the lost loved one present and allowing the spectator to witness and perhaps let go.

"Before the Flood"

Anderson returns to childhood once again in *Moonrise Kingdom*, this time ruminating on the first flood of young love in the wake of traumatic beginnings. In *Moonrise Kingdom*, 12-year-old Sam (Jared Gilman) and Suzy (Kara Hayward) first see one another backstage. She is dressed as a raven for *Noye's Fludde* at St. Jack's Church on the island of New Penzance. The whole film is framed by the narrator (Bob Balaban) speaking straight into the camera while distributing facts about the island, its inhabitants, and the weather. This acknowledgment of the camera and an audience watching the spectacle unfold brings forth a kind of "cinema of attractions" that makes the whole film framed by an intentional theatricality and address to the audience.

The framing of the camera and the theatricality of Benjamin Britten's music and children's opera *Noye's Fludde* and *The Young Person's Guide to the Orchestra* surrounds the narrative of the film like a proscenium opening containing a play. The opera *Noye's Fludde* finds parallel doppelgängers in the film through the literal flood that encompasses the narrative in the climax of the film and the "flood" of emotion that young love brings. In opposition to this blossoming young love that leads the young Suzy and Sam on an adventure throughout the island is the love between Suzy's parents, Laura (Frances McDormand) and Walt Bishop (Bill Murray), which is decayed, withered, and autumnal by contrast. Additionally, Captain Sharp (Bruce Willis), who is also having an affair with Laura, and Scout Master Ward (Edward Norton) are melancholic, albeit diligent and hardworking, in their task of caring for the scouts and finding the escaped young lovers.

The narrative is laid out before the audience by the narrator, very much like the Stage Manager's setting of the scenes in Thornton Wilder's *Our Town*. The opera's backdrop along with the flood of both love and water washes out the old, tired love between the Bishops and provides a new kernel of parental love between Captain Sharp and Sam, which leads to Sharp's eventual decision to take Sam into his home as his guardian. All of this is framed on-screen by the screened stage—what I refer to as "scenes

of theatre and performance within film"—that started with Sam and Suzy encountering one another backstage, before the flood.

The trauma of aging love, the drifting apart of the parents, forms one part of a grief-in-motion that starts the film. The other traumatic anchor to the film is Sam's dead parents. Their absence creates the hole that Sam tries to fill on the cusp of his adolescence with new love and, later, a new parental figure. His uncaring foster parents (Larry Pine and Liz Callahan) write to Sam and tell him that he is unwelcome to return; this rejection forms a kind of isolation that roots all of the characters together as being lost souls (each their own island) quite out to sea. The flood, in one rush, brings them together both as a community and as love itself. The floodwater purifies each character and leaves them ready to establish new or refreshed relationships with one another.

What began in miniature on the stage is mirrored and magnified in the climactic big storm scenes where each character's mettle and connection to one another are tested. Love becomes what is staged as they struggle, bumble, and stumble to save one another from the ravages of being alone on the open sea. Noah's Ark, the anchoring tale of the film, tells the story of animals "two by two"; *Moonrise Kingdom* takes the isolated and brings them together into the ark that is the island as each takes another to make the voyage through life. The mourning for what is lost, what is hard and decaying in life, is finally staged as being purged. What is left is a shining orchestra that plays each note alone, but together makes a community and a performance that calls for a togetherness despite the holes left by those gone, betrayed, and cruel. The camera frames each scene as if on a proscenium stage that offers the flood, both literal and metaphorical, to acquire a distance that neatly assembles each of its parts, much like Suzy's suitcase of books and records and basket with a kitten inside that she carries on her journey.

Suzy's collection and the letters that punctuate the early sections of the film are theatrical manifestations of the love that can blossom from trauma and pain. Suzy's difficult childhood, along with Sam's loneliness without his parents, sets them both on a voyage that will carry them along the storm of coming adolescence. The backstage meeting that hits them both like the lighting strikes later in the film places the stage once again at the center of the action, helping characters to navigate and contain both grief and love. The return of the stage later in the film cements it as a pivotal space in which love begins as suddenly as a strike of lightning and anchors that love in its reappearance. The stage mirrors the narrative of the film, and its appearance at the beginning and end solidifies it as the island within the island.

"I've Been out to Sea for a Long Time"

Susan Stewart asserts that "the body presents the paradox of contained and container at once" (104). This containing container of the body is the contained invisible stuff of the body: emotion, memories, and thought. At the same time, the body is like an object surrounding and holding that very stuff encased by skin and bone. Both subject and object, inside and outside—this contained container is mirrored in the miniaturized stages within Anderson's films. Theatricality within the film (the screened stage) is also both contained and container. Housed within the screen, the screened stage is contained by the flatness of filmic reproducibility, all the while gesturing to a sense of depth and presence. This presence offers "liveness" within the reproducible, a moment of the present moment contained within the past. The stage on-screen contains the aura of the present and past and yet is housed within the flickering repetition of the endless possibilities of filmic repetition. Contained and container, the screened stage becomes a portal to other worlds, other times, and offers the restaging of moments collected within the proscenium frame.

Max Fischer says, "I've been out to sea for a long time." Each of Anderson's films represents a collection of characters who have been metaphorically out to sea, lost in their lives, losses, and traumas, including Anthony Adams (Luke Wilson) in *Bottle Rocket*, Richie Tenenbaum in *The Royal Tenenbaums*, Steve Zissou (Bill Murray) in *The Life Aquatic with Steve Zissou*, Mr. Fox (George Clooney) in *Fantastic Mr. Fox*. We see the sea as a collection of objects in Anderson's world. Somehow characters find their way past thingness and into meaningful connection with one another. The stage, whether in *Rushmore* or *Moonrise Kingdom*, offers a secure containing container to finally see that which was missed, overlooked, or ignored. This seeing, with the connection of others, offers a space of love. This kernel of love leads from the flood and from the shit into some new formation of life past that which was seemingly frozen, dead, and eternally housed in a still (stagnant but beautiful) collection of memories. The enactment of those memories upon screened stages brings the inanimate to life and makes the lost object present enough to perhaps say good-bye.

Notes

1. For example, Suzy Bishop's suitcase of treasured books and kitten in *Moonrise Kingdom* serves as a kind of "home" away from home. The potential loss of family is replaced by trinkets she takes from the place she has fled. Max

Fischer's love object, Rosemary Cross, lives in her ex-husband's childhood room surrounded by her lost loved one's toys and special objects. She cannot move past her grief and melancholy because she is literally still immersed in her husband's collection of objects.
2. I discuss the notion of *screened stages* in my dissertation "Screened Stages: Representations of Theatre within Cinema." The study argues that relationship between liveness and reproducibility is brought to the fore when screened stages appear within narrative films.

Works Cited

Caruth, Cathy. *Unclaimed Experience: Trauma, Narrative, and History*. Baltimore, MD: Johns Hopkins UP, 1996. Print.
Chabon, Michael. "Wes Anderson's Worlds." *The New York Review of Books*, January 31, 2013. Web.
Freud, Sigmund. *Beyond the Pleasure Principle*. Translated by James Strachey. New York: W. W. Norton, 1990. Print.
_____. "Mourning and Melancholia." In *The Freud Reader*, edited by Peter Gay, translated by James Strachey, 584–88. New York: W.W. Norton, 1989. Print.
Gunning, Tom. "The Cinema of Attraction: Early Film, Its Spectator and the Avant-Garde." *Wide Angle* 8.3/4 (1986): 229–35. Print.
_____. "'Now You See It, Now You Don't': The Temporality of the Cinema of Attractions." In *The Silent Cinema Reader*, edited by Lee Grieveson and Peter Krämer, 41–50. New York: Routledge, 2004. Print.
Joseph, Rachel. "Screened Stages: Representations of Theatre within Cinema." PhD diss., Stanford University, 2009.
Kaplan, E. Ann. *Trauma Culture: The Politics of Terror and Loss in Media and Literature*. New Brunswick, NJ: Rutgers UP, 2005. Print.
LaCapra, Dominick. "Trauma, Absence, Loss." *Critical Inquiry* 25.4 (1999): 696–727. Print.
Leys, Ruth. *Trauma: A Genealogy*. Chicago: University of Chicago Press, 2000. Print.
Newmark, Kevin. "Traumatic Poetry: Charles Baudelaire and the Shock of Laughter." In *Trauma: Explorations in Memory*, edited by Cathy Caruth, 236–55. Baltimore, MD: Johns Hopkins UP, 1995. Print.
Orgeron, Devin. "La Camera-Crayola: Authorship Comes of Age in the Cinema of Wes Anderson." *Cinema Journal* 46.2 (Winter 2007): 40–65. Print.
Phelan, Peggy. *Mourning Sex: Performing Public Memories*. New York: Routledge, 1997. Print.
Robé, Chris. "'Because I Hate Fathers, and I Never Wanted to Be One': Wes Anderson, Entitled Masculinity, and the 'Crisis' of the Patriarch." In *Millennial Masculinity: Men in Contemporary American Cinema*, edited by Timothy Shary, 101–21. Detroit, MI: Wayne Street University Press, 2012. Print.

Schivelbusch, Wolfgang. *The Culture of Defeat: On National Trauma, Mourning, and Recovery*. New York: Metropolitan Press, 2003. Print.

Stewart, Susan. *On Longing: Narratives of the Miniature, the Gigantic, the Souvenir, the Collection*. Durham, NC: Duke UP, 1993. Print.

Weber, Samuel. *Theatricality as a Medium*. New York: Fordham UP, 2004. Print.

5

"Who's to Say?": The Role of Pets in Wes Anderson's Films

C. Ryan Knight

Film scholars and cinephiles alike have commonly identified in Wes Anderson's films the recurrent theme of isolation and the need to reconnect to community (particularly family). Devin Orgeron has argued that, beyond being about childhood, Anderson's films are also "about family and the need, in the face of familial abandonment, to create communities in its place" (42). Many characters in his films live in close proximity and interact with one another on a daily basis, yet they are relationally stranded and distant from one another; each film's narrative, or diegesis, is concerned with what Jesse Fox Mayshark describes as "character arcs of maturity" characters must traverse to reach "a form of redemption within [their] peer group" (136, 177). Characters in Anderson's films experience both a desire to reconnect to those around them and revulsion when those attempts are foiled by other continuing irresponsible behavior. Generally the reunion takes place but not without difficulties, for Anderson's films resist cutting "emotional corners" (Jones 23–24).

What remains to be seen, and what I wish to focus on here, is precisely how animals—specifically pets—in Anderson's films influence characters' paths toward reentering community.[1] Many characters encounter, interact with, and are significantly affected in some way by pets. They either own or come into close contact with the pets, generally during a pivotal scene in Anderson's films. Animals first appear in *Rushmore* (1998), most notably Ms. Cross's (Olivia Williams) fish in her classroom, which increase in number once Max Fischer (Jason Schwartzman) buys and gives her more;

however, animals are not interwoven with the themes of Anderson's films until his follow-up to *Rushmore*, *The Royal Tenenbaums* (2001). Starting with *The Royal Tenenbaums* and continuing, to varying extents, in all his films after *Tenenbaums*, pets have become integral parts of Anderson's cinematic landscape and thus merit careful attention.

I propose that the point at which characters lose (or, in Richie Tenenbaum's case, is reunited with) a pet marks the point where they become ready and able to reconnect with their family and community. This recurrent phenomenon takes place most apparently in *The Royal Tenenbaums*, *The Life Aquatic with Steve Zissou* (2004), and *Moonrise Kingdom* (2012). Without the pets in these films, it is far less likely that characters would have been able to traverse the distance they have allowed to separate themselves from their family and friends. The pets enable these characters to reprioritize relationships, and these characters finally overcome barriers and reconnect with those around them.

Like Anderson, scholars and theorists have investigated what importance animals have in helping humans orient themselves, particularly as contemporary society mechanizes more and more, destabilizing people's notion of selfhood. The very notion of *animality* prompts discussion of the differences between species, and this discussion drives theorist Donna J. Haraway to reexamine the Latinate origins of the term *species*: *specere*, "to look/behold" (17). In beholding the animal, people better grasp basic concepts of ontology, positioning them to begin to construct identity, morality, and so forth. People examine themselves against the Other, the animal, and thence begin exploring the contours of their unique existence. It seems no surprise, then, that many characters in Anderson's films need the mirroring of an animal to help them along their character arc to maturity.

Perceiving the way in which animals introduce people to their own perspective and propensity toward ontological construction of reality, Glen A. Mazis has argued that "animality is constitutive of what we think of as most human about ourselves" (5), meaning people conceive of emotions, morality, and other major issues based on what they witness and intuit while watching animals act by themselves and among others. Animals best introduce people to the Other, for they enable people to realize that "*to be fully within a point of view is also to be without (in others), and to be without (in others) is also to be within a point of view*" (175, italics in the original). Modern life, driven as it is by technology, increasingly alienates people from meaningful contact with others, thus increasing the importance of discovering the Other through animals.

Theorist Kelly Oliver explains that the experience of the Other through animals can be described as *animal pedagogy*, "the ways in which animals ... teach us to be human" (5), a central lesson many of Anderson's

characters need to learn as they mature. From observing animals, people better grasp their tendency toward cruelty but also their opposite tendencies toward community, coexistence, and codependence. Oliver focuses on the encounter of animals in philosophical texts, but readers also encounter animals in everyday life and draw similar conclusions about animals—and, by extension, themselves. Without animals, people lack a meaningful mirror against which they can measure themselves and truthfully reflect upon their own nature as human beings. Without this mirror, people are bound to behave upon their instinctive impulses without giving thought to the consequences of behaving in this manner. The very act of beholding the animal, however, initiates one's conscience, and one's conscience inaugurates cognitive proceedings that develop one's morality by weighing and evaluating the results of one's actions within her or his society.

The foundational lesson animals teach humans whose conscience has been activated is the notion of a "dwelling-world," which biophilosopher Jakob von Uexküll describes in Heideggerian terms as the spatial world to which animals are subject and by which they are limited (139). They must cope with and adapt to their respective limitations, thereby discovering how to survive, perhaps even how to thrive, if they acclimate to their respective dwelling-world. In discovering their dwelling-world, humans are challenged by animals to grapple with serious ontological and existential questions about their life. Humans wrestle not only with how to cultivate their dwelling-world but also with what the existential implications are in their ability to perceive their domestication of the dwelling-world, as well as their ability to perceive the different ways in which animals also domesticate their dwelling-world.

Introduction to one's dwelling-world quickly expands beyond autonomous interests to far wider social interests, for people quickly discover upon identifying their dwelling-world that they share their dwelling-world with others around them. To exist, then, becomes an exercise in learning to live in community with one another, preserving one's own survival and, when and where possible, inaugurating some form of symbiosis to improve the general quality of life by living together. When in community with others, one's sense of isolation lessens and, inversely, one's quality of life generally improves upon entering community since one's weaknesses are oftentimes made up for by others' strengths.

In Anderson's films, people must discover instructive insights into themselves and use those insights for good once they are enabled by animals to perceive their dwelling-world and the social implications therein. Anderson's characters measure their lives against those of the animals around them, a measurement they oftentimes conduct subconsciously and from which they derive beneficial lessons from the operation of differentiation,

of their encounter with the Other. Most importantly, the death, loss, or (less common) return of the animal closest to them compels them to reconnect and commune with others around them.

In *The Royal Tenenbaums*, brothers Chas (Ben Stiller) and Richie Tenenbaum (Luke Wilson) are able to reconnect with their family due largely to their pets. Both have alienated themselves from their family in response to their troubled childhood and rocky years in early adulthood. Chas kept his bitterness from childhood at bay by overworking himself and utilizing his business skills; once his wife Rachael dies in a plane crash, however, Chas becomes paranoid, obsessed about safety, and dysfunctional as a father to his sons, Ari (Grant Rosenmeyer) and Uzi (Jonah Meyerson). Meanwhile, Richie Tenenbaum is driven away from home by his quasi-incestuous love for his sister, Margot (Gwyneth Paltrow), who was adopted into the family. Margot's marriage to Raleigh St. Clair (Bill Murray) leads Richie to give up his tennis career and escape from home even further by traveling the world by ship for a year. Richie's sending away of his hawk, Mordecai, signifies his belief that he must exile himself due to his illicit love for Margot.

Chas's dog, Buckley, becomes simultaneously a reminder of loss and also a testament of survival, as established by the shot of Buckley in his crate atop the plane wreckage. Chas tries unsuccessfully to go on living as though his dwelling-world were not dramatically altered by Rachael's (Jennifer Wachtell) death, and Buckley's presence reminds Chas of the unspoken absence of Rachael that he tries to avoid. Ever since Rachael died in the plane crash, Chas is despondent and even further disconnected from others around him. Like many characters in Anderson's films, Chas uses "a range of displacement tactics to avoid engaging with the reality of life" (Browning 38). Furthermore, Chas's failure to see Buckley as a symbol of survival affects his relationship with Ari and Uzi, who were in the plane crash with Rachael and Buckley; they, too, are mostly ignored as Chas dwells on Rachael's death rather than their survival.

The paradoxical twofold purpose Buckley serves in the film is starkly featured in the scene where Chas stages a late-night fire drill, which he believes they fail and thus "die" in the imagined fire. Outside, they realize they left Buckley behind in the apartment. Disheartened by their pace, Chas replies that forgetting Buckley does not matter since they all would have "burned to a crisp" due to their slow pace anyway. Buckley is once again a reminder of loss and the impossibility of survival. Just as Buckley should not have survived the plane crash but did, so too do Chas and his sons survive even though they theoretically should have died in a fire based on the training drill; Chas, however, remains blind to survival since he is fixated on loss and danger.

Sadly, Buckley does finally die at the end of the film; interestingly, though, his death initiates Chas's reconnection with his sons and even his estranged father, Royal (Gene Hackman). After Eli Cash (Owen Wilson) runs over Buckley in a drug-induced rampage, Chas is finally able to admit the six months since Rachael's death have been difficult for him and that he needs help. It is precisely when Buckley, the reminder of loss and the testament to survival, dies that Chas finally sees and acknowledges his damaged dwelling-world and seeks to reconnect with others. Chas is now able to perceive his sons as individuals and not as "extensions" of himself; he finally allows them breathing room to be themselves. Royal sees the opportunity to meet Chas and steps in to help his son. In an act Browning describes as a "rehabilitation" (49), Royal buys a Dalmatian named Sparkplug from the firefighters responding to the accident, and Royal tells Chas he understands the recent months have been hard. The film concludes with Chas, Royal, Ari, and Uzi on good terms and enjoying their time together.

Mordecai also returns to Richie in the exact scene where he visits Royal and the two are able to reconnect with each other. Richie comes to ask his father for advice regarding what to do about his feelings for Margot. No longer does Richie feel he has to run from his feelings and escape from his family lest they be disgusted by his love for his sister. Rather than condemn his son, Royal is encouraging, and this encouragement enables Richie and Royal to reconnect for the first time since Royal's faked cancer was discovered. The parallel between Richie's and Mordecai's leaving home and eventually returning confirms for Richie the conflicting nature within him: the temptation toward evasion and the call to return home to community with others. Though evasion remains a temptation for him (as signified by his attempted suicide, the final act of evasion), he nonetheless finds the strength to remain home, despite his questionable love for Margot.

Like Chas and Richie (though for very different reasons and under different circumstances), Steve Zissou (Bill Murray) also encounters a dog that enables him to reconnect at long last with those around him—in Zissou's case, his *Belafonte* crew. At the start of *The Life Aquatic with Steve Zissou*, Steve's marriage to Eleanor (Anjelica Huston) is severely strained. The death of his right-hand man, Esteban (Seymour Cassel), on the last maritime expedition has created further tension between Zissou and his crew. Motivated by his desire to avenge Esteban's death, Zissou launches out on another adventure without proper funding and with failing equipment, but his crew is no longer willing to tolerate his behavior as a "colonial chief in his kingdom" while jeopardizing their lives (Browning 54). Blinded by his desire for revenge as well as his longtime eccentricity, Zissou neglects his responsibilities to those around him, causing him to make irrational and dangerous decisions.

The scene in which Zissou acquires a pet—a dog he later names Cody—marks the transitional point for Zissou in his character arc toward maturity and reentrance into community. Philippine pirates overtake the *Belafonte*; enraged and humiliated, Zissou singlehandedly retakes the *Belafonte* from the pirates. After running off the pirates, Zissou discovers they left behind a three-legged dog. For a man who has seemed washed-up and fallen from the height of his fame and success, Zissou is suddenly in tune with his dwelling-world, *The Belafonte* and its crew (and now also Cody), and he exhibits bravery in reclaiming his vessel.

Cody's presence is concurrent with Zissou's attempts at restoring his relationships. The damage wrought on the *Belafonte* and Zissou's growing financial constraints force him to accept the help of his nemesis, Alistair Hennessey (Jeff Goldblum). Only Cody accompanies Zissou aboard Hennessey's ship, a scene in which Zissou and Hennessey remain enemies but come to understand, and perhaps even respect, each other for the first time. When Hennessey disciplines Cody and scolds him to be quiet, the audience sees a symbolic representation of what is transpiring concomitantly between Zissou and Hennessey in this scene: Hennessey is reprimanding Zissou for allowing his professional life and career to collapse and degrade in recent years.

Though Cody does not die in the film, he is left behind during the Ping Island Lightning Strike rescue operation. When Zissou realizes they left Cody behind on the island, he says they have to go back to rescue Cody. His team says nothing in reply, but their solemn faces indicate to Zissou that returning for Cody is too dangerous. This moment reveals to Zissou the consequences others suffer because of his oversight and, furthermore, the realization that others in his past have also suffered as a result of Zissou's reckless choices. Just after Zissou's crew leaves Cody behind, Zissou addresses his crew regarding their near mutiny before the lightning strike. The speech results in renewed commitment from his team to finish the expedition. Zissou's relationship with Eleanor improves. (She had left him earlier in protest against his unwise decisions regarding the current expedition.) Zissou also finally establishes a father-son relationship with Ned (Owen Wilson), who also now goes by the name Kingsley Zissou, the name Zissou says he would have given Ned had he been present for Ned's birth. Zissou ultimately remains distant from others, but he realizes the danger of his harsh nature and is thereby drawn closer than he has been for many years to those around him as a result of his renewed vigor—and, it turns out, the silent but important influence of Cody.

In *Moonrise Kingdom*, Anderson veers from the direct relationship between a character and his pet featured in *The Royal Tenenbaums* and *The Life Aquatic*, but he nevertheless still allows the loss of an animal to serve as the point at which Sam is able to connect with others. Snoopy meets a

tragicomic end, as did Buckley in *The Royal Tenenbaums*. Snoopy's death marks the point at which Sam and Suzy (Jared Gilman and Kara Hayward) start to grasp the seriousness of their relationship. Prior to Snoopy's death, Sam and Suzy's budding relationship is marked chiefly by naiveté and levity. Snoopy's death shakes up Suzy, who asks Sam, "Was he a good dog?" Sam asks in response, "Who's to say?" The bluntness of Sam's question rhetorically suggests a negative answer to his own question: no one can say whether an animal's life is good because no clear moral or ethical categories enable the question to be answered easily. Having witnessed Snoopy's death, Sam and Suzy discover they must do all they can together to find meaning in their lives through their time together—something their consciences convince them only they, and not animals, are able to do.

Sam's reconnection with his troop also changes after Snoopy's death. When the troop reunites with Sam in the scene where the adult search party finally locates Sam and Suzy, the troop demonstrates a changed collective attitude toward Sam, an attitude of respect, admiration, and even awe that Sam dared this feat with Suzy. Moreover, the troop recognizes the authenticity of Sam and Suzy's relationship, and they commit to bettering their relationship with Sam by helping him reunite with Suzy. Sam is cautious about accepting the scout troop's help, but he slowly reciprocates their expressions of goodwill and reunites with Suzy and his peers.

Sam and Suzy find their love strong enough to provide meaning and importance to their lives, but the conclusion of *Moonrise Kingdom* signals the answer adults collectively give to the same question. They struggle to recognize the authenticity of the young couple's love because of the disillusions about love and relationships that come with adulthood. Viewers see this disillusion most clearly in the scene just before the "marriage" ceremony at Fort Lebanon; Suzy's parents, Walt and Laura Bishop (Bill Murray and Frances McDormand), lie in separate beds. After reviewing work-related matters with each other, Laura tells Walt, "We're all [the kids have] got, Walt." Sadly, Walt replies, "It's not enough." The remainder of the film, then, becomes an attempt to convince adults like Suzy's parents of the legitimacy and sufficiency of their young love, which is enough for them. Without the influence of animals, the adults' consciences remain inactivate and thus unaware of how they could possibly find meaning in their lives as Sam and Suzy have managed to do. The adults in the film hesitate to embrace Sam and Suzy's relationship but are all convinced by the end; as a result, they reconnect not just with the children but also with their fellow adults.

The various characters in Anderson's films discussed above experience similar epiphanies as do Sam and Suzy after Snoopy's death. Their lives all seem to be empty and meaningless; it is only their relationships and engagements with one another that achieve any sort of authentic and legitimate

meaning in their lives. Thanks to Buckley, Chas Tenenbaum learns he cannot encase those around him with safety protocol. Steve Zissou learns the importance of doing everything he can to revisit his past and right his mistakes, and to grieve when he is unable in some cases to make things right. Sam and Suzy face the meaninglessness of life when they stand over Snoopy's corpse and realize their love is all that can add meaning to their lives.

Anderson's *Fantastic Mr. Fox* (2009) offers considerable illumination into why animalsare able to convey these important lessons and points to humans in his movies. The animals' personification in *Fantastic Mr. Fox* elucidates the mixed nature of humankind: it is gentle and loving because of its civilization, its community, and its relationships; yet it is also harsh and instinct driven because it is also an animal, distinguished only by its specific mode of civilization. Life, then, becomes a careful balancing act in which people must neither suppress or disavow their instincts nor jeopardize their dwelling-world when acting upon their instincts.

Early in *Fantastic Mr. Fox*, Mr. F. F. Fox (George Clooney) demonstrates his discontent with routine civilized life (a recurrent theme in Anderson's films) and expresses nostalgia for his earlier days of being a burglar, which he found far more fulfilling than being a writer whose newspaper column goes, he believes (and fears), largely unread. One night, he stands with Kylie (Wallace Wolodarsky), a possum, and asks, "Who am I?" Realizing he could have been any number of other animals, he wonders what it means for him to be a fox. Fox tells Kylie he can't be happy as a fox unless "there's a chicken between my teeth." Fox's musings worry Kylie, who tells Fox, "I don't know what you're talking about, but it sounds illegal." By no means is Kylie's objection thorough or clear, but it nonetheless is a call for Fox to consider the consequences of whatever plan he is hatching in his head. Fox opts for executing his three-part master plan as a way of rediscovering his wild nature, forgoing Kylie's passive warning against getting into trouble. Fox's choice indicates his interest in rediscovering his instincts but also his neglect of his dwelling-world.

Strong as the natural impulses and the desire for happiness are, they come to face more formidable challenges than Kylie's passive warning. Once the farmers retaliate against Fox for having stolen from them, the dialogue between Fox and his wife, Felicity (Meryl Streep), after their new tree-home is destroyed unveils this tension between civilization and animal instinct. Mrs. Fox forces her husband to reconsider whether his endeavor was worth all the suffering and trouble he has now caused, not just for himself but also for those closest to him: his wife; his son, Ash (Jason Schwartzman); and his nephew, Kristofferson (Eric Chase Anderson). After clawing Fox out of anger, Mrs. Fox tearfully asks him why he had to break his promise not to steal anymore. His response is that he is a wild animal who cannot deny his

innate fox nature—that is, he cannot do other than what his instincts drive him to do. Mrs. Fox quickly rebuts his point, though, saying that beyond being a fox, Mr. Fox is "a husband and a father." Here Mr. Fox is confronted with the clash of instinct against civilization: he is what he is and cannot change that, but he also has taken on familial responsibilities and cannot evade those simply to pursue his natural instincts. Both instinct and responsibility must be kept in balance.

Mrs. Fox is right that Fox has assumed responsibility for her and Ash's well-being, but even she does not realize (or at least state) the much broader scope of Fox's responsibility to his community and dwelling-world. After the confrontation between Mrs. and Mr. Fox, viewers see all the other animals that have fled their habitats because of Fox's actions and the ecological destruction wrought by the three vengeful farmers. Badger (Bill Murray) stresses this to Fox when he growls and says, "A lot of good animals are *probably gonna die* because of you!" Their lost habitat and being denied access to necessary provisions like food and water place all the animals in mortal danger, as Badger indicates. Fox stole to feel less poor and provide delicious food and beverages for his immediate family, but he realizes once he sees everyone underground with him the terrible mistake he has made. His selfishness and conceit have always distanced him from those around him, but now the wake of his poor decision makes him responsible for the likely and pending decimation of wildlife.

Aware of his primary responsibility for this terrible predicament, Fox confesses his mistake to his wife and informs her of his "suicide mission": to give himself up to be killed by the farmers so they will leave all the other animals alone, thereby reinstating the animals' chances of survival after his mistake. Fox's plan represents an attempt at the mortification of instinct, killing what is dangerous within him by taking a course of action that guarantees his death. The pushback Fox gets from his wife in this scene and also the elevated confidence he feels after saving Ash from Rat's (Willem Dafoe) attempt to kidnap Ash combine to reinvigorate Fox's will to live and also to save his community by uniting them all rather than giving himself up and hoping the farmers will let be the other animals. Mrs. Fox drives her husband to commit himself to his dwelling-world once more and do all he can to make right all that is wrong.

The film's conclusion depicts Fox as committed wholeheartedly to the well-being of those around him. Fox's lesson about responsibility and community is an important one characters in Anderson's other films must learn. Mayshark rightly argues that Anderson's cinematic characters are "emotional misfits whose maturity lags behind their accomplishments" and that the best development a character can undergo in an Anderson film is "simply to grow up" (116). But this lesson Mayshark identifies is

not strictly a personal lesson. It is indeed personal, but the ramifications of whether or not the character learns this lesson affect, negatively or positively, those around that character needing to grow up in some way. Had, for instance, Fox not "grown up" quick enough, his defeatism might have led to disaster for his fellow animals under attack by the farmers.

An integral part of growing up and maturing into adulthood is taking responsibility not just for oneself but also responsibility to preserve and actively seek the well-being of others with whom one is in community—in short, to understand and participate in one's dwelling-world. Chas's sons would not have been able to grow up functionally had Chas failed to allow them room to live and relinquished his iron grip on their upbringing. Zissou experienced success in years past largely thanks to the help his crew rendered, often behind the scenes, to enable him to become a star documentary filmmaker. Sam and Suzy might have ended in cynicism like Suzy's parents had they not found inspiration to instill meaning in their lives. Part of human life is living together, and had characters failed to learn this and incorporate it, their process of maturation would have been short-lived and incomplete.

Had the characters discussed in this essay not had animals against which they could compare themselves analogously and hierarchically, they might not have entered into community with others as properly and effectively as they do. The presence of animals in their lives gives them a better understanding of how they must treat those around them in order to uphold their responsibilities to others. Having gained consciousness of their dwelling-world and having been introduced to the concept through interaction with animals, Anderson's characters are thereby better prepared to complete their character arc toward maturity, allowing them reentry into community.

Note

1. Space does not allow an analysis of the role of all animals in Anderson's films: the exotic and animated animals, the dolphins, Zissou's cat (which died from a poisonous snakebite), and the jaguar shark—all featured in *The Life Aquatic with Steve Zissou*; the medieval play *Noye's Fludde* in *Moonrise Kingdom*; and more. These are all fruitful topics for further discussion and investigation, but they are not within the scope of the present discussion.

Works Cited

Browning, Mark. *Wes Anderson: Why His Movies Matter*. Santa Barbara, CA: Praeger, 2011. Print.

The Darjeeling Limited. Directed by Wes Anderson, with performances by Owen Wilson, Adrien Brody, and Jason Schwartzman. Fox Searchlight, 2007. DVD.

Fantastic Mr. Fox. Directed by Wes Anderson, with performances by George Clooney, Meryl Streep, Jason Schwartzman, and Bill Murray. Twentieth Century Fox, 2009. Blu-Ray.

Haraway, Donna J. *When Species Meet*. Minneapolis, MN: University of Minnesota Press, 2007. Print.

The Life Aquatic with Steve Zissou. Directed by Wes Anderson, with performances by Bill Murray, Owen Wilson, Cate Blanchett, and Anjelica Houston. Touchstone Pictures, 2004. DVD.

Jones, Kent. "Animal Planet." *Film Comment*, November/December 2009, 22–25. Print.

Mayshark, Jesse Fox. *Post-Pop Cinema: The Search for Meaning in New American Film*. Westport, CT: Praeger, 2007. Print.

Mazis, Glen A. *Humans, Animals, Machines: Blurring Boundaries*. Albany, NY: State University of New York Press, 2008. Print.

Moonrise Kingdom. Directed by Wes Anderson, with performances by Jared Gilman, Kara Hayward, Bruce Willis, and Edward Norton. Indian Paintbrush, 2012. Blu-Ray.

Oliver, Kelly. *Animal Lessons: How They Teach Us to Be Human*. New York: Columbia UP, 2009. Print.

Orgeron, Devin. "La Camera-Crayola: Authorship Comes of Age in the Cinema of Wes Anderson." *Cinema Journal* 46.2 (2007): 40–65. Print.

The Royal Tenenbaums. Directed by Wes Anderson, with performances by Gene Hackman, Anjelica Houston, Ben Stiller, and Gwyneth Paltrow. Touchstone Pictures, 2001. DVD.

Rushmore. Directed by Wes Anderson, with performances by Jason Schwartzman, Bill Murray, Olivia Williams, and Seymour Cassel. American Empirical Pictures, 1999. DVD.

Uexküll, Jakob von. *A Foray into the World of Animals and Humans: With a Theory of Meaning*. Translated by Joseph D. O'Neil. Minneapolis, MN: University of Minnesota Press, 2010. Print.

6

"American Empirical" Time and Space: The (In)Visibility of Popular Culture in the Films of Wes Anderson

Jason Davids Scott

Wes Anderson's films have demonstrated a very unique relationship with American popular culture. Several critics have remarked upon the "quirky" nature of Anderson's films as one of the director's trademarks (MacDowell, Nelson), citing Anderson's antiheroic protagonists, stringent visual style, abrupt shifts in narrative tone, and unconventional use of popular music on the soundtrack as elements of quirkiness. What also strikes one while reviewing all of Anderson's work is how much his films, both in terms of narrative content and visual form, seem to be in constant discourse with the "real" world outside the cinema. For example, Anderson's films are not only timeless in a sense, but placeless, defined by familiar but wholly fictional spaces—New Penzance in *Moonrise Kingdom*, the Ping Islands in *The Life Aquatic with Steve Zissou*, the home on "Archer Avenue" in *The Royal Tenenbaums*. It is no great difficulty for even the most casual viewer to quickly translate these settings into their real life equivalencies (coastal New England, the Mediterranean Sea, the Upper West Side), but Anderson constantly forces his viewers to engage and reckon with the tension between the settings of his films and what they are intended to represent.

This tension is perhaps no more evident than in the ways in which Anderson's films appropriate—or, in many cases, refuse to appropriate—the signifiers of contemporary popular culture that often help viewers "ground" a cinematic text during the process of viewing. Consider, for

example, the ways in which some of Anderson's more noted contemporaries approach similar material. Richard Linklater's *Dazed and Confused* (1993) is, according to a title card at the beginning of the film, set on a specific day—the last day of school in 1976—but the location is a generic suburb located in Texas. (Even the Texas location is downplayed, as only car license plates, the relative importance of high-school football, and the accents of very few characters indicate the film's regional origins.) Anderson's *Rushmore* (1998), like *Dazed*, was in fact filmed in Anderson's home state of Texas, with Anderson's own alma mater (St. John's School in Houston) playing the part of Rushmore Academy, but there is no indication as to where in the United States Rushmore is actually located. Similarly, there are only very small indications that *Rushmore* is set in the "present" of the late 1990s: the headstone of Max's mother indicates that she died in 1989 (when he was a child); his Swiss Army Knife is inscribed with the years "1985–1997"; and Max (Jason Schwartzman) briefly uses a cell phone to call Blume (Bill Murray) at one point. In direct contrast, most of the more explicit cultural references in *Rushmore* seem to deliberately obfuscate the film's temporal setting: to wit, Max's stage adaptation of *Serpico*, a film released in 1973; the presence of *Playboy* magazine pinups from the 1970s in a backstage dressing room; the pneumatic tubes used for communication in Blume's office; and students at Rushmore viewing educational material via film projectors.[1]

In a commercial cinematic landscape where product placement, in-jokes about other cultural forms (television, music, Internet memes), and other devices are used to bridge the gap between text and audience, drawing the viewer in to reassure him or her that the world on the screen is the same one as the world outside the Cineplex, Anderson's films consistently reject that easy assumption on the most basic of levels. The result is a cinematic style that is not only "quirky," but deliberately undermining the relationship between film and spectator by forcing the viewer to constantly shift attention from the story and characters to the visual and aural "stuff" of the film, challenging audiences to not merely receive, but actively interpret and engage with Anderson's imagined and constructed reality. In examining pointed references to other artistic forms (other films, works of art, and literature) and the "ghosting" of on-screen objects (particularly vehicles, costumes, and props) that seem to provocatively evoke anachronism, this chapter will suggest how Anderson's films represent a rejection of popular culture through its painstaking recreation. By refusing to consistently, coherently, and directly reference elements of popular culture from a specific time and place, Anderson's films succeed in underscoring the themes of otherness and outsider status that are reflected and performed in his characters and narratives.

Hollywood Narrative and the Hermetically Sealed Diegesis

To appreciate the unique manner in which Wes Anderson's films appropriate elements of popular culture, it helps to consider the traditions of film narrative in which Anderson (born in 1969) would have been exposed to as a young filmgoer and how the relationship between popular culture and film narrative shifted in the era coincident to Anderson's childhood and adolescence.

Prior to the 1970s, the standard position for Hollywood films vis-à-vis popular culture might be best described as a believable but fictive facsimile. For example, with the exception of stories set in major cities like New York, Los Angeles, or Washington DC, fictional films usually featured generic settings and locations. Small towns were called "Bedford Falls" (*It's a Wonderful Life* [Capra, 1946]), "Morgan's Creek" (*The Miracle of Morgan's Creek* [Sturges, 1944]), or "Grandview" (*Magic Town* [Wellman, 1947]). Likewise, these narratives represented an America identified by a fictional popular-culture universe as opposed to appropriating actual elements of popular culture. For example, *Citizen Kane* (Welles, 1941), although understood by audiences then and now as being inspired by the life of William Randolph Hearst, obfuscates that connection by representing Charles Foster Kane (Orson Welles) in a world that has no direct, explicit connection to the life of Hearst. Aside from (brief) mentions of historical events (the Spanish-American War, the Great Depression), the fictional world of Kane is almost entirely removed from the real world of Hearst. The name of the newspaper Kane first takes over, his mistress's interest in opera (instead of films), Kane's thwarted political career, and other potential "clues" that Kane and Hearst are equivalent are a reflection of this hermetically sealed diegesis, one in which popular culture must be read through equivalencies and transpositions, rather than direct reference.

Furthermore, in this tradition, products mentioned by name in Hollywood films are almost always fictional: "Klenzrite" soap (*It's Always Fair Weather* [Donen and Kelly, 1955]), "Dazzledent" toothpaste (*The Seven Year Itch* [Wilder, 1955]), or "Maxford House" coffee (*Christmas in July* [Sturges, 1940]). Organizations are also fictionalized ("Monumental Pictures" in *Singin' in the Rain* [Donen and Kelly, 1952], "The La Salle Agency" in *The Girl Can't Help It* [Tashlin, 1956]); celebrities are abstracted to generic types (Jerri Jordan in *The Girl Can't Help It*; Norman Maine and Esther Blodgett/Vicki Lester in *A Star is Born* [Cukor, 1954]); and political affiliations of elected officials are assiduously avoided (*Mr. Smith Goes to Washington* [Capra, 1939]). Indeed, references to actual popular culture, when they do occur, seem almost shocking in their self-reflexivity, shattering the seal that separates the closed diegesis from the audience: in *His Girl Friday* (Hawks, 1940), Walter Burns (Cary Grant) describes the character of Bruce Baldwin (played by Ralph Bellamy) as "looking like that actor, Ralph Bellamy."[2]

This trend towards the diegetically sealed narrative began to change as a new generation of Hollywood filmmakers came of age in the mid-1960s and early 1970s. The music-driven editing techniques featured in various sequences of *Easy Rider* (Hopper, 1969), for example, stylistically quote the avant-garde techniques of filmmakers like Stan Brakhage and Bruce Conner. *Targets* (Bogdanovich, 1968), a film produced by Roger Corman, includes clips of an actual previous Corman film (*The Terror* [Corman, 1963]) and features a character based on actor Boris Karloff actually played Karloff himself (and named "Orlok," itself a reference to the vampire character played by Max Schreck in the silent classic *Nosferatu* [Murnau 1922]). This shift was also quite pronounced in television: *The Brady Bunch* (1969–1974) at various times featured cameos from Davy Jones, Joe Namath, and baseball player Wes Parker, even though the Bradys lived in an unnamed suburb surrounded by generic products, television programs, and cultural organizations. Overall, the 1970s saw an increasing tendency for the diegeses of film and television shows to be more permeable, and the next generation of filmmakers and audiences came to rely more and more on the presence of real pop-culture artifacts to encourage narrative verisimilitude.

A tipping point for the relationship between Hollywood narratives and pop-culture references is 1982's *E.T. the Extra-Terrestrial* (Spielberg). More than any other young characters in films to that date, the children in *E.T.* frequently make and perform direct reference to elements of popular culture that situate them in the real world, as opposed to the typical sealed Hollywood diegesis. Part of this is a result of a (at the time, unique) product-placement arrangement with the candy company Hershey to feature their new snack, Reese's Pieces, as a primary narrative device in an early section of the film, which allowed the new candy to then be marketed as "E.T.'s Favorite Snack." The filmmakers originally intended to use the more popular and well-established M&M candy—William Kotzwinkle's novelization of the film, released in conjunction with the movie, in fact has E.T. loving M&Ms. But the M&M/Mars Company, following traditional corporate protocol, denied the production permission for use of the product. Since then, product placement and corporate tie-ins with fast food, candy, board games, and other ancillary products have often been the impetus behind the presence of pop-culture icons and brands in film and television.[3]

But *E.T.*'s connection to popular culture does not stop with Reese's Pieces. E.T. gets drunk on Coors beer and watches a scene from the John Ford film *The Quiet Man* (1952) in a sequence intended to highlight the new psychic connection between E.T. and Elliott (Henry Thomas); Elliott's brother (Robert MacNaughton) and his friends play Dungeons and Dragons, which had been aggressively revised and remarketed to suburban teens beginning in 1980; his brother later mocks Elliott's discovery of an

alien creature by imitating Yoda from *The Empire Strikes Back* (released in 1980); and later while trick-or-treating, E.T. takes active notice of a youngster in a Yoda costume. The new and complex confluence between popular culture and the real world is perhaps best exemplified at the end of the film when Elliott recruits his brother and friends to help E.T. return to his home ship. "Can't he just beam up?" incredulously asks friend Greg (K. C. Martel), referring to the space-age technology of the recently revived *Star Trek* franchise (the first feature film was released in 1979). "This is reality, Greg," retorts Elliott.

Whether or not *E.T.* specifically had an influence on an adolescent Wes Anderson (who turned 13, or just about Elliot's age, three weeks before the film was released), the new paradigm of utilizing elements of real popular culture in fictional narrative spaces soon dominated Hollywood filmmaking, particularly in blockbusters like the *Back to the Future* trilogy (Zemeckis, 1985, 1989, 1990), *Who Framed Roger Rabbit?* (Zemeckis, 1988), and films targeted toward younger audiences. Characters in films were more likely to reference real musical artists, songs, product brands, films, television programs, sports figures, and locations, as opposed to inhabiting a world that was dominated by disguised facsimiles. Indeed, the appropriation of popular culture came to seem so obvious that it was almost intrusive in terms of helping a film achieve narrative verisimilitude. By the next decade, the subject of what could and couldn't be referred to as determined by legal arrangement became a series of self-reflexive in-jokes in the *Wayne's World* films (Spheeris, 1992; Surjik, 1993), which openly mocked its corporate sponsors and expressly forbade its characters from playing the legally protected song "Stairway to Heaven" on the guitar.

Negotiating the Sealed Diegesis

To say that Wes Anderson's films take place in an entirely imagined diegesis is mistaken. While a viewer might be struck by the comparative lack of popular culture referents in Anderson's film (minus the soundtrack), attentive viewing often reveals that Anderson has carefully punctured a few holes in the hermetic seals that make his films at first glance seem to be a return to Hollywood's previous tradition.

Crucially, nearly each Anderson film makes some explicit reference to at least one element of popular culture—usually a novel or work of art—while featuring implicit stylistic nods to other cultural works as well. Many of these have been documented elsewhere but deserve repeated mention here in the context of other intertextual and cultural references. Additionally, through specific visual reference to iconic brands and products, Anderson not only creates interesting narrative equivalencies between scenes,

but also effectively "ghosts" his films by evoking eras that are often in contradiction to the narrative's "actual" intended setting. The term "ghosting" comes from Marvin Carlson's *The Haunted Stage*, which observes:

> Theatre, as a simulacrum of the cultural and historical process itself... has always provided society with the most tangible records of its attempts to understand its own operations. It is the repository of cultural memory, but, like the memory of each individual, it is also subject to continual adjustment and modification as the memory is recalled in new circumstances and contexts. The present experience is always ghosted by previous experiences and associations while these ghosts are simultaneously shifted and modified by the processes of recycling and recollection. (2)

Cinema, perhaps even more so than theatre because of the comparative permanence of the film text, is likewise a ghosting machine, a process by which audiences understand the present experience of the film through the "continual adjustment and modification" of memories that are provoked by the presence of familiar objects.

Many critics have observed the similarities between *The Life Aquatic* and Herman Melville's *Moby-Dick* (Colatrella, Govender); *The Royal Tenenbaums*, with its novelistic framework and use of "chapters," elicited comparisons to the work of John Irving (Ebert) and J. D. Salinger (Scott). Going beyond the similarities in narrative structure and characterizations, Anderson's films often contain more fleeting intertextual references that are equally compelling, if not as obvious. These are most often seen in the books that are read by the characters, which offer clues to their character and their motivations. In *Rushmore*, Max first finds a potential connection to Ms. Cross (Olivia Williams) when he checks out the book *Diving for Sunken Treasure* by Jacques Cousteau, while she is seen reading *Twenty Thousand Leagues under the Sea* by Jules Verne. These books help introduce the "underwater" motif in *Rushmore* that is echoed in Max's pursuit of building an aquarium for the school, an admirable if futile effort symbolic of Max's pursuit of Ms. Cross.

Anderson further evokes the underwater motif in a sequence at the home of Mr. Blume, where he is throwing a party for his two ungrateful sons. Blume dives into the pool and remains underwater as if to escape from the outside world. The shot of Blume underwater resembles any one of a number of shots employed by Mike Nichols in *The Graduate* (1967), who likewise used the metaphor of Benjamin Braddock underwater as a way of expressing isolation and/or escape—*The Graduate* itself being a narrative about a young, alienated male protagonist who falls for an inappropriately older woman, with disastrous personal results. Chris Robé observes that this sequence speaks to Blume's "emotionally arrested development,"

describing him as "a grown man who can only indirectly gesture at his alienation from underneath the hidden safety of his pool" (104). We also later learn (in the scene described below in Ms. Cross's bedroom) that her late husband drowned. It is not merely that Anderson is borrowing or appropriating stylistic elements or narrative themes from other films, but that he is connecting them together as a means of telling the story of his own film. The underwater motif is not merely employed to define a character's emotional state, but is in fact constructed through references—Robé's "indirect gestures"—to various artifacts of popular culture.[4]

Rushmore is also unique in that it features barely any corporate logos: in fact, there is only one logo, for Coca-Cola, conspicuously featured at two separate times in the film. The first instance is at the Rushmore wrestling match (directly before the underwater scene referred to above). A concessions table prominently features the red-and-white logo on the far-right portion of the screen. Several scenes later, when Max takes refuge in Ms. Cross's bedroom, there is a small Coke poster located on the screen-right side of the bed—not nearly as prominent as the previous logo, but placed in the same position so as to indicate a graphic match. Both signs are for "Coke" in the company's modern (1990s) script, as opposed to the cursive and more classic "Coca-Cola" logo. The presence of this more modern logo in a bedroom that presumably was decorated decades ago is something of an anachronism.[5] However, the presence of the sign in each case prefigures a physical "clinch" in which Max engages (and ultimately both times fails): first in the wrestling ring, where he surprises Blume (and us) by quickly stripping out of his Rushmore uniform to take part in the match against a rival school; and later in Ms. Cross's bed ("So this is where it all happens," Max says as he lies down), where he is ultimately disappointed that she does not reciprocate his romantic intentions despite their physically intimate position (one where Max almost reflexively assumes passivity, lying back on the bed as Ms. Cross hovers over him).[6]

The presence of corporate logos helps begin the discussion of how other objects are ghosted in Anderson's films, deliberately invoking specific cultural memories for the viewers in order to evoke specific emotional connections. *Bottle Rocket*, although it lacks visual representation of any corporate logos, manages to evoke a sense of ghosting through the use of vehicles that have iconic status and occupy a unique place in the film in terms of narrative and character. For example, Dignan (Owen Wilson) recruits Bob Mapplethorpe (Robert Musgrave) as a getaway driver, in fact, because Bob "is the only one with a car," a 1970s-era Ford LTD (although Bob's keychain contains a pendant with a Mercedes logo, indicating his unrealized ambition for social status). "Fact: Mr. Henry drives a Jaguar," Dignan later says in order to establish Mr. Henry's (James Caan) credibility.

After first attempting to break into a Cadillac, Dignan instead steals a late-1960s-era MG convertible (which evokes in both shape and spirit Benjamin Braddock's Alfa Romeo, as well as Mr. Henry's convertible Jag). Applejack's sedan is a lime-avocado color that was particularly prominent in the 1970s. Dignan is at one point reduced to driving an undersized minibike while Bob's brother, Future Man, is seen in an early model, mustard-yellow Ford Bronco (the color mirroring that of Dignan's jumpsuit[7]).

For a film that seems to invest so much in the historical resonance of cars, in fact there are very few "background" vehicles in *Bottle Rocket*: as Dignan and Anthony (Luke Wilson) ride in the stolen convertible (which later breaks down), there is nary a car in sight. Other scenes are conducted in back alleys, public parks, empty warehouse lots, and at the ends of long driveways, completely avoiding the possible presence of passing cars or even cars parked along the street. In a sense, this deliberate and specific choice of when to feature vehicles (and which vehicles to feature) is emblematic of how Anderson's films incorporate popular culture on a visual level: when things are shown, they have significance. They are not merely background objects there to "fill out" the space, but carefully chosen elements that resonate with meaning for viewers even on a subconscious level.

This heightened significance is where many elements in Anderson's film start to fulfill the function of ghosting. This is perhaps most clearly seen in the meticulously designed *The Royal Tenenbaums*. Brendan Kredell has examined how the stylized urban landscape of *Tenenbaums* represents a "broader gentrification of cinema that has helped to define the American indie film over the past two decades." Furthermore, "Anderson's construction of the urban environment in *Tenenbaums* sets him apart from most of his contemporaries in this regard. In *Tenenbaums*, we can see the purest manifestation of the gentrifying impulse, a desire to selectively reappropriate the city as an aesthetic object, while discarding and/or redesigning elements of the urban built environment that do not accord with a preexisting set of taste preferences for what should constitute 'urban living'" (85–86). This reappropriation of the urban landscape, like Anderson's use of vehicles in *Bottle Rocket*, can be seen in selected elements of popular culture in *The Royal Tenenbaums*.

Specifically, visual references to popular culture in *Tenenbaums* seem to confine the characters to an earlier era—while references to the current era (2001) are more abstracted and fictionalized, in the tradition of the hermetically sealed diegesis.[8] Stefano Baschiera describes how these "nostalgic" objects in domestic spaces contribute to the construction of patriarchy and family relationships in the film, how "'things' cover an active role in his films' narratives" (121). My points here largely echo his, but from the perspective of how the audience constructs and connects meaning through

displaced popular culture, not merely as a referent to the nostalgic state of the characters for their childhood home. Not all viewers will have emotional or nostalgic connections to objects and logos from the 1970s: the point is then not only to identify with the characters, but to call attention to the constructed nature of popular culture itself.

For example, the Adidas tracksuits worn by Chas (Ben Stiller) and his sons (Grant Rosenmeyer and Jonah Meyerson) were common in the late 1970s and early 1980s, roughly coinciding with the adolescence of the Tenenbaum children (and of Anderson himself). The Tenenbaum game closet is populated with board games from the same era (in their vintage boxes), such as Risk and The Ungame (the latter being a particularly notable reference, a self-help/confessional game designed to promote therapeutic dialogue). Richie Tenenbaum (Luke Wilson), meanwhile, is consistently costumed and groomed to resemble a tennis star from the same era (particularly five-time Wimbledon champ Björn Borg, who had a scruffy beard and wore head- and wristbands). This despite the fact that, if we are to believe that Richie is roughly the same age as Anderson (born in 1969) and currently (2001) in his early to mid-30s, his career would have peaked in the era of more clean-cut stars like Stefan Edberg (born 1966) or Pete Sampras (born 1971). As in *Bottle Rocket*, street vehicles and picture cars are only used specifically for transportation of characters, as the streets of the unnamed metropolis the family resides in is almost always empty of vehicles: with the exception of the 2001 models briefly seen in the shots at the cemetery, these vehicles are of older vintage.

Wes Anderson's films do not merely use objects and references to pop culture anachronistically to illustrate the emotionally arrested worlds of the characters: they offer astute viewers a glimpse into an aesthetic modality that also governs narrative and visual structure. They help to tell the story, not merely to set the stage. In Anderson's earlier films, with lower budgets and fewer expectations from critics and fans, this tendency is particularly pronounced. In his more recent efforts, instead of further embracing popular culture, cashing in on product placement and further integrating his film work with that of the real world of his audiences, Anderson seems to be getting even more distant. *Fantastic Mr. Fox* takes place in a wholly imagined world (though one where the character Kylie [Wallace Wolodarsky] unironically quotes James Dean from *Rebel Without a Cause* [Ray, 1955]), and *The Darjeeling Limited* moves its American characters to the Far East, where poisonous snakes, meditation, and burial rituals seem rooted in religious and mythological (and not merely "pop") culture. *Moonrise Kingdom* is the first Anderson film set in a specific era— the first week of September in 1965—though aside from Sam's coonskin cap and use of Tang as a drink, the visual landscape is either totally generic

(supplies labeled "drinking water") or deliberately anachronistic (a Colonial flag with 13 stars flies above the police station and post office).[9]

It is impossible in this short space to detail all of the ways in which Anderson's films make references to popular culture that reshape the ways in which viewers perceive and interpret the films' narratives. Indeed, when turning to the characters' names, as well as the actors who play them, there is further room for study. Bill Murray, James Caan, Seymour Cassel, and Gene Hackman all provocatively suggest films and filmmaking styles from the same era (roughly 1973–83) that represents Anderson's childhood and adolescence. And when Anderson gives characters names such as Bob Mapplethorpe (*Bottle Rocket*); Blume and Guggenheim (*Rushmore*); and Redford, Izod, Roosevelt, and Nickelby (*Moonrise Kingdom*), the connection to other works of literature, visual art, and popular culture becomes even richer.

Baschiera argues that "clothing, technology and artifacts all belong to a past that does not match the diegetic time of the film, contributing ... to a nostalgic dislocation of the characters from contemporary time" (129). For Baschiera, these dislocated objects "dictate an old mode of production for the characters, as they have to make new things ... with a vintage technology, as their missing fathers did before them." In addition, the dislocated objects and other references to popular culture indicate that Anderson seems to be operating in a "vintage" aesthetic that represents the transitional era between the hermetically sealed diegesis of Old Hollywood and the pop culture–saturated narratives of the present. Just as his characters might be "stuck" in a displaced era that evokes the late 1970s and early 1980s, so too does Anderson seem to be recreating that era cinematically, deliberately placing elements of those eras within the visual frame to convey information about narrative and character, while simultaneously delivering to his audience members a nostalgic experience that is as disquieting and complex as it is effective and evocative.

Notes

1. The other way in which the films of Anderson (and others) locate themselves vis-à-vis popular culture is through soundtrack music, and this comparison is no exception. The subject of Anderson's use of popular music is an area of study taken up elsewhere in this collection and thus will not be a focus of this chapter.
2. There are some notable exceptions to this rule, such as *Sunset Boulevard* (Wilder, 1950), which connects the fictional star Norma Desmond to an actual movie studio (Paramount) and a lapsed professional relationship with a real director (Cecil B. DeMille). Another broad area of exception is the use of popular songs in film soundtracks, which would have instantly reminded astute

viewers of previous films and versions of the same song that are familiar from other cultural texts (*Singin' in the Rain* being the most obvious example).

3. Indeed, since corporate logos are strictly protected and cannot be featured without legal permission, the lack of ubiquity of these logos in the films of Wes Anderson (or any other filmmaker) should not entirely be read as a creative choice from the filmmakers, but might also be one of legal necessity.

4. The underwater motif is also obviously an important element of *The Life Aquatic*, with its more obvious references to *Moby-Dick* and the documentary films of Jacques Cousteau; but even *The Life Aquatic* has some more veiled references to popular culture to explore this conceit, such as the resemblance of the *Deep Search* boat to the animated *Yellow Submarine* in the 1968 film based on the Beatles song.

5. Furthermore, the logo in the bedroom has the number "876" in block letters affixed to the top portion of the logo; I am unable to discern whether there is any relevant meaning in this beyond indicating that the poster has been modified by its owner.

6. Robé's observations about inherited, "entitled masculinity" become even more resonant in this scene, as the logo links *Rushmore*'s most masculine/homosocial space (the wrestling arena) with a space that is heterosocial, simultaneously feminine (belonging to Ms. Cross) and masculine (populated with objects inherited from her husband). The possibility that women, too, can "inherit" identities, traumas, and cultural artifacts from lost male figures is missing from Robé's essay and might be suitable for understanding characters like Ms. Cross, Margot Tenenbaum (Gwyneth Paltrow), Jane Winslett-Richardson (Cate Blanchett), and Patricia Whitman (Anjelica Huston).

7. The yellow jumpsuits worn by Dignan and the crew also evoke the image of the late-1970s New Wave band Devo—whose leader, Mark Mothersbaugh, composed the soundtrack music for *Bottle Rocket*.

8. Robé also observes how popular culture references help define Royal Tenenbaum's not-so-latent racism, as he refers to the character of Henry (Danny Glover) as "Coltrane" and asks if Henry wants to talk "in jive," locating Royal's understanding of African American identity as a product of the 1960s and 1970s. (116)

9. Even the two specific pop-culture references are at least somewhat temporally displaced and create a nostalgic frame for Sam: Davy Crockett–style coonskin caps were popular after the Disney-produced *Davy Crockett* films first aired on television in 1955, ten years before *Moonrise Kingdom* takes place, and Tang had been associated with astronauts and exploration since 1962.

Works Cited

Baschiera, Stefano. "Nostalgically Man Dwells on This Earth: Objects and Domestic Space in *The Royal Tenenbaums* and *The Darjeeling Ltd.*" *New Review of Film and Television Studies* 10.1 (March 2012): 118–31. Print.

Carlson, Marvin. *The Haunted Stage: Theatre as Memory Machine*. Ann Arbor, MI: University of Michigan Press, 2003. Print.

Colatrella, Carol. "The Life Aquatic of Melville, Cousteau, and Zissou: Narrative at Sea." *Leviathan* 11.3 (October 2009): 79–90. Print.

Ebert, Roger. Review of *The Royal Tenenbaums*. Rogerebert.suntimes.com, December 21, 2001, n.p. Web.

Govender, Dyalan. "Wes Anderson's *The Life Aquatic with Steve Zissou* and Melville's *Moby Dick*: A Comparative Study." *Literature/Film Quarterly* 36.1 (2008): 61–67. Print.

Kredell, Brendan. "Wes Anderson and the City Spaces of Indie Cinema." *New Review of Film and Television Studies* 10.1 (March 2012): 83–96. Print.

MacDowell, James. "Wes Anderson, Tone and the Quirky Sensibility." *New Review of Film and Television Studies* 10.1 (March 2012): 6–27. Print.

Nelson, Max. "April and August: *Moonrise Kingdom*." *Senses of Cinema* 63 (July 21, 2012): n.p. Web.

Robé, Chris. "'Because I Hate Fathers, and I Never Wanted to Be One': Wes Anderson, Entitled Masculinity, and the 'Crisis' of the Patriarch." In *Millennial Masculinity: Men in Contemporary American Cinema*, edited by Timothy Shary, 101–21. Detroit, MI: Wayne State University Press, 2013. Print.

Scott, A. O. "Please Do Not Feed or Annoy the Woebegone Prodigies." *New York Times*, December 14, 2001. Web.

Part II

7

From the Mixed-Up Films of Mr. Wesley W. Anderson: Children's Literature as Intertexts

Peter C. Kunze

For a director whose body of work includes seven features, a handful of short films, and a few television commercials, Wes Anderson has garnered considerable attention from film critics and scholars. He has been the subject of one monograph, one special journal issue, and several articles in leading film and media studies journals, including three in *Cinema Journal* alone. Regardless of their critical conclusions, his proponents and detractors seem to agree that he is an original filmmaker with a unique style—so much so that Stefano Baschiera contends "every single frame shot by the director of *Fantastic Mr. Fox* (2009) [is] both distinctive and easily recognizable" (118). In the introduction to this volume, I outlined numerous traits that are characteristic of Anderson's films, but I want to make clear, as Anderson has, that he is not wholly original. Despite the substantial amount of critical interest, few critics have offered extended analyses of the various influences that Anderson draws upon, plays with, and reinvents in his work. This fact is made all the more surprising by Anderson's willingness to acknowledge his cinematic forebears, including François Truffaut, Louis Malle, Michael Powell and Emeric Pressburger, Satyajit Ray, Woody Allen, Jean Renoir, John Cassavetes, Alfred Hitchcock, Luis Buñuel, Mike Nichols, Jean-Luc Godard, Peter Bogdanovich, Martin Scorsese, Steven Spielberg, Howard Hawks, Stanley Kubrick, Jean-Pierre Melville, Ernst Lubitsch, Ken Loach, Maurice Pialat, and Leo McCarey.

Reviewers, interviewers, and critics also consistently credit J. D. Salinger as a major inspiration for Anderson; in a conversation for *Interview*, filmmaker Arnaud Desplechin went so far as to tell Anderson, "You are to American cinema what J. D. Salinger is to American literature." Anderson does not deny the impact of Salinger's work on his own, and he also credits F. Scott Fitzgerald and Ernest Hemingway as influences. Indeed Anderson is among the most intentionally eclectic directors in film today, carefully situating himself among artists in various art forms beyond film, including literature and music. Tracing influence in his films—or any artist's work—allows us to appreciate the artwork within a historical and cultural context while delineating key divergences from his or her predecessors and peers.

While any of the aforementioned "mentors" would make for a worthwhile analysis of artistic influence, I wish to turn my attention instead to an even lesser acknowledged inspiration for Wes Anderson: children's culture. Again, Anderson himself has not shied away from giving credit to the formative role in his own work of literature, television, music, and cinema created for youth audiences, but no critic has yet addressed the obvious relevance of these art forms to Anderson's work. This neglect is, in part, related to the previously discussed scarcity of studies of influence as well as an implied insistence that Anderson is innovative and, perhaps, on some level, sui generis. Clearly such a faulty premise is problematic for discussions of any artist; to properly understand a director's style, I would argue it is essential to consider him or her in relation to fellow filmmakers as well as collaborators. What makes Anderson fascinating to me is that his films draw from not only cinema, but from across the art world, broadly defined—be it painter David Hockney in *Bottle Rocket* or composer Benjamin Britten in *Moonrise Kingdom*.[1] Hopefully, art historians, musicologists, and literary scholars will join film scholars in the discussion of the complexity of Anderson's work. My small contribution to this critical conversation will be focused on children's culture because too often Anglophone children's culture is not taken seriously in the academy at large, despite over 40 years of theoretically engaged, intellectually rigorous criticism from scholars in Europe, Australia, and North America.[2] Graduate programs and numerous journals are devoted to its study, yet the continuing marginalization of children's culture in the academy appears to be symptomatic of a general prejudice that misperceives such creative work as simplistic and frivolous. As a result, discussions of childhood and children in Anderson criticism rely on naïve assumptions that fail to engage with the implications of the false binary of child/adult and the constructed nature of childhood (and, consequently, adulthood).

A full consideration of the roles of children and childhood in the films of Wes Anderson extends beyond the scope of this chapter, but by

considering the role of children's culture in his body of work, I hope to initiate an ongoing discussion of how these concerns surface and operate within Anderson's aesthetic, both visually and thematically. Such attention not only serves to articulate the distinctiveness of Anderson's films, but also helps to explain further his role in what has alternately been called the "New Sincerity" (Collins), "smart films" (Sconce), "post-pop cinema" (Mayshark), and "quirky" films (MacDowell). After a brief explanation of childhood and children's culture, I will offer three close readings that consider different ways in which children's culture informs Anderson's films. For example, the director alludes to several children's texts in *The Royal Tenenbaums*, and obviously Roald Dahl's novel, *Fantastic Mr. Fox*, is the primary basis for Anderson's film of the same name. In the third part, I will discuss how children's novels are an essential prop in *Moonrise Kingdom*. With a soundtrack partly comprised of music written for and performed by children, the film itself arguably becomes a work of children's cinema. Together, these uses of children's literature allow Anderson to deconstruct the unstable child/adult binary that structures such interpersonal relationships in his films and society at large.

While I focus on the aforementioned films, the impact of children's culture across Anderson's oeuvre is palpable. In *Bottle Rocket*, Dignan's (Owen Wilson) enthusiastic thirst for danger seems evocative of a quixotic obsession with adventure narratives that some may characterize as "boyish." He proudly proclaims, "They'll never catch me, man—'cos I'm *fuckin' innocent*."—only to be caught soon after. *Rushmore* clearly continues the tradition of the "school story" found in children's literature. As Beverly Lyon Clark explains, school stories often take place at boarding schools, feature students at the secondary level, and address middle-class concerns (3). *Rushmore* actively examines the role of class and status in personal identity, as Max (Jason Schwartzman) engages in a cross-class performance, going so far as to insist his father (Seymour Cassel), a barber, is a doctor and wearing a crested Rushmore blazer to public school after his expulsion from the academy. More importantly, the school serves as a "microcosm of the larger world, in which minor events and concerns loom large and older children, at least, have powers, responsibilities and an importance they do not have in the world outside" (Ray 467); therefore, the school in the school story serves as a training ground for socializing characters (and arguably the implied child readers as well) to take their place in the world. A clear homage to Jacques Cousteau, Steve Zissou (Bill Murray) of *The Life Aquatic with Steve Zissou* is himself a creator of children's culture, inspiring not only Klaus's nephew Werner (Leonardo Giovannelli), but also Ned Plimpton (Owen Wilson) and Jane Winslett-Richardson (Cate Blanchett) (Gibbs 142). In his DVD commentary for the film, Wes Anderson contends he

loosely based the cross-section shot of Zissou's ship, *The Belafonte*, on illustrations from *The World Book Encyclopedia* for children, and the mystical, colorful world presented in *The Darjeeling Limited* seems lifted out of the Orientalist renderings of India found in the children's books of Rudyard Kipling and Frances Hodgson Burnett. Indeed commentators often apply the term "storybook" as an adjective for describing the shots and visual style of Anderson's films (Past 53, Gross, Whipp). Though I will only briefly mention those films hereafter, my analytical focus on *The Royal Tenenbaums*, *Fantastic Mr. Fox*, and *Moonrise Kingdom* underscores the role of childhood in Anderson's oeuvre as well as the function of nostalgia in a strain of contemporary Hollywood cinema that often navigates between modes of irony and sincerity.[3]

Philippe Ariès's *Centuries of Childhood* (1960), along with developments in poststructuralist theories of ideology and social constructionism, have triggered an investigation in the humanities regarding the "constructedness" of children and childhood. The study of children's literature in Anglo-American criticism blossomed from there, and by the 1970s, degree programs, discipline-specific journals, and conferences had emerged to address this growing field of inquiry. Yet from the beginning, studies of children's literature were troubled by the fundamental concern of self-definition; unlike other fields defined by nation of origin, historical period, or the social and cultural identities of the author, the definition of children's literature relied on the texts' presumed audience.[4] Immediately, this explanation proved problematic for multiple reasons, not the least of which being that children often read texts that were not specifically intended for them, most obviously, the Bible. Furthermore, children did not write the texts being studied, though there were a few examples of child-produced texts. Therefore, as Jacqueline Rose controversially contended, children's fiction was an impossibility since it "sets up a world in which the adult comes first (author, maker, giver) and the child comes after (reader, product, receiver), but where neither of them enter the space in between" (1–2). Rose's argument launched heated rebuttals, but as Susan Honeyman notes, "If one cannot 'grasp' children, one cannot define them as an audience or define a literature as 'age-appropriate' for that audience." (9). Consequently, over the past 15 years of so, studies of children's literature have broadened into what Richard Flynn refers to as "childhood studies" and Karen S. Coats calls "children's studies."[5]

This dynamic field of inquiry encourages scholars to consider how the concepts of children and childhood are historically and culturally contingent. Scholars now study representations of childhood in texts geared toward all audiences, as well as in children's reading practices, be it of a work of so-called children's literature or not. Richard Flynn outlines four

strategies for childhood studies to proceed along, hoping to encourage criticism that

1. examines the representation of children and childhood throughout literature and culture;
2. analyzes the impact of the concept 'childhood' on the life and experience of children past and present;
3. investigates childhood as a temporal state that is often experienced more in memory than in actuality;
4. explores childhood as a discursive category whose language may provide a potentially useful perspective from which to describe the human person and to understand subjectivity. (144)

My concern in this essay is Flynn's third method of analysis because it connects to earlier criticism of Anderson's films, which emphasizes the role of nostalgia, especially in terms of costumes, music, and carefully arranged objects. Furthermore, it helps me to challenge the glib assessment of many reviewers and film scholars that children and adults swap places in Anderson's films. This sentiment is captured in David Riedel's derisive response to *Moonrise Kingdom*: "And let's not forget Anderson's adults-are-childish-and-children-act-like-adults-but-still-have-the-innocence-of-children thing that he has cultivated into pseudo-art" ("Lotta Quirky"). Not only does this critique continue a common anti-intellectual trend of dismissing Anderson because of his popularity among a hard-to-define subculture most often referred to as "hipsters," but it hastily rejects *Moonrise Kingdom* without nuance or explanation. My consideration of the impact of children's literature on Wes Anderson's films complicates the child-as-adult/adult-as-child observation while also furthering the argument for the cultural relevance of both children's literature *and* Wes Anderson's films. Anderson does not allow the child and the adult to swap places in a comic fashion, but rather blurs any sense of a sharp distinction.

Children's Culture as Allusion: *The Royal Tenenbaums*

Wes Anderson's third feature film, *The Royal Tenenbaums*, chronicles Royal Tenenbaum (Gene Hackman), a charming schemer who feigns a fatal illness so he can reenter the lives of his estranged wife, Etheline (Anjelica Huston), and their adult children, all of whom are former child prodigies. His return is prompted by his eviction from his residential hotel and news that his wife has been fraternizing with her mild-mannered accountant, Henry Sherman (Danny Glover). Richie Tenenbaum (Luke Wilson), the golden child and former tennis star who has fallen

from grace, welcomes Royal back, but his son Chas (Ben Stiller) and adopted daughter, Margot (Gwyneth Paltrow), harbor ongoing resentment stemming from incidents much earlier in their lives. Though Wes Anderson features young characters in his first two films, including Grace (Shea Fowler) in *Bottle Rocket* and the students of Rushmore Academy in *Rushmore*, his third film, *The Royal Tenenbaums*, is his first film to show characters in two stages of their lives: the so-called child and adult phases. This split characterization emphasizes the continuing burdens the adult characters carry with them from childhood, signified by Richie's tendency to wear a Björn Borg–like headband and Margot's penchant for vintage dresses and a bob hairstyle with a barrette. Stefano Baschiera argues this presentation demonstrates "the clearest objectification of their nostalgia and of their attempt to live in the past" (124), but I find this notion troubling because it suggests a clear delineation between the past and the present, or at least some form of vague demarcation. After all, characters, like humans, are the products of the past living in the ungraspable present. While we may call this "nostalgic dislocation" (Baschiera 129), I see it as a stylistic tactic to underscore the fluidity between the children's past and their present lives—a continuation essential to all human experience. Jesse Fox Mayshark interprets this behavior as symptomatic of the "arrested development" that plagues many of Anderson's characters (136); in fact, Mayshark contends, "The greatest achievement for a character in a Wes Anderson movie is to simply grow up" (116). Similarly, Daniel Cross Turner compares Anderson's characters to "empty shells, idiot savants, walking models of mode nostalgia" (164). Such statements problematically imply an ideal, achievable state of emotional well-being—analogous to adulthood and maturity—exists. The emotional damage of childhood, therefore, is either negligible to reasonable people (i.e., adults) or conquerable through maturation. Not only does this analysis actively underestimate the role of the past in the characters' daily lives, it also denies children the agency to articulate their emotional and mental states. It suggests the problems of children are irrelevant in the eyes of critics who either delight in the "childish" antics or decry the absurd, artificial conduct of supposed "man-child" characters.

The plasticity perceived by some reviewers is among the most reductive arguments posited against claims of Wes Anderson's mastery and originality. For such critics, the foolish behavior, deadpan responsiveness, and irrationality characteristic of many of Anderson's characters has been read as evidence of the director's "shut[ting] down [of] any possibility of genuine emotion" and his seeming inability "to understand real people" (Kelly 96–97). Again, what masquerades as criticism comes across as simplifying, idiosyncratic diatribes. For an artist, especially in an era of cultural

production dominated by the celebration of artificiality and self-reflexivity, to be chastised for failing to produce realistic and identifiable characters seems outdated, to say the least. As Michael Chabon states in his defense of Wes Anderson's films, film is an essentially artificial medium, and "artifice, openly expressed, is the only true 'authenticity' an artist can lay claim to."

By borrowing from children's literature, *The Royal Tenenbaums* not only works itself into the Anglo-American tradition of coming-of-age narratives, but captures the profound effect of childhood and its culture on the "development" of the characters. In the DVD commentary, Anderson admits he drew the scene in which Richie (Amedeo Turturro) and Margot (Irene Gorovaia), as children, run away to live in the Public Archives from E. L. Konigsburg's *From the Mixed-Up Files of Mrs. Basil E. Frankweiler*. In the 1967 novel, Claudia Kincaid and her little brother, Jamie, flee their family home for the Metropolitan Museum of Art in New York, where they take it upon themselves to discover whether a recent museum acquisition is, in fact, the work of Michelangelo. The children eventually go to the home of the statue's previous owner, Mrs. Basil E. Frankweiler, who is also the narrator of the story. Konigsburg writes the novel as a letter to Mrs. Frankweiler's attorney, Saxonberg, who we later learn is the children's grandfather. Anderson frames his story similarly, though instead of a letter in the process of being written, the film is a novel being read by the narrator (Alec Baldwin). Mark Browning suggests Claudia (whom he mistakenly identifies as "Claire"), who runs away from the museum, "is bored with her life and acts in secretive ways to try and inject some excitement into it" (156). Actually, Claudia is tired of being unappreciated by her family, while her brother is the one who demonstrates a propensity for adventures. Since Browning misnames and misreads Claudia Kincaid, his effort to draw parallels between her, Anderson's Margot Tenenbaum, and J. D. Salinger's Franny Glass (from *Franny and Zooey*) is fairly unconvincing. Anderson himself suggests the reference results from the book's lingering resonance in his consciousness, which reinforces my larger argument that Anderson refuses to draw a sharp line between childhood and adulthood. Instead, selective moments of the past—be it 30 years or 30 minutes ago—remain in one's consciousness. A stronger argument for Anderson's allusion to *From the Mixed-Up Files of Mrs. Basil E. Frankweiler* rests in the fact that the novel's action, like *The Royal Tenenbaums*'s, is motivated by an unsatisfying family life in New York City. As the sole female child, Claudia is confined to a traditional feminine role in the household that leaves her dissatisfied and dejected. This appreciation of children's emotions and respect for their complexity echoes throughout Anderson's work. Anderson's parents divorced when he was a child, and unhappy marriages and fractured families echo throughout his films.

Though I have not found acknowledgment from Anderson to this fact, I would argue *The Royal Tenenbaums* also borrows from another popular children's book: Jean Craighead George's *My Side of the Mountain*. In this popular 1959 novel, Sam Gribley runs away from his family's overcrowded apartment in New York City to take up residency in the woods near his great-grandfather's land in the Catskill Mountains. He hollows out a home for himself in a tree and learns to survive in the wilderness. The most memorable aspect of the novel (and its sequels) is Sam's relationship with Frightful, a peregrine falcon who becomes his primary companion. By the novel's conclusion, Sam's parents find him, and his father agrees to build a house on the land. For Richie, his falcon serves as both a pet and a friend, yet when the Tenenbaum children return to the household, the narrator reports that Richie "had decided birds should not be kept in cages, fed Mordecai three sardines, and set him free." Presumably, Richie's rationale is that he and Margot are finally reunited. Mordecai later returns after Richie's feelings for Margot have become known by the family and she reluctantly rejects him as a lover. Richie's relationship with Mordecai underscores Richie's desire for connection; unable to date his adopted sister, he finds companionship in Mordecai, who seems to demonstrate a supernatural ability to detect that Richie needs him once again. The extensive scholarship on *The Royal Tenenbaums* has little to say of Richie and his falcon, but a clear parallel can be drawn between the novel and the film, especially regarding the texts' shared interest in an urban family seeking to mend their fractured relationships as well as a child's personal process of learning to become self-sufficient and independent.

A common critical opinion is that *The Royal Tenenbaums* clearly owes a debt of gratitude to J. D. Salinger's stories of the Glass family (Orgeron, Mayshark, Browning). While Anderson has admitted this fact on several occasions, insisting on this fact as the sole or even dominant analogue reduces the countless literary, cinematic, musical, and artistic influences that inform any one of Anderson's feature films. In fact, in a recent interview, Anderson credited not J. D. Salinger, but a series of children's books by Helen Cresswell, collectively known as *The Bagthorpe Saga*, as the source for "practically the whole storyline" ("The Iconoclast" 162). Beginning with *Ordinary Jack*, Cresswell tells the story of an eccentric family of geniuses and Jack, the "ordinary" member, seeking to prove he is also worthy. Whether these books were overlooked because they are British or because they are works of children's literature, their influence testifies to the enduring importance of children's literature in Wes Anderson's life and, therefore, his films. By invoking Konigsburg, George, and Cresswell alongside the likes of Fitzgerald, Hemingway, and Salinger in his films, he celebrates the writers who inspired him throughout his life while equalizing their legitimacy as works of art.

Children's Culture as Source: *Fantastic Mr. Fox*

Fantastic Mr. Fox not only pays tribute to Anderson's favorite childhood text, Roald Dahl's novel of the same name, but it also revives an older form of animation—stop-motion—associated with Rankin/Bass holiday specials and the film work of Ray Harryhausen, the animator behind *The 7th Voyage of Sinbad* (Juran, 1958), *Jason and the Argonauts* (Chaffey, 1963), and *Clash of the Titans* (Davis, 1981). The color palette of the film itself evokes an English autumn, rich in browns, oranges, and golds. Anderson's Mr. Fox appears to be a fusion of Donald Chaffin's original illustrations and Anderson's own public image, and the director has claimed to have commissioned a suit made of the same corduroy (Brody). Despite being his first film adaptation, Anderson clearly infuses *Fantastic Mr. Fox* with his own aesthetic. While some would contend he tampers with the original in the process (an inevitability, and therefore a moot point),[6] I argue the novel is an ideal text for film adaptation because its relative lack of detail provides plenty of opportunity to further develop the plot and characters, thereby permitting Anderson to infuse it with his recurring themes as well as his visual and musical sensibilities.

Film reviewer Hank Sartin claims the film speaks more to Wes Anderson than children, but such a critique condescends to children. After all, many contemporary children's films—most notably, *Up* (Docter, Peterson, 2009)—wrestle with themes commonly associated with adulthood, like losing a spouse and finding one's purpose. While children may not have experienced these emotions yet, we should not assume they cannot comprehend or should not be intellectually challenged by such material. For example, Terry Gross drew Anderson's attention to the film's existentialist themes, but Anderson wryly dismissed such an observation by saying, "I think [Mr. Fox] likes the word 'existentialism' more than anything else" ("For Wes Anderson"). Perhaps the term "family film" is more appropriate here, especially since the large budgets of studio-produced films often make films primarily targeted at children too great of a financial risk and *Fantastic Mr. Fox* certainly has potential for appeal to (and has indeed found success among) a variety of age groups.

Mark Browning and Tom Dorey separately have claimed Wes Anderson is positioning himself as Roald Dahl's heir, despite clear distinctions in tone and an absence of Dahl's tendency to moralize. Others have implied Anderson vainly appropriated and tainted Dahl's tale. Despite film scholars long frustration with fidelity-based analyses of adaptation, Adrienne Kertzer invokes it in her analysis of *Fantastic Mr. Fox*, observing, "Whatever Anderson's stated intentions about making a film faithful to Roald Dahl, the considerable differences between the film and the book produce

an ambivalent portrait of the author and a significantly altered story" (11–12). Yet art thrives on such appropriation and revision, and Dahl's text is a sparse one. Unlike other titles, like *Charlie and the Chocolate Factory* and *Matilda*, which have given rise to richly imagined (and considerably altered) filmic worlds, *Fantastic Mr. Fox* is a brief novel presumably intended for a younger readership, focused more on story than characterization or detail. (Fortunately, those latter two aspects are where Anderson excels; Anderson's plots, however, are often loose, digressive, and episodic.) *Fantastic Mr. Fox*'s pared-down nature allows Anderson to infuse the story with his recurring themes of fractured family life, melancholy, and existential ennui. The text is best understood as an homage to Roald Dahl that fuses each author's art with minimal compromise: "For the first time, Anderson has shown how he can incorporate the work of another author within his style of filmmaking without sacrificing his auteur authority" (Dorey 183). What we have is not a lesser product, but a new work of art. The "original" Anderson continues his trend of renewing the old in a way that is both innovative in its presentation and respectful in its invocation. The film itself as an object can be seen as an adult's return to an earlier stage in his life, placing his impression on a text that itself had a profound effect on him. More than anything else, tribute seems an apt description of Anderson's approach to Dahl's text.

Children's Culture as Prop: *Moonrise Kingdom*

Wes Anderson's seventh feature film, *Moonrise Kingdom*, is not only his second-most commercially successful film (averaging $130,000 per theater in its opening weekend, according to the website Box Office Mojo[7]), but also his first film to focus primarily on the lives of children. While the adult leads—Walt Bishop (Bill Murray), Laura Bishop (Frances McDormand), Captain Sharp (Bruce Willis), and Scout Master Ward (Edward Norton)—have their own subplots and conflicts, the film clearly belongs to Sam Shakusky (Jared Gilman) and Suzy Bishop (Kara Hayward). Detailing Sam and Suzy's developing romance and their eventual flight into the woods, *Moonrise Kingdom* offers a film about children that refuses to exploit the romantic vision of childhood as sexually innocent and intellectually naïve. Operating somewhere between the chaste whimsy of *Melody* (Hussein, 1971) and the frank eroticism of *The Blue Lagoon* (Kleiser, 1980), Anderson's film chronicles preteen romance without perpetuating a condescending attitude toward its young protagonists. Anderson apparently takes his characters seriously, and the possibility of sentimentality is defused by the film's honest exploration of young people grappling with desire, love, and sexuality. Yet the children's hope to express their affection

sincerely is complicated by their awkwardness and vague notions of how to do so properly. Herein lies the role of children's literature in the film as a prop: it allows Suzy to escape from the world she lives in and to construct her identity within it, but it offers her limited guidance for navigating the world outside the text. Especially designed for the film, all of the books are fantasy novels—"stories with magic powers in them, either in kingdoms on earth or on foreign planets . . . also, time travel, if they make it realistic"—as Suzy explains, clarifying her desire to transcend her stifling existence on the charming, but isolated, island of New Penzance. Just as Max in *Rushmore* insists on wearing his crested blazer and Peter Whitman (Adrien Brody) clings to his father's sunglasses, Suzy's identity is expressed through the children's books she takes with her into the woods as she imagines herself to be a heroine like her books' protagonists.

Children's escape into the woods and their mythologization of that space is a common convention of children's fiction, perhaps most notably in Katherine Paterson's 1977 novel, *Bridge to Terabithia*. Sam and Suzy eventually set up camp alongside a lagoon-like body of water, where they swim, dance, kiss, and cook dinner. The life they lead there is idyllic, away from the controlling influence of parents and scoutmasters, and their conversations reveal articulate, sensitive people. They also, however, reveal the limitations of sentimental, "feel-good" literature as a guide to the so-called real world. Suzy sincerely tells Sam, "I always wished I was an orphan. Most of my favorite characters are. I think your lives are more special." Sam, in an Andersonian deadpan, responds, "I love you, but you have no idea what you're talking about." We can see Anderson critiquing children's literature here, or more accurately, the depiction of children in literature. While texts often romanticize the plight of the innocent child, Sam's objection reveals that the realities of an orphan's life are far less enchanting than literature suggests. Once more Anderson shows that not only do children demonstrate an adult-like maturity and articulateness, but that the false binary that keeps children at a distance is illusory and self-serving.

Of course Sam and Suzy's secluded waterside sanctuary, "Moonrise Kingdom," is fated. Both the name and the location recall the "kingdom by the sea" of another doomed pair, the speaker and his departed sweetheart in Edgar Allan Poe's "Annabel Lee." In that poem, the speaker explains that the angels envied their love so much that they took Annabel Lee from him; in Anderson's film, the envious angels are the adults, each of whom is burdened with the professional, emotional, and romantic failures their lives have become. Indeed Sam and Suzy are not the only star-crossed lovers, as Laura Bishop has been secretly meeting with Captain Sharp. Though docile and fairly ineffectual, Sharp seizes the opportunity to take control of the search effort in a failed attempt to prove his capabilities to Laura—and

himself. Alas, their romance fails when Laura ends it, partly because Suzy has learned of their indiscretions. Anderson's decision to portray the children's relationship as the healthiest in the film is open to multiple readings, but the strongest may be that their love is the most selfless and sincere. The adults may be older, but clearly they have not figured it out. One could argue that they are immature, as evidenced by both Captain Sharp's cap and shorts and Scout Master Ward's Khaki Scout uniform, but in the worlds of Wes Anderson, no one ever matures—not because it is difficult to do so, but because it implies an artificial sense of progress, as if childhood and adulthood are wholly distinctive periods of human existence. Instead the filmmaker reveals the reality of that artificiality, of what Nick Pinkerton calls "a sense in the film . . . of a lost paradise—something that can't be recaptured" (19). More than whimsy, *Moonrise Kingdom* operates with a brutal honesty often left out of earlier children's books, one captured in the "tint of comic bruising" that affects Captain Sharp's hangdog demeanor (Lane 134).

Conclusion

Rather than tracing a direct strain throughout Wes Anderson's work, I hope this essay has drawn attention to the various ways in which children's culture has influenced Anderson and inspired his work. His originality comes not so much from completely new stories, but like all artists, from revising and re-envisioning the narratives that came before him. Anderson successfully manages to synthesize various art forms into his films, making a distinctive impression on the landscapes and soundscapes one finds there. Furthermore, we can make two important conclusions from the repurposing he engages in to varying degrees throughout his oeuvre.

The first concern I wish to underscore is the tendency to see one work inspiring a film. Though *Fantastic Mr. Fox* most obviously adapts Roald Dahl's *Fantastic Mr. Fox*, it also draws inspiration from stop-motion children's entertainment, other Dahl works (*Danny, the Champion of the World*), and the 1973 Disney version of *Robin Hood* (Reitherman, 1973). The final dance sequence seems reminiscent of the *Peanuts* television specials (and the influence of Charles Schulz and *Peanuts* is clear in the soundtracks of several Anderson films, especially *The Royal Tenenbaums*). A fruitful area for greater inquiry in adaptation studies would be how a film may draw upon several literary sources in the creation of a cinematic adaptation. Thomas Leitch emphasized this imperative when he encouraged scholars of adaption to exhibit a "sensitive and rigorous attention to the widest possible array of a film's precursor texts" (165). Such analysis would help to emphasize the artistry and complexity of film, which critics and popular

audiences alike too often view as a pale imitator of the presumably superior work of literature.

The second, and most important, concern is the importance of children's literature, not only as a source for Wes Anderson, but as a socializing, educating, and entertaining tool in children's upbringing. By drawing on E. L. Konigsburg and Orson Welles in *The Royal Tenenbaums* or Roald Dahl and Arthur Penn in *Fantastic Mr. Fox*, Anderson acknowledges influences on his life while refusing to privilege one as superior or more serious. Michael Chabon has compared an Anderson film to Joseph Cornell's assemblage boxes because Anderson's attention to detail helps to "draw a boundary around the things it contains, and forces them in a defined relationship, not merely with one another, but with everything outside the box." Chabon's metaphor captures Anderson's penchant for tableau shots, but it falters in its inability to consider the fluid nature of cinema, especially Anderson's use of tracking shots. More accurately, Anderson's films form a combination of living tableaux and scrapbooks: they stage a work of carefully designed art, but they also bring together a lifetime of influences that continue to resonate with the director or his cowriters, whether it is a book they read early in life or a movie they watched three years ago. Fellow filmmaker Noah Baumbach, Anderson's cowriter on *The Life Aquatic with Steve Zissou* and *Fantastic Mr. Fox*, captured it best when he said, "Let's put in things that the director likes and connects to, and people he likes and connects to, and make a movie out of it" (Brody). These works of art remain with him, and his films consistently emphasize the obvious fact that the childhoods of most of the characters continue to resonate in their everyday lives. While some critics gloss over this tendency as Anderson depicting immature or childlike adults, a more accurate assessment, generally speaking, is that Anderson challenges the idea that the binary of child/adult is an analogue for innocence/experience. Rather, he dissolves any implied social separation between childhood and adulthood, refusing to see either as advantageous, to demonstrate that such delineations are inherently superficial and impractical. The idea that his characters want to return to being children is consistently ill-founded, since we often see children in Anderson's films—Ari (Grant Rosenmeyer) and Uzi (Jonah Meyerson) in *The Royal Tenenbaums*, Ash (Jason Schwartzman) in *Fantastic Mr. Fox*, and Sam and Suzy in *Moonrise Kingdom*—who are neither innocent nor happy, but rather lead lives that are emotionally complex and far from perfect. Admittedly, there are some seemingly innocent children in Anderson's films—the boy (Kyle Ryan Urquhart) who swims by Herman when he sinks to the bottom of the pool in *Rushmore* or Werner, Klaus's congenial nephew who gives the dejected documentarian a crayon ponyfish in *The Life Aquatic with Steve Zissou*—but these representations of childhood are

broad characterizations that demonstrate how adults often look to children for answers and inspiration, even when the child only responds with a smile, at best. The idyllic childhood fetishized by nostalgia, like all of the past, is ultimately unattainable, not because one is distanced from the original period in time, but because it never existed to begin with. Anderson refuses to condescend to his child characters by suggesting they have it easier or even that they are implicitly good people. They are merely people at a different stage of life than the older characters, but this fact does not negate the difficulties they may experience at that station.

Anderson's deconstruction of the child/adult binary, therefore, draws greater attention to the adult tendency to construct childhood in a manner that is inherently patronizing and self-serving. This sensibility echoes Karen S. Coats's observation that "we tend to perceive [children] as raw sources of current selves, or as that which is oppressed, repressed, and simply unattainable within us" (142). Because of this solipsistic habit, children's concerns are superseded by those that we impose upon them in the name of serving their best interests. With *Moonrise Kingdom*, Wes Anderson's developing perspective on this subjugation comes full circle, portraying the world of two young lovers with an apprehensive sexuality and antagonism toward both adulthood and the authority it supposedly bestows on its "membership." Therefore, *Moonrise Kingdom* not only draws on a lifetime of consuming children's culture and "adult" culture, but represents a film that understands children are not a separate audience that must be talked down to, but one that should be allowed to talk back as willful, intelligent persons. In doing so, children are no longer a reminder of one's constructed past, but equals worthy of respect. Through an embrace of the nostalgic mode, Anderson acknowledges the tension between the seeming stability of subjectivity and the ever-changing nature of the world around us. F. Scott Fitzgerald, one of Anderson's favorite writers, famously concludes *The Great Gatsby*, "So we beat on, boats against the current, borne back ceaselessly into the past" (180). In the films of Wes Anderson, the rower may share the sentiment, but he wistfully surrenders to the inevitable violence of the waves.

Notes

1. In his interview with Jacob Weisberg, Wes Anderson notes, "I can't think of any books that would affect my visual style, but maybe there are some. I remember when we were doing *Bottle Rocket*, there was a book of Hockney's body of work up to that point. That had quite an effect on *Bottle Rocket* somehow" ("The World").
2. Some of the key figures in the critical study of children's literature include Peter Hunt, Perry Nodelman, U. C. Knoepflmacher, Jacqueline Rose, Beverly

Lyon Clark, Roderick McGillis, Richard Flynn, Lissa Paul, Kimberley Reynolds, Maria Nikolajeva, Kenneth Kidd, Karen S. Coats, and Philip Nel.
3. There seems to a be a habit of misreading Jim Collins's 1993 discussion of the "New Sincerity" in *Dances With Wolves* (Costner, 1990), *Hook* (Spielberg, 1991), and *Field of Dreams* (Robinson, 1989) by applying it to studio-made independent films that navigate between irony and sincerity. Collins clearly states that the New Sincerity "rejects any form of irony in its sanctimonious pursuit of lost purity" (243); he also characterizes studio-made, big-budget films as emblematic of this trend. Critics have deemed Wes Anderson's films part of this strain, despite the fact that his films are usually distributed by the independent film division of studios (most recently, Focus Features) and quite often exhibit a considerable amount of irony without ultimately being cynical and despondent. Warren Buckland recently contended "sincerity" is more accurate for Collins and that the "new sincerity *incorporates* postmodern irony and cynicism; it operates in conjunction with irony" (2). While Buckland's explanation seems to define how Collins's term is now used, it is worth noting this permutation diverges considerably from Collins's original articulation.
4. For a discussion of the inadequacy of this definition (and other models for defining children's literature), consult Marah Gubar's recent article in *PMLA*.
5. Karen S. Coats's concept of "children's studies" moves beyond Richard Flynn's discursive analysis to include, in the spirit of women's studies, social-science investigations into the lived experiences of children. As Coats explains (with some hesitancy over the use of the word "actual"), "Including actual children in academic Children's Studies is a radical and necessary idea" (141). Perhaps as a reflection of disciplinary territorialism, humanities-based scholars seem to favor "childhood studies."
6. Consult Thomas Leitch's "Twelve Fallacies in Contemporary Adaptation Theory," especially the fourth and ninth fallacies.
7. Consult http://boxofficemojo.com/movies/?id=moonrisekingdom.htm.

Works Cited

Anderson, Wes. "The Iconoclast." Interview by J. C. Gabel. *Playboy*, July/August 2012, 70–72, 160, 162–63. Print.

———. Interview with Arnaud Desplechin. *Interview*, October/November 2009. Web. March 3, 2013.

———. Interview with Tod Lippy. In *Projections 11: New York Film-makers on Film-making*, edited by Tod Lippy, 108–21. London: Faber and Faber, 2000. Print.

———. "Wes Anderson, Creating a Singular *Kingdom*." Interview by Terry Gross. *Fresh Air*. NPR (WHYY, May 29, 2012). Radio.

———. "The World According to Wes." Interview with Jacob Weisberg. *Slate*, May 25, 2012. Web. April 3, 2013.

Anderson, Wes, director, and Noah Baumbach, coscreenwriter. *The Life Aquatic with Steve Zissou*. Audio Commentary. Miramax Home Entertainment, 2005. DVD.

Ariès, Philippe. *Centuries of Childhood: A Social History of Family Life*. Translated by Robert Baldick. New York: Random House, 1962. Print.

Baschiera, Stefano. "Nostalgically Man Dwells on This Earth: Objects and Domestic Space in *The Royal Tenenbaums* and *The Darjeeling Ltd.*" *New Review of Film and Television Studies* 10.1 (2012): 118–31. Print.

Brody, Richard. "Wild, Wild Wes." *The New Yorker* 85.35 (2009): 48–57. Academic Search Complete. Web. May 2, 2013.

Browning, Mark. *Wes Anderson: Why His Movies Matter*. Denver, CO: Praeger, 2011. Print.

Buckland, Warren. "Wes Anderson: A 'Smart' Director of the New Sincerity?" *New Review of Film and Television Studies* 10.1 (2012): 1–5. Print.

Chabon, Michael. "Wes Anderson's Worlds." *The New York Review of Books Blog*. January 31, 2013. Web. April 29, 2013.

Clark, Beverly Lyon. *Regendering the School Story: Sassy Sissies and Tattling Tomboys*. New York: Routledge, 2001. Print.

Coats, Karen S. "Keepin' It Plural: Children's Studies in the Academy." *Children's Literature Association Quarterly* 26.3 (2001): 140–50.

Collins, Jim. "Genericity in the Nineties: Eclectic Irony and the New Sincerity." In *Film Theory Goes to the Movies*, edited by Jim Collins, Hilary Radner, and Ava Preacher Collins, 242–63. New York: Routledge, 1993. Print.

Dorey, Tom. "Fantastic Mr. Filmmaker: Paratexts and the Positioning of Wes Anderson as Roald Dahl's Cinematic Heir." *New Review of Film and Television Studies* 10.1 (March 2012): 169–85. Print.

Fitzgerald, F. Scott. *The Great Gatsby*. New York: Scribner, 2004. Print.

Flynn, Richard. "The Intersection of Children's Literature and Childhood Studies." *Children's Literature Association Quarterly* 22.3 (1997): 143–45. Print.

Gibbs, John. "Balancing Act: Exploring the Tone of *The Life Aquatic with Steve Zissou*." *New Review of Film and Television Studies* 10.1 (2012): 132–51. Print.

Gubar, Marah. "On Not Defining Children's Literature." *PMLA* 126.1 (2011): 209–16. Print.

Honeyman, Susan. *Elusive Childhood: Impossible Representations in Modern Fiction*. Columbus, OH: Ohio University Press, 2005. Print.

Kelly, Christopher. "Wes Is More; or, How I Learned to Stop Hating the Director of *Rushmore* and Love *Moonrise Kingdom*." *Texas Monthly* 40.11 (November 2012): 96–97, 106. Print.

Kertzer, Adrienne. "Fidelity, Felicity, and Playing Around in Wes Anderson's *Fantastic Mr. Fox*." *Children's Literature Association Quarterly* 36.1 (Spring 2011): 4–24. Print.

Lane, Anthony. "Stormy Weather." Review of *Moonrise Kingdom*. *The New Yorker*, June 4 & 11, 2012. 132–34. Print.

Leitch, Thomas. "Twelve Fallacies in Contemporary Adaptation Theory." *Criticism* 45.2 (2003): 149–71. Print.

MacDowell, James. "Notes on Quirky." *Movie: A Journal of Film Criticism* 1 (2010): 1–16. Web.

———. "Wes Anderson, Tone, and the Quirky Sensibility." *New Review of Film and Television Studies* 10.1 (March 2012): 6–27. Print.

Mayshark, Jesse. *Post-Pop Cinema: The Search for Meaning in New American Film.* Westport, CT: Praeger, 2007. Print.

Orgeron, Devin. "La Camera-Crayola: Authorship Comes of Age in the Cinema of Wes Anderson." *Cinema Journal* 46.2 (Winter 2007): 40–65. Print.

Past, Elena. "Lives Aquatic: Mediterranean Cinema and an Ethics of Underwater Existence."*Cinema Journal* 48.3 (Spring 2009): 52–65. Print.

Pinkerton, Nick. "An Island of His Own." Review of *Moonrise Kingdom. Sight & Sound* 22.6 (2012): 16–19. Print.

Ray, Sheila. "School Stories." In *International Companion Encyclopedia of Children's Literature*, edited by Peter Hunt, 467–80. New York: Routledge, 2004. Print.

Riedel, David. "Lotta Quirky Goin' On." Review of *Moonrise Kingdom. Santa Fe Reporter*, June 27, 2012. Web. March 24, 2013.

Rose, Jacqueline. *The Case of Peter Pan, or the Impossibility of Children's Fiction.* Philadelphia, PA: University of Pennsylvania Press, 1993. Print.

Sartin, Hank. Review of *Fantastic Mr. Fox. Time Out Chicago*, November 25, 2009. Web. April 12, 2013.

Sconce, Jeffrey. "Irony, Nihilism and the New American 'Smart' Film." *Screen* 43.4 (Winter 2002): 349–69. Print.

Turner, Daniel Cross. "The American Family (Film) in Retro: Nostalgia as Mode in Wes Anderson's *The Royal Tenenbaums*." In *Violating Time: History, Memory, and Nostalgia in Cinema*, edited by Christina Lee, 159–76. New York: Continuum, 2008. Print.

Whipp, Glenn. "Oscar 8-Ball: Wes Anderson's *Moonrise Kingdom*." Review of *Moonrise Kingdom. Los Angeles Times.* August 29, 2012. Web. February 14, 2013.

8

A Shared Approach to Familial Dysfunction and Sound Design: Wes Anderson's Influence on the Films of Noah Baumbach

Jennifer O'Meara

Rob Dennis asserts that Noah Baumbach and Wes Anderson are two figures "integral to our conception of 'indie dysfunction'" (164). Comparing *The Squid and the Whale* (Baumbach, 2005) with *The Royal Tenenbaums* (Anderson, 2001), he concludes that, although diverging stylistically, they offer "conjoined portraits of familial disharmony" (164). Baumbach cowrote the screenplays for *The Life Aquatic with Steve Zissou* (2004) and *Fantastic Mr. Fox* (2009), but it is difficult to gauge the extent of his contribution. However, in a manifesto for screenwriter analysis entitled "The Schreiber Theory," David Kipen explains that, despite screenwriting collaboration being used as justification for singular, director-centered models of authorship, one can uncover aspects common to each of a film's writers: "collaboration doesn't preclude analysis; it compels analysis" (29). In this chapter I aim to do just that by considering Baumbach's work before and after his collaborations with Anderson. In addition to discussing Anderson's potential influence on him, I chart areas of common ground in their bodies of work and a few ways in which Baumbach appears to have influenced Anderson. Aside from increasing our understanding of the individual filmmakers, this approach provides a case study of collaboration and auteurship coexisting within Indiewood cinema.

Baumbach's first film, *Kicking and Screaming* (1995), was released a year ahead of Anderson's *Bottle Rocket* (1996). Its witty take on the difficulties of

life after college made it a successful low-budget indie, which he followed with *Mr. Jealousy* (1997), another take on masculinity in crisis. Baumbach then took a break from cinema for a few years, during which time he befriended Anderson and cowrote *The Life Aquatic*. His status as writer-director has subsequently risen, particularly since the critical success of *The Squid and the Whale*, for which he was nominated for an Academy Award for Writing (Original Screenplay). In comparing Baumbach's work with Anderson's, my chapter focuses on this film and his subsequent two releases, *Margot at the Wedding* (2007) and *Greenberg* (2010). While it is not feasible to reduce all of Anderson's and Baumbach's points of convergence and contrast to a single chapter, I begin by outlining some of their broader similarities, expanding on Dennis's remarks about their films as joint portraits of dysfunctional families. The next section considers how competition between family members is used as a fulcrum for dramatic tension. It is argued that both filmmakers draw a parallel between characters being competitive (in terms of sport, careers, or affection) and "winning" in conversational battles. I then look at broader similarities in their approach to sound design, by detailing how the characters are granted control over the preexisting music being played, along with how both create synergies across the three soundtrack dimensions of music, effects, and dialogue.

Shared Themes, Influences, and Approaches

On reading summaries of Anderson's work, it is easy to substitute his name with Baumbach's and for the comments still to hold; Joshua Gooch notes that Anderson has "an innate understanding of the connection between humor and pain" (29), something matched in Baumbach's self-proclaimed interest in "a cinematic world where the pain and humor exist simultaneously" (Horn). The source of the dark humor in Anderson's and Baumbach's films is often the frank way in which the characters converse or how unapologetically they place themselves at the center of the world. And, like Carole Lyn Piechota and Joseph Aisenberg note of Anderson, many of Baumbach's characters suffer from deep emotional damage and are held in stunted adolescence, although Baumbach does not convey this through cartoonish costumes that recall youth. Both filmmakers are concerned with the family's potential to oppress, and their films include adult characters who are often more immature than the children. Piechota is one of several scholars to interpret particular Anderson films, or scenes, psychoanalytically. With *The Royal Tenenbaums*, she argues that Margot's (Gwyneth Paltrow) attraction to Richie could be a result of her adoption; denied Etheline's (Anjelica Huston) breast, "Margot's desire for Richie is inextricably

linked to her longing for Etheline" (par. 5). Gooch has analyzed *Rushmore*, *The Royal Tenenbaums*, and *The Life Aquatic* through a Lacanian lens, while Deanna K. Kreisel considers the latter in relation to aspects of the Oedipus complex. Baumbach's narratives also reward such readings; in *Margot at the Wedding*, the title character (Nicole Kidman) has an uncomfortably close relationship with her adolescent son, Claude (Zane Pais), whom she treats with alternating affection and contempt. In *Squid*, the father and son make romantic progress with the same college student, similar to Max (Jason Schwartzman) and Blume's (Bill Murray) generational competition for Miss Cross (Olivia Williams) in *Rushmore* (1998) and Ned (Owen Wilson) and Steve's (Bill Murray) for Jane (Cate Blanchett) in *The Life Aquatic*.

In terms of inspiration, both Anderson and Baumbach have incorporated autobiographical elements, particularly those related to childhood and their early experiences of the creative process. *Bottle Rocket* and *Rushmore* were made in Anderson's native Texas, with the latter filmed in Anderson's high school, where he, like Max, staged plays (Hancock par. 3; Olsen par. 4). While, like Walt (Jesse Eisenberg) in *The Squid and the Whale*, Baumbach grew up in Brooklyn with two writers; his father, Jonathan Baumbach, is a successful novelist like Bernard (Jeff Daniels), with his actual clothes worn by Daniels in the film. Furthermore, both filmmakers have a strong interest in the literary world. While *The Royal Tenenbaums* is regularly compared to the work of J. D. Salinger (Kertzer 6), *Greenberg* was inspired by the title character of Saul Bellow's *Herzog* (1964). So, like Mark Olsen notes of Anderson, Baumbach is "as likely to make a literary reference as a cinematic one" (par. 18). For instance, in a *New York Times* interview, Baumbach cites Philip Roth as an artistic hero, as well as discussing the high value he places on books (Solomon).[1] The French New Wave is another important influence for both, which is manifest in their general style and content, and also through their carefully selected allusions. Olsen identifies François Truffaut's coming-of-age films as a point of reference for *Bottle Rocket* and *Rushmore* (par. 13), while Baumbach instead makes clear references to the work of Éric Rohmer (particularly in *Margot at the Wedding*, which copies Rohmer's preference for a remote seaside location, as well as the film's title and character names). *Squid* includes allusions to *The Mother and the Whore* (Eustache, 1973) and borrows heavily from *Murmur of the Heart* (Malle, 1971). Given their joint interest in the French New Wave, it is unsurprising that, despite being based on a quintessentially English Roald Dahl book, *Fantastic Mr. Fox*'s soundtrack also pays homage to this period in its use of Georges Delerue's music for *Day for Night* (Truffaut, 1973) (Kertzer 10). With the general similarities between Anderson and Baumbach outlined, I turn now to a fuller consideration of the role of the competitive, dysfunctional family unit in their work.

Familial Competition

Anderson's and Baumbach's films are filled with characters that are notably competitive, be it with siblings, cousins, or spouses. Often concerned with measures of success or recognition, their narratives probe the causes and effects of resenting another's triumph. Sometimes the rivalry is overt, as with Malcolm (Jack Black) in *Margot at the Wedding*, who Pauline (Jennifer Jason Leigh) notes is "competitive with everyone" since he doesn't "subscribe to the credo that there's enough room for everyone to be successful." In *Rushmore*, Max's friendship with Blume is damaged when the two compete for the affections of Miss Cross, while in *The Royal Tenenbaums*, the children have spent their lives competing for the affections of their parents, birth or adoptive. In Richie's (Luke Wilson) case, this is entwined with his professional tennis career, since Royal's (Gene Hackman) support for him was largely dependent on his continued success. Indeed, as Piechota notes, Richie is unwilling to remove his tennis clothes since they symbolize, "both his athletic glory and the only Tenenbaum achievement that made his father proud" (par. 16). Anderson and Baumbach's collaborations on *The Life Aquatic* and *Fantastic Mr. Fox* also bring issues of rivalry to the fore; in the former, Steve competes with his son, Ned, for the affection of Jane. While in the latter, Mr. Fox's insecure son, Ash (Jason Schwartzman), resents his cousin Kristofferson's (Eric Chase Anderson) natural athletic ability, particularly since it leads to a bond with his father that Ash is struggling to develop.[2] Close analysis from several scenes in *The Squid and the Whale* and *Margot at the Wedding* can reveal this more effectively.

Baumbach establishes rivalry immediately in *Squid*, which opens on a tennis court with a brutal game of family doubles. In fact, the entire narrative is summarized by Frank's (Owen Kline) voiceover that precedes the first image: "Mom and me versus you and Dad." Bernard tells Walt how he should take advantage of his mother's weaknesses, before he hits her with a forceful shot. Joan (Laura Linney) walks off the court and Bernard follows. In a scene of palpable tension, the camera stays behind the boys, who watch as their parents argue out of earshot. Bernard resents that his wife's literary career has usurped his own, with the premise of a family at war strengthened by the repeated use of the Pink Floyd song "Hey You." Performed at one point by Walt and Frank, it is repeated throughout in various formats, with the final line ("Together we stand, divided we fall") connecting strongly with Frank's opening declaration.

Baumbach mines the dramatic potential of a competitive family again with *Margot at the Wedding*, in which harsh dialogue at unexpected moments sounds out of place. Margot reacts to her son, Claude, almost drowning in the pool with, "Now we're even," in reference to him laughing

at her embarrassment in an earlier sequence. Also, in a scene in which the family plays croquet, Pauline, disregards the norm of going easier on children, by verbalizing how she wants to use her shot to remove Claude from the game. Although less aphoristic than Royal's declaration to his young son in *Tenenbaums* that "There are no teams," the every-woman-for-herself mentality is nonetheless conveyed. Like Anderson, Baumbach tends to focus on a male perspective, although *Margot at the Wedding* centers around a troubled relationship between two adult sisters. They compete over sexual matters rather than career success; at one point Margot suggests they count out their partners to see who has had more. Pauline dismisses the question, so, in another attempt to one-up her sister, Margot cheats during a subsequent swimming race.

It should be noted that much of the conflict in Baumbach's first two films also stems from the fallout of competition. However, since working with Anderson, Baumbach has shifted the competitive focus from writers to family members, including a subtly developed resentment in *Greenberg* between Roger (Ben Stiller) and his more successful brother (Chris Messina). But Anderson does include writer-characters (in *Rushmore*, *The Royal Tenenbaums*, *The Life Aquatic*, and *Fantastic Mr. Fox*), meaning each has focused on rivalry from both perspectives, sometimes simultaneously. Writer-characters can reasonably be expected to have a good command of language, and, as I will now demonstrate, this is central to Anderson's and Baumbach's combative speech.

War of the Words

Familial competition aligns well with Anderson's representations of dysfunctional kinship, which are largely based on alienation and discomfort in conventional social roles. Aside from isolated hurtful remarks that reveal underlying competiveness, bickering in both Anderson's and Baumbach's work shows how verbal exchanges are inherently competitive, with strategic moves, injured parties, and, ultimately, a winner and loser. Donna Peberdy notes insensitivity toward children, bluntness, lack of empathy, and a preference for unembellished facts as features of *Tenenbaums* and *The Life Aquatic* (65). However, these could equally be applied to Baumbach's writing in *Squid*, *Margot*, and *Greenberg*. To give just two examples, in *Squid* Frank tells his mother, "You're ugly," while in *Margot*, the title character tells her son, matter-of-factly, that he will get cancer if he uses deodorant. Conversational games are something that children and adolescents must learn to play, as made clear in *Margot*; sensitive and constantly upset by his mother's put-downs, Claude is the film's most sympathetic

character. However, his speech gradually becomes more hostile, as when he casually dismisses his cousin, telling her, "You're starting to annoy me." Also, both filmmakers regularly have characters cut one another off mid-sentence, and this is written explicitly into the quick-fire dialogue of their original screenplays, as in the following example from *Fantastic Mr. Fox* (Anderson and Baumbach 20):

> FOX: His only security is a few old hunting beagles and a low stone wall. Now a word about beagles: never look a beagle directly in the eye. And if—
> KYLIE (voice-over) (*interrupting*) Why not?

Murray Pomerance describes the interaction between characters in *The Royal Tenenbaums* as "startlingly cerebral," but lacking in "emotional connection" (302). Exchanges between family members in *Squid* and *Margot* are also intellectually precise and emotionally detached.[3] Roger, in *Greenberg*, also regularly corrects others' choice of words or draws attention to their ambiguity. In their insistence on one meaning of a word over another, Anderson's and Baumbach's characters reveal a pedantic nature and, in their inflexibility, become humorous. For example, in *Rushmore* Max asks Miss Cross if she wants him to "grab a dictionary" to define the word "relationship," after she implies that he wants to be more than just friends; her presupposition is correct, but he uses semantics to deny it. Similarly, in *Squid*, following their parents' divorce, Bernard argues back and forth with Frank over the correct terms for each location ("our house" versus "your mother's house"). This recalls the following exchange between Royal and Henry in *Tenenbaums*:

> ROYAL: I want you out of my house.
> HENRY: This is not your house.
> ROYAL: Don't play semantics with me.

Anderson's language, however, is also precise in that characters often reveal the close attention they pay to measuring things. Such numeric precision is found in *Bottle Rocket*, as with Dignan's "75-year plan" and Antony's agreement to help him again on "three conditions," which he then lists in the format "first . . . second . . . third." In *Tenenbaums*, the time-specific language of the external narration seems to spill over from voiceover to character; Margot was adopted "at age two," and in "the ninth grade" she won a grant "of $50,000." She disappeared "four years later" and was gone "for two weeks." The characters' *own* words also tie them to time in this way, as when Royal takes Margot to a restaurant and she tells him, "I only have five minutes."

Then, on discovering a faded pack of cigarettes she hid behind a brick, Richie (Luke Wilson) asks her how old she thinks they are; after one puff she decides "about ten years." I would therefore argue that, when a feature is made of numbers in the Anderson-Baumbach screenplays, it is most likely Anderson's contribution; for instance, in *The Life Aquatic*, Steve discusses their route on the map in terms of inches ("four" versus "an inch and a half"), and, in *Fantastic Mr. Fox*, Bean asks for "three shovels, two pick-axes, [and] 500 rounds of ammunition." In this way, dialogue that is unnaturally specific can be considered the textual equivalent of Anderson's detailed visual style, which Aisenberg describes as showing the calculation of a museum curator (par. 1).

Returning to Baumbach, Frank's poor relationship with his father in *Squid* is shown as a function of language and culture; Bernard is bothered that he is more interested in tennis than developing his knowledge of the arts. When Bernard brands Ivan (William Baldwin), the tennis coach, a "philistine," Frank repeats Bernard's improvised definition, word for word, to Ivan. Again, attention is drawn to language as inherited. Frank's inappropriate curses throughout also explain why, in the opening scene, Joan is bothered when Bernard curses in frustration during the tennis match. We also see the spreading of labels in *Tenenbaums*, as when Margot is routinely referred to as "adopted" by Royal and by herself. As the following excerpt from the published screenplay shows, Richie has internalized the term and the distinction it represents, leading him to "quickly" and reflexively use the word as a shield when Eli questions his romantic interest in Margot (Anderson and Wilson 71):

ELI: She's married, you know.
RICHIE: Yeah.
ELI: And she's your sister.
RICHIE: (*quickly*) Adopted.

In these ways, the viewer is encouraged to see language as both contagious and scarring, especially when particular terms are repeated. Both Anderson's and Baumbach's dialogue is scripted to reveal family life as an ongoing war of the words, in keeping with Pomerance's description of kinship in *Tenenbaums* as "something of an elaborate game" (302). However, as will be discussed below, the players of Baumbach's games often face more serious, or ambiguous, consequences.

Integrated Soundtracks

Several scholars (Piechota, Winters, Boschi, and McNelis) have noted that Anderson's work aims to maximize the creative potential of the soundtrack.

Can the same be said of Baumbach's? Claudia Gorbman's principle of *melomania* helps answer this question. In a discussion of "Auteur Music," she uses the term *mélomane* to describe directors whose love of music is such that it becomes "a key thematic element and a marker of [their] authorial style" (149). She applies the term to a group of contemporary filmmakers, including Jean-Luc Godard, Martin Scorsese, and Quentin Tarantino. Gorbman mentions neither Anderson nor Baumbach, but I think the term suits Anderson's work, in general, and Baumbach's work since *The Life Aquatic*. By looking, in the sections to follow, at how their music is integrated with sound effects and dialogue, it seems they are not strictly *mélomanes*, but sound conscious in general.[4]

Character as DJ

Boschi and McNelis have outlined how Anderson's characters are often given temporary control of the soundtrack when they play music diegetically, and Baumbach seems strongly influenced by this technique. Ben Winters considers Anderson's use of this strategy in detail, noting that his characters, like the filmmaker himself, "take great care in selecting music to play" (46). The choice of song is often based on lyrics, another way of incorporating verbal style, which provides "an outward manifestation" of a character's psyche, as Piechota notes in regard to Margot in *Tenenbaums* (par. 8). But when Baumbach's characters are granted control, their musical choices are often based less on suitability of lyrics, than the song's mood or connection with that character's past. However, for both filmmakers, giving a character temporary control of the music can have broader implications for the integrated soundtrack, particularly when the connection between music and dialogue is strengthened when they explain what might otherwise be an out-of-place song. The character's words can increase the sense of musical realism, or the justification may be humorously implausible, like in *Moonrise Kingdom* (2012) when Suzy (Kara Hayward) explains matter-of-factly that she listens to Françoise Hardy records since her aunt is French. The dialogue can therefore draw attention to the contrived nature of soundtrack selections, as when a villain in *Fantastic Mr. Fox* chastises his employee for making up a song as he goes along: "That's just bad songwriting, Petey."[5]

In *Greenberg* most of the music is controlled diegetically by Roger, who expresses his feelings for Florence (Greta Gerwig) indirectly via music, rather than directly through speech. On first meeting, he tries to connect by playing and discussing Albert Hammond's "It Never Rains in Southern California." Throughout, in another example of close integration between sound and speech, his and Florence's differing relationships with music

mirror their characters' dialogue; Roger is overly controlling and dismissive of others' opinions, while Florence is polite and self-effacing. She undermines the CDs in her car, while Roger is confident that he knows the perfect song for every situation. Florence warmly invites him to watch her sing, but Roger plans a letter of complaint as he listens and later provides her with a CD of older songs she could perform instead. However, he intends this purely as a romantic gesture, and, when Florence plays his CD in her car and sings along drunk to it in her home, it recalls Max bringing his own music (a French cassette tape) into Miss Cross's home when attempting to woo her in *Rushmore*. In both cases, romantic connections are overtly negotiated via music, largely because the male characters refuse to say what they are actually feeling. By carefully spreading meaning across the spoken word and sung lyrics, Anderson and Baumbach allow them this inarticulacy, while ensuring the audience still gains a strong sense of inner complexity.

Baumbach also makes use of Anderson's technique of smoothly transitioning from nondiegetic to diegetic music in order to underline an unconscious link between characters. Piechota astutely notes of *Tenenbaums* that when Nick Drake's song "Fly" moves from dramatic score (when Richie travels home) to source music (when he moves upstairs and Margot is playing it in his room), the impression is of Margot "telepathically calling him home" (par. 22). Baumbach achieves something similar in the opening sequence to *Greenberg* when "Jet Airliner" by the Steve Miller Band plays as Florence drives home; although Florence and Roger have not met, he soon arrives on a plane from the East Coast (and will subsequently complain about the flight). Like in *Tenenbaums*, the choice of song therefore links them ahead of time, and, in the case of *Greenberg*, Roger's speech is what makes this link apparent. Also, the volume and lack of reverb indicates "Jet Airliner" is nondiegetic, but the music stops when Florence slams the car door, requiring the viewer reinterpret the music as something she could also hear. Like with Anderson, the point at which the music seems to shift from nondiegetic to diegetic does not figure realistically, since it should have cut out when Florence turned off the engine (a moment we do not see), not when the car door closes. Winters's conclusion that Anderson playfully blurs "film musicology's traditionally held distinction" between the nondiegetic and the diegetic therefore also applies to Baumbach (54).

Like Anderson, Baumbach also foregrounds the sound design by anchoring the music visually; both reveal the source of the music through close-up shots of records, CDs, record players, and radios. Indeed, Winters has considered the tendency for Anderson's characters to shape their own "sonic environment" in considerable detail (47–51).[6] The same could be said of Baumbach's; just as we get close-ups of Mr. Fox switching on a radio

attached to his belt, in *Greenberg* Roger is shown choosing his music, with the song and artist legible on his iPod screen. And, like when we are shown Steve putting on a cassette in *The Life Aquatic*, Roger turns up the music on his friend's car radio. Indeed, in a humorous continuation of his and Florence's miscommunication via music, she urges him to turn it down again.

Conversely, one element of sound design that Anderson appears to have borrowed from Baumbach is dialogue that is used as a sound bridge to increase pace. In a scene in *The Squid and the Whale*, Lili (Anna Paquin), Bernard's student, is introduced when her words "I absorb sex indiscriminately" are layered over the closing images from a scene that takes place the night before (when Bernard invites Walt to come to class the next day). The camera cuts to the source of the voice and circles the room of students while Lili continues to read. It stops at Walt and Bernard, who, unlike the rest, are staring at Lili and not a copy of her work. The camera pauses on them before cutting to the drive home. The scene lasts just 27 seconds but makes it clear that Bernard and Walt are both interested in Lili. Similarly, in *Moonrise Kingdom* we hear the start of the scout master's (Edward Norton) log over the unrelated closing images of Suzy spying on her mother. There is no such overlap in the published screenplay; instead the scout master speaks *after* an insert of the "reel-to-reel tape recorder" into which he delivers the monologue (Anderson and Coppola 16). But in the finished film, he has already said three lines *before* we cut to this insert, as he begins his descriptive report. The pace is notably increased since the viewer processes the two simultaneously. Again, each uses the components of soundtrack efficiently, and to powerful effect.

As a brief aside, we can also see Baumbach's possible intervention on Anderson in the age of the protagonists in *Moonrise Kingdom*; many of his characters are young at heart, but aside from the younger versions of the Tenenbaum children, Anderson had never centered a narrative around those on the cusp of adolescence. Baumbach, on the other hand, has spoken about the revelatory moment when he realized *The Squid and the Whale* should be told from the perspective of the sons, rather than the parents. Frank's 12-year-old perspective is then continued on by Claude in *Margot at the Wedding*; he is roughly the same age, and his developing understanding of his family's dysfunction is crucial from the opening sequence.

The Sound Effect–Dialogue Border

Returning to Anderson's and Baumbach's integrated soundtracks, in addition to a similar treatment of music and the use of sound to increase pace, both negotiate an interesting relationship between sound effects and

dialogue. In *Bottle Rocket*, Dignan's (Owen Wilson) dialogue includes moments when he verbalizes what would normally be a sound effect. Toasting to a successful robbery, he says, "Great work; great work, both of you," and, over the sound of their glasses touching, he adds a redundant, "Clink, clink." During the robbery itself, he speaks a bird sound ("cuckaw, cuckaw") and uses his hand to mime a beak, which Bob (Robert Musgrave) responds to in kind. These vocal sound effects strengthen the general impression created by Dignan's dialogue; he is more enthusiastic about his plans than anyone else. When Bob abandons them in the middle of the night, Dignan describes how he "flew the coop," referencing birds again and highlighting the strong links between speech and sound effects. While Anderson's simple sound effects add to *Bottle Rocket*'s overall playfulness, Baumbach mixes dialogue and sound effects to highlight tension between family members. In *Margot at the Wedding*, a character often reacts to the words of another with a noise rather than words. When Margot continuously insults their guests in the garden, a frustrated Pauline returns to the house, where she cuts off Margot's speech by slamming down plates.

As discussed, in several films both Baumbach and Anderson equate being competitive at sport with being competitive in conversation, with the relationship between sound effects and dialogue in *Squid* highlighting this. Aside from in the opening scene, tennis and table-tennis matches recur throughout, with the sound of the ball going back and forth equivalent to the to-and-fro of their speech. In a later sequence, the sound of verbal and physical sparring combine again when, each with a boxing glove, Frank defends Joan and Walt defends Bernard. As their argument escalates so too does the boxing, and Frank instinctively hits Walt harder when he calls Joan a liar. The loud smack of the glove hitting Walt provides a finality and punctuation to the conversational battle.

Both Anderson and Baumbach also include moments when dialogue clarity is sacrificed, and words become more of a personalized sound effect than signifier of narrative information. In *Rushmore*, Anderson makes a feature of the characters' attempts to be heard over the sound of machinery. Max shouts over them, while Herman puts his head down a pipe when he asks a question, his voice booming as a result. With Baumbach's *Margot*, on the other hand, several reviewers complained about unclear dialogue.[7] Yet the shooting script reveals that it was not accidental, since references to muttering, mumbling, and expressive breathing abound.[8] While in *Greenberg*, Roger frequently responds not with words, but frustrated sighs of resignation. In each case, the mouth becomes a source for sound effects, as opposed to revealing purely semantic meaning through speech. Indeed, considering Baumbach's use of nonverbal vocalizations together, I would argue that he is more likely responsible for Ash's habit of spitting rather

than speaking a response when frustrated by someone's words in *Fantastic Mr. Fox*. This habit also underscores that he is ultimately an animal, and so has animal as well as human traits.

In keeping with Kipen's argument that, even with collaborative screenwriting, one can uncover aspects common to each of a film's writers, other things that come out of the characters' mouths in the film align more with Anderson; the use of French and Latin phrases (like *comme ci, comme ça* and *sic transit gloria*), for example. Incorporation of non-English language is standard for Anderson, with Portuguese, French, Italian, and Latin incorporated into several of his films. Therefore, when the animals of *Fantastic Mr. Fox* are referred to by their Latin names, or the deckhand in *The Life Aquatic* sings Portuguese lyrics to the tunes of David Bowie, it is most likely Anderson's mark. Ultimately, Anderson's verbal aesthetic is as stylized as his visual, something made clear in Jeff Jaeckle's analysis of Anderson's use of literary techniques such as rhyming and alliteration (156–57). I would add to this the use of measurements, discussed above, which conveys the sense that characters are misplaced in time and/or obsessed with small details. Baumbach's mise-en-scène and editing are less intricate, but he shares Anderson's talent for making an aesthetic feature of speech. Both therefore imbue their dialogue with the same kind of careful detail as the other two elements of the sound design.

Divided by Sentimentality, United by Verbal and Sound Design

Despite considerable common ground, Anderson and Baumbach diverge on more than visual style. Film critic Kent Jones points out the discrepancy between Anderson's "winning, warm movies" and the "angry, disassociated people" that inhabit them (2001, 26), while Aisenberg comments on the films' "soggy sentimental strain" (par. 2). Baumbach contrasts with Anderson in his commitment to the complexity of his characters' problems and his preference for ambiguous rather than resolved endings. Indeed, part of the reason it took so long to get *Squid* made was because both financiers and actors wanted Bernard's character to have a redemptive moment (Baumbach 2005 118). Baumbach therefore knew Jeff Daniels was the right actor to portray him since he was "against any kind of forced sentimentality" (Lethem). Baumbach's characters generally move forward only in marginal ways, with their behavior or relationships rarely transformed. It is therefore not surprising that Anderson takes responsibility for the ending of *Fantastic Mr. Fox*. He explains how, despite the film being bleaker than Dahl's book, "I had always pictured [the ending] being more positive" (Brody par. 2). On the other hand, MacDowell points out that Ned's death

in *The Life Aquatic* has little "conventional emotional appeal" and uses dialogue that is "functional" rather than emotive (20; 16).[9] The moment seems to bear Baumbach's mark, since his dialogue is particularly effective at drawing deeper meaning from unfeeling words. Given their varying tolerances for optimism, I would argue that Baumbach is more likely responsible for moments when detachment triumphs in their screenplays, and Anderson, sentiment. But since *The Life Aquatic* takes Anderson's self-consciously childlike aesthetic to an extreme (MacDowell 16), it is perhaps too easy to ignore Baumbach's influence on the screenplay.

Given the substantial overlaps in Anderson and Baumbach's work, I have deliberately avoided contextualizing Baumbach's films in terms of certain debates around Anderson. For example, while the Anderson special edition of the *New Review of Film and Television Studies* includes many references to his work in terms of the "smart" film or a "New Sincerity" movement, I did not do the same for Baumbach. Instead, guided by David Kipen's argument that collaboration compels rather than resists analysis, this chapter provided an overview of the overlaps in their work and attempted to trace Anderson's influence on Baumbach, along with Baumbach's potential influence on *The Life Aquatic* and *Fantastic Mr. Fox*. Competition between family members was identified as an important trope in their work, both dramatically and verbally; unwilling to let words be casually chosen, characters respond argumentatively to most things that are said. Furthermore, from the early stages of writing, Anderson and Baumbach also pay attention not just to music or verbal precision, but the possibilities of the entire soundtrack. Its three elements are integrated in creative ways, blurring boundaries between the categories and making the case for them not strictly as *mélomanes*, but sound conscious in general. By highlighting non-English words and nonverbal vocalization (like muttering and sighs), their films make a stylistic feature of spoken sound effects, while creating a more complex representation of social interaction. Baumbach approaches similar material in a more realist way and with a less distinctive visual style. However, his verbal style and approach to sound design bears many of the marks of Anderson's work. In this way, Baumbach's creative collaboration with Anderson does not fully end when they finish a screenplay together; Anderson's influence resonates, unofficially, in Baumbach's solo projects. To a lesser extent, the reverse is also true.

Notes

1. Baumbach's references to Saul Bellow and Philip Roth can also be tied to his broader concerns with Jewish American identity and culture, something

that distinguishes him from Anderson. Baumbach explores this most fully in *Greenberg*; the title character helps reveal the complex nature of a partly Jewish identity when he reacts badly to assumptions, based on cultural stereotyping, that he must be Jewish.

2. This discussion of competitiveness could also be tied to the deconstruction of human and beast, which one arguably finds in *Fantastic Mr. Fox*.

3. It should be noted that other scholars have instead interpreted Anderson's portrayals more in terms of emotional damage than emotional detachment: Devin Orgeron suggests that his films detail the need to create alternate communities of meaning "in the face of familial abandonment" (42). While in his discussion of masculinity in Anderson's films, Chris Robé explores "the emotionally debilitating crises that result from the affective foreclosures necessitated by entitled masculinity" (102); Herman Blume, Royal Tenenbaum, and Steve Zissou each channel their emotions into those that are stereotypically male, like assertiveness, anger, and pride (103).

4. My discussion extends on Boschi and McNelis's analysis of aspects of Anderson's audio-visual stylistics, in which they convincingly argue that sound, music, and visuals "act synergistically to produce narrative and guide our journey through [Anderson's] film world" (44). As they note, Anderson's musical choices are not solely his own; Randall Poster has served as music supervisor on every Anderson film since *Rushmore*, and on *The Squid and the Whale* (29).

5. As Kertzer explains, after Petey stammers that he was "just kind of making it up as [he] was going along," Bean (the film's chief villain) unexpectedly expresses his aesthetic views (7).

6. Boschi and McNelis also discuss how shots of transistor radios and phonographs are particularly important in Anderson's films when the technology has nostalgic connotations (40–42).

7. See Christopher Disher, review of *Margot at the Wedding*, dvdizzy.com, February 19, 2008; Johnny Betts, review of *Margot at the Wedding*, Therighteousremnant.com, n.d.

8. For instance, Claude "blushes and mumbles" when he sits beside a stranger, while Margot is described as "whispering" and speaking "under her breath" (Baumbach, *Margot*, 1, 68, 25).

9. MacDowell explains that this is because it is accompanied by purely functional dialogue ("Maybe we could've crashed a little softer—probably wouldn't have made any difference though") and because "Steve's emotions when on shore [are] beyond our view" (16).

Works Cited

Aisenberg, Joseph. "Wes's World: Riding Wes Anderson's Vision Limited." *Bright Lights Film Journal* 59. Web. February 2008.

Anderson, Wes, and Owen Wilson. *The Royal Tenenbaums*. New York: Faber and Faber, 2001. Print.

Anderson, Wes, and Noah Baumbach. *Fantastic Mr. Fox*. June 2009. http://rushmoreacademy.com/wp-content/uploads/2007/06/fmf.pdf. Web.

Anderson, Wes, and Roman Coppola. *Moonrise Kingdom* (screenplay dated May 1, 2011). http://www.focusawards2012.com/scripts/MoonriseKingdom.pdf. Web.

Baumbach, Noah. *The Squid and the Whale*—The Shooting Script. New York: Newmarket, 2005. Print.

———. *Margot at the Wedding*—The Shooting Script. London: NickHern, 2007. Print.

Boschi, Elena, and Tim McNelis. "Same Old Song: On Audio-Visual Style in the Films of Wes Anderson." *New Review of Film and Television Studies* 10.1 (March 2012): 28–45. Print.

Brody, Richard. "Wild, Wild Wes." *The New Yorker*, November 2, 2009. Web.

Buckland, Warren. "Wes Anderson: A 'Smart' Director of the New Sincerity?" *New Review of Film and Television Studies* 10.1 (2012): 1–5. Print.

Dennis, Rob. "Familial Dysfunction." In *Directory of World Cinema: American Independent*, edited by John Berra, 162–80. Bristol: Intellect, 2010. Print.

Felando, Cynthia. "A Certain Age: Wes Anderson, Anjelica Huston and Modern Femininity." *New Review of Film and Television Studies* 10.1 (March 2012): 68–82. Print.

Gooch, Joshua. "Making a Go of It: Paternity and Prohibition in the Films of Wes Anderson." *Cinema Journal* 47.1 (Autumn 2007): 26–48. Print.

Gorbman, Claudia. "Auteur Music." In *Beyond the Soundtrack: Representing Music in Cinema*, edited by Daniel Goldmark, Lawrence Kramer, and Richard Leppert, 149–62. Berkeley, CA: University of California Press, 2007: Print.

Hancock, Brannon M. "A Community of Characters: The Narrative Self in the Films of Wes Anderson." *The Journal of Religion and Film* 9.2 (October 2005): n.p. Web.

Horn, Jordana. "Noah Baumbach on Why *Greenberg* Isn't as Depressing as You'd Think." Vulture.com. March 2010. Web.

Jaeckle, Jeff. "The Shared Verbal Stylistics of Preston Sturges and Wes Anderson." *New Review of Film and Television Studies* 11.2 (2012): 154–70. Print.

Jones, Kent. "Family Romance." *Film Comment*, November/December 2001, 25–27. Print.

Kertzer, Adrienne. "Fidelity, Felicity, and Playing Around in Wes Anderson's *Fantastic Mr. Fox*." *Children's Literature Association Quarterly* 36.1 (Spring 2011): 4–24. Print.

Kipen, David. *The Schreiber Theory: A Radical Rewrite of American Film History*. Hoboken, NJ: Melville House, 2006. Print.

Kreisel, Deanna K. "What Maxie Knew: The Gift and Oedipus in *What Maisie Knew* and *Rushmore*." *Mosaic* 38.2 (June 2005): 1–17. Print.

Lethem, Jonathan. "Noah Baumbach." *BOMB Magazine* 94 (Fall 2005): n.p. Web.

MacDowell, James. "Wes Anderson, Tone and the Quirky Sensibility." *New Review of Film and Television Studies* 10.1 (March 2012): 6–27. Print.

Olsen, Mark. "If I Can Dream: The Everlasting Boyhoods of Wes Anderson." *Film Comment*, January/February 1999, 12–17. Web.

Orgeron, Devin. "La Camera-Crayola: Authorship Comes of Age in the Cinema of Wes Anderson." *Cinema Journal* 46.2 (Winter 2007): 40–65. Print.

Peberdy, Donna. "'I'm Just a Character in Your Film': Acting and Performance from Autism to Zissou." *New Review of Film and Television Studies* 10.1 (March 2012): 46–67. Print.

Piechota, Carole Lyn. "Give Me a Second Grace: Music as Absolution in *The Royal Tenenbaums*." *Senses of Cinema* 63 (February 7, 2006): n.p. Web.

Pomerance, Murray. "The Look of Love: Cinema and the Dramaturgy of Kinship." In *A Family Affair: Cinema Calls Home*, edited by Murray Pomerance, 293–303. New York: Wallflower, 2008.

Robé, Chris. "'Because I Hate Fathers, and I Never Wanted to Be One': Wes Anderson, Entitled Masculinity, and the 'Crisis' of the Patriarch." In *Millennial Masculinity: Men in Contemporary American Cinema*, edited by Timothy Shary, 101–121. Detroit, MI: Wayne State University Press, 2013. Print.

Solomon, Deborah. "'The Intelligentsia Indie." *New York Times*, October 9, 2005. Web.

Winters, Ben. "It's All Really Happening: Sonic Shaping in the Films of Wes Anderson." In *Music, Sound and Filmmakers: Sonic Style in Cinema*, edited by James Wierzbicki, 45–60. New York: Routledge, 2005. Print.

9

Bill Murray and Wes Anderson, or the Curmudgeon as Muse

Colleen Kennedy-Karpat

As Melena Ryzik joked in a report from a Golden Globes after-party, "Ain't no party like a Bill Murray party, because a Bill Murray party don't stop."[1] Although it was meant to encapsulate the antics of a single evening, Ryzik's observation resonates beyond one star-studded gala into the arc of Murray's entire career, and director Wes Anderson has certainly enjoyed a Bill Murray party that seems like it won't soon stop.

Over the course of six (soon to be seven) feature films, Anderson and Murray have formed a core partnership with a rotating additional cast of actors, screenwriters, and technical collaborators. Anderson's tendency to partner with the same people time and again has created an exceptionally close-knit cinematic family, united by the pursuit of his overarching vision. Murray was the first true star to work with Anderson, playing the disgruntled, self-made millionaire Herman Blume in *Rushmore* (1998), the studio follow-up to Anderson's breakout feature, *Bottle Rocket* (a film Murray claims never to have seen).[2] Since *Rushmore*, Murray has been involved in all of Anderson's feature films, with roles ranging in importance from the eponymous oceanographer in *The Life Aquatic with Steve Zissou* (2005) to a nameless businessman in *The Darjeeling Limited* (2007). Anderson's casting of Murray, though grounded in the actor's previous work, shows subtle yet significant modifications to his star persona that other directors have since adopted. By mapping out new, more "melancomic" terrain (to borrow Deborah J. Thomas's term), Anderson pushed Murray's persona to evolve beyond the high-concept setups of Hollywood comedy to focus instead on quotidian struggles involving family, love, and finding one's place as an aging boomer in a changing world.[3]

Behind the scenes, too, Murray has shaped the way that Anderson's films are made and marketed to fans, with DVD releases and auteur discourse that highlights the teamwork between the director and his favorite muse. This seemingly required inclusion of Murray in both the films and their digital afterlife gestures toward a subversion of the term *auteur* as applied to Anderson; far from a lone genius behind the camera, Anderson's collective of cinema professionals—with Bill Murray as its core performer—offers an Indiewood variation on Thomas Elsaesser's likening of twenty-first-century auteurs to military officers, directing their troops according to a concept that stretches across multiple films and even multiple media platforms (288). Before examining more closely how Murray's ubiquity in the Andersonian universe challenges the notion of the auteur, we should explore the trajectory that led him to this partnership in the first place.

Bill Murray began his acting career in the late 1970s, first on the small screen, most notably *Saturday Night Live*, before appearing in feature films. In the 1980s, Murray played a pothead groundskeeper in *Caddyshack* (Ramis, 1980), an unlikely soldier in *Stripes* (Reitman, 1981), a skeptical confidant in *Tootsie* (Pollack, 1982), and, perhaps most famously, a smart-mouthed policeman of the paranormal in *Ghostbusters* (Reitman, 1984) and *Ghostbusters II* (Reitman, 1989). At this early stage of his career, Murray's rare excursions outside comedy underwhelmed both audiences and critics; in 1984, *The Razor's Edge* (Byrum) featured Murray as a dramatic lead, but critical and popular responses ranged from tepid to hostile. When Murray returned to mass-market comedy in the early 1990s, he kicked off a period during which, as Ryan Gilbey asserts, his fans "stopped having to apologize for the films in which their idol appeared," with roles that combined humor with serious themes in more plausible, even pointedly philosophical ways (27). *Groundhog Day* (Ramis, 1992), one of Murray's most enduring performances, uses its core conceit to venture into startlingly dark territory, with a somber premise that complements Murray's inherent resistance to schmaltz. Summarizing Murray's comic appeal around this time, Pauline Kael declared that "we like Murray because of his oddity and because he seems so fundamentally untrustworthy. There's something grungy to the soul that he knows how to work and it's wonderful" (Gilbey 53).

Murray retained this tainted-soul image into the late 1990s, when his attention turned toward less-commercial projects, including *Rushmore*. In Anderson's films, Murray's essential "grunge" defies the polished dialogue and meticulous mise-en-scène, a contrast that makes him a surprising yet compelling figure within the Andersonian universe. Anderson and his coauthors write with specific actors in mind, and for *Rushmore*, Bill Murray inspired the character Herman Blume before he ever signed on to play

him.[4] While Blume neither reverses nor rejects the preexisting Murray persona, Anderson and coauthor Owen Wilson introduce significant innovations. Before *Rushmore*, Murray's leading roles either burst forth in medias res like the robbery in *Quick Change* (Murray and Franklin, 1990), or they get a flimsy backstory: lingering romantic regret in *Scrooged* (Donner, 1988), a persistent social maladjustment in *What About Bob?* (Oz, 1991). These stock characters all but require Murray's presence to make them credible: *of course* Bill Murray would dress as a clown to rob a bank before attempting the perfect getaway, *of course* Bill Murray would be a cutthroat TV boss, *of course* Bill Murray would have psychological problems. But it takes Bill Murray to sell these characters to the audience. Likewise, his supporting roles, such as the skeptical best friend in *Tootsie*, are indelibly shaped by his idiosyncrasies. In roles both major and minor, many directors also relied on Murray's gift for improvising dialogue.[5]

Despite his recognized talent for invention under pressure, what convinced Murray to work with Anderson on *Rushmore* was his conviction that the script would not require his comic enhancement. He explained to Charlie Rose that the screenplay "was so precisely written, I mean you could tell that [Anderson] knew exactly what he was doing. He knew exactly what he wanted to make, exactly how he wanted each scene to go. I've never really seen [a script] that was that precise. I looked at it and I went, this one's different. He knows exactly what he's doing, and I'll go with it. Anybody who can write that well, I feel confidence in."[6] The clarity of vision Murray saw in *Rushmore* extends to the source of his character's discontent. Like nearly every Murray antihero, Herman Blume is miserable. But unlike the vaguely defined, yet definitively performed malaise that motivates Grimm in *Quick Change*, John in *Stripes*, and Phil in *Groundhog Day*, *Rushmore* takes pains to establish *why* Herman Blume is miserable. His marriage is foundering. He despises his sons. He has achieved much, yet feels empty. And then, he finds an unlikely antidote to this midlife ennui: his sons' precocious classmate Max Fischer (Jason Schwartzman), whose friendship offers Blume a meaningful human connection.

In Murray's estimation, it speaks volumes about Blume that, after bootstrapping his way to millions, he responds so strongly to the schemes of a plucky high schooler: "That's a guy who wants to start over again. He wants to cut off the limb he's on and go back to the root somewhere; he wants to get back down. And I've had that feeling many times, that I could cut it off and start over."[7] Blume longs to return (if not *regress*) to the beginning and take another shot at life, seeking a spiritual and emotional rebaptism to match the literal immersion at his sons' pool party in an early sequence. Several visual and emotional parallels link this scene in *Rushmore*, which introduces Blume, to Mike Nichols's 1967 film *The Graduate*, a connection that

Donna Peberdy explores (67). However, Peberdy elides one very important distinction between Ben Braddock (Dustin Hoffman) and Herman Blume: Braddock might be reluctant to launch himself into adulthood, but once he does, he will charge forth for the first time. Blume, on the other hand, has long since forged his path; now facing midlife, he finds that this trajectory has brought at least as much heartache as success. Hesitating at the start is not the same as yearning to take it all back, and starting over can be conceived only after the first attempt has been thoroughly botched. Still, what these characters share is more significant than what separates them: a 21-year-old Braddock in 1967 would be roughly the same age as Blume in 1998. These characters both belong to the baby-boomer generation, even if these films capture very different moments in their lives.

In *Rushmore*, for the first time, Murray allows his star persona to be hitched to specifically midlife moments of strife. As Peberdy explains, Murray began to eschew his mugging, "goofball persona" in pursuit of more subdued expressions of angst, and he began to win critical acclaim for his portrayal of the crises of white, male middle age (71–73). In *Rushmore* and the films that followed it—whether directed by Anderson or one of his contemporaries—Murray may have come of age, but this has not solved his problems so much as created new ones. Murray points out that Herman Blume was his first character "who was old enough to have children, in a way. I mean, I was old enough, always, probably, but it was the first one where I was definitely somebody who could've been relating to his own son."[8] Recognizing this shift in social station and its concomitant responsibilities marks an important transition for Murray, who in *Rushmore* and later Anderson films moves beyond romantic coupling to delve instead into the much thornier negotiations of family life.

The life of a family man requires different skills than those involved in seduction. In the 1980s and '90s, many of Murray's roles figure him as a playboy, or at least a character whose narrative's closure involves gaining, regaining, or maintaining a heterosexual partnership (e.g., *Scrooged* and *Groundhog Day*), sometimes alongside meaningful homosocial bonds (e.g., *Stripes*, the friend role in *Tootsie*). Importantly, these romantic plots and subplots do not revolve around eliminating a rival; when it comes to love, these comedies make Murray his own worst enemy. In contrast, Anderson situates Murray as potentially attractive to women, but never prioritizes the ups, downs, and triangulations of this attraction in his narrative arc. Other relationships always take center stage. Walt Bishop's troubled marriage in *Moonrise Kingdom* serves as a backdrop to the budding love between his daughter and a runaway Khaki Scout, pitting the singular dedication of young love against the tedium and tribulations of a long-term, adult partnership. In *Rushmore*, Blume's pursuit of Miss Cross takes second place to

his friendship with Max, although these romantic overtures abruptly turn Max against him. In *Life Aquatic*, Eleanor's departure rekindles the professional rivalry between Zissou and her ex-husband Alistair Hennessey (Jeff Goldblum), a romantic defeat compounded by Zissou's unrequited crush on Jane (Cate Blanchett), who prefers his alleged son, Ned (Owen Wilson). Both *Life Aquatic* and *Rushmore* refuse to place the focus on Murray's character's failure to tend to his marriage while fruitlessly pursuing a new love interest; instead, each film gives far more attention to the intergenerational relationship between two men and how it interacts with these romantic exploits.

As they navigate the long haul of marriage, Murray's characters often discover that their wives have been unfaithful, even if they themselves aren't the cheating kind. Blume's wife in *Rushmore* flirts with a young man at the pool party before kicking Blume out of the house over his affair with Miss Cross; after an early sequence in *Life Aquatic* suggests that Zissou has been a fairly unapologetic philanderer, he tries in vain to appease both his wife and his new (unrequited) flame. But in *The Royal Tenenbaums*, Raleigh St. Clair shows calm devotion to his troubled, much younger wife, Margot (Gwyneth Paltrow), a dedication that veers into despair after a detective uncovers her myriad affairs. Here, Raleigh emerges as the victim, not the perpetrator, with his only consolation prize a newfound public recognition for his work. As both a cuckold and an indifferent—or perhaps ambivalent—father,[9] Walt Bishop in *Moonrise Kingdom* recombines many of the defining characteristics of Murray's previous work with Anderson. Walt doesn't need a private eye to reveal his wife's affair; moreover, the fissures in their marriage exceed this obvious infidelity: twin beds, intrahousehold communication via megaphone, and his own simmering rage. Shirtless, a bottle of wine in hand, Walt fishes an ax out of a closet and crosses the frame as he announces to his three young sons, "I'll be out back. I'm gonna go find a tree to chop down." When the search party finds Suzy and Sam's campsite, Walt does not tap gently on the kids' tent door—he rips the whole thing up from its rigging.

This physical manifestation of private turmoil, in *Moonrise* as in other Anderson films, introduces a measure of sad-sack slapstick to which Murray's persona is well suited. In *Rushmore*, his fleeting bursts of physical humor threaten to disrupt Anderson's careful mise-en-scène: Blume falling to the ground after climbing a fence, Blume jogging out of the frame after an encounter with Miss Cross, Blume flailing in a swarm of bees that Max has surreptitiously released into his hotel room. *Life Aquatic*'s island rescue sequence features physical humor involving multiple characters, but Murray's battles with leeches and a staircase trump them all. James MacDowell notes that when a film's comic performances are generally restrained,

moments like these "often surprise with [their] suddenness and borderline-surreal incongruity," a blend of styles that he identifies as a mark of the "quirky" (8–9). According to MacDowell, Wes Anderson is a prime example of this sensibility, making Murray's ability to combine physical comedy with deadpan delivery a key asset in the conception and execution of the director's vision. Indeed, Peberdy locates the term "deadpan" in a number of reviews of Murray's performances, indicating its importance to his overall persona. But the effort to humanize this element of Murray's image sets Anderson's work apart from other directors, who until *Rushmore* had deployed his comedic talents to very different ends.

As for his own cinematic influences, Anderson tends to wear them on his sleeve. Much of his own self-criticism refers to favorite films and filmmakers that reveal a clear predilection for European cinema: Louis Malle, François Truffaut, Roman Polanski, Luis Buñuel, Bernardo Bertolucci. Few Americans or Asians appear in his canon, although he mentions Stanley Kubrick and Orson Welles, and intertextual references in *Darjeeling* intimate a familiarity with Bollywood. Self-consciously aligning his tastes with the Continental aesthetic, Anderson named his production company American Empirical Productions, ironically recalling the European arthouse tradition that sprouted just as the continent's colonial empires had finally begun to break apart. From an aesthetic perspective, at least, Anderson's films "see" geography through this trans-Atlantic lens.

Even Anderson's approach to America differs from that of, for example, Alexander Payne, a fellow Indiewood director whose films wryly yet sympathetically observe specific corners of America and the people who inhabit them. Payne's vision falls in closely with regional ethnic stereotypes: overwhelmingly white for the Midwest of *About Schmidt* (2002), appropriately heterogeneous for the Hawaii of *The Descendants* (2011). In contrast, Anderson takes places that *could* be represented as culturally or ethnically narrow and carefully broadens them to emphasize diversity. The titular private school in *Rushmore*, filmed at an actual school in Texas where coauthor Owen Wilson spent some of his formative years, features the British Miss Cross (Olivia Williams) and a Scottish school bully (Stephen McCole). Scottish actor Brian Cox was sought out for the role of headmaster Dr. Guggenheim, although the character's national origins are unclear. The groundskeeper, Mr. Littlejeans (Kumar Pallana), and Max's geometry teacher (Deepak Pallana, son of Kumar) point to a local, integrated South Asian population. However indirectly, these characters all embody pieces of the British empire, introducing connotations of ambition and Old World prestige that exaggerate the stereotypes that would normally populate a school like Rushmore Academy. In contrast, once Max enrolls at the local public high school, he finds a wider range of ethnic diversity (but no foreign

accents). In the midst of this heterogeneity, Herman Blume presents an archetypal iteration of the American dream; Blume, once a scholarship student like Max, has gone on to build his own industrial empire. However, his emotional turmoil underscores the instability of this achievement, and part of his angst could stem from the bewildering forces of globalization and multiculturalism that threaten to push middle-aged white men out of their familiar positions of power. Blume's wealth clearly matters to the narrative,[10] but, less obviously, so does his whiteness.

Even Blume's nationality becomes a factor that singles him out in an environment like Rushmore, and casting a famous comic actor like Murray in the role underscores something specifically American in his appeal. Murray's attitude, his manner of speaking, and his star persona all took root in American comedy, and in the global film industry, comedy tends to travel less well than dramatic fare. *The Royal Tenenbaums* downplays Murray's cultural specificity by situating him among kindred folk, and *Rushmore* at least grants him home-field advantage, but the Mediterranean setting of *Life Aquatic* underscores the sensation that Murray is literally charting unfamiliar territory. *Life Aquatic* brought Wes Anderson's cast and crew out of America for the first time, filming at Italy's legendary Cinecittà studios. Producer Barry Mendel emphasizes how this location affected the process: "There's something very Italian and European which has kind of crept into this film and made [. . .] a unique fabric that wouldn't feel the same if it were made in America. [. . . .] That [European] flavor is actually a powerful force in the film."[11] Yet this European veneer never subsumes Bill Murray's Americanness. Like Max at Rushmore Academy, Zissou is surrounded by foreign and/or ethnically marked characters: the German Klaus Daimler (Willem Dafoe), the British Jane Winslett-Richardson (Cate Blanchett), the Brazilian Pelé Dos Santos (Seu Jorge), the Sikh cameraman Vikram (Waris Ahluwalia), and so on. Even Zissou's wife, Eleanor, gloriously incarnated by Anjelica Huston, may be American (we never find out), but wherever she is, she seems to feel at home in a way her husband apparently does not. Only Ned Plimpton (Owen Wilson) shares Zissou's evident Americanness, although his Air Kentucky affiliation, his Southern drawl, and his genteel manners underscore the idea that region, not nation, better encapsulates his identity.

Moving even farther afield of the Americas, *The Darjeeling Limited* emphasizes still more clearly the foreignness of the setting relative to its protagonists, even though here Murray's appearance amounts to little more than a cameo. The opening sequence shows Murray in the backseat of a tiny cab, zooming through Indian streets crowded with pedestrians, animals, and other obstacles both living and inanimate. Alternating anxious glances at his watch with even more anxious glances at his surroundings, Murray

is clearly in a hurry, and the driver does his best to oblige. But when the cab pulls into the train station, Murray sprints away without paying, barely looking back as he cuts into the line at the ticket window. Throughout his career, Murray has frequently played men of privilege,[12] but in *Darjeeling* this privilege takes a highly specific form: the "ugly American" abroad. Mining the same vein, Jim Jarmusch cast Murray in his enigmatic quest film *The Limits of Control* (2009) as an ambiguously evil businessman, one figure in a cast of characters named according to national, descriptive, and metonymic identifiers: Lone Man (Isaach de Bankolé, the protagonist), Créole, French, Waiter, Blonde, Guitar, Mexican, Driver. As for Murray, his character is, simply, *American*. Reduced to a nationality, yet incarnated by a star, this character and this casting allow Jarmusch to distill Murray's identity down to a specific cultural core.[13]

While Anderson has made strong use of this particular nuance in Murray's updated star image, he did not invent this twist. Before *Life Aquatic*, Sofia Coppola's *Lost in Translation* (2003) cast Murray in an ambiguously romantic friendship between two Americans in Japan, a relationship with echoes of *Rushmore*: a pair of loners, decades apart in age, strike up a friendship at a fraught moment in each of their lives. Of course, Coppola's film moves this rapport in a new direction by making the younger character a woman (Scarlett Johansson), thus introducing the notion of heterosexual romance, and by setting the story in Tokyo. This cultural estrangement amplifies the characters' sense of isolation, imposing it from without even as it wells up from within. The fact that Murray plays a prominent actor on the decline—with a name, Bob Harris, that seems like an alternate-universe rendering of his own—also lends this character a more overt suggestion of autobiography than Anderson put into Herman Blume or Raleigh St. Clair. Anderson's personal and professional connections to the Coppola family— his *Moonrise Kingdom* cowriter, Roman; director, Sofia (Roman's sister); and their cousin, Jason Schwartzman—suggest that they share a similar outlook on Bill Murray as a star. From outside this family circle, Jarmusch also emphasizes feelings of loss and alienation in his use of Murray, and all of their work has collectively reinforced and extended his post-*Rushmore* persona.

Beyond tailoring Murray's star image for a new kind of film, Anderson has also drawn inspiration from his presence behind the camera. Even when Murray plays a minor role in the ensemble, copious DVD extras suggest his near omnipresence behind the scenes. These featurettes, as Devin Orgeron explains, have helped construct an image of Anderson as a "not-too-authoritative" auteur, who makes "his *dependence* on others a proud thing, the defining feature of his particular brand of authorship" (56, 59). In several cases, Murray is interviewed at least as extensively as Anderson,

and while sharing the virtual space of DVD extras may seem like a purely practical move, as Timothy Corrigan explains,

> the interview... is one of the few extratextual spaces that can be documented where the auteur, in addressing fans and critical viewers, engages and disperses his or her own organizing agency as an auteur. Here, the standard directorial interview might be described according to the action of promotion and explanation; it is the writing and explaining of a film through the promotion of a certain intentional self, and it is frequently the commercial dramatization of self as the motivating agent of textuality. (52)[14]

If Anderson openly shares something as sacred (and typically self-aggrandizing) as interview footage, this alone makes a strong case for considering him as a different kind of auteur. Taking inventory of these DVD extras (especially, though not exclusively, those on Criterion Collection releases), it becomes clear that Anderson's "commercial dramatization of self" involves reenacting and reinforcing the collaborative spirit of his filmmaking. While the director himself is neither reclusive nor self-effacing in these assembled extras, as Orgeron suggests, these featurettes strive not to create a singular vision in the classic auteurist mold, but rather emphasize how many people both behind and before the cameras have united under the Anderson brand to create the film in question. In addition to stars, these glimpses behind the scenes also emphasize writing and production design, neither of which are usually acknowledged as part of a team effort in the context of auteurist aesthetics.

While writers and designers get an unusually bright spotlight in the Andersonian collective, the industry focus on stars (including the treatment of auteur directors as a particular kind of star) makes their inclusion *de rigueur*. Considering that Anderson has directed only one feature film without him—*Bottle Rocket*, his first—Bill Murray has played a more consistent role than anyone in shaping the Andersonian aegis for audiences and fans. Before Anderson had met Murray, the actor's freewheeling reputation caused some trepidation. As Anderson tells Charlie Rose,

> I was a little terrified, because I'd heard stories about him. [. . .] You know that he's a guy who can walk into a crowd of people and take control of it, in a way that I never could. He's really funny; everyone loves him already [. . .] And then I'd also heard about him throwing someone in a lake on one thing, and if he didn't like the situation, he's going to fix it his way. So I was scared before I met him.

But once they came face-to-face, Anderson realized that Murray's charisma could be channeled and that Murray was fully prepared to let him

channel it. Anderson continues, "As soon as I met [Murray], I felt so comfortable with him; I felt he was so intelligent, and he was so clearly getting involved with us for all the right reasons, and he wanted to do what we wanted to do. And then I just realized that everything I was afraid of—I can use all that stuff. He's going to bring that to this, and we can benefit from it."

While Anderson painstakingly crafts his vision down to the tiniest detail, he concedes that he expects the actors to add a measure of unpredictability to the mix.[15] Murray's loose approach exemplifies this premeditated randomness; in an interview conducted after filming *Tenenbaums*, Murray admits that he prefers "to play a different way every time. I want to get my money's worth. I want to work out. Before, I felt like I had to be pretty responsible and professional, because I don't know how these people [costars] work, but then I realized, you know what, they're going to do it their way no matter what, so I'm just going to keep doing it my way. That's when I finally just had fun."[16] This shake-it-up strategy held fast when he took on a meatier role as Steve Zissou in *Life Aquatic*: "Every take is different," Murray says. "It's fun for me to just go, just let the lines fly."[17] Zissou's central position in the narrative naturally makes Bill Murray a mainstay in the extras that accompany the film's Criterion DVD release—and including Steve Zissou in the title underscores the character's role as an old-school auteur, one whose authority presides over the making and interpretation of a film, making Murray's role in *Life Aquatic* a kind of parodic anti-Anderson.[18]

Anderson praises Murray for being "quick" to understand the requirements of a scene, declaring: "I've never met anybody else like him. [. . .] He really has an effect on people, and he has an effect on a group of actors, and he has an effect on a crew of people who will just never forget him."[19] Murray's costars confirm Anderson's statement, and the "Starz on the Set" featurette included with *Life Aquatic* shows them chiming in with firsthand impressions. Cate Blanchett says that Murray "galvanized everyone," a sentiment echoed by Willem Dafoe, who adds that "Bill's been an important support" to Anderson's work. Murray also connected with the crew who filmed "This Is an Adventure," a featurette helmed by cinematographer and documentarian Albert Maysles. In their acknowledgments for "This Is an Adventure," the crew folds a number of inside jokes into their somewhat cryptic, penultimate message, which is ostensibly aimed at Murray: "Super Duper Shout Out to Bill for taking us in and making us feel at home so far away. We learned a lot. P.S. Sorry about the foot thing during the World Series." Meanwhile, their final, far less intimate acknowledgment recognizes Anderson: "Thanks for letting us into your precious world. It's always an adventure." A sincere sentiment, to be sure, yet the message to the man

running the show lacks the camaraderie of the "Super Duper Shout Out" dedicated to its star. Anderson's early remarks about Murray's magnetism shine through in this expression of fraternal respect.

The extras on Anderson's latest release, *Moonrise Kingdom*,[20] show a disproportionate focus on Murray relative to his screen time in the film, including the "Set Tour with Bill Murray" that lets him loose behind the scenes. The contrast between Murray's quick, anarchic wit and the scrupulously constructed set pieces underscores yet again how Murray's signature contribution to an Anderson film lies precisely in their disparate approaches to filmmaking: Murray's intelligent chaos meets Anderson's cultivated imagination, both on-screen and on set, both within Murray's characters and within Murray the star. Their continuing partnership[21] showcases Anderson's uniformity of vision even as it confirms Murray's vital role in the authorial team recognized under the name "Wes Anderson." Bill Murray may seem like an unlikely muse, but working with Anderson has infused his star persona with the failed ambitions and squandered potential of Herman Blume, Raleigh St. Clair, Steve Zissou, even the anonymous suit running late for his Indian train. These themes are Anderson's, but this man's face is always Murray's.

Notes

1. Tom Shone's profile of Murray in the *Guardian* (December 7, 2012) explores how Murray's effervescent sociability spills into fans' lives as well.
2. Murray has repeated this claim in a number of sources, perhaps most insistently in his interview with Charlie Rose on the Criterion DVD release of *Rushmore*, during which he admits having received, but never viewed, multiple DVD copies of *Bottle Rocket* before accepting the role based solely on the quality of the screenplay.
3. *Rushmore* was not the first time a director appropriated Murray's "type" for a major supporting role outside his usual range. Tim Burton's *Ed Wood* (1994) cast him as Bunny Breckinridge, the titular filmmaker's flamboyantly gay sidekick. But Murray's over-the-top, one-note portrayal of Breckinridge fails to foreshadow his more nuanced, post-*Rushmore* roles.
4. See especially the Charlie Rose interview in the Criterion release of *Rushmore*. In his commentary for *Tenenbaums* (Criterion), Anderson states that Raleigh St. Clair was written to give Bill Murray a role in the film, and Royal Tenenbaum was written with Gene Hackman in mind.
5. Gilbey emphasizes Murray's role in crafting dialogue for *Groundhog Day*, inviting his reader to "simply be thankful that Bill Murray exists. Without him, comic improvisation would be a mediocre discipline in which pretty good might be good enough" (22).
6. Interview, Criterion release of *Rushmore*.

7. Behind-the-scenes featurette directed by Eric Chase Anderson, available on the Criterion DVD of *Rushmore*.
8. Eric Chase Anderson featurette, Criterion DVD of *Rushmore*.
9. See Robé for an examination of fathers in Anderson's films.
10. Robé discusses how class resentment underscores the narrative dynamics in *Rushmore* (113–15).
11. "The Look Aquatic" featurette, Criterion release of *Life Aquatic*.
12. Murray's early characters occupy either side of the class spectrum, dividing the downtrodden (e.g., *Stripes, Caddyshack, Quick Change, What About Bob?*) from the privileged (e.g., *Scrooged, Groundhog Day*). However, post-*Rushmore*, Anderson and others (e.g., Sofia Coppola, Jim Jarmusch) have made Murray's persona more consistently connotative of wealth and high social station.
13. Murray also played the protagonist in Jarmusch's *Broken Flowers* (2005); see Peberdy for an in-depth analysis of this film. In *Coffee and Cigarettes* (2003), Jarmusch followed a different trend in star casting, turning Murray into an exaggerated version of himself. Murray also "played himself" under very different narrative circumstances in *Zombieland* (Fleischer, 2009). Other actors have been similarly cast—perhaps most famously Neil Patrick Harris in *Harold and Kumar Go to White Castle* (Leiner, 2004)—but this approach to casting and cameos does not suit Wes Anderson, who relies on writing extant star personae into thoroughly fictional characters.
14. See also Elsaesser 295.
15. From Albert Maysles's behind-the-scenes documentary accompanying the Criterion DVD of *Tenenbaums*.
16. Interview with Bill Murray, Criterion release of *Tenenbaums*.
17. "Building a Scene" featurette, Criterion release of *Life Aquatic*.
18. See Corrigan 40.
19. Director commentary track on the Criterion release of *Life Aquatic*.
20. Universal dual DVD/Blu-Ray release. No word on whether *Moonrise Kingdom* will eventually get the Criterion treatment, but this release shows that other labels have recognized the benefit of DVD extras. For a discussion of the significance of DVD releases and the extras they contain, see Elsaesser 286.
21. Murray will appear in Anderson's *The Grand Budapest Hotel*, set for a 2014 theatrical release.

Works Cited

Corrigan, Timothy. "Auteurs and the New Hollywood." In *The New American Cinema*, edited by Jon Lewis, 38–63. Durham, NC: Duke UP, 1998. Print.

Elsaesser, Thomas. "Auteurism Today: Signature Products, Concept-Authors and Access for All: *Avatar*." In *The Persistence of Hollywood*, 281–304. New York: Routledge, 2012. Print.

Gehring, Wes D. *Personality Comedians as Genre: Selected Players*. Westport, CT: Greenwood Press, 1997. Print.

Gilbey, Ryan. *Groundhog Day*. BFI Modern Classics. London: BFI, 2004. Print.

MacDowell, James. "Wes Anderson, Tone and the Quirky Sensibility." *New Review of Film and Television Studies* 10.1 (March 2012): 6–27. Print.

Orgeron, Devin. "La Camera-Crayola: Authorship Comes of Age in the Cinema of Wes Anderson." *Cinema Journal* 46.2 (Winter 2007): 40–65. Print.

Peberdy, Donna. *Masculinity and Film Performance: Male Angst in Contemporary American Cinema*. Basingstoke, UK: Palgrave Macmillan, 2011. Print.

Robé, Chris. "'Because I Hate Fathers, and I Never Wanted to Be One': Wes Anderson, Entitled Masculinity, and the 'Crisis' of the Patriarch." In *Millennial Masculinity: Men in Contemporary American Cinema*, edited by Timothy Shary, 101–121. Detroit, MI: Wayne State UP, 2012. Print.

Ryzik, Melena. "Golden Globes, Before and After." *New York Times*, January 14, 2013. Web. January 14, 2013.

Shone, Tom. "Bill Murray: Actor, Hipster, Genius, FDR... God." *Guardian* December 7, 2012. Web. December 12, 2012.

Thomas, Deborah J. "Framing the 'Melancomic': Character, Aesthetics, and Affect in Wes Anderson's *Rushmore*." *New Review of Film and Television Studies* 10.1 (Mar 2012): 97–117. Print.

10

Life on Mars or Life on the Sea: Seu Jorge, David Bowie, and the Musical World in Wes Anderson's *The Life Aquatic with Steve Zissou*

Lara Hrycaj

American film director Wes Anderson conveys a distinctive visual and aural style in his films. The importance Anderson places on the music is indicative of what Claudia Gorbman describes as an *auteur mélomane*—a director with a passion for music ("Auteur Music" 149). Anderson's films feature a variety of music, highlighting songs of the Rolling Stones and other British Invasion artists, an original score by Mark Mothersbaugh, and music from film and television, along with jazz, classical, and Christmas music. Anderson uses music in his films in a variety of ways, but the three specific uses that contribute to his overall authorial signature are songs associated with montage, songs associated with slow motion sequences, and songs that emanate from musical devices. Anderson's musical signatures begin to change and expand with his fourth film, *The Life Aquatic with Steve Zissou* (2004).[1]

The Life Aquatic centers on oceanographer and documentary filmmaker, Steve Zissou (Bill Murray), in the grip of a crisis, though his problems extend far beyond a mere midlife crisis. Steve just lost Esteban (Seymour Cassel), his best friend and fellow Team Zissou crew member, to a jaguar shark. He soon meets Ned (Owen Wilson), the son he did not know he had nor even wanted to know he had, and his career as a filmmaker is on the

decline. Plus he has several interpersonal relationship issues with his wife, Eleanor (Anjelica Huston); his archrival, Hennessey (Jeff Goldblum), his love interest, Jane (Cate Blanchett); and the Team Zissou crew. Despite this crisis, he wants to impress everyone around him as the same leader, director, hero, and captain of Team Zissou as depicted in his successful documentaries. The film on the surface is about Steve's search for the jaguar shark that killed his friend, but it is actually about Steve's search for himself and his coming to grips with things out of his control; he is getting older and no longer the hero and star he once was.

Musically, Anderson employs several elements of his authorial musical signature in *The Life Aquatic*, but he also moves away from some of the minor signatures found in his three previous films: *Bottle Rocket* (1996), *Rushmore* (1998), and *The Royal Tenenbaums* (2001). Additionally, Anderson forgoes the use of songs by the Rolling Stones or Christmas music; he instead features the music of David Bowie and the performances of Bowie's songs in Portuguese by musician and actor Seu Jorge. A minor signature Anderson does employ to great effect in this film is the dollhouse shot—a tracking shot "revealing levels and layers of a place," which can make sets or "real locations look like a diorama"—with the life-sized cross-section of the boat, the *Belafonte*, set to Mothersbaugh's original score and Seu Jorge's rendition of "Five Years" (Seitz).

As a *mélomane*, Anderson feels strongly about having David Bowie songs in the film. In fact, he states in the film's audio commentary that he "wanted to use a lot of David Bowie songs" and created the character Pelé (Seu Jorge) to perform the songs. These performances by Jorge push the music to the forefront of *The Life Aquatic*, more so than in any of Anderson's other films. Most of Jorge's songs move in and out of the diegesis, starting or ending with the character of Pelé performing the song, but Anderson uses one of these songs to score a dollhouse shot. In this chapter, I focus exclusively on Anderson's use of David Bowie songs in the film, how these songs contribute to the narrative world of *The Life Aquatic*, and how they contribute, challenge, and expand on Anderson's authorial signature.

The music provides additional information about characters within the film, specifically the main character, Steve Zissou. Jorge's songs provide an otherworldliness and strangeness while serving as a Greek chorus to Steve; Jorge's lyrics highlight the film's themes of life, death, dreams, and change. The David Bowie songs, both the originals and Jorge's renditions, provide information about Steve's psychological and emotional states of mind. The music in *The Life Aquatic* utilizes narrative cueing, a film music function Claudia Gorbman describes in *Unheard Melodies* as a way music can establish characters and interpret events in the film (73); in this case, the music

cues viewers to the world of Steve Zissou. This is an idealized fantasy world in which he sees himself and wants others to see him. According to Michel Chion, songs in film can create "a link between individual characters' destinies and the human collectivity to which they belong" (*Sound Art* 428), thus I believe the David Bowie songs in *The Life Aquatic* provide a link to Steve Zissou's destiny and his place in the world.

Slow Motion and David Bowie

Anderson reinforces his signature of pop songs used with slow motion in *The Life Aquatic* through his use of two original David Bowie songs. Bowie's "Life on Mars?" is heard toward the beginning of the film during a party on the *Belafonte* in which the character Pelé entertains partygoers with other Bowie songs in Portuguese and on acoustic guitar. Anderson includes Bowie's version of "Life on Mars?" and a brief moment of slow motion to signal a change in Steve's world. Toward the end of the film, Anderson uses Bowie's "Queen Bitch" to accompany Steve descending the film-festival staircase in slow motion and to signal Steve's triumphant change.[2]

During the party on the *Belafonte*, the music primarily features Pelé singing David Bowie songs, except for the moment Bowie's original "Life on Mars?" enters the soundtrack when Steve and Ned meet. It might seem odd to hear a Bowie original nondiegetically so soon after Pelé's performance of several Bowie's songs; however, the song cues the audience to the world Steve lives in and how meeting Ned disturbs Steve's world. Their meeting triggers emotions in Steve that he cannot control, which makes the original "Life on Mars?" play on the soundtrack. Anderson uses "Life on Mars?" to depict visually and aurally Steve's uneasiness when he learns of the death of a former lover and that he may have a son. The song takes over the soundtrack as Steve walks through the party to the prow of the ship. In this sequence, Anderson uses the lyric "sailors fighting in the dancehall" to comment on Steve's younger, wilder days when he met Ned's mother and as a premonition of his fight with the pirates. As Bowie sings, "Is there life on Mars?" Steve lights up a marijuana cigarette and takes a puff, and the subsequent on-screen action changes slightly to slow motion. The slow motion allows the audience to vicariously experience the marijuana's calming effect. The use of this song and Pelé's cover versions of Bowie songs in Portuguese at the party have an alien feel, and they separate Steve's world from reality while commenting on this world at the same time.

Anderson features a Bowie original on the soundtrack a second time during a slow motion sequence toward the end of the film. "Queen Bitch"

begins as the scene goes into slow motion: Steve descends the staircase with Werner (Leonardo Giovannelli)—the nephew of Klaus Daimler (Willem Dafoe), one of his crew members—on his shoulders and the paparazzi taking photos of him. The lyrics to the song at this moment are about the song's protagonist feeling low "up on the eleventh floor" while watching the action below. Steve is physically descending, getting lower, like the way the protagonist in the song feels. However, Steve is changed, and his lowest moments are currently behind him. This is a moment of triumph. Anderson reinforces Steve's triumph by switching the action back to normal speed with a new shot of Werner on Steve's shoulders, and then by cutting to a sequence of Steve and Team Zissou in new uniforms walking toward and boarding a new-looking *Belafonte*. Additionally, the lyrics reinforce Steve's triumph, with "it could have been me," and Steve could have stayed the same, a "queen bitch," but he has a renewed sense of purpose as shown with the new uniforms, a larger Team Zissou, and a repaired *Belafonte*. The "Life on Mars?" sequence is a call for Steve to change, and "Queen Bitch" signals that Steve has changed.

The slow motion sequences featuring David Bowie songs, at the end of the film in particular, contribute to Anderson's musical signature of featuring slow motion sequences in all of his films, typically set to pop songs. The lyrics of these songs comment on and contribute to Steve's character and his world. While Anderson's use of David Bowie songs firmly reinforces Anderson's authorial signature in his films, the use of Seu Jorge's renditions of Bowie songs challenge and expand on Anderson's signature, as well as contribute to the world of Steve Zissou.

Pelé as Greek Chorus and Steve's Destiny

Music in film, especially popular music, can provide multiple levels of meaning to a film, scene, or character. *The Life Aquatic* includes several different types of music that contribute to the overall narrative of the film, but the early 1970s-era David Bowie songs performed on screen by Brazilian musician and actor Seu Jorge, with its allusive qualities and ability to move freely throughout the film, may be the most unique. Jorge's Pelé dos Santos acts as a Greek chorus; he comments on and warns Steve throughout the film, warnings Steve appears neither to hear nor understand since the lyrics are in Portuguese. Jorge translates Bowie's lyrics into Portuguese and favors lyrics complementing the themes of the film over faithful translations of Bowie's original lyrics. Thus, these songs provide multiple levels of meaning to the scene and the film, depending on the audiences' knowledge of the original song and Portuguese. Jorge's adaptations of the Bowie songs

allow the director in the film (Steve) and the director of the film (Anderson) to lose control over the narrative while contributing to the narrative at the same time.

Classically, the Greek chorus was implemented in theater and later film as a way of commenting on the actions or revealing hidden character thoughts or motivations. In this vein, Pelé's songs reflect the filmic world of Steve Zissou and provide additional information about events in the film and the main character, Steve. Pelé's lyrics communicate information that Steve and other characters cannot communicate and act as a guide for Steve, even if Steve does not completely understand these lyrics. Pelé's songs work as a guide to Steve's destiny as, according to Chion, songs have a special ability in film to be linked to a character's destiny (*Sound Art* 425–30). As Team Zissou's safety expert, Pelé has a special place within Steve and Anderson's world since he is able to predict, or at least sense, danger within this world. Additionally, Anderson allows these songs to move in and out of the diegesis, and they are much freer than purely diegetic music since, according to Chion, songs are freer from the barriers of time and space in film (*Audio-Vision* 81). Pelé's songs' ability to move in and out of the diegesis further supports the importance Anderson places on these songs within the film.

A key to fully understanding the film is the answer to the question: what is Pelé actually singing? Jorge adapts the songs with the world of *The Life Aquatic* and the character of Steve Zissou in mind, instead of straight interpretations of the original Bowie songs.[3] These adaptations reflect major themes in the film: fatherhood, exploration, reality, dreams, nostalgia, life, death, love, change, failure, and control. For the remainder of this chapter, I will focus on songs that relate to Steve and the themes of change, life, death, dreams, and control. The main songs about change, life, and death are "Changes," "Rebel Rebel," and "Rock and Roll Suicide." The songs about dreams and control are "Space Oddity," "Five Years," and "When I Live My Dreams."[4] These songs reflect the negative and positive realms of Steve's world and the importance of Steve's need to change.

"Rock and Roll Suicide"—Life, Death, and Change

Anderson introduces the character of Pelé during the *Belafonte* party scene discussed earlier. Pelé performs four Bowie songs in Portuguese and on acoustic guitar—"Ziggy Stardust," "Starman," "Oh! You Pretty Things," and "Changes"—thus defamiliarizing the original rock-and-roll versions. Of the four songs featured in this party sequence, "Changes" comments the most on how Steve needs to change and Pelé's function as a Greek chorus.

While Steve and Ned smoke and talk on the bridge of the ship, Pelé sings "Changes" audibly in the background. Anderson uses this song to signal the change both men will experience after this meeting and the journey they will embark on together. They are trying to get to know each other; Ned tells Steve he is an airline pilot and was a fan of Steve's in his youth. Steve offers his marijuana cigarette to Ned, who takes a few puffs but then switches to a tobacco pipe since he normally does not "try grass." The lyrics to "Changes," both Bowie's original and Jorge's version, give this conversation more meaning since Steve's and Ned's lives will change forever. The lyrics in both songs are about changes—Bowie's original chorus features the line "Just gonna have to be a different man," and Jorge's chorus is about change coming, "Always going ahead / Never going back." "Changes" complements and comments on how Steve and Ned are about to become changed men after meeting each other.

In addition to "Changes," all the songs Pelé sings establish and contribute to the major themes found in the film: "Starman" is about Steve's dreams and reality, and "Oh! You Pretty Things" is about his love for Eleanor and his need for her in order to be successful. After the party scene, Anderson features two other songs performed by Pelé—"Rebel Rebel" and "Rock and Roll Suicide"—to highlight the major themes of change, life, and death in the film while at the same time comment on and warn Steve.

When Steve flies Ned to the Team Zissou compound, Pelé is singing "Rebel Rebel." However, instead of singing the "rebel rebel" chorus in Bowie's version, Jorge sings *"zero a zero"* or *"zero to zero,"* which loosely translates to "nothing happens."[5] Anderson again features Pelé performing "Rebel Rebel" on top of a lighthouse as Steve brings Ned to his island and Eleanor greets them. "Rebel Rebel"—unlike "Changes"—is about nothing changing but Steve staying his same old self. Unless Steve makes a change, things will continue to get worse, which Pelé is ultimately warning in "Rock and Roll Suicide."

Pelé's "Rock and Roll Suicide" links Steve to the concept of death; he will harm and kill others unless he changes. The song plays as Eleanor and Steve are talking in their bedroom at the Team Zissou compound. The lyrics, and Eleanor, warn Steve not to go on his next voyage, or it will lead to death. The lyrics to the song are very similar to Bowie's, one of the only Seu Jorge adaptations that adheres closely to the original song. Both songs have the lines "You're a rock 'n' roll suicide" and "Oh my love, you're not alone," and both end with "Give me your hands" and "Wonderful," respectively. Jorge's version further stresses the themes of life and death in the film and in Steve's world by including the lines "You're old, but you're alive / And you're too young to die" and "Your flame is burning with nostalgia." Here Anderson reinforces Steve's connection to death by foregrounding

the lyric "You're a rock 'n' roll suicide," just as Eleanor tells Steve to not go on his next adventure since one of the members of Team Zissou is already dead. Anderson wants the audience to believe she is referring to Esteban, by inserting a portrait of him, but I argue she is talking about Ned. In the previous scene, Ned would have drowned if not for Steve saving him with CPR. Steve does not listen to Eleanor or Pelé; he continues to plan his next adventure with Ned, and she leaves. This next mission is a suicide mission, and people are going to get hurt and killed. Eleanor sees this, and Pelé foresees this in his song, but Steve is consciously or unconsciously unaware. Steve takes on a Captain Ahab persona, and his desire for revenge overrides rational thought.

Steve's suicide mission threatens his dream, the *Belafonte*, and his control over his crew, Team Zissou. If Steve does not change his ways, he will lose all that he loves. While Steve is a major cause of his own possible demise, the outside forces of pirates, Ned, and Jane threaten Steve's dreams and control over his world. Pelé sings of dreams and control in the songs "Space Oddity," "Five Years," and "When I Live My Dreams," and these songs comment on and guide Steve toward his dream and destiny.

"When I Live My Dream"—Dreams and Control

The issue of control really comes into play with the scene featuring "Space Oddity." Anderson uses this song, about a doomed spaceship, in a humorous way to depict Steve losing control of his ship and his crew to pirates, as well as a moment when Pelé is unable to warn Steve about this impending doom. Pelé himself is unsure of the event prior to the pirate raid of the ship, as evident by Anderson's staging of the scene and how he edits it with the next shot. Pelé sings the countdown to "Space Oddity" while sitting out on the deck of the *Belafonte* as a small boat in the background slowly floats closer. The countdown in the song acts as the countdown to the pirates taking over the boat and Steve losing control. Pelé sings his adaptation of the lyrics of "Space Oddity"—"This is the great control of Major Tom, so great that in fact I don't know, almost anything"—when the ladder from the pirate's boat makes contact with the *Belafonte*. Anderson then immediately cuts to Steve smoking pot in the sauna, and the sounds of a struggle can be heard in the background. Anderson's use of "Space Oddity" at this moment not only comments on the impending doom on the *Belafonte* but on how effective or ineffective Pelé is as Greek chorus; the audience hears Pelé's countdown and sees what Pelé is unable to describe and warn Steve about—the arrival of the pirates. Steve is only temporarily like Major Tom on a doomed mission and will soon regain control of his boat. This boat,

the *Belafonte*, represents Steve's dreams, and losing the boat is a nightmare to him. Pelé is unable to warn Steve with "Space Oddity," which almost causes Steve to lose his boat, his dream, and his control.

While Steve does regain control of his boat from the pirates, he continues to lose control of his crew, his dreams, and his world as depicted in the scene featuring "Five Years." Additionally, this scene features one of Anderson's minor signatures, the dollhouse shot. The combination of Jorge's version of "Five Years" and the dollhouse shot tracking through a life-sized cross-section of the *Belafonte* highlights a moment of truth for Steve and Ned on the set of an obviously fake ship and conveys how Steve's dreams are slipping away from him. The themes of reality, authenticity, and fiction—in addition to the themes of dreams and control—are presented visually and aurally in this scene. Steve is upset with Ned because he is sleeping with Jane, whom Steve is somewhat attracted to. Ned finally stands up to Steve, initially to defend Jane, but then he is driven to challenge Steve's authority and career. He finally makes Steve tell the truth about any knowledge of Ned prior to their first meeting.

"Five Years" starts on the soundtrack when Ned asks to speak with Steve privately and plays throughout the scene as they wind through the *Belafonte*, trying to find some privacy. As they walk, it is clear by the way Steve is treating his crew that he is losing control. Steve yells at the cameraman, Vikram (Waris Ahluwalia), to stop shooting, but Vikram ignores him. Pelé and the composer, Wolodarsky (Noah Taylor), are shown performing what seems to be the song "Five Years." Steve tells them to go to bed, but "Five Years" continues for the remainder of the scene, undermining Steve's command. Additionally, Pelé and Wolodarsky's "playing" of their instruments—guitar and keyboards, respectively—does not match the music, and Pelé is not singing, which reinforces the tension of reality and fantasy in the scene. The crew is losing respect for Steve as a leader. Anderson further undermines Steve's authority and words when he pulls back the camera in the dollhouse tracking shot to reveal that the boat is cut in half. Steve retorts to Ned's comment about being a character in his film with, "It's a documentary. It's all really happening"—the ultimate moment of reality and fantasy clashing. The song continues to play as Steve, Ned, and the scene move to a more private and realistic setting on top of the *Belafonte*, with the chorus of "five years" the most audible lyrics on the soundtrack.

The chorus emphasizes the fact that Steve has known about Ned for more than five years. In fact, Steve states that he knew about Ned ever since he was born. In addition to highlighting the lyrics "five years" to punctuate Steve being honest with Ned, there are lyrics reflecting the current state of Steve's world and dreams. Pelé sings, as if he is Steve, "I've been spending my days at the seas" and "My mission in this world is to search for

animals / Diving in the dark for real dangers," yet now, "I haven't seen anything these five years" because Steve is isolated. Steve's life has been about traveling and searching the big blue sea, but lately he has been wandering and not seeing anything. He does not want to accept change, but he has to if he wants to live his dream. Anderson's use of "Five Years" points to the current state of Steve's world and his desire to live his dream again with his ship, his crew, and his wife. The threat of losing his boat, his dream, and his control fades after the death of Ned and during the song "When I Live My Dreams."

During Ned's wake, Pelé performs "When I Live My Dreams" for all of the surviving members of the crew and Steve's extended Team Zissou family. Steve, while sad over the loss of Ned, seems content with where he is in life, in his world. He is resigned to the fact that he is no longer in control of his world, but he can still live his dream. He begins to follow his destiny. Reinforcing this fact, Pelé begins his lyrics by asking where Steve's dream has gone, and later he sings about Steve surrendering control and about the possibility of Steve living his dreams again. While it is not explicitly clear whether Steve hears what Pelé is singing, he seems to receive Pelé's message. He finally ceases trying to control everything about his world and allows the truth about him to be known. This fact is punctuated when Steve tells Jane, the reporter, that her story about him will reveal he is a "showboat" and "prick"—but he tells her she is a good writer, and he *is* a prick and a showboat. Steve's relinquishing of control over his world and listening to Pelé allows him to live his dreams again, to be the leader of Team Zissou again, to be an oceanographer and filmmaker again, and, finally, to see the jaguar shark again.

It is when Steve is able to finally be truthful with himself and to others that it seems he finally listens to, or at least gets, the message Pelé is sending him. These songs work to guide Steve's destiny, something he realizes he ultimately cannot control. Steve's dreams and other worlds become reality when he listens to Pelé's songs.

Wes Anderson, David Bowie, and Seu Jorge

As previously mentioned, Wes Anderson's passion for and use of music qualifies him to be considered an *auteur mélomane*, which Gorbman describes as a director who controls the choice and placement of the songs and music in a film ("Auteur Music" 150). Anderson had several ideas going into this film about how it would sound musically, specifically featuring songs by David Bowie and including a character singing David Bowie songs. In terms of cultural capital, Anderson privileges audience members already familiar with David Bowie and his songs. Viewers that have no

or little familiarity with Bowie's music or the meanings behind his songs are not necessarily going to "get" Anderson's usage of these songs in either their original or modified contexts. While Anderson privileges audiences with knowledge of the Bowie songs, audiences with an understanding of Portuguese—specifically, Brazilian Portuguese—have an even greater understanding of the songs adapted by Seu Jorge.

Anderson's familiarity with the Bowie songs influences which songs he wants Seu Jorge to adapt, but his limited knowledge of Portuguese limits his control over what Jorge is actually singing. Anderson states in *The Life Aquatic with Steve Zissou—Original Soundtrack* liner notes that he never read a complete translation of Jorge's Bowie covers. For example, he asked Jorge which word he sang in Portuguese meant "cigarette," but Jorge told him, "Something very poetic about friendship and hope and the future—but no 'cigarette.'" Anderson then suggested that he add "rebel rebel" every once in a while. While Jorge does not sing the words "rebel rebel" in the song but sings a similar sounding "*zero to zero,*" Jorge does heed Anderson's suggestion regarding "Rock and Roll Suicide" by singing, "You're a rock and roll suicide," and featuring an almost identical translation of Bowie's original lyrics. Furthermore, Anderson tells interviewer Nancy Miller, "I guess the idea wasn't effectively communicated to him that he was to sing translated lyrics of Bowie songs," but as he concludes in the liner notes, "In the end I am convinced that Jorge's words—and unquestionably his beautiful performances—capture the spirit of David Bowie's. Exactly what we were looking for." These songs contribute more to the world of Steve Zissou than I believe Anderson could have imagined by having these songs warn, comment, and complement Steve's world.

Anderson is able to regain control over the film through the manipulation of the music on and from the soundtrack. The songs by Seu Jorge are featured throughout the film and move in and out of the soundtrack wherever Anderson wants them.[6] The soundtrack album and supplementary materials on the Criterion Collection–edition of *The Life Aquatic with Steve Zissou* DVD feature several of Seu Jorge's performances recorded during production. The supplementary materials, including the commentary tracks and the soundtrack albums, contribute to Anderson's status as an auteur and his brand of authorship. Anderson's comments about Seu Jorge's translations of the Bowie lyrics in the liner notes of *The Life Aquatic with Steve Zissou—Original Soundtrack* and in the interview with Nancy Miller is a way for Anderson to regain control by controlling the story he is telling. Devin Orgeron writes about how Anderson controls his brand of authorship through the supplementary materials by documenting his collaborations with others while at the same time maintaining "his centrality . . . his celebrity, his authority" (59). As Steve Zissou markets and

brands everything Team Zissou, including running shoes and pinball games, Anderson is able to market products outside of the film, including the soundtrack album. *The Life Aquatic* has two soundtrack albums: *The Original Soundtrack* and *The Life Aquatic Studio Sessions Featuring Seu Jorge*.[7] These soundtrack albums, as with the other soundtrack albums for his films, can be seen as part of Timothy Corrigan's commodification of the auteur, a way of branding directors and linking them with audiences, but it is the branding of these soundtracks that makes Anderson accessible and reachable to audiences (Orgeron 41). The supplementary materials and the soundtrack albums allow audiences to experience the world of Steve Zissou and Wes Anderson beyond the film.

This soundtrack to *The Life Aquatic* is freer of the constraints of Anderson's previous film soundtracks, and I agree with Derek Hill that this is a transitional movie for Anderson, with an "openness" and "looseness" not found in his previous films (102–4). Anderson's desire to have David Bowie songs in Portuguese, but letting Seu Jorge adapt these songs himself, allows the musical world of the film to be more than just a "Life on Mars;" Anderson gets a world depicting Steve's dreams and destiny—Steve's life aquatic.

Notes

1. I will refer to the film by the shorter title *The Life Aquatic* for the remainder of the chapter.
2. These songs are originally featured on Bowie's *Hunky Dory* album from 1971 (RCA Records).
3. I had Maria Luiza Cardoso de Aguiar translate Jorge's lyrics into English in order to gain a full understanding of what Jorge is singing. Aguiar translated all of the different versions of the songs Seu Jorge recorded for the film, including the songs featured in the supplemental material on the Criterion Collection Special Edition DVD and the two soundtrack albums: *The Life Aquatic with Steve Zissou—Original Soundtrack* and *The Life Aquatic Studio Sessions*.
4. The original versions of these Bowie songs appear on various albums from the 1960s and 1970s: "Changes" *Hunky Dory* (RCA Records, 1971), "Rebel Rebel" *Diamond Dogs* (RCA Records, 1974), "Rock 'N' Roll Suicide" and "Five Years" *The Rise and Fall of Ziggy Stardust and the Spiders from Mars* (RCA Records 1972), "Space Oddity" *David Bowie* (Mercury, 1969), and "When I Live My Dreams" *David Bowie* (Deram 1967).
5. According to Aguiar, "zero a zero" is a sports term typically used in a sexual context that "means that something does not have progression; nothing happens."
6. Steve Zissou is shown manipulating the music in his documentary by using the music "composed" by the character Wolodarsky (Noah Taylor) in the rough cuts. Wolodarsky's compositions were written by Mark Mothersbaugh.

Anderson mixes the compositions written for Wolodarsky for the documentary within the film and Mothersbaugh's original score for the entire film, sometimes seamlessly, further contributing to the "looseness" of all the music in the film.

7. Touchstone Pictures and their music distribution company, Hollywood Records, can be seen as marketing Wes Anderson's brand and *The Life Aquatic with Steve Zissou* through the two soundtrack albums for the film.

Works Cited

Anderson, Wes, dir. *The Life Aquatic with Steve Zissou*. Touchtone. 2004. Criterion Collection Special Edition, Buena Vista, 2005. DVD.

———. Liner Notes. *The Life Aquatic with Steve Zissou—Original Soundtrack*. Hollywood Records, 2004. CD.

Bowie, David. *David Bowie*. Deram, 1967. LP.

———. *David Bowie*. Mercury Records, 1969. LP.

———. *Diamond Dogs*. RCA Records, 1974. LP.

———. *Hunky Dory*. RCA Records, 1971. LP.

———. *The Rise and Fall of Ziggy Stardust and the Spiders from Mars*. RCA Records, 1972. LP.

Chion, Michel. *Audio-Vision: Sound on Screen*. Edited and translated by Claudia Gorbman. New York: Columbia UP, 1994. Print.

———. *Film, a Sound Art*. Translated by Claudia Gorbman. New York: Columbia UP, 2009. Print.

Corrigan, Timothy. "The Commerce of Auteurism." In *Film and Authorship*, edited by Virginia Wright Wexman, 96–111. New Brunswick, NJ: Rutgers UP, 2003. Print.

Gorbman, Claudia. "Auteur Music." In *Beyond The Soundtrack: Representing Music in Cinema*, edited by Daniel Goldmark, Lawrence Kramer, and Richard Leppert, 149–62. Berkeley, CA: University of California Press, 2007. Print.

———. *Unheard Melodies: Narrative Film Music*. Bloomington, IN: Indiana UP, 1987. Print.

Hill, Derek. *Charlie Kaufman and Hollywood's Merry Band of Pranksters, Fabulists and Dreamers: An Excursion into the American New Wave*. Harpenden, UK: Kamera Books, 2008. Print.

Hollywood Records. *The Life Aquatic Studio Sessions*. Jorge, Seu. 2005. CD.

———. *The Life Aquatic with Steve Zissou—Original Soundtrack*. 2004. CD.

Miller, Nancy. "The Life Melodic." *Entertainment Weekly*, December 20, 2004. Web.

Orgeron, Devin. "La Camera-Crayola: Authorship Comes of Age in the Cinema of Wes Anderson." *Cinema Journal* 46.2 (2007): 40–65. Print.

Seitz, Matt Zoller. "The Substance of Style." *The Moving Image Source*, March 30, 2009. Web.

Part III

11

The Andersonian, the Quirky, and "Innocence"

James MacDowell

Several strands have come into focus within the critical work on Wes Anderson. One strand establishes and considers him as an auteur,[1] a self-evidently important task for the critical discussion of a director whose oeuvre, even more so than most auteur filmmakers', exhibits such manifest consistencies in approach and theme; related and indebted to this strand has been the repeated use in scholarship of the word "Andersonian" to evoke his characteristic aesthetic.[2] Another trend in the scholarship has been to attempt to capture something of what the Andersonian aesthetic might be—in terms of specific stylistic choices, such as his uses of framing,[3] music,[4] and mise-en-scène,[5] and also in terms of the fundamental and more all-pervasive issue of his films' very distinctive *tones*.[6] A final critical strand has been concerned with the ideological implications of Anderson's films; with a few notable exceptions,[7] this area of the criticism has tended to paint an unfavorable picture of Anderson's movies—representing them variously as apolitical,[8] ahistorical,[9] conservatively nostalgic,[10] endorsements of white privilege,[11] or even tacitly fascistic.[12] This chapter will be primarily relevant to the first two strands of work on the director, extending considerations of Andersonian tone to include a recurring feature of his films that is frequently noted but has not yet received extended consideration of its own: their seeming preoccupation with childhood and, more generally, "innocence." I also hope, however, to begin a conversation about a possible relationship between this aspect of the Andersonian and ideological strands of criticism on the director by placing such matters of tone and innocence within a particular sociohistorical context.

The Andersonian and the Quirky

In one of the first pieces of serious critical writing on Anderson, Mark Olsen argued that, unlike some of his contemporaries, this director "does not view his characters from some distant Olympus of irony. He stands beside them—or rather, just behind them," going on to use the phrase "New Sincerity" to describe this tonal approach (13). I have elsewhere extended this consideration of irony and sincerity (and associated strategies) beyond Anderson's oeuvre, situating him as a key player within what I have called the "quirky" sensibility (MacDowell, "Notes"). Arguing that we rescue this ubiquitous descriptor from serving simply as an Indiewood buzzword, I have claimed that the notion of the "quirky" can serve productively as an umbrella term for a particular but widespread strain of comedy and comedic drama that emerged during the last two decades of American indie filmmaking. This sensibility, I suggest, is observable in a group of films and filmmakers of the 1990s and post-2000s, encompassing names such as Michel Gondry, Jared Hess, Spike Jonze, Miranda July, Charlie Kaufman, and Mike Mills, as well as films like *Punch-Drunk Love* (Anderson, P. T., 2002), *I Heart Huckabees* (Russell, 2004), *Lars and the Real Girl* (Gillespie, 2007), *Juno* (Reitman, 2008), *Paper Heart* (Jasenovec, 2009), and so forth.

The quirky as I define it is often recognizable by its inclusion of one or more of a number of conventions: a modal combination of the melodramatic with the comedic; a mixing of comic styles such as bathetic deadpan, comedy of embarrassment, and slapstick; a visual and aural style that frequently courts a fastidious and simplified sense of artificiality; and a thematic interest in childhood and innocence. Most pervasive, however, is a tone that balances ironic "detachment" from and sincere "engagement" with the films' fictional worlds and their characters.[13] One of the most intangible yet immanent aspects of any cultural artifact, the tone of a film "cannot be reduced to story, style or authorial disposition in isolation" (Sconce, "Irony" 352), but should rather be thought of as a result of "the ways in which the film addresses its spectator and implicitly invites us to understand its attitude to its material and the stylistic register it employs" (Pye 7). As I have suggested previously, the conflicted tone of the quirky—seemingly forever oscillating between ironic and sincere address—is particularly key to Anderson's cinema.[14] One clear measure of this is that his films' tones frequently lampoon *and* celebrate misguided or shortsighted protagonists on quixotic quests. The Andersonian take on the characteristic quirky tone ensures that most such central characters' statuses as heroes are to an extent qualified via their being treated in something like what Northrop Frye defined as the "ironic mode"—wherein protagonists are suggested to be in some sense "inferior in power or intelligence

to ourselves" (33–34); yet, at the same time, their utter commitment and dedication is nonetheless implicitly implied to be praiseworthy, resulting in a mixed tonal register of simultaneous distance and sympathy (more on this shortly).

The quirky, furthermore, is merely one example of several other recent cinematic tendencies that commentators have described, in comparable terms, as "navigating the terrain between sincerity and irony" (Rombes 85): for instance, "post-pop" cinema (Mayshark), contemporary "historical anachronism" (Gorfinkel), "New Punk Cinema" (Rombes), and so on. One of the reasons that I and others have drawn attention to developments concerning how irony functions within indie and popular American cinema is in order to suggest that we can observe certain shifts and evolutions in the tonal strategies of such cinema in recent years. In particular, I have suggested that the quirky needs to be seen as being in dialogue with, yet distinct from, another millennial indie sensibility: what Jeffrey Sconce famously defined as the ironic and darkly comic indie "smart film" of the 1990s and 2000s—associated especially with the early work of directors such as Todd Solondz and Neil LaBute—whose own tonal strategies tended towards "detachment" ("Irony" 352), "dispassion" (359), "disengagement" (359), "disinterest" (359), and "disaffection" (350) (again, more shortly).[15]

Of course, irony need not be synonymous with cynicism or apathy. However, one thing that irony can surely never be is innocent[16]—a concept with which I have suggested the quirky sensibility is frequently concerned, and which also consistently crops up in the commentary on Anderson. How, then, might a sensibility and a director so concerned with the tension between irony and sincerity deal with such a concept as "innocence"?

The Andersonian, Childhood, and "Innocence"

As already mentioned, critics have frequently noted the importance of children to the Andersonian aesthetic.[17] However, at least until *Moonrise Kingdom*, actual (preadolescent) children are seldom central characters in Anderson's films, but instead suggestively populate the periphery: Grace (Shea Fowler) in *Bottle Rocket*, Max's friend Dirk (Mason Gamble) and Miss Cross's pupils in *Rushmore*, the young Tenenbaums (plus Ari [Grant Rosenmeyer] and Uzi [Jonah Meyerson]) in *The Royal Tenenbaums*, Werner (Leonardo Giovannelli) in *The Life Aquatic*, the Indian children saved from drowning in *The Darjeeling Limited*. Equally, children may be materially absent but seem to serve as an emotionally and metaphorically significant *promise*, via a pregnancy: Jane's (Cate Blanchett) in *The Life Aquatic*, Alice's (Peter's wife, played by Camilla Rutherford) in *The Darjeeling Limited*, and Felicity's (Meryl Streep) in *Fantastic Mr. Fox*. Together,

this might suggest that Anderson's work is less interested in *children* than with *childhood* as an abstract concept. In *The Royal Tenenbaums*, it is for the most part not via flashbacks showing, or discussions concerning, the particulars of their pasts that the adult Tenenbaum children are shown engaged in their retrospection, but rather through a return to the places and signifiers of childhood—a return that marks their simultaneous continuity with and distance from those childhoods: Chas's (Ben Stiller) delight at rediscovering his old tie rack, Richie (Luke Wilson) camping out in the tent he and Margot (Gwyneth Paltrow) used for their temporary escape from home, the fact that Margot wears the same design of fur coat as her younger self (Irene Gorovaia), and so on.[18] In general, it is less through a focus on child characters themselves and more via older characters' relationship to and views *of* childhood that this subject comes to permeate the Andersonian. The moment when Anthony (Luke Wilson) is perhaps most agitated and upset in *Bottle Rocket* comes after meeting his beloved little sister, Grace, and being disturbed by her lack of faith in himself and his frequently misguided but always-driven childhood friend, Dignan (Owen Wilson): "How did Grace get so *cynical*?" he vents. Speaking for his brothers, in *The Darjeeling Limited* Francis (Owen Wilson) responds to their mother's statement, "Yes, the past happened, but it's over, isn't it?" with "Not for us"—effectively expressing a paradox haunting many adult Anderson characters: childhood's enduring presence as an acutely felt absence. This motif finds perhaps its most bald incarnation in *The Life Aquatic*, in which we may discover both Jane proclaiming that "The Zissou of my childhood represents all the dreams I've come to regret," and Steve (Bill Murray) admitting in the climactic scene with the jaguar shark that 11 and a half was his favorite age. What, though, is the importance of this adult relationship to childhood for Andersonian tone?

These examples from Anderson's films in one sense can be seen simply as nostalgic—as adults yearning for a childhood that represents a simpler, more innocent time: an idealized romantic past existing far from the messiness and complications of comparatively difficult, grown-up presents. Such moments certainly permit this kind of reading, making it unsurprising that some critics should have made pronouncements to the effect that "all Anderson's movies share one overriding theme: the fundamentally disappointing quality of adulthood" (Lorentzen 1). Such instances as those mentioned above, however, require placement within wider contexts—firstly, in the context of the characteristically dual-registered tone of the quirky. For instance, presenting the 12-year-old Margot wearing the same fur coat as her adult self during a single-shot flashback labeled "AGE 12: STARTS SMOKING" functions not only as an insight into an adult character's lingering nostalgia, but also as a gently absurd visual gag that

foregrounds again the staged quality of what we are seeing—one among many of the strategies through which "the film draws attention to its artificiality throughout" (Plantinga 91). Equally, the moment in *The Life Aquatic* when Steve tearfully reminisces about having loved being a particular age as a child, although certainly inviting us to be moved, is also somewhat complicated in its emotional appeal—both by the line before it having been such a dramatic non sequitur (Jane, referring to her unborn baby: "In 12 years he'll be 11 and a half"), and by the scene taking place in a cartoonishly small, comically cramped, bright yellow submarine, within a manifestly artificial underwater environment, and in the presence of a pointedly fake stop-motion animated shark. The sense of distance made possible by Andersonian style and tone can thus frequently function, on this level, to qualify what other tonal registers might allow to be treated simply as straightforward, unquestioned nostalgia.

While this aspect of the Andersonian has seldom been explored in detail, we can find instances of critics acknowledging that his films tend to be less than wholly naïve in their engagement with childhood and nostalgia as subjects. In an interesting aside in his critique of contemporary "hipster" taste, Mark Greif links Anderson to other strands of millennial culture (Dave Eggers, *The Believer*, etc.), arguing that in such art "the tensions of the work revolve around the very old dyad of knowingness and naïveté, adulthood and a child-centered world—but with a radical and vertiginous alternation between the two"; ultimately, he suggests, "reflexivity is used purely to get back to emotion, especially in the drive toward childhood" (10-11). It should be said that Greif's account here is not in fact intended as a recommendation;[19] however, it seems possible to probe further Greif's suggestive characterization of Anderson's approach, and to ask whether there is any potential value in what I agree is indeed a recurrent feature of his work: a somehow knowing-yet-naïve "drive toward childhood." How, firstly, might his films use "reflexivity" to "get back to" something like childhood?

I suggest that the significance of Andersonian style for his films' relationship to innocence is not only its capacity to qualify an engagement with the concept, but also to in some sense assist in its expression. It has frequently been suggested in passing that Anderson's visual style tends to imply not just artificiality but also something of an intentional naïveté, with critics referring to his "childlike aesthetic" (Orgeron, "La Camera-Crayola" 60), his characters' "childlike environments" (Piechota 1), and to "Anderson's dollhouse mise-en-scène" (Sabo 1). This may refer, I think, not only to aspects of his films that carry such explicit childhood associations— say, cut-away dollhouse-like sets (*The Life Aquatic*'s boat, *The Darjeeling Limited*'s train compartments) or an impossibly precarious treehouse

(in *Moonrise Kingdom*)—but to familiar aspects of the Andersonian more generally. In particular, the director's trademark flat, symmetrical, tableau framings of carefully arranged characters within colorful, fastidiously decorated sets invite one to register not merely their patent unnaturalism and self-consciousness, but their resolutely exquisite *distillation* as well. This particular stylistic foregrounding of artificiality is not necessarily concerned to create a sense of critical "distantiation" in the Brechtian sense (in the manner of Godard or, say, Lars von Trier's *Dogville* [2003]), nor to imply the kind of detached "clinical observation" associated with the smart film (Sconce, "Irony" 360). Instead—if their indulgent, excessive, yet attractive neatness might not quite encourage comparisons with aesthetic objects that a child might make—their tendency toward willful oversimplification does permit associations with objects that might be addressed *to* children: for instance, the model theater sets belonging to Margot, the children's book covers featured in *Moonrise Kingdom*, or the fly-away staging for *Noye's Fludde* in that film (or indeed, as Michael Chabon has pointed out, the boxes of Joseph Cornell).[20] Equally, they might make us remember that Andersonian children do generally seem to be drawn to aesthetic precision: Richie's toy car collection and wall of portraits in *The Royal Tenenbaums*, Sam's (Jared Gilman) meticulous inventories and pitch sites in *Moonrise Kingdom*, and so on.

By evoking such modes of aesthetic address, it seems to me that Anderson's style is frequently able to encourage both a detachment from a naïve investment in the fiction *and* a sense of wonder at a childlike aesthetic of the orderly and the miniature. Features like *The Life Aquatic*'s judderingly animated stop-motion shark or *Moonrise Kingdom*'s stop-motion maps are especially obvious instances of this—serving both to undercut naïve credulity and to a significant extent seduce through the preciousness and naïveté of their style. I would also, though, attribute similar effects to any number of Anderson's familiarly planimetric shots, his vertical overhead close-ups of minutely arranged objects, and indeed perhaps to his meticulous color pallets and pointedly neat mise-en-scène more generally—all of which contribute to the "dominant or systemic aspects" of tone within his films (Pye 12). This is a peculiar and delicate tonal effect of the Andersonian: strategies that might appear at first glance to allow for ironic distance—for instance, from naïve nostalgic yearning—also, at the very same time, express and encourage something *of* that yearning themselves. This is an intriguing strategy in and of itself, taking as it does a familiar aspect of the quirky's aesthetic drive towards calculated oversimplification further than any of Anderson's contemporaries (see MacDowell, "Notes" 4–10). Yet there may also be more at stake in this tendency of putting potentially

ironic strategies in the service of sincere evocations of "innocent" aesthetic address and appreciation.

Andersonian "Innocence" and Structures of Feeling

Anderson has been said to have constructed a "largely apolitical aesthetic" (Browning 126), and he is, categorically, not what we are likely to call a "political" filmmaker—in that he seldom seems concerned explicitly to confront political or social contradictions in the conventional senses of such terms. Given what we have been discussing thus far, this might seem entirely unsurprising. As noted above, when Greif associated the Andersonian with childhood, it was not intended as complimentary, and it is easy to see why it might not be. Any longing to return to the innocence of childhood seems a manifestly regressive impulse: not only does childhood conventionally imply "an age of innocence not yet tainted by politics, economics, moral failure, disappointments, class frustrations," and so forth (Higonnet 1), but such nostalgic desire might even invite us to invoke the familiar Marxist position whereby "the very concept of ideology implies a kind of basic, constitutive naïveté" (Žižek 28). To wish to return to a state of innocence does instinctively seem an aggressively apolitical, and possibly even reactionary, impulse. It is true that we have already noted that the Andersonian treatment of characters' nostalgic yearnings ensures that they cannot be described as merely uncomplicated endorsements of such impulses. Yet I have also suggested that the films' styles seem simultaneously to encourage an appreciation of what we might consider a childlike aesthetic. Is there anything to be taken from this other than a potentially troubling reveling in regression (whatever qualifications may attach to it)? To address this question we need to consider the sociohistorical and cultural moment in which Anderson, and the films of the quirky more generally, emerged.

As acknowledged by Sconce, the aforementioned smart film—to whose detached ironic tone I have contrasted the quirky—demands relating to the postmodern. More specifically, it is in dialogue with a discursive context in which "irony has become—many believe—the cultural signature of the entire postmodern condition" (Fernández and Huber vii). We need not here revisit any of the voluminous work questioning the usefulness of labeling particular aesthetic practices "postmodern," let alone the wider issue of the usefulness of "postmodernism" itself as either a philosophical concept or a term for a historical epoch. The particular importance of the postmodern for my purposes is specifically its nature as a significant late-twentieth- and early-twenty-first-century "structure of feeling": Raymond Williams's difficult but indispensable concept, whose aim is to offer an appropriate

vocabulary for describing ways in which sociohistorical moments can be observed and experienced in "the most delicate and least tangible parts of our activity" (*Long* 64). In the case of the smart film, the relevant sociohistorical moment is one saturated in discourses that circulated in 1980s/1990s/2000s US popular, journalistic, and political culture concerning the perceived hegemony of postmodern irony among members of the fabled generation X (see Sconce, "Irony")—discourses that defined the perceived generation and its culture as being "too full of irony, sarcasm, detachment" (Achenbach 1), not to mention equating it with disengagement, apathy, "pessimism and cynicism" (Gottschalk 1). A structure of feeling, Williams argues, is a matter of "feeling much more than of thought—a pattern of impulses, restraints, tones" (*Politics* 159), and tone is, in turn, something that is likely to be, Sconce argues, "only fully realized"—and, we might add, perhaps only fully graspable—"within a narrow historical moment" ("Irony" 351–52).

It therefore seems telling that neither the quirky sensibility nor any of the other aforementioned ironic/sincere cinematic tendencies stand alone in their tonal preoccupations, but are rather individual iterations of broader movements in millennial and postmillennial culture. As many have by now acknowledged, art that seems concerned to "blur the boundaries between irony and earnestness" (Shakar 140) appears to have been experiencing an increasingly popular renaissance during the last fifteen or twenty years—be it in the fiction of David Foster Wallace and Dave Eggers (Konstantinou), the poetry of the self-proclaimed "New Sincerists" (Robinson), the "corn" of indie music (Seigworth), the phenomena gathered under Charlotte Taylor's banner of "intellectual whimsy," or visual artists in whose work one may witness "Sincerity and Irony Hug it Out" (Saltz) or who call for a strategy of "Maximum Irony! Maximum Sincerity" (Holden).[21] Since such culture appears to strike a particular relationship to a key signifier of the postmodern, it is unsurprising that the critical work concerned to account for this current aesthetic predilection for tensions between irony and sincerity should not only have been drawn toward terms such as "postironic" (Konstantinou) or "New Sincerity" (Morris), but should also have referred to a "post-postmodern" (Timmer) turn in culture—or, as Timotheus Vermeulen and Robin van den Akker persuasively define it, a "metamodern" oscillation between "postmodern irony (encompassing nihilism, sarcasm, and the distrust and deconstruction of grand narratives . . .) and modern enthusiasm (encompassing everything from utopianism to the unconditional belief in Reason)" (4). As I have argued elsewhere (MacDowell, "Wes Anderson" and "Quirky"), the tone and attitude of the quirky (and, more specifically for our current purposes, the Andersonian) can thus be seen as one expression of what appears to be an emerging contemporary structure of feeling, whatever name we assign to it. This structure of feeling is,

broadly speaking, one which, as Lee Konstantinou puts it, "[seeks] to use postmodernist techniques toward sincere ends" (v).

Why might this be a worthwhile enterprise? In characterizations of postmodern irony that associate the discourse with detachment, cynicism, pessimism, or even nihilism, we begin to see the potential horizons of a competing structure of feeling that might be concerned to move beyond (or in an alternative direction than) its forebear—towards a contemporary approach that incorporates the possibility of both critical distance *and* enthusiastic engagement, skeptical cynicism *and* affirmation, irony *and* sincerity. When discussing the quirky, I and others have hitherto tended to focus on what the sensibility's tone seems to make possible in terms of emotional and moral sympathy with characters.[22] It is also necessary, however, to consider its possible political significance and the possible strategic importance of innocence to such an approach.

An important recurring critique of postmodern modes of thought in philosophy and cultural theory is that, while the irony associated with such discourses seems to offer the potential for demystification, it must lead ultimately only to a position of "cynical reason" (Sloterdijk), which, "with all its ironic detachment, leaves untouched the fundamental level of ideological fantasy, the level on which ideology structures the social reality" (Žižek 30). This is to say: discourses reliant upon strategies of postmodern irony can finally offer only infinite negation, a self-defeating stasis that makes impossible a commitment to any positive alternative that can be affirmed—in other words, a "complete inability to propose an intelligible strategy of cultural/political resistance to the social conditions they describe" (Britton 485). While I am less concerned here with the ironic operations of the postmodern as philosophy or cultural theory define them, and instead more interested in conceptualizing it as a more modestly defined localized structure of feeling,[23] the philosophical diagnosis of the pitfalls of postmodern irony nonetheless seem relevant in this case too. David Foster Wallace, one of the key authors in most discussions of a literary New Sincerity, identified similar problems with irony having become "the dominant mode of hip expression" within his US cultural moment of the mid-1990s (183). Denouncing what he clearly regarded (if not in so many words) as a contemporary structure of feeling, he lamented that "irony tyrannizes us," further arguing, "Irony's singularly unuseful when it comes to constructing anything to replace the hypocrisies it debunks" (183). His proposition for a strategy of aesthetic resistance was the emergence of a movement of artists who "eschew self-consciousness and fatigue" and who "have the childish gall to actually endorse single-entendre values," willingly risking accusations of being "too sincere. Clearly repressed. Backward, quaint, naïve" (192–93).

In Wallace's invocation of the "childish" and "naïve" here, we see seeds of a cultural and tonal logic that also finds its expression in the quirky, and especially in the Andersonian's engagement with the subject and concept of innocence. If to "endorse single-entendre values" within a postmodern structure of feeling is to appear childish, then one aesthetic solution—if one does indeed wish to affirm particular values—is to embrace that apparent "childishness" in one's art. Yet, of course, if one is not *oneself* a child, then this strategy can only ever be attempted with a certain kind of distance—or, at least, can only be accompanied by a sense of self-consciousness about its inherent limitations. In other words, it may require an approach that is both sincere *and* ironic. In a discussion of the films of Guy Maddin that engages many of the concerns of the postironic or metamodern, William Beard argues that this director's strategy of self-consciously appropriating melodramatic silent-movie aesthetics constitutes a perpetually knowing "[attempt] to rediscover and rehabilitate innocence and belief in the face of a ruling sentiment of incredulity and cynicism" (11). I would say something similar about the tone of the Andersonian, whose aesthetic—as I have argued—encourages both what we might call an ironic detachment from aspects of the fiction *and* a sincere endorsement of the childlike and the innocent. Yet, to what ends? In the pursuit of what possible "single-entendre values"? As admitted, Anderson is certainly not an explicitly "political" filmmaker. Given this, is his ambivalent "drive towards childhood" (Greif 10–11) itself only ever destined to be regressive, rather than put in the service of anything more productive?

As mentioned earlier, the tone of the Andersonian repeatedly treats quixotic dreamers with a mixture of distance and approbation; we may see this in, for instance, Dignan's ill-conceived heists in *Bottle Rocket*, Max's excessive extracurricular activities and romantic pursuits in *Rushmore*, Francis's culturally clueless attempts at a spiritual journey through India in *The Darjeeling Limited*, or Sam and Suzy's temporarily liberating but necessarily naïve romantic runaway plot in *Moonrise Kingdom*. While their films may allow us to acknowledge and find amusing failings or limitations to which these characters are themselves blind, we are nonetheless encouraged to admire the tireless enthusiasm with which such protagonists pursue their ambitions. This enthusiasm itself stems from a kind of innocence—a somewhat literal kind in the case of Sam and Suzy, but elsewhere a more metaphorical one: an unwavering belief and faith undaunted by the probability of failure. Thus, while I agree with Greif when he speaks of Anderson's seeming desire to use childhood as a means to "get back to emotion," I would also suggest that we might consider reformulating this as a desire to reengage with *innocence* to get back to *enthusiasm*.

THE ANDERSONIAN, THE QUIRKY, AND "INNOCENCE" 163

This connection is made particularly plain in Anderson's debut film, *Bottle Rocket*. At one moment in this movie, Anthony writes a letter to his little sister, Grace, updating her on his life, which we hear in voiceover:

> I've been coaching a little league soccer team called The Hurricanes. They're mostly beginners, but they got a lot of spirit, and they don't let defeat get them down. They remind me of Dignan in that way. Say what you will about him, he's no cynic and he's no quitter.

As we hear these words, we see Anthony first leading a team chant and then passionately cheering on and yelling advice to the diminutive players in his

Figure 11.1 *Bottle Rocket*: The Hurricanes "don't let defeat get them down."

Figure 11.2 *Bottle Rocket*: Dignan is "fuckin' innocent."

charge from the sidelines of a match. The payoff of Dignan's reported spirit, lack of cynicism, and refusal to quit ultimately comes during the film's climactic botched robbery attempt. With the alarm of the cold storage warehouse having been tripped, the cops on their way, and an injured member of the ragtag criminal team left inside, Anthony tries to talk Dignan out of his intended doomed-but-heroic attempt to rescue his coconspirator from the law: "You *know* what's going to happen if you go back there," he counsels. "No, I don't," Dignan replies in close-up, his eyes determinedly and excitedly scanning the horizon. "They'll never catch me, man—'cos I'm *fuckin' innocent*." And with this, he hurtles off at a sprint past Anthony and back into the warehouse to the rousing strains of The Rolling Stones's "2000 Man"; minutes later he is, of course, apprehended and sentenced to two years. These two moments allow us to see something of the scope of what "innocence" can represent within the Andersonian: the resilient verve and enthusiasm of childhood (embodied by the Hurricanes) is linked with another form of innocence—a guileless comic but stirring refusal to acknowledge the possibility of failure predicted by Anthony—which is in turn shown to be a prerequisite for a heroic plan of action. It is true both that Dignan's action *does*, inevitably, fail and that there is more than a hint that he undertakes it as much out of self-valorization as out of a sense of responsibility to his endangered teammate ("You *gotta* give me this one," he has pleaded with Anthony). Nonetheless, as with the Hurricanes, the action does still remain an act of bravery and commitment despite, and perhaps *because*, of its foolhardy, innocent naïveté.

Politically, this may not seem to amount to very much, and in terms of specific narrative content, it certainly does not. However, if considered instead as a minor expression of a broader structure of feeling—one dedicated, however ambivalently, to moving past the ultimately apathetic stasis of ever-increasing negation to which postmodern irony always seemed destined to lead—it grows incrementally in significance. The combination of tonal strategies and endorsements of certain kinds of innocence within the Andersonian may seem so far to have permitted tentative commitment only to the relatively "safe," indeed largely bourgeois, values pursued by most of his protagonists: say, romantic love and temporary escape from one's parents in *Moonrise Kingdom*, spiritual growth and familial relations in *The Darjeeling Limited*, or friendship, artistic achievement, and coming-of-age in *Rushmore*. However, a tone that permits affirmation and action in the face of doubt via a strategic deployment of innocent enthusiasm is something that might—in this cultural moment—be considered an encouraging development in and of itself. Moreover, it is also an approach whose political horizons need not necessarily be so restricted.

I have elsewhere pointed out the repeated use of the gesture of the raised-fist salute by Anderson characters (in *Rushmore*, *The Royal Tenenbaums*, and *Fantastic Mr. Fox*)—an act whose enthusiastic expression of solidarity

Figure 11.3 *Fantastic Mr. Fox*: Raised-first salutes.

in each instance is contextualized by a tone that means that "its slight preposterousness . . . is both key and yet does not empty the gesture of its power" (MacDowell, "Wes Anderson" 21). It may also be worth noting that the Anderson film most explicitly concerned to create a childlike aesthetic, *Fantastic Mr. Fox*, is one depicting a battle between our heroes and the representatives of a three-pronged corporate monopoly (Boggis, Bunce, and Bean), and whose climax sees the triumph of an effective underclass of wild creatures whose motto upon raiding the chain supermarket owned by their capitalist foes is "Get enough to share with everybody" (a principle that might, in turn, prompt us to remember that Anderson's films in general "repeatedly valorize the group" [Orgeron, "Wes Anderson" 19]).[24] It is in large part by addressing his audience with a simultaneously self-conscious and innocent tone that allows Anderson—and us—to indulge in and finally affirm such a utopian impulse. It certainly appears unlikely that the Andersonian could ever become a politically radical aesthetic; but it does not seem beyond the realm of possibility that some preposterous but heartfelt raised fists could yet be summoned in support of more politically suggestive causes, whose idealistic aims may seem impractical or even bound for failure, but to which it still remains vitally important to stay enthusiastically committed.[25]

Notes

1. See Orgeron, Dorey.
2. See Orgeron, Dorey, Boschi and McNelis.
3. See Browning.
4. See Boschi and McNelis, Winters.
5. See Baschiera.

6. See MacDowell ("Wes Anderson" 13–22), Gibbs, Thomas, Peberdy, Perkins.
7. See Boyle, Felando.
8. See Browning.
9. See Kredell.
10. See Sconce, "Whites."
11. See Dean-Ruzicka.
12. See Nordstrom.
13. See MacDowell ("Notes" 4–14) for more.
14. See MacDowell ("Wes Anderson" 13–22) for more.
15. Anderson was originally identified by Sconce as a participant in the smart-film aesthetic (and has recently been analysed as such in greater depth by Claire Perkins [2011]), but I suggest that he and others of his contemporaries are more productively explained in relation to the logic of the quirky as I define it.
16. As Claire Colebrook argues, the very concept of ironic speech relies upon the ultimate impossibility of such a thing as "an innocent language" (173).
17. See Orgeron, Piechota, Sabo, Lorentzen, and so forth.
18. See Baschiera for a discussion of the nostalgia associated with spaces and objects in Anderson's work.
19. It grows out of a broader attack on strains in "postironic" or "metamodern" literary and intellectual culture that his magazine, *n+1*, has dubbed a "regressive avant-garde" (represented especially by Dave Eggers and associated "Eggersards").
20. See Chabon's 2013 article, "Wes Anderson's Worlds."
21. See Konstantinou, Timmer, and Vermeulen and van den Akker for helpful overviews of such trends in the arts and popular culture.
22. See MacDowell ("Notes" 10–13, "Wes Anderson" 13–22), King, Gibbs, Brown.
23. Being especially cautious about generalizing too far in his discussion of "postironic" culture, Konstantinou proposes that "postmodern irony is, at best, a notable cultural microclimate among elite producers and consumers of culture" (14–15).
24. See Halberstam (183–85) for an intriguing interpretation of the political resonances of the raised fists exchanged between Fox and the wolf toward the end of *Fantastic Mr. Fox*.
25. I would like to thank Annie Holden for the many enjoyable and enlightening discussions of Anderson we shared at the University of Reading during my time writing this chapter.

Works Cited

Achenbach, Joel. "Putting All the X in One Basket." *The Washington Post*. April 27, 1994. Web.

Baschiera, Stefano. "Nostalgically Man Dwells on This Earth: Objects and Domestic Space in *The Royal Tenenbaums* and *The Darjeeling Limited*." *New Review of Film & Television Studies* 10. 1 (March 2012): 118–31. Print.

Beard, William. "Maddin and Melodrama." *Canadian Journal of Film Studies* 14.1 (Autumn 2005): 2–17. Print.

Boschi, Elena, and Tim McNelis. "'Same Old Song': On Audio-Visual Style in the Films of Wes Anderson." *New Review of Film and Television Studies* 10.1 (March 2012): 28–45. Print.

Boyle, Kirk. "Reading the Dialectical Ontology of *The Life Aquatic with Steve Zissou* Against the Ontological Monism of *Adaptation*." *Film-Philosophy* 11.1. Web.

Britton, Andrew. "The Myth of Postmodernism: The Bourgeois Intelligentsia in the Age of Reagan." In *Britton on Film: The Complete Film Criticism of Andrew Britton*, edited by Barry Keith Grant, 435–67. Detroit, MI: Wayne State UP, 2009. Print.

Brown, Tom. *Breaking the Fourth Wall: Direct Address in the Cinema*. Edinburgh: Edinburgh UP, 2012. Print.

Browning, Mark. *Wes Anderson: Why His Movies Matter*. London: Praeger, 2011. Print.

Chabon, Michael. "Wes Anderson's Worlds." *New York Review of Books*, January 31, 2013, n.p. Web.

Colebrook, Claire. *Irony*. New York: Routledge, 2004. Print.

Dean-Ruzicka, Rachel. "Themes of Privilege and Whiteness in the Films of Wes Anderson." *Quarterly Review of Film and Video* 30.1 (2013): 25–40. Print.

Felando, Cynthia. "A Certain Age: Wes Anderson, Anjelica Huston and Modern Femininity." *New Review of Film and Television Studies* 10.1 (March 2012): 68–82. Print.

Fernández, James W. and Mary Taylor Huber. "Introduction: The Anthropology of Irony." In *Irony in Action: Anthropology, Practice, and the Moral Imagination*, edited by James W. Fernández and Mary Taylor Huber, 1–37. Chicago: University of Chicago Press, 2001. Print.

Frye, Northrop. *Anatomy of Criticism: Four Essays*. Princeton, NJ: Princeton UP, 1957. Print.

Gibbs, John. "Balancing Act: Exploring the Tone of *The Life Aquatic with Steve Zissou*." *New Review of Film and Television Studies* 10.1 (2012): 132–151. Print.

Gorfinkel, Elena. "The Future of Anachronism: Todd Haynes and the Magnificent Andersons." In *Cinephilia: Movies, Love and Memory*, edited by Marijke de Valck and Malte Hagener, 153–68. Amsterdam: Amsterdam UP, 2005. Print.

Gottschalk, Simon. "Uncomfortably Numb: Countercultural Impulses in the Postmodern Era." *Symbolic Interaction* 16.4 (1993): 351–78. Print.

Greif, Mark. "Positions." In *What Was the Hipster? A Sociological Investigation*, edited by Mark Greif, Dayna Tortorici, and Kathleen Ross, 4-11. New York: Sherridan Press, 2010. Print.

Halberstam, Judith. *The Queer Art of Failure*. Durham, NC: Duke UP, 2011. Print.

Higonnet, Anne. "Picturing Innocence: An Interview with Anne Higonnet." Interview by Sina Najafi. *Cabinet* 9 (Winter 2002/03): n.p. Web.

Holden, Andy. Interview by Chris Fite-Wassilak. *Frieze* 148 (June–August 2012): n.p. Web.

King, Geoff. "Striking a Balance Between Culture and Fun: 'Quality' Meets Hitman Genre in *In Bruges*." *New Review of Film and Television Studies* 9.2 (2011): 132–151. Print.

Konstantinou, Lee. "Wipe That Smirk off Your Face: Postironic Literature and the Politics of Character." PhD diss. Stanford University, 2009. Web.

Kredell, Brendan. "Wes Anderson and the City Spaces of Indie Cinema." *New Review of Film and Television Studies* 10.1 (March 2012): 83–96. Print.

Lorentzen, Christian. "Captain Neato." *n+1*, April 23, 2010, n.p. Web.

MacDowell, James. "Notes on Quirky." *Movie: A Journal of Film Criticism* 1 (2010): 1–16. Web.

―――. "Quirky: Buzzword or Sensibility?" In *American Independent Cinema: Indie, Indiewood and Beyond*, edited by Geoff King, Claire Molloy, and Yannis Tzioumakis, 53–64. New York: Routledge, 2012. Print.

―――. "Wes Anderson, Tone and the Quirky Sensibility." *New Review of Film and Television Studies* 10.1 (March 2012): 6–27. Print.

Morris, Jason. "The Time Between Time: Messianism & the Promise of a 'New Sincerity.'" *Jacket* 35 (2005): n.p. Web.

Nordstrom, David. "The Life Fascistic: Fascist Aesthetics in the Films of Wes Anderson." *The High Hat* 6 (Spring 2006): n.p. Web.

Olsen, Mark. "If I Can Dream: The Everlasting Boyhoods of Wes Anderson." *Film Comment* 35.1 (January/February 1999): 12–13. Print.

Orgeron, Devin. "La Camera-Crayola: Authorship Comes of Age in the Cinema of Wes Anderson." *Cinema Journal* 46.2 (Winter 2007): 40–65. Print.

―――. "Wes Anderson." In *Fifty Contemporary Filmmakers*, 2nd ed., edited by Yvonne Tasker, 18–27. New York: Routledge, 2010. Print.

Peberdy, Donna "'I'm just a character in your film': Acting and Performance from Autism to Zissou." *The New Review of Film and Television Studies* 10.1 (2012): 46–67. Print.

Perkins, Claire. *American Smart Cinema*. Edinburgh: Edinburgh UP, 2011. Print.

Piechota, Carole Lyn. "Give Me Second Grace: Music as Absolution in *The Royal Tenenbaums*." *Senses of Cinema* 38 (2006): n.p. Web.

Plantinga, Carl. *Moving Viewers: American Film and the Spectator's Experience*. Los Angeles: University of California Press, 2009. Print.

Pye, Douglas. "Movies and Tone." In *Close-Up 02*, edited by John Gibbs and Douglas Pye, 1–80. London: Wallflower Press, 2007. Print.

Robinson, Anthony. "A Few Notes from a New Sincerist." Blog post. *Geneva Convention Archives*, July 22, 2005. Web.

Rombes, Nicholas. "Irony and Sincerity." In *New Punk Cinema*, edited by Nicholas Rombes, 72–85. Edinburgh: Edinburgh University Press, 2005. Print.

Sabo, Lee Weston. "Inimitable Charm: Wes Anderson's *Fantastic Mr. Fox*." *Bright Lights Film Journal* 67 (2010): n.p. Web.

Saltz, Jerry. "Sincerity and Irony Hug It Out." *New York Magazine*, May 27, 2010. Web.

Sconce, Jeffrey. "Irony, Nihilism and the New American 'Smart' Film." *Screen* 43.4 (Winter 2002): 349–69. Print.

———. "Whites, Whimsy, and *Moonrise Kingdom*." *Ludic Despair*, July 2, 2012. Web.

Seigworth, Gregory J. "The Affect of Corn." *M/C Journal* 8.6 (Dec. 2005): n.p. Web.

Shakar, Alex. *The Savage Girl*. New York: Harper Perennial, 2002. Print.

Sloterdijk, Peter. *Critique of Cynical Reason*. Translated by Michael Eldred. Minneapolis, MN: University of Minnesota Press, 1987. Print.

Taylor, Charlotte. "The Importance of Being Earnest." *Frieze* June/August 2005, n.p. Web.

Timmer, Nicoline. *Do You Feel It Too? The Post-Postmodern Syndrome in American Fiction at the Turn of the Millennium*. Amsterdam: Rodopi Press, 2010. Print.

Vermeulen, Timotheus, and Robin van den Akker. "Notes on Metamodernism." *Journal of Aesthetics and Culture* 2 (2010): n.p. Web.

Wallace, David Foster. "E Unibus Pluram: Television and U.S. Fiction." *Review of Contemporary Fiction* 13.2 (Summer 1993): 151–93. Print.

Williams, Raymond. *The Long Revolution*. Harmondsworth, UK: Penguin, 1993. Print.

———. *Politics and Letters: Interviews with* New Left Review. London: New Left Books, 1979. Print.

Winters, Ben. "'It's All Really Happening': Sonic Shaping in the Films of Wes Anderson." In *Music, Sound and Filmmakers: Sonic Style in Cinema*, edited by James Eugene Wierzbicki, 45–60, New York: Routledge, 2012. Print.

Žižek, Slavoj. *The Sublime Object of Ideology*. New York: Verso Books, 1989. Print.

12

"I Always Wanted to Be a Tenenbaum": Class Mobility as Neoliberal Fantasy in Wes Anderson's *The Royal Tenenbaums*

Jen Hedler Phillis

When Richie Tenenbaum (Luke Wilson) and his father Royal (Gene Hackman) confront Eli Cash (Owen Wilson) about Eli's drug problem in Wes Anderson's 2001 film, *The Royal Tenenbaums*, Eli admits, "I always wanted to be a Tenenbaum." His statement comes as no surprise: Eli is depicted as an outsider hoping to be accepted into the family throughout the film. He is Richie's childhood best friend, described by the narrator as "a regular fixture" at the Tenenbaum house. He continues to send Etheline Tenenbaum (Angelica Huston), the matriarch of the family, his grades, press clippings, and reviews. After Richie disappears, Eli begins an affair with Margot Tenenbaum (Gwyneth Paltrow), Royal's adopted daughter. Margot admits the affair was sparked by their shared affection for Richie, explaining that she and Eli "mostly just talked about" Richie. What is surprising about the scene, then, is not Eli's admitted desire "to be a Tenenbaum." Instead, it is that Royal Tenenbaum—Etheline's husband and Richie's father—responds, "Me, too."

Although it is surprising that Royal would put it that way—that he has "always wanted to be a Tenenbaum"—it is not surprising that he wants to be a part of the family. The film is set in motion when Royal returns home after having lived away from his wife and children for 22 years. Although

the reasons for his homecoming are perfectly selfish—he has run out of money and discovered Etheline wants to remarry—he eventually realizes that he "want[s] this family to love" him. But, when Royal puts his desire to be loved in terms of his identity—he wants "to be a Tenenbaum"—the audience must reconsider what is at stake for the characters in the film. What does it take "to be a Tenenbaum"?

I argue that understanding what it takes to be a Tenenbaum is essential not only for understanding the film, but, moreover, for understanding one of the central critical debates surrounding Anderson's work: whether his studied aesthetic choices ultimately enrich or evacuate the emotional impact of his work. Anderson's characters are compared, variously, to "walking fashion plates" (Turner 161), "prize specimens" (Scott), and "model-kit[s]" (Chabon). For some critics, his aesthetic indicates a central inauthenticity in his work that prevents viewers from emotionally engaging with the characters or plot. For others—most recently, Michael Chabon—Anderson's stylization indicates just the opposite: Chabon writes, "the hand-built, model-kit artifice on display" in Anderson's films "is a guarantor of authenticity." Underlying the claims of Anderson's authenticity (or lack thereof) is a deeper question about filmic form: to what extent do formal choices that draw attention to their own constructedness contribute to (or impede) the content's effect on the audience? That is, when critics worry over the filmmaker's authenticity, they are asking whether or not the film has anything to say about our world. I contend that Anderson has quite a bit to say about our world, and that his formal choices are central to the message. In *Tenenbaums* and 1998's *Rushmore*, class affiliation is presented as a choice, a representation that mirrors the rhetoric of neoliberalism. But, when neoliberal rhetoric is couched so fully in the fictional, inauthentic, and self-consciously made world of Anderson's films, Anderson reveals the essential fictionality, inauthenticity, and madness of neoliberalism itself.

"Royal" and "Cash"—the names of the two characters desperate "to be ... Tenenbaum[s]"—describe two ways of determining class affiliation, neither of which is sufficient for membership in the family. Royalty is inherited, so that there is no way to become "royal" except by birth or marriage. But, as we have already seen, being a Tenenbaum has nothing to do with a person's blood relations; if it did, Royal would be a Tenenbaum, and Margot would not. "Cash" can also determine class affiliation, but based on what's in a person's bank account instead of what's in a person's blood. But, Eli Cash—who is likely the wealthiest of the younger characters—is not a Tenenbaum, indicating that being a Tenenbaum has nothing to do with money, either.

What does set the four Tenenbaums apart from Royal and Eli is their relationship to education. After Royal and Etheline separated, she made the children's education her "highest priority."[1] They attended an elite private

school and were engaged in a variety of extracurricular lessons and activities (the script lists them as "guitar, ballet, yoga, scuba-diving" [*Tenenbaums* 7]). We see Margot reading *The Cherry Orchard* as a child, and learn that Chas (Ben Stiller) "started buying real estate in his early teens." Etheline documented her education method in a book, *Family of Geniuses*. As indicated by the various activities she has planned for the children, Etheline's style of education depends, at least in part, on a careful selection of the kinds of things the children are exposed to. All of them—from playwriting and international finance to ballet and yoga—would be typically considered the pursuits of an elite class.

Eli, although he attended the same private school as the Tenenbaum children, did not benefit from Etheline's attention. This is evident in his chosen career. Many of the characters in the film are writers, but they produce work that either appeals to an elite class (as Margot's plays do) or depends upon their expert knowledge of a subject (as Etheline's education guide, Raleigh St. Clair's [Bill Murray] neurological texts, and Henry Sherman's [Danny Glover] accounting book do). In contrast, Eli writes in a popular genre—the speculative western—and is not particularly articulate about his work. When asked to describe the premise of Old Custer, he reports, "Well, everyone knows Custer died at Little Bighorn. What this book presupposes is . . . maybe he didn't?" While Eli can recognize that many of the Tenenbaums are writers—and that, therefore, writing is associated with genius—what he does not understand is the difference between being a scholar or a playwright and being a pulp novelist: he does not understand cultural hierarchy. As a result, he is explicitly not considered a genius. In one of the first scenes set in the present day, Eli talks on the phone, complaining about a negative review. He asks, "Why would a reviewer make the point of saying someone's not a genius? I mean, do you think I'm especially not a genius? Isn't that—" There is a very brief pause, and Eli says, "You didn't even have to think about it, did you?" Anderson finally reveals with whom he's speaking: Margot Tenenbaum, who explains, "I just don't use that word lightly."

If what Etheline's educational program gave her children was an understanding of the different strata of cultural productions, then a small detail from Royal's life begins to make sense. Throughout the film, Anderson makes a point of showing or mentioning Royal's encyclopedias. They appear on screen when he is first thrown out of the hotel; he expresses concerns about their whereabouts after he is evicted; and he leaves the books to his grandchildren, Ari (Grant Rosenmeyer) and Uzi (Jonah Meyerson).[2] Unlike Etheline's curated extracurricular activities that gave her children an innate understanding of cultural hierarchy, an encyclopedia is organized with no hierarchy: the entries are alphabetized, and no entry is given

priority over the others. While Etheline carefully selected what her children would learn, Royal's legacy to Ari and Uzi is education without hierarchy.

Moreover, when Royal does interact with his children and grandchildren, he exposes them to activities that are decidedly not associated with the elites. Although Royal was absent for much of his children's youth and adolescence, he did take Richie on outings—the flashback shows the two betting on a dogfight—from which the other children were excluded. When he returns to the house, he repeats the trip with Chas's sons, Ari and Uzi, taking them out to jaywalk, shoplift, throw water balloons at passing cars, and (just like Richie) bet on dogfights. Anderson constructs Etheline's and Royal's relationships to their children's and grandchildren's education and development as opposites: while Etheline is careful about teaching the children the right kind of culture, Royal wants the children to experience all kinds of culture.

The relationship between social class, education, and culture is well documented, perhaps most famously in Pierre Bourdieu's *Distinction*. Bourdieu argues that people raised in a privileged environment tend to have access to better education and a wider range of culture than people raised with less money; for that reason, they tend to prefer "high" art and culture. The Tenenbaum children bear this out: Margot, the playwright, also practices ballet; Richie, along with his professional tennis career, is a painter (although, as the narrator notes, he "failed to develop"). But, in Anderson's films, culture is not deployed to mark the characters' class backgrounds. Instead, it replaces economic class, defining each person's position in the social order by their relationship to cultural hierarchy. The difference between Bourdieu's portrayal of cultural class and Anderson's is that, for Bourdieu, economic class determines a person's education and relationship to culture, while, for Anderson, a person's relationship to culture determines that person's class status. That is, Royal and Eli belong to a lower social class than the Tenenbaums not because of where they come from or because of how much money they have, but because of how they relate to culture. It is not enough to be Royal; nor is it enough to have (or be) cash: to be a Tenenbaum, you have to have the right relationship to culture.

The version of cultural class Anderson deploys in *The Royal Tenenbaums* is a marker of neoliberalism. The neoliberal turn in American politics was initiated by a massive realignment of the voting practices of working-class Americans—especially males—in the 1970s. Following the fractious and violent 1968 Democratic National Convention, the party splintered between the traditional Democratic base—New Deal Democrats, mostly white working-class voters—and the New Left, drawn to the Democrats' socially liberal and antiwar agendas. The Republican party capitalized on this division, using white working-class discontent with

racial integration (especially urban school busing), sexual liberation, and pacifism to build a new coalition, based not on economic equality (as the traditional Democratic coalition was), but on a particular set of cultural values. Royal's character represents, in a few key ways, the 1970s working-class male. His mother's gravestone is inscribed simply with "The Salt of the Earth" (*Tenenbaums* 59). Although Royal was once a successful lawyer, he was disbarred and imprisoned; at the end of the film, he accepts a job as an elevator operator, looking forward to the "bump" in pay he'll receive when he joins the union (*Tenenbaums* 122). At the same time, Royal uses anachronistic, racially incendiary language when addressing Henry Sherman. He addresses him as "Coltrane" and accuses him of "talk[ing] jive" (*Tenenbaums* 93–94). Not only does Royal's language smack of outdated racism, but Henry, who speaks almost entirely in bureaucratic legalese, is presented to the audience as someone who has never once "talk[ed] jive."[3] Royal is depicted as a stereotype of the 1970s working-class male: reckless, uneducated, broke, and racist.

Richard Nixon was the first major Republican candidate who succeeded in luring working-class voters away from the Democratic party. Jefferson Cowie, whose 2010 text *Stayin' Alive* traces the dissolution of the left coalition and the consolidation of the new right coalition, writes that Nixon strongly believed that "people's natural political alliances stemmed from their values," not their economic position (126). Nixon capitalized on white working-class Americans' fears over desegregation, urban violence, and social liberalism, giving him a landslide victory in the 1972 election.[4] Republican strategist Richard Viguerie, quoted in Cowie, explains, "We never really won until we began stressing issues like busing, abortion, school prayer, and gun control . . . [W]e didn't start winning majorities in elections until we got down to gut level issues" (227). One way of understanding the shift in political allegiance in the 1970s, then, is a shift from voting based on your economic interests to voting based on your moral interests or values.

While Nixon and his strategists created a political bloc that effaced class, his economic policies still focused on finding a balance between workers' rights and corporate profits. In many ways, Nixon was still a part of the postwar American tradition, signing into a law "a huge wave of regulatory reform . . . governing everything from environmental protection to occupational safety and health, civil rights, and consumer protection" (Harvey 13). His (limited) prolabor policies were made possible because, at least until 1973, the postwar boom allowed businesses to work with labor unions and make profits. As inflation and unemployment rose in the mid-1970s, however, such a position was no longer possible.

The 1970s were the end of an economic era, both in the United States and globally. The decade was marked by rampant inflation and high

unemployment, a combination thought impossible by most economists. For the first time since the Great Depression, the share of wealth controlled by the top 1 percent of the population dropped significantly (Harvey 16). What followed was the neoliberal turn in American economic policy, which crushed labor unions, deregulated businesses, and shifted wealth back into the highest stratum of American society. As David Harvey details in *A Brief History of Neoliberalism*, the effect has been nothing short of "the restoration or reconstruction of the power of economic elites" (19). There are many statistics that demonstrate this economic shift, but perhaps the most telling is that while real wages have declined by almost two dollars since 1973, CEOs have seen their income increase, on average, tenfold (Harvey 25, 18). The effacement of class that was central to Nixon's election strategy was designed to promote a socially conservative, law-and-order platform. The same class effacement, however, was later marshaled to improve economic conditions for only a small percentage of the conservative bloc.

We have seen already that Royal is something like a caricature of the 1970s working-class male, whose vote authorized the disastrous economic policies that were enacted in the 1980s and continue today. While his character is anachronistic for the viewers, it isn't anachronistic within the world of the film.[5] The music, costuming, and sets all seem to place the film in the 1970s or early 1980s. Because Anderson withholds the date from the audience, it is not clear exactly when he imagines the action of the film taking place. What does allow us to date the film is the explicitly stated length of time between the prologue and the main film: 22 years. And, what is immediately apparent at the beginning of the present day of the film is that, for many of the characters, style hasn't changed.[6] Many of the adult actors wear the same clothes as the child actors: Margot wears a brown fur coat, thick black eyeliner, and a plastic barrette in her hair in the prologue and throughout the film; Eli, who is wearing imitation buckskin pajamas at Margot's party, continues to dress "western," wearing a very similar outfit when he crashes his car into the Tenenbaum house at the end of the film.[7] Eli's present-day costume gives us a clue as to why the characters haven't changed clothes in so long. Margot's party marks the last time Royal was a part of the children's lives. The narrator highlights Royal's ejection from the house, explaining, "In fact, virtually all memory of the young Tenenbaums' brilliance had been erased by two decades of betrayal, failure, and disaster." The "in fact" suggests a direct link between Royal's ejection from the house and the stagnation—both internal and external—of the Tenenbaum children.

The plot confirms the narrator's emphasis on "in fact." It is only after Royal is reintegrated into the family that the children begin to move forward: Richie and Margot admit their love for each other, although they promise to keep it secret; Margot writes her first play in seven years (which

is, incidentally, also how long it has been since Etheline and Royal last spoke at the start of the film, implying a direct connection between Margot's career and her parents' relationship); and Royal grants Etheline a divorce, so she can remarry. Anderson underlines the importance of Royal's lower class status by having Eli provide the final resolution of the film. When Eli crashes his car into the front of the Tenenbaum house, almost hitting Chas's two sons and killing their dog, he provides the means to resolve the remaining conflicts. Royal saves the boys (and replaces the dog), which is finally enough for Chas to forgive him. The crash is also what finally sends Eli to rehab—fittingly, to a North Dakotan in-patient clinic, where his western affectations feel more at home. It seems, then, that even though Royal and Eli do not count as Tenenbaums, their presence is central to the Tenenbaums' success: while being a Tenenbaum is determined by cultural class, it turns out that being a genius requires the presence of both upper-class elements (represented by Etheline) and lower-class elements (represented by Royal and Eli).

So, while it should be clear by now that the central pieces of *Tenenbaums* have corollaries in American political history, it is not immediately obvious to what use Anderson puts them. I contend that the artificiality that marks all of Anderson's work is intended to color the audience's reaction to the political and economic elements in his films. This is most evident in the framing devices he uses in both *Tenenbaums* and *Rushmore*. In *Tenenbaums*, a library book functions as the framing device. The first shot of the film shows someone opening the book, and the narrator begins to read the text of Chapter One (*Tenenbaums* 3). This is a reference, of course, to Orson Welles's *The Magnificent Ambersons* (1942), but it also serves to connect the story with the only novelist we meet, Eli Cash. Likewise, *Rushmore* uses insert shots where the month during which the events take place is projected onto a velvet curtain as its framing device. The nondiegetic curtain serves two purposes: first, to remind the audience we are watching a film and, second, to focus our attention on the final Max Fischer production, a Vietnam War melodrama called *Heaven and Hell*. Max, standing in front of a red velvet curtain, dedicates the play to his late mother and the late husband of Miss Cross (Olivia Williams), his object of affection. The composition of the shot—where the spotlight takes the place of the previously projected months—links *Heaven and Hell* to Rushmore: it is clear Anderson wants us to read the two as similar. *Heaven and Hell* ends when Esposito (played by Max) proposes to Le-Chahn (played by Max's new girlfriend, Margaret Yang [Sara Tanaka]); it uses the marriage of Esposito and Le-Chahn as a stand-in for the resolution of the Vietnam War. Likewise, the romantic pairings at the end of the film provide resolution to the conflict that set the plot in motion. While the central conflict in *Rushmore* is the rivalry between Mr. Blume and Max for Miss Cross's affection, we would

not be wrong to see Max's relationship with Mr. Blume as the one that needs to be solidified at the end. After all, Anderson presents both couples (Max and Margaret, Blume and Cross) ambivalently: Margaret insists she is Max's girlfriend, over his objections, and the film closes on a shot that finds the couples once again mismatched, as Blume dances with Margaret and Max leads Cross to the dance floor. Such ambivalence directs us to the real couple at the center of the film: Max and Mr. Blume. Although we can make certain assumptions about the class status of the women in the film—Miss Cross attended Harvard; Margaret goes to Grover Cleveland High, not Rushmore Academy—Max and Mr. Blume are the only characters whose socioeconomic positions are explicitly stated: despite his affectations, Max is a "barber's son," and, despite his humble beginnings, Mr. Blume is a steel tycoon. Because we cannot read the final romantic pairings as a definite solution to the conflict of the film, Anderson directs us to the friendship as the real heart of *Rushmore* and presents the reunion between Max and Mr. Blume as the resolution. For two characters so troubled by their class position, it is hard to read their reconciliation as anything but a reconciliation of class difference. But, importantly, neither character's class difference changes: the film doesn't end with Mr. Blume promising to pay for Max to attend Oxford or the Sorbonne (or even Harvard, Max's "safety" school); nor does it end with Max being readmitted to Rushmore and the elite environment in which we first met him. Instead, the film ends with everyone in their right economic place. The message of *Rushmore* is not that Max can (or cannot) transcend his social class, it is that his social class does not matter.

It would be easy to read the ending, then, as a version of the neoliberal rhetoric that has so damaged the global lower and working classes. But Anderson's artificiality means that we are not intended to understand the films as realistic: they are as fictional as Max Fischer's plays, which, as Owen Wilson explains on the commentary to *Rushmore*, are "crowd-pleasers." The framing device of the curtain—or, in *Tenenbaums*, the library book—forces us to recognize the fictionality of the films and, as a result, the fantastical nature of their resolutions.

Both Anderson and Wilson, who collaborated on the screenplays for *Rushmore* and *Tenenbaums*, point to the "fable-like" quality of their films. This overstylization and overtheatricality cannot be taken seriously at the time the films were produced. That is, both films tell stories in which the promise of the neoliberal turn (economic class does not matter) is made reality, but in such a theatrical and stylized way that the audience cannot help but question its veracity. The final scenes propose group affiliation that transcends class; they are utopian visions of the neoliberal effacement of social class. What *Rushmore* and *The Royal Tenenbaums* ask their viewers is, what if when we stopped paying attention to class difference,

class difference did, in fact, stop mattering? What if the real effects of economic inequality disappeared when their impact on politics did? The final scenes of both films revel in the reconciliation between people who initially seemed impossibly divided. Anderson's films are utopian mirrors of the neoliberal dystopia. When American voters abandoned economics and embraced values, they did not erase the material effects of inequality. Instead, they authorized a massive redistribution of wealth into the hands of the richest Americans. Neoliberalism requires cross-class solidarity, while favoring only the highest social strata. Anderson's films produce cross-class solidarity that renders class difference unimportant, while forcing his audience to recognize the fictionality of such a union.

Notes

1. Education is central to *Rushmore* as well. When we first meet Max Fischer (Jason Schwartzman), he is a student at the elite Rushmore Academy. He is so enamored of his school that he tells his new friend, Mr. Blume (Bill Murray), that the secret to life is "to find something that you love, then do it for the rest of your life. For me, it's going to Rushmore" (*Rushmore* 16). Importantly, however, Max is a terrible student and is put on "sudden death academic promotion" (9). This indicates—as my reading of *Tenenbaums* does as well—that education, for Anderson, is not about learning, except insofar as you might learn how to belong.
2. This detail does not appear in the printed screenplay but is in the final shooting script.
3. His proposal to Etheline is prefaced by an explanation of why it would be "advantageous for [her] marital status to be legally established as single . . . for tax purposes"; in the aftermath of Eli crashing his car into the house, he explains to his son that even though the damaged section of the house "aren't structure-bearing elements . . . It's still best to file another force majeure and recoup the deductible."
4. Nixon barely won against Hubert Humphrey in 1968, earning just over 500,000 more votes than the Democrat. In 1972, he easily defeated George McGovern, earning 18 million more votes.
5. For a counterargument, see Daniel Cross Turner's "The American Family (Film) in Retro," in *Violating Time*. There, Turner reads Anderson's incessant quoting—of other films, other filmmakers, and outdated styles—as a critique of the auteur theory of filmmaking that has been replaced by a corporate vision. According to Turner, *Tenenbaums* is about the instantiation of the commodity in the place of authenticity.
6. Costumes are also central to *Rushmore*, but there Anderson draws our attention to the fact that Max is a skilled costumer, putting on and taking off clothes so as to better match the identity he is trying to inhabit. We see this most obviously when he impersonates a waiter to fill Mr. Blume's hotel room with bees.

The clothes he wears when he isn't acting reflect the close connection between clothing and identity. He wears his Rushmore uniform exclusively for the first third of the film, even after he is expelled from Rushmore and starts attending Grover Cleveland High School. When he is arrested and gives up on the "pipe dreams" of becoming a "senator or diplomat," admitting that, after all, he's "a barber's son," Max begins to wear a brown parka, black work pants, and barber's smock: he is, again, dressing the part.

7. Chas is unique in this regard. He and his sons wear matching red Adidas warm-up suits. Anderson explains on the commentary that he eventually decided they wear these for safety reasons—they are easier to spot in a crowd—which indicates the outfits are part of Chas's obsession with safety.

Works Cited

Anderson, Wes and Owen Wilson. *The Royal Tenenbaums*. New York: Faber and Faber, 2002. Print.

———. *Rushmore*. New York: Faber and Faber, 1999. Print.

Bourdieu, Pierre. *Distinction*. Translated by Richard Nice. Cambridge, MA: Harvard UP, 1984. Print.

Chabon, Michael. "Wes Anderson's Worlds." *The New York Review of Books*, January 31 2013. Web.

Cowie, Jefferson. *Stayin' Alive: The 1970s and the Last Days of the Working Class*. New York: New Press, 2010. Print.

Harvey, David. *A Brief History of Neoliberalism*. New York: Oxford UP, 2005. Print.

The Royal Tenenbaums, directed by Wes Anderson, with performances by Gene Hackman, Angelica Huston, Gwyneth Paltrow, Luke Wilson, Owen Wilson. Touchstone, 2001. DVD.

Rushmore, directed by Wes Anderson, with performances by Bill Murray, Jason Schwartzman, Olivia Williams. Touchstone, 1998. DVD.

Scott, A. O. "Brought Up to Be Prodigies, Three Siblings Share a Melancholy Oddness." *The New York Times*, October 5, 2001. Web.

Turner, Daniel Cross. "The American Family (Film) in Retro: Nostalgia as Mode in Wes Anderson's *The Royal Tenenbaums*." In *Violating Time: History, Memory, and Nostalgia in Cinema*, edited by Christina Lee, 159–76. London: Continuum, 2008. Print.

13

Objects/Desire/Oedipus: Wes Anderson as Late-Capitalist Auteur

Joshua Gooch

Wes Anderson's films often seem to be about nothing except fathers: from the obscene and betraying father figures of *Bottle Rocket* and *Rushmore* to the failed yet redeemed father of *The Royal Tenenbaums*, and the nonfather father of *The Life Aquatic with Steve Zissou*, Anderson returns time and again not merely to the problematic relation between children and fathers, but to the problem of paternity as such and the role it plays in the subjective construction of his characters. His most recent films confront the limits of this idée fixe. *The Darjeeling Limited* relies on an absent yet always present father as three brothers squabble across India in search of their emotionally inaccessible mother after their father's death, and Anderson's most explicit scene of paternal castration as a cause of subject-formation—perhaps even better than the severing of Margot's (Gwyneth Paltrow) finger in *The Royal Tenenbaums*—appears in his children's film, *Fantastic Mr. Fox*, as Mr. Fox's (George Clooney) maturity coincides with the loss of his tail. Fatherhood even provides narrative closure to the otherwise anarchic story of young love in *Moonrise Kingdom*, disrupting the potential suicidal closure solicited by its preadolescent pastiche of *Badlands* (Malick, 1973) and *Bonnie and Clyde* (Penn, 1967).

In the past, I have followed these paternal thematics by exploring the Lacanian implications of Anderson's early films, focusing in particular on castration's role in organizing Anderson's intensively narrativized mise-en-scène. Although I believe that this analysis remains a cogent interpretation of Anderson's thematics and aesthetics, most especially the castration

aesthetics of stop-motion animation now writ large in *Fantastic Mr. Fox*, Anderson's continued fixation on Oedipal subjectivity, both in his recent feature films and his forays into the world of commercial advertisement, increasingly highlights psychoanalysis's role in Anderson's self-construction as an auteur for market, and critical, consumption. Furthermore, Anderson's fixation on problems of paternity and castration helps displace social and economic antagonisms that his plots solicit but cannot resolve. Psychoanalysis's Oedipal concepts thus offer Anderson organizing strategies for more problematic dispersals of social, cultural, political, and aesthetic desires. One way to connect these intensive Oedipal thematics to the external world is to discern the difference between "molar" Oedipal narratives and "molecular" productions of desire in Anderson's films and ads—in other words, to mount, following the work of Gilles Deleuze and Felix Guattari, an anti-Oedipal reading.

Such an approach clarifies and reframes a set of problems in Anderson's films that I previously addressed using Slavoj Žižek's reading of Hegel's Jena notebooks and their account of a nightmare experience of presubjective *membra disjecta*—free-floating objects that exist outside the framework of the Lacanian imaginary and should not be understood as partial objects because they do not serve as phallic substitutes. (After all, Lacan's imaginary and symbolic are not separate and distinct developmental phases but rather uneven coexisting orders.) Using Žižek, Hegel, and Lacan, I attempted to articulate a problem that continues to mark Anderson's films: they are at once highly Oedipal *and* stuffed full of apparently non-Oedipal objects that, like the membra disjecta, stand outside and in tension with his narrative Oedipalization. In retrospect, I fear this distinction remains too grounded in a framework that inexorably returns to castration and the name-of-the-father as answers to these issues rather than indicators of a continued tension that informs Anderson's filmmaking. As a result, my prior analysis tended to privilege Anderson's plots over his style, or, at least, as overdeterminations of his style. However, because Anderson's cultural impact is more a result of his style than his narrative techniques, I want to return attention to the continuing and unresolved tension in Anderson's work between style and his use of formal and narrativized Oedipalization.

As one might expect, Anderson's images, most especially his production design and mise-en-scène, provide key sites where social and cultural desires can be disengaged from Oedipalization. Yet once his overarching psychoanalytic focus on Oedipal processes recedes, Anderson's films threaten to disintegrate into little more than the stylistic cues that have defined his cultural uptake in mainstream indie feature films of the 2000s, such as *Juno* (Reitman, 2007), *Napoleon Dynamite* (Hess, 2004), *Son of Rambow* (Jennings, 2007), *The Brothers Bloom* (Johnson, 2008), and so forth,

and in television commercials.[1] Anderson critics have tended to address his style as a tension between mise-en-scène and affect. For example, Jeffrey Sconce locates Anderson's style as part of the blank style of "smart cinema," a formalist cinema of ironic disengagement. By contrast, Mark Olsen argues Anderson is instead a filmmaker of "new sincerity," focused on a particular affect of ironic sincerity contrary to the alienating formal ironies of smart cinema. Deborah J. Thomas bridges these differences to examine what she calls Anderson's construction of the "melancomic," which uses distancing irony alongside formal constructions that place particular demands on audience members to imaginatively construct their relationship to the characters and film world.[2] Devin Orgeron connects Anderson's style and affect by highlighting the narrative importance of reflexive author-characters to Anderson's films. I find Orgeron's account persuasive, but would add that Anderson's paternal thematics give these reflexive characters a coherent, if limited, narrative structure while also providing a set of psychoanalytic themes that Anderson uses to construct himself as an auteur. Such strategies help explain, in part, why Anderson has little to say about the larger social world, most especially issues of race, class, and gender: his use of Oedipalization blocks those themes and keeps narrative attention on his films' white male protagonists, as Rachel Dean-Ruzicka notes, and away from other points of connection that his stories and mise-en-scène may solicit.

Yet if we look at Anderson's recent films, we also see an increasing awareness that paternal plots limit what his characters—and films—can do. Such awareness appears in self-referential and reflexive moments about paternity, though it would likely be too much to claim that such moments deconstruct the problems posed by these paternal blockages. Instead, these moments display an auteur aware of his prior themes and attempting to sustain an oeuvre in response to a set of problems that increasingly seem like creative blocks. The results, then, tend to be narrative attempts to overcome the blockage or, once again, make peace with paternity. This is most clearly the case with *The Darjeeling Limited*, which tells the story of three brothers on a supposed spiritual journey across India on the one-year anniversary of their father's death, a journey undertaken, in essence, to overcome this death. Indeed, for the whole of the film, the brothers carry around objects affectively connected to their deceased father, most obviously his personalized luggage. The film begins with a montage that provides its thematic matrix as Bill Murray, the paternal figure in Anderson's three prior films, frantically tries to catch the film's titular train before he is overtaken on the platform by one of the brothers (fig. 1), a thematic prolepsis of the brothers surpassing their father. The film thematically reiterates this surpassing in its concluding sequence as the brothers run for another train, abandoning their father's luggage in the process (fig. 2). Here, slow

Figure 13.1 *The Darjeeling Limited*: Adrien Brody outruns Bill Murray's metatextual paternal figure.

Figure 13.2 *The Darjeeling Limited*: Sons shed their paternal baggage.

motion serves its usual purpose for Anderson, becoming an imaged inflection point for character subjectivity, viewer identification, and the projection of affect. It also provides a narratively overdetermined connection to paternity through the film's other slow motion sequence in which the brothers attend a young man's funeral. Each of these scenes serves as a substitute for another, seemingly more primal scene, this one of the father's missed funeral. Moreover, the film only images this scene as the event of a nonevent, offering a flashback of the encounter at a New York garage that kept them from the funeral. The father's impossible position fits the

film's use of Murray as the dead-yet-present father, not only in its opening but also in its most elaborate sequence: the camera pans across a series of cutaway train cars carrying the brother's affective others in a variety of disparate spaces (New York City apartments, Italian hotels, etc.). Murray is in the final car, which is itself a train car and not an imagined space (fig. 3), before the film cuts to an animated tiger. As one might expect of such psychoanalytic themes, the figure of the father anchors the film's affective chains, not only holding back primal desires but also blocking access to the maternal body. Indeed, the mother serves a similar psychoanalytic purpose in the narrative, acting as a lost or continually receding object: they find her in an isolated convent, where, after a brief nonverbal and seemingly satisfying encounter, she disappears. The film thus seems to map the problem of escaping a nameless and omnipresent paternal prohibition and the loss of the mother's body, which the brothers have attempted to replace with a variety of partial objects made acceptable by their paternal coding as objects belonging to their dead father.

The psychoanalytic motifs in *The Darjeeling Limited* are so explicit that the film seemed Anderson's explicit adieu to paternal thematics. (Indeed, Richard Brody's account of the production indicates Anderson intended for it to be a different kind of film.) Yet Anderson's next film, *Fantastic Mr. Fox*, operates within the same thematic space and effectively installs the patriarchal family as an expansive social unit. Furthermore, paternity remains an important means for Anderson to bring the anarchic desiring narrative of *Moonrise Kingdom* to a close: Captain Sharp provides the anchor to a paternal signifying chain, agreeing to adopt Sam via a verbal contract with Social Services (Tilda Swinton) while keeping Sam (Jared

Figure 13.3 *The Darjeeling Limited*: The paternal figure anchors a desiring chain of train cars.

Gilman) and Suzy (Kara Hayward) from falling to their deaths—and into literal graves—by holding on to Suzy's hand, turning the object of desire into a mediation of paternal authority. In short, Anderson now seems to be explicitly using Oedipal narratives to represent and contain desire, both in terms of the problematic diegetic desires of characters, for example, preadolescent sexuality, and of the desiring connections his films' may solicit to the world outside, connections that threaten the enclosed textual construction central to Anderson's style (e.g., the context of *Moonrise Kingdom*—the northeastern US in 1965—and the actions of its female characters solicit women's liberation without touching on anything of the sort).

I would argue that we can link Anderson's use of these freighted psychoanalytic thematics and studied mise-en-scène to his self-construction as a postmodern (capitalist) auteur. The Oedipal tensions his films trace between object-desires and paternal narratives resonate with tensions in postmodern capitalism between forces of what Deleuze and Guattari term *deterritorialization* and *reterritorialization*, the libidinal and economic release and capture of flows of desires. Anderson's focus on objects speaks to these desires, most especially the objects that characters use to connect to other objects and desires. We see this in *Moonrise Kingdom* with the books and records Suzy carries with her as points of connection with nonfamilial others, both the immediately present Sam and the distant community of readers, fans, and artists also connected to such objects. Yet these desires and objects confront endless if also partial reinscriptions by paternal narrations, creating subjects at once aware and accepting of the limits that the nuclear family poses to desire, while also diverting desires' excesses to creative work that produces more—now potentially alienable—objects of desire. While psychoanalysis would see in these movements a tension between repression and sublimation—operations Freud insists are innately different—Deleuze and Guattari's account of desiring production reveals productive connections and tensions between these mechanisms.

Such emphasis on the relation of objects and desire helps explain Anderson's influence on advertising and his subsequent entrance into directing advertisements: postmodern capitalism has uses for what Anderson's filmmaking does with objects and desires for an audience. The advertising-industry press certainly noticed his entry into the field: not only did *AdWeek* feature a collection of Anderson's ads titled "10 Great TV Spots Directed by Wes Anderson," but a writer from a marketing company used Anderson's advertising work as an opportunity to offer four theses on successful advertising on the *Forbes* website. These consist of "strong, central brand idea," "a consistent flavor," "experiment and surprise," "give people a way to take part" (Swann). In short, Anderson's ads accomplish at a metalevel modern advertising's linkage of product and lifestyle: he creates idiosyncratic

object worlds in which desire skids in unexpected ways through his mise-en-scène from one idiosyncratic object to another until it grinds to a halt in the more readily accessible product that the ad means to sell.[3]

These constructs even retain Mommy and Daddy as the figures that bring the metonymy of desire to an end by endowing desire on that specific object to be owned. Sometimes Anderson accomplishes this through a dual focalization, as in his Hyundai ads, where he moves between the perspectives of children and parents. In one ad, a man watches his children in a house chaotically filled with strange toys while speaking over the phone with his wife, who claims to be stuck in traffic; in fact, she is in the driveway, relaxing in the car. Another spot follows children in the car's backseat as it undergoes a variety of animated transformations, from flying car a la *Chitty Chitty Bang Bang* (Hughes, 1968) to submarine to Batmobile, before cutting to a father using the Hyundai's navigation system. Even in spots without explicit parental figures, Anderson returns to Oedipalization to structure the play and disruptions of desiring-machines. His spot for Heineken follows a couple back to an imagined sixties bachelor pad; while the man is in the bathroom, the woman plays with a machine that controls the Bond-villain features of his seduction lair until the machine swallows the woman and pours a Heineken. The returning man isn't fazed by the loss of the female body, however. He seems more than satisfied with the substitution not just of a beer but a Heineken: branding supplants the law of the father.

These ads offer a way to reevaluate Anderson's mise-en-scène and Oedipalization as mediatory practices embedded in the particular structures of postmodern capitalism. That's not to say that representations of such historical-material issues impinge directly on Anderson's films, but rather on his formal strategies. And in a further turn of the screw, Anderson's style allows him to reassert his auteur status in these ads, thus reinscribing desires from the social field—I want that car, that phone, that piece of furniture—as desires that can once more infuse his images. The popular press helped this turn by treating Anderson's ads like the releases of short films, most especially on the Internet, where they were featured and commented on by blogs for *The New Yorker*, *Slate*, and *The Guardian*. Furthermore, by including these pieces on the Criterion Collection releases of his films, these ads become part of how Anderson constructs and curates his oeuvre. In 2007, Devin Orgeron rightly noted Anderson's use of DVD extras in his Criterion releases to construct his persona as an auteur, and Anderson has continued this strategy with subsequent rereleases by Criterion of *Bottle Rocket* and, more importantly for my point, *The Darjeeling Limited*, which includes Anderson's American Express ad. Anderson's explicit use of pastiche in his ads—whether of Truffaut, Cassavetes, or

Tati—asserts a particular kind of cinematic knowledge that locates these ads in film history and as part of Anderson's oeuvre.

The multiple addresses and purposes of these ads also helps explain how they created a brief furor as bloggers and Twitter users argued about whether Anderson had "sold out" by directing them.[4] Such arguments may seem strikingly naïve given the realities of commercial filmmaking, but the issue becomes more legible once one considers how Anderson's style in these ads display the object worlds and Oedipal thematics of his films disconnected from the construction of characters. Confronted by a series of intricately constructed worlds of commodity-desires motivated not by interiority or development but economic interest, viewers veered between discomfort and visual rapture. Blogger Colin Marshall's description of one of Anderson's Hyundai commercials nicely captures the problematic of visual and affective charge in Anderson's ads:

> Enthusiasts of his pictures' meticulous production design—as nearly every enthusiast of his pictures must be—will find plenty of opportunities to pause the video and marvel at the elements of the beleaguered father's house: the deep red oven knobs; the corner drum set; the vintage toy robots tucked here and there; the miniature helicopter; each kid's elaborate, inexplicable costume; the camera movement straight through the front wall, revealing the house's theatrical "cutaway" construction. The strangest element proves, ironically, to be the car itself . . . So many of us long to live in Wes Anderson's world, but the Hyundai Azera seems a highly unsuitable vehicle to take us there. You could probably drive it to a showing of *Moonrise Kingdom*, though. ("New Commercials")

As one might expect, Marshall sees Anderson's style as a mise-en-scène dense with strange objects imbued with a particular affective charge for viewers. By framing the car as the ad's "strangest element," Marshall does not so much reveal an irony as the convergence of the ad's logic with Anderson's style in a move that effectively completes the ad's rhetorical appeal: the car's banality is its strangeness and thus its connection to Anderson's seemingly more idiosyncratic object network. Anderson's ads reveal an overarching logic to his style as an exploration of productive tensions between commodity fetishism and highly personalized—in some ways, estranging—object cathexes. Marshall's imagined viewer pausing over such object-worlds leads us toward the potentials that Anderson's style may retain, but only insofar as one remains focused on the middle, before Oedipal, cultural, economic, and narrative closure.

Addressing Anderson through a psychoanalytic lens, then, directs us to closure and paternal authority, moments that are admittedly rife in Anderson's films. To connect Anderson's work to the social world, one has to find a

way to maintain the autonomy of the objects that populate his frame and to examine how they are subject to narrative inscriptions that turn social desires into family dramas. Deleuze and Guattari's work in *Anti-Oedipus* offers one way to link object-desires, paternal thematics, and the apparently elided issue of class in Anderson's films. In tracing movements of de- and reterritorialization, I want to highlight the importance not just of desire and desiring-production but also the importance—and ambivalence—of antiproduction in freeing, constructing, and controlling flows of desire. A revision of Freudian Thanatos, antiproduction becomes not a drive toward quiescence but instead a necessary and productive force that introduces breaks between desiring-machines, creating sites of primary repression as well as other "surfaces" on which social and subjective production can be recorded. Moreover, by creating autonomous zones from desire's initial connections, antiproduction introduces points of indetermination that open new potentialities.

With this concept, we can see the extent to which Deleuze and Guattari's approach differs from Lacanian psychoanalysis. First and foremost, antiproduction reconceives lack as something produced and distributed in specific historical and material conditions rather than an existential problem that results from the loss of the mother's body and the subject's ascension to language. Thus partial objects—desiring-machines—are not constitutively lost, determined by Oedipal desires, or separate from material history, but rather historically specific, productively autonomous, and able to enter into new, even potentially resistant, constructions. For an analysis of Anderson, the autonomy of prepersonal partial objects is of particular use because it emphasizes the realm of object-desires in Anderson's mise-en-scène without immediately subsuming them into Oedipal narratives. Indeed, what matters in an anti-Oedipal reading of Anderson is not simply that partial objects retain a certain autonomy, but that lack itself is reframed as socially produced and distributed rather than existentially present and yoked to the visual matrix of the family. This has particular ramifications for subjectivity: for Deleuze and Guattari, subjects are not constitutively confronted by an inaccessible Real but instead appear in particular conjunctures where antiproduction attempts to police desire. Oedipalization is the form of antiproduction suited to capitalism's capturing of value by unequal forces of de- and reterritorialization. Oedipus produces subjects in response to the abstractions of capitalism's social production. How? It not only insists that desire identify two abstract entities—Daddy and Mommy, male and female—but that it also renounce the one object it can find (the mother's body) while acceding to the demands of a nearly immaterial figure due to an inescapable threat of death (the father's injunction). Capitalism creates the Oedipal process to produce obedient ascetic subjects who defer their wants and obey their bosses by creating a forced class choice between the

oppressed mass of the mother's body and the oppressing authority of the father's command. Moreover, it localizes subject production in the nuclear family with the father as antiproduction's key figure separating desiring production and social production. The result suits a cultural conjuncture that insists work and desire are innately different rather than separated by particular material historical organizations.

Anderson's films essentially trace the edge between these decoded flows and an-Oedipal partial objects and capitalism's Oedipal recoding by juxtaposition of an object-dense mise-en-scène and narrative closure predicated on paternal thematics. By locating this tension, one can begin to interrogate questions of economics and class that his films solicit and refuse to engage in any depth. The crux in Anderson's films is the way paternity works as a knot of antiproduction to intersect with social desires and deflect engagement with economic issues. Social inequality seems a mere reflection of the characteristics of paternal figures who are often thieves (e.g., Mr. Henry [James Caan], Royal Tenenbaum [Gene Hackman], and Mr. Fox [George Clooney]) or liars (e.g., Steve Zissou [Bill Murray], Captain Sharp [Bruce Willis]). A Lacanian would likely identify these qualities with the obscene father, the obsessional's father who knows and gathers all pleasure to himself, or, in Žižek's words, "the obscene, uncanny, shadowy double of the Name of the Father" (*Enjoy Your Symptom!* 158). But we don't need to split the obscene father from the name-of-the-father in an anti-Oedipal reading: the Oedipal father figure is one of capitalism's paranoid and despotic figures of antiproduction and reterritorialization. Moreover, these partial objects do not need to be reduced to pieces of the mother's body, or even, as Stefano Baschiera has argued of *Darjeeling Limited*, the nostalgic replacement for a lost home. Indeed, such an approach resituates the dead father of *The Darjeeling Limited* as an extension of the problems posed by Anderson's other paternal figures, now explicitly as a figure bound up with global capital: his overbearing presence initially subsumes all pleasures in his sons' lives while giving them their privileged class position, including their ability to travel to India in search of their mother. The film's development follows the sons as they discover new objects and paths of escape by releasing old, paternally coded objects (e.g., car, luggage, sunglasses). If the father can be overcome in the abstract, though, the class position and power he represents cannot: the sons remain encased in upper-class privilege, emphasized by their experience as tourists in India and raised to a problematic level of metatextuality by Anderson's pastiche of Indian cinema.

Although there is no doubt that Anderson's films psychoanalytically interpellate their audiences into making peace with the loss of the mother's body and castration's inescapability—what I located in my earlier work as part of Max Fischer's call in *Rushmore* "to make a go of it"—part of their appeal lies in the way they retain lines of flight through the objects of

Anderson's visually dense and yet highly organized mise-en-scène. Anderson's ambivalent character studies are the result: on the one hand, these objects often bind characters to the family drama, and Anderson's regimented framing (e.g., stable frame line, limited camera movements, use of medium-length shots) emphasizes a tightly constructed and highly controlled world; on the other hand, these decoded flows introduce chaos into his plots and indirectly reveal the impact of economic and social production on subjectivity by connecting characters and audiences to nonfamilial subject groups of aesthetic producers. Indeed, Anderson's work plays with the tensions engendered by this fundamental incommensurability between forces of de- and reterritorializing in capitalism and the family. And, as Deleuze and Guattari often explain, artistic production itself operates by an unleashing of flows similar to the deterritorializing of flows by capital.

One particularly freighted set of objects encapsulates this tension between control and affective connection across Anderson's work: costume. Anderson consistently uses costume as a means for elaborating character and marking social types. *The Royal Tenenbaums*'s use of culturally coded clothing for each of the three children—the jogger, the tennis player, the bohemian model—at once signifies belonging and creates surfaces that play out the problem of self- and social construction (e.g., Richie Tenenbaum's [Luke Wilson] ritualized unmasking before attempting suicide). Much like Teufelsdröckh's philosophy in Carlyle's *Sartor Resartus*, Anderson intertwines clothing and subjectivity: costume expresses the minutiae of character not as interior essence but as exterior surface. As such, costumes are both affectively endowed objects and a means for constructing social surfaces; that is to say, they are objects of desiring-production and antiproduction, mapping in the diegesis how characters view themselves and are viewed, and how they connect to the historical-material world of nondiegetic reality. Not simply one kind of affectively freighted object among many in Anderson's films, costume is the object that most directly connects characters to who they are and to the outside world.

In this sense, his use of costume does not accidentally resemble Carlyle's; it rather takes up a representational technique from nineteenth-century literature: the social type. Anderson, however, uses social types to demarcate characters visually, emptying them into image and denuding types of historical and political significance. The results appear most clearly in Anderson's persistent use of uniforms, from Dignan's (Owen Wilson) bright yellow jumpsuits in *Bottle Rocket* and the school uniforms of *Rushmore* to the Zissou team uniforms in *Life Aquatic* and the train personnel's uniforms in *Darjeeling Limited*. Perhaps the most striking set of uniforms are those of the scouts and police in *Moonrise Kingdom*. In addition to marking social types, these uniforms also provide subjective surfaces on which objects coalesce and connect. Consider Sam's scouting uniform. Introduced

192 JOSHUA GOOCH

in montage, it offers an apparatus for engaging with an institution, an imagined wilderness, and a self: a felt flag on his canoe bears his scout number, his shirt carries the troop name in stitching, a primitive raccoon patch covers one pocket, and his deceased mother's broach and a painted button are attached to the shirt (fig. 4). Although the montage ends with this maternally freighted object, subsequent shots reveal it to be embedded in an aggregate of desiring-machines, from the mundane (horn-rimmed glasses) to the culturally signifying (coonskin hat and corncob pipe) (fig. 5). Moreover, the uniform's attempt at social inscription is ambivalent: Sam has

Figure 13.4 *Moonrise Kingdom*: The an-Oedipal objects of Sam's costume.

Figure 13.5 *Moonrise Kingdom*: Sam's costume acts as an assemblage.

resigned from the scouts, and his later acceptance by them forms a key plot point. If we understand objects in Anderson's films as potentially able to express desires that are social and not connected to Oedipus—and that his plots delay returning these desires to a proper paternal relation in order to explain the creation of art—then we can connect these desiring-machines to characters and the social world beyond the family, revealing machinic chains of desire that traverse objects and individuals.

Indeed, the majority of the film focuses not on the need to reassert the role of paternal authority—a concern localized in the film's adult characters—but on the play of male adolescent desire as it engages with objects attached to others, most especially the clothing and cultural assemblages carried by Sam and Suzy as they follow the Old Chickshaw Harvest Migration trail. This play of desire and potential reproduction in an ironic primal wilderness thus conjures the existence of native peoples, their role as cultural objects in the 1950s and '60s, and boomer nostalgia for those objects while blocking adjacent material, social, and historical virtualities by turning wilderness into a metaphor of adolescent desire. Clearly, the scout uprising in the film's third act prefers to be read as an anarchic play of desire—culminating in Sam and Suzy's faux wedding—rather than as a commentary on the dispossession of native peoples in America. However, its attempt to yoke specific objects and desires nonetheless threatens to conjure such countervailing flows of desire and resistance.

Suzy, and the objects attached (or not), most clearly conjures problematic virtualities for the film. Suzy carries objects of passive consumption and viewership, for example, records and books (fig. 6). Her binoculars

Figure 13.6 *Moonrise Kingdom*: Suzy's objects are largely those of passive consumption like this portable record player.

imply similarly passive desires, but as it is also the most important object to her as a character—the film's comedic third act frolic begins with Sam attempting to retrieve her lost binoculars from an injured foe—it may also form a contrasting object to Sam's thick glasses. The film uses vision as a key mechanism for navigating the new object-worlds Sam and Suzy bring to one another, most especially in its use of different modes of the gaze to convey desire: Suzy surveying the island from her lighthouse for signs of Sam (and her mother's infidelities), and Sam squinting through his glasses as he paints Suzy in a state of undress on the beach. Yet while this use of vision seems to connect these two in flows of objects, perhaps most especially of the body of the other, they also effectively limit Suzy to a passive role that reiterates her scopic status in the film. At best, one might argue that Anderson means to establish a dialectic of scopic relations by representing an active female viewership; however, Suzy's passive reception of cultural objects, Sam's active construction of them, and the alignment of painting with filmmaking in the closing shot undermines such an argument.

This active play of objects thus also traces the emergence of a form of antiproduction, not only in this problematic return of the scopic but also with the return of the paternity narrative and its subsequent limiting of desire to artistic production. We can see this in the film's climactic storm, which stages a confrontation between desire, cast as renewing and creative forces, and social control, to reassert the power of institutional and Oedipal structures. Yet desire isn't lost; rather, Oedipus yokes desires to social and institutional structures that benefit the social and material world: the bumper corn crop brought by the storm, Sam's adoption, and the retreat of these two adolescents into the consumption and production of cultural

Figure 13.7 *Moonrise Kingdom*: As part of the film's thematics of policed desire, Sam swaps his Scouts uniform for that of his adopted father.

objects. Sam's clothing here offers the film's narrative matrix in addition to his character: the family as social institution replaces the desire for connection and escape as Sam trades in his scouts uniform for the black-and-white lines of the Island Police (a uniform replicating that of his adopted father) (fig. 7). Paternity and mise-en-scène join forces to police desire.

Nowhere is this clearer than in the film's closing sequence, which repeats and reverses the film's opening shot to reveal Sam in the position of the director. Although he has the social sanction to be with Suzy in the family home, and, indeed, to paint her, Sam has chosen not to paint a less scandalous version of Suzy, or any kind of picture of her at all. Instead, he has painted the isolated beach where they kissed, with the words "Moonrise Kingdom" added in rocks (fig. 8). Anderson thus emphasizes the connection between film and diegetic artistic production by cutting from the painting to a shot of the beach, which now replicates Sam's painting in contrast to earlier establishing shots (fig. 9); moreover, he does so with an uncharacteristic edit, a dissolve, which formally signals the image's non-diegetic character. It is a captured image of desire lost yet saved by art. Oedipal forces have canalized desire into the production of more objects.

It is in this valorization of object production and desire that one can most clearly see the resonances between Anderson's filmmaking and the structure of capital. This is not to claim Anderson as an auteur of reification so much as an especially vexed case of an auteur confronting, however accidentally, a confrontation between his self-construction and his historical and material ground in the continued play of desire's movement of de- and reterritorialization.

Figure 13.8 *Moonrise Kingdom*: In place of his earlier painting of adolescent desire, Sam substitutes a representation of its scene in the film's concluding sequence.

Figure 13.9 *Moonrise Kingdom*: To emphasize the connection between art, cinema, and the capture of desire, the film ends with a dissolve from Sam's painting to this shot of the beach.

Notes

1. Internet pop-culture columnists not only spot these intersections, but they also help promulgate these stylistic tics by highlighting (and sometime attempting to shame) them. *Slate* seems particularly Anderson-focused. See Venture and Haglund.
2. Such a seemingly ambiguous narrative strategy, however, is far from new. Critics of Anthony Trollope are familiar with such distancing irony in his use of what Ruth apRoberts calls his "dual vision," a move from the distant ironic voice of Trollope's narrator while viewing a character to a suddenly close and sympathetic focalization through the just ironized character.
3. Anderson worked with the same art director, Adam Stockhausen, for *The Darjeeling Limited*, *Moonrise Kingdom*, and his ads for Hyundai and AT&T. See Murphy.
4. The web provides an interesting snapshot of this argument because of its existence as an online debate. The commentary thus extends beyond the authors cited themselves and includes the sometimes extensive blog commentaries (most especially on *The Guardian*'s site). For articles and comments, see Brody, Michael, Marshall, Wickman.

Works Cited

apRoberts, Ruth. *The Moral Trollope*. Athens, OH: Ohio UP, 1971. Print.
Baschiera, Stefano. "Nostalgically Man Dwells on This Earth: Objects and Domestic Space in *The Royal Tenenbaums* and *The Darjeeling Limited*." *New Review of Film and Television Studies* 10.1 (2012): 118–31. Print.

Brody, Richard. "Wes Anderson: Classics and Commercials." *The Front Row. The New Yorker*, March 8, 2012. Web. January 31, 2013.
_____. "The Anderson Redux." *The Front Row. The New Yorker*, March 16, 2012. Web. January 31, 2013.
_____. "Voyage to India." *The Darjeeling Limited*. The Criterion Collection. 2010. Print.
The Darjeeling Limited, directed by Wes Anderson. Touchstone, 2007.
Carlyle, Thomas. *Sartor Resartus*. Edited by Kerry McSweeney and Peter Sabor. Oxford: Oxford UP, 1987. Print.
Dean-Ruzicka, Rachel. "Themes of Privilege and Whiteness in the Films of Wes Anderson." *Quarterly Review of Film and Video* 30.1 (2013): 25–40. Print.
Deleuze, Gilles, and Felix Guattari. *Anti-Oedipus: Capitalism and Schizophrenia*. Translated by Robert Hurley, Mark Seem, and Helen R. Lane. Minneapolis, MN: University of Minnesota Press, 1977. Print.
Fantastic Mr. Fox, directed by Wes Anderson. Twentieth-Century Fox, 2009.
Freud, Sigmund. "On Narcissism." In *The Standard Edition of the Complete Psychological Works of Sigmund Freud, Volume 14 (1914–1916): On the History of the Psycho-Analytic Movement, Papers on Metapsychology and Other Works*, translated by James Strachey, 67–102. London: Hogarth, 1964. Print.
Gooch, Joshua. "'Making a Go of It': Paternity and Prohibition in the Films of Wes Anderson."*Cinema Journal* 47.1 (2007): 26–48. Print.
Haglund, David. "The Worst Wes Anderson Inspired Ad Yet?" *Slate*, December 28, 2011. Web. January 31, 2013.
Marshall, Colin. "Wes Anderson's New Commercials Sell the Hyundai Azera." *Open Culture*, March 7, 2012. Web. January 31, 2013.
_____. "Has Wes Anderson Sold Out? Can He Sell Out? Critics Take Up the Debate." *Open Culture*, March 19, 2012. Web. January 31, 2013.
Michael, Chris. "Why Wes Anderson's Car Ads Are Sellouts." *Film Blog: The Guardian*, March 16, 2012. Web. January 31, 2013.
Moonrise Kingdom, directed by Wes Anderson. Universal, 2012.
Murphy, Mekado. "Below the Line: Designing *Moonrise Kingdom*." *The Carpetbagger: The Awards Season Blog of The New York Times*, January 16, 2013. Web. January 31, 2013.
Nudd, Tim. "10 Great TV Spots Directed by Wes Anderson." *Ad Week*, April 3, 2012. Web. January 31, 2013.
Olsen, Mark. "If I Can Dream: The Everlasting Boyhoods of Wes Anderson." *Film Comment* 35.1 (1999): 12–14, 17. Print.
Orgeron, Devin. "La Camera-Crayola: Authorship Comes of Age in the Cinema of Wes Anderson." *Cinema Journal* 46.2 (2007): 40–65. Print.
Sconce, Jeffrey. "Irony, Nihilism and the New American 'Smart' Film." *Screen* 43.4 (2002): 349–69. Print.
Swann, Adam. "What Wes Anderson Can Teach Us About Advertising." *GyroVoice* (blog). *Forbes*, May 24, 2012. Web. January 31, 2013.
Thomas, Deborah J. "Framing the 'Melancomic': Character, Aesthetics and Affect in Wes Anderson's *Rushmore*." *New Review of Film and Television Studies* 10.1 (2012): 91–117. Print.

Venture, Elbert. "The Ubiquitous Anderson: *The Brothers Bloom* and the Problem of Wes Anderson's Pervasive Influence." *Slate*, May 21, 2009. Web. January 31, 2013.

Wickman, Forrest. "There's Still Such a Thing as 'Selling Out.'" *Slate*, March 9, 2012. Web. January 31, 2013.

———. "A Delightful Wes Anderson Ad (That's Not a Sellout)." *Slate*, March 22, 2012. Web. January 31, 2013.

Žižek, Slavoj. *The Ticklish Subject: The Absent Centre of Political Ontology*. New York: Verso, 1999. Print.

———. *Enjoy Your Symptom! Jacques Lacan in Hollywood and Out*, revised edition. New York: Routledge, 2001. Print.

14

Systems Thinking in *The Life Aquatic with Steve Zissou* and *Moonrise Kingdom*

Laura Shackelford

Wes Anderson's films are preoccupied with his characters' and their postmodern cultures' vexing relations to the material world and nonhuman animals. So clearly central to *The Life Aquatic with Steve Zissou* (2004), these concerns remain a thoroughgoing component of *Fantastic Mr. Fox* (2009) and *Moonrise Kingdom* (2012). The films confront us with the question of where and how we draw or unwittingly run up against these boundaries between our fictions, our significantly fictive selves and forms of social life, and the material and nonhuman worlds against and through which they unfold. As characters self-consciously negotiate tenuous, shifting distinctions between the natural, cultural, and technological, they reveal the boundaries between natural and cultural or human and nonhuman domains in contemporary, technologically dense lifeworlds are far from absolute, contrary to what humanism inculcates. Instead, it is through discrepant modes of observing, identifying, and disidentifying with, adhering to, and renegotiating such contingent boundaries between human selves, social systems, and their nonhuman animal and material environments that characters' life trajectories and social interactions emerge. Think of young Suzy Bishop's (Kara Hayward) remarkable costumed appearance as a raven in the opera *Noye's Fludde* in *Moonrise Kingdom*, Sam Shakusky's (Jared Gilman) careful remapping of the island's wandering coastline, and the account of a storm of the century (rivaling Noah's flood) in the scenes that frame this retrospective narrative of first love. While they might seem to be playful foreshadowings of the movie's climactic flood scene, it's worth reconsidering how these charged

relations between human subjects, social systems, and their unpredictable nonhuman environments dynamically inform characters' intersubjective life in Anderson's films.

Returning to *The Life Aquatic with Steve Zissou*, its references to post-World War II sciences of cybernetics, information, and systems theory and their continued late-twentieth-century influence on American digital cultures is notable. Giving a tour of his research ship early in the film, Steve Zissou (Bill Murray) comments that the *Belafonte* is "a long-range missile sub hunter he bought from the US Navy," and, apparently, the two cybernetic "albino dolphin scouts" (connected to the ship through two-way radio transmitters and equipped with head-mounted surveillance cameras) came with the ship. In a later scene, Zissou asks his shipmate Vladimir Wolodarsky (Noah Taylor) to signal the dolphins, saying, "Let's just see if you can get one of these dolphins to swim under the hull and give us a look." Not getting the desired response, Wolodarsky says, "Nah, either they can't hear us or they don't understand," a view wholly undercut by the dolphins' responsive, expectant, playful swimming toward the underwater cameras. Zissou's vexed reply, "Son of a bitch, I'm sick of these dolphins," is one of a series of wry commentaries the film provides on the unexpected effects of postwar cybernetics and other attempts to stabilize and instrumentalize humans relations to nonhuman animals and material lifeworlds, efforts which significantly destabilized the boundaries they intended to secure. The film references this scientific backdrop of postwar cybernetics, which designed informational relays to traverse human,

Figure 14.1 *The Life Aquatic with Steve Zissou*: Communicating with cybernetic "albino dolphin scouts."

nonhuman animal, material, and technological domains. These inquiries into the relations between biological, material, social, and technological systems and the processes through which they coemerge initiated a *systems thinking* that continues to catalyze a wide range of informatic, process-based, recursive systems in fields of biomedicine, computer, and cognitive science in digital cultures today, though more often serving as an unremarked, "technological unconscious" (Thrift 212). These sciences' abilities to link human, nonhuman animal, technological, and material environments calls into question the boundaries of the human, previously believed to secure the human's autonomy and superiority. This context subtly prompts *The Life Aquatic*'s exploration of how the human and shifting modes of social life emerge through their vexed, ongoing differentiation from a larger and unknowably complex material world and from the other (nonhuman) animals that cohabit that world. The film inquires into the resulting, emergent understanding of the human in ongoing coevolution with the human's material and technological late-twentieth-century environments and its destabilization of the gendered and racialized distinctions that guide our intersubjective life. What I, therefore, describe as the film's *systems thinking* is particularly interested in how film, alongside other low- and high-tech media, participates in the ongoing (re)enactment of historically and culturally specific modes of gendered and racialized human subjectivity and social forms: its interest in how these media selectively enframe and elaborate on our material lifeworlds and selves in distinct ways that inform that social life and its potential relations to a more complex material world. While analyses of *The Life Aquatic* are sharply polarized, tending to divide along lines recommending we either identify or disidentify with Steve Zissou in light of the troubling legacies of white, patriarchal, heterosexist, liberal humanist masculinity he both reiterates and, to a lesser degree, redirects, it is equally important to register the film's pointed observation of the *processes* through which such modes of gendered human intersubjectivity and their relations to material lifeworlds are inconsistently though persistently reproduced. The film's insight into the simultaneous openness and closure of the human and human social forms, and the dynamic modes of gendered and racialized intersubjectivity they open onto or foreclose, adds an additional, quite important dimension to any momentary take on the human as embodied, for better and worse, in Steve Zissou.

One of the most obvious ways in which *The Life Aquatic* reexamines these unstable boundaries between human social systems and their material environments is through its interrogation and practice of filmmaking as a mode of world building. It reflects on the processes through which film, documentary film, literary narrative, and other media establish their fictional worlds

by differentiating the storyworld from a larger discursive and material environment. Describing "Wes Anderson's Worlds," Michael Chabon compares his films, as "scale models" or "miniatures" of the world, to a Joseph Cornell box that functions as "a gesture—it draws a boundary around the things it contains, and forces them into a defined relationship, not merely with one another, but with everything outside the box." Anderson is, thus, concerned with the film as miniature box and frame that contains and excludes, yet especially with the relation this establishes with the *extrafilmic world*.

Not content to make this artistic gesture and move on, *The Life Aquatic*'s opening scene inaugurates a proliferating series of storyworlds embedded within storyworlds. A thoroughly melancholic oceanographic explorer, Steve Zissou attends the screening of his documentary film depicting the traumatic death of his closest friend, Esteban du Plantier (Seymour Cassel), in a fatal jaguar shark attack. This embedding of Zissou's documentary nature film within Anderson's film initiates the ongoing incursion of storyworlds into other storyworlds in the film, which destabilizes the line between diegetic levels within the film as well as between the film and its outside-world contexts. The film marks its world-building potential to define and realize a storyworld, suggesting not only how our storyworlds enter into our material environments, but the inverse as the jaguar shark is clearly an uninvited guest in Zissou's documentary, for instance, and catalyzes his subsequent life trajectory.

As if the documentary film within the fictional film were not enough to destabilize the film's fictional boundaries and conflate the levels on which events occur, Zissou's aquatic team doubles French oceanographic explorer and documentary filmmaker, Jacques Cousteau, replicating his team's trademark red caps and matching blue jumpsuits, and even indexing Cousteau's tragic loss of his son Phillippe in a flying-boat crash. It reveals how our at once discursive and material worlds enter into our storyworlds and our storyworlds, in turn, reenter our discursive and material lifeworlds, turning inside out like a Möbius strip or the opening of a string of nested Russian-doll boxes that refuse to spare historical events and individuals from this winding, circular, recursive process of embedded world building.[1] When Zissou's adopted son, Ned (Owen Wilson), complains he is treated as if he's only a "character" in Zissou's films, we share his discomfort at this blurring of lines between the documentary film and events in Anderson's film. Though not at all reassured by Zissou's reply that "It's a documentary. It's all really happening," we are forced to acknowledge that the absolute distinction we desire between ontologically distinct, fictive and real worlds is a bit more complicated; we also need to register their frequent, complex redoubling. The film willfully confounds us by transgressing such boundaries between filmic inside and outside. As

Ben Winters notes, even sonic elements participate in this transgression as the Team Zissou members listen to music piped into their scuba gear that merges with what we might have assumed to be the soundtrack of the film (54).

Confounding our ability to stabilize the boundary between the film's inside and outside, *The Life Aquatic* reconceives world building, filmic and otherwise, as an ongoing process. We might even claim there is no final frame to the film that securely ends its world building. Critics such as Mark Browning suggest that the film comes full circle, opening and closing with a premiere at the "Loquasto" film festival. Yet close attention to *The Life Aquatic*'s final scene featuring Team Zissou along the seaside—including the now deceased Ned—reveals that we are watching a prerecorded scene from the conclusion of Zissou's documentary film, not the end to Anderson's film, which paradoxically relocates *The Life Aquatic* within Zissou's documentary.

In this way, *The Life Aquatic* flags its concern with the ongoing production and reproduction of variously fictional worlds and the lifeworlds through, in, and against which they unfold. The film's self-referential concerns with filmic world building, if read in relation to its systems thinking, can be understood to explore how film and other media serve as a means through which human cultures and their social systems realize a highly contingent set of relations to their material and nonhuman worlds by selectively engaging with and, thus, reductively enframing them. Through their media-specific circumscriptions, our descriptions of the world—filmic, documentary, literary, televisual, animated, scientific, and sonic, among others—set momentary parameters on and, thus, complexly enter into human social systems' ongoing, unfolding relations to that world.

One might easily and convincingly argue that *The Life Aquatic*, like postmodern cultures, takes its world-building proclivities too far, reducing material lifeworlds and nonhuman animals to mere literary, filmic, and social fictions. The film undoubtedly indexes the increasingly symbolic character of postmodern culture and its late-capitalist, digital-information economies. The proliferation of symbolic simulations without any clear relation to an ontological real is a familiar feature of contemporary digital cultures. Through its excessive unreeling of recursive fictions, *The Life Aquatic* seems to situate us amid this discursive "life aquatic" of digital cultures, melancholically dog-paddling alongside Zissou. It depicts a material world thoroughly overcoded, if not wholly eclipsed by the human cultures it engenders, a world in which "the natural world's been turned upside down," to borrow Zissou's phrase. He is describing the "Arctic night-lights," referencing the northern lights' momentary reversal of night and day, but this phrase resonates with the film's concern that the relation between nature and culture has been inverted in postmodern cultures, granting

human cultures and their symbolic capacities, not nature, the apparent power to originate a world.

Invoking this perspective on postmodernism as "the end of nature" (McKibben), as entailing a wholesale reduction of material lifeworlds to our current digitized, informational frame, the film considers whether Steve Zissou and, by extension, postmodern cultures might be living within and fatally trapped by their own symbolic projections (of projections). The juxtaposition of Henry Selick's computer-generated, stop-motion animations of imaginary sea life alongside filmed sea life initially seems to reinforce our Disneyfied and virtualized relation to nonhuman animals and material lifeworlds, as manipulable and commodifiable digital information. The fantastic, hybrid names of the animated sea life—"jaguar shark," "crayon ponyfish," and "electric jellyfish"—accentuate their status as wholly symbolic cultural constructions, from this perspective. Nothing in this seascape is real anymore (Zissou's doubling of Cousteau included), and this appears to trap our protagonist in an endless, recursive spiral of self-referential societal and individual projections.

The film unfolds a pointed critique of Zissou's and, by extension, contemporary American culture's absorption in self-generated symbolic fictions. Recurring shots of the ship's round portholes and references to bounded, self-enclosed entities such as the ship, its submarine, and a private island owned by Zissou's wife, Eleanor (played by a cool Anjelica Huston), which repeat themselves to comic effect, reinforce the omnipresence of self-referential logics and practices. Zissou's character epitomizes the fatal flaws in such narcissistic self-absorption with one's own, largely self-projected image. Surrounding himself with an elaborate array of Zissou Society spinoffs (including Adidas shoes and action figures), it's not at all clear whether Zissou himself can tell the difference between these and events in his life. This is made all the more pathetic by the fact that his commodified image is now in peril, financial support for his films and the Zissou brand apparently dwindling. The film ironically comments on Zissou's claim that he is a "dying species." Nostalgically watching an old episode of their documentary television series in which they dramatically rescue a "wild snow mongoose," Zissou and his second-hand man, Klaus Daimler (Willem Dafoe), mourn the good old days when they had real adventures. The subtext to this decline is clearly that this lineage of white colonialist gentleman-explorers—perpetuated by Alistair Hennessey (Jeff Goldblum)—finds itself out of a job, in part due to the devastating environmental consequences of precisely the self-absorbed anthropocentrism they display. While Zissou remains too self-involved to see this, the fact that the jaguar shark that he plans to murder to avenge his friend's death is, itself, on the endangered species list and much of the sea life the team

documents are animations, not filmed sea life, intimates the dire environmental consequences of postmodern American culture's self-referential tendencies.

Zissou's journey to recapture the jaguar shark that eludes his understanding and control is initially motivated by a desire to recapture his former glory as the adventurous master of these increasingly discursive, unpredictable seas and to reestablish the previous world of masculine adventure and conquest. Through this return to what he perceives as a more primordial "life aquatic," he intends to reestablish the primacy and difference of the human through his conquest of the natural world. He actually plans to blow up the jaguar shark with dynamite to avenge his friend's death and, symbolically, to reinstate the species divide that defines modern liberal humanism and its anthropocentrism, reestablishing the human through its violent differentiation from the nonhuman animal. This megalomaniacal effort to resecure and resolidify the autonomy and mastery of the human in contradistinction to nonhuman animals and the material environment is a familiarly American mode of white heterosexist masculine subjectivity, one adapted straight out of a long lineage of American sea tales, Herman Melville's *Moby-Dick* preeminent among them. In her article, "The Life Aquatic of Melville, Cousteau, and Zissou," Carol Colatrella unpacks the film's multiple, complex references to sea tales such as *Moby-Dick* and to sea captains.

Initially aligning Zissou with the infamous Ahab, the film proceeds to identify a bifurcation in this discourse of the white masculine human's relations to his nonhuman and material lifeworlds in late-twentieth-century American culture. This alternate trajectory is apparent in Zissou's transformation near the end of the film and parallels a broader cultural destabilization and rethinking of the human's self-reference, autonomy, and interrelations to material and nonhuman animal lifeworlds, an unexpected outgrowth of post–World War II cybernetics. As mentioned above, cybernetics was initially conceived as a means of establishing and extending human control and maintaining a stable, homeostatic, closed system through its establishment of mechanical and informational feedback loops between humans, animals, machines, and their environments. It pursued precisely the kinds of absolute, exceptional autonomy of the human through the instrumental control of the material environment that Zissou exhibits as he sets out to detonate the shark. Studying recursive feedback loops in both mechanical systems and in self-reinforcing biological, psychological, and social processes, researchers soon realized that the circularity of such feedback loops does not necessarily secure the human's instrumental control. Instead, they noted that in systems comprised by a recursive feedback loop, like a furnace thermostat or human autonomic responses, A causes

B *and* B causes A at once: the room temperature causes the furnace to produce heat, and the furnace heat causes the room temperature to increase; or, in the second example, stress over a social conflict causes one's heart to race, or one's racing heart causes one to feel stressed about a social conflict.

This paradoxical self-reference of circular systems whose output is their input, and vice versa, led second-order cyberneticists—Chilean biologist, Humberto Maturana, and his student, philosopher Francisco Varela—to redescribe the self-referential, circular feedback loops living systems use to sustain their operations as processes of *autopoiesis*, or self-making (47). They argued that autopoietic systems as varied as a cell or human cognition rely on a self-referential distinction between system and environment to reproduce the system by differentiating it from an unmanageably complex environment, and, in this way, they are selectively enacting and "bringing forth a world" (Maturana and Varela 11) by routinizing a set of relations to their environment through their system-specific operations and second-order observations. Later extending this thinking about recursive, autopoietic systems to include social as well as biological systems, second-order cyberneticists' systems thinking suggested how ongoing processes of system formation that rely on highly contingent boundaries between biological organisms, human subjects, social systems, and their environments do not involve the absolute closure or autonomy of either the human or the social from a more complex material environment. Instead, they indicate how the process of drawing a boundary and differentiating the system, while instituting a mode of selective closure that marks the system inside against its outside, simultaneously allows that system to establish and realize a specific set of relations to that lifeworld, to bring forth a world through that reciprocal, contingent interrelation. With this principle of openness from closure, as Niklas Luhmann describes it, such systems thinking reconceives the relations between social systems' insides and outsides as a recursive, ongoing *process* (rather than a stable opposition). Social systems and subjects differentiate themselves from their unmanageably complex environmental "outside," yet through this ongoing, dynamic, self-referential closure are able to establish a kind of openness in that this distinction provides the system with a selective way of engaging this over-complex environment and developing interrelations with it and with other systems in the environment.

This systems theoretical account of recursive, self-referential processes as a dynamic, highly contingent means through which the human, subjects, and social systems differentiate themselves from a larger nonhuman animal and material environment, yet in doing so establish a dynamic set of relations to them, sheds significant light on Zissou's transformation and the film's reflection on shifting understandings of the human in contemporary

technological seascapes. Zissou's interactions with the cybernetic dolphin scouts, cited above, and his character's transformations directly index this systems thinking about self-referential, recursive processes and its consequence to how we think about the human's potential interrelations to a broader material environment. These are cybernetic dolphins who, according to Wolodarsky *either fail or refuse to listen to and understand* Zissou's electrotransmitted commands to survey the hull of the ship. When the film cuts to the two screens providing black-and-white images from the ship's underwater surveillance cameras, the dolphins engage their human audience, swimming engagingly toward the camera and suggesting lack of understanding is *not* the reason they do not follow Zissou's commands. This scene seems to directly parallel cyberneticists' realization that the insular, instrumental networks of human control they intended to establish through these networks of communication between species and their material environments, as a result of this recursivity between human, nonhuman animal, machine, and environment, quickly turn into mutually transformative interrelations that are far less predictable.

This humorous scene anticipates Zissou's subsequent recognition of the agency of a lifeaquatic of nonhuman animals and material forces that he cannot anticipate, understand, evade, or control, much to his chagrin. The life aquatic's unsettling agency is amplified in the film by additional shots depicting the dolphins or sea orcas gazing through the ship's portholes, observing events from their own, nonhuman perspective and confronting the viewer with their intelligent gazes. Over the course of his search for the enigmatic jaguar shark, Zissou slowly comes to realize and come to unsettling terms with a life aquatic that serves as a more complex figure for the nonhuman animals, material complexity, and the temporal force of evolution on human animals and their social life. He seems to recognize his own coimplication within the life aquatic, the material force of evolutionary time through which human animals (alongside their nonhuman counterparts) and social systems reiteratively distinguish themselves from a broader, more complex environment (no longer seen in wholly oppositional terms as Other).

While Steve Zissou initially mourns the loss of real adventure, perceiving the natural world as a wholly inaccessible outside, viewers can see the myriad ways in which he is being worked over, taken up, and transformed by the experiential, material force of evolutionary time he imagines completely eradicated or overcome. *The Life Aquatic* foregrounds these barely perceptible, shifting modalities of the human, changes that are continually taking place at a nonconscious operational level and not easily perceived. In the opening scene, Zissou tells his wife, Eleanor, "I'm right on the edge; I don't know what comes next," which registers his ongoing evolution, his subtle alteration and refiguration in this processual "real time." This is the

first in a series of references to the process of life and experiential time that flag the emergent, ongoing processes of change, variation, and drift that inform and deform life—the trademark of biological and cultural evolution. Fittingly, part 1 of Zissou's film is described as a "cliffhanger," he gives all his student interns "incompletes," and a Portuguese adaptation of David Bowie's "Changes" is being sung by Pele dos Santos, a Brazilian member of the Zissou Team (Brazilian singer Seu Jorge) in case one fails to register the force and impetus of evolutionary and cultural processes towards variation, unpredictability, and mutation.

"Nobody knows what's going to happen next, and then we film it; that's the whole concept," he later reminds his crew members. While this suggests that nature documentaries are designed to capture the unexpected turns and surprises characteristic of evolutionary time, writ small, this processual logic opens onto an alternate understanding of the human in the film. Reconceiving the self-referential processes that involve the human animal in a series of ongoing, coproductive (if unknowable) interrelations to the life aquatic, the film shifts attention onto the subtle forces of time in the service of evolutionary change. If we accept that "the natural is *not* the inert, passive, unchanging element against which culture elaborates itself but the matter of the cultural, that which . . . ensures that the cultural, including its subject-agents, are never self-identical," as philosopher Elizabeth Grosz argues in her feminist rereading of Darwinian evolution, then Zissou can be understood to encounter the "nature of culture," the complicity of the natural and the social, and the change and difference that are a consequence of these mutually dynamic interchanges (47, 43). From this vantage, the stop-motion animated sea life might be perceived as the latest in an expanding series of nature-culture hybrids, not simply a sign of the wholly virtual status of material lifeworlds in postmodernism.

Initially outraged by the forces escaping his understanding and control, Zissou slowly begins to embrace the dynamic, subhuman force and unpredictability of nature, or life aquatic, in which he participates, opting to pursue the open-ended, processual (though not unmediated) dimensions to human subjectivity and cultural forms in open defiance of liberal humanism's penchant for individualist closure and its absolute boundary between human culture and nature. Though he retains his recalcitrant traits and his transformation is appropriately incomplete, even unsatisfactory, near the end of the film Zissou's character reveals (even if he is unable to adequately pursue) the relations of continuity, the shared involvement of human subjects and cultures along with nonhuman animal others in evolutionary processes. His turn to embrace an understanding of the human in an ongoing process of evolutionary becoming reaches its peak at the close of the film when he recognizes a kinship with the nonhuman animal other, the

Figure 14.2 *The Life Aquatic with Steve Zissou*: Underwater in the *Deep Search*.

jaguar shark he initially set out to murder with dynamite. In this scene, he and the entire cast are underwater in the *Deep Search* submarine, explicitly signifying his realization of his shared, yet distinct, coimplication in the material force and unpredictable adventure of evolutionary time—notably alongside nonhuman animals, his motley crew, and the women and men he previously homophobically and misogynistically maligned as "bull dykes," "rich bitches," and "slick faggots." Agreeing not to kill the shark, and then asking if the shark "remembers him," Zissou recognizes a relation of continuity, as well as difference, between them. It is a kinship reinforced by his desire to "breathe underwater." Unbeknownst to Zissou, he is unable to reproduce. His wife, Eleanor, confides that he "shoots blanks" as a result of having spent half his life underwater, suggesting his transformative, cross-species affiliation with sea life at levels he cannot, as yet, fully actualize.

This shift in his understanding of the human as engaged in an open-ended conversation with the life aquatic is directly correlated with a shift in his understanding of potential social relations. Throughout the film, Zissou identifies with the sea as a place enabling more fluid, nontraditional social relations. He describes his relationship to his multinational crew as an ad hoc, hybrid alternate to the nuclear family's biological affiliations, noting, "We're a pack of strays," and explains to Ned, "I hate fathers and never wanted to be one." Disliking fathers is, of course, supremely oedipal, which suggests that Zissou's genuine efforts to avoid reproducing patriarchal white heterosexist masculinity have backfired and, combined with his egoism, have turned him into its best exemplar. It is not until after Ned's death and during the crew's shared submersion and encounter with the jaguar

shark that we see a more genuine opening of Zissou's character to nonoedipal, nonbiological kinship across difference as opposed to supporting a patriarchal logic of reproducing the same—that is, a patriarchal logic that relies on the subordination of the female, natural, and nonwhite Other to the name-of-the-father.

Zissou's coming to terms with the life aquatic and the at-once threatening and sublime jaguar shark is paralleled with his coming to terms with Jane Winslett-Richardson (Cate Blanchett), a plucky, pregnant journalist who adamantly spurns Zissou's sexual advances. During their first encounter, when she makes it clear she's not interested in him and begins to raise questions about his professional character, Zissou questions her sexual orientation, calling her a "bull dyke," and suggests to Ned she has something against them (and, presumably, men in general, as the stereotype goes). When Ned challenges Zissou's claim and notes that she is pregnant, Zissou stresses that unfortunately today "bull dykes can get pregnant too," underscoring the enhanced threat of women to patriarchal reproduction, thanks to biomedicine, in these contemporary seascapes. It is no coincidence that Zissou's eventual reconciliation with Jane and the jaguar shark coincide. As he acknowledges his affinities with this threatening nonhuman animal and accepts its agency and difference, he also relinquishes his need to dominate the female Other, Jane.

The film's alignment of this female character, nonhuman sea life, and the life aquatic deserves pause as it repeats a familiar, problematic equation of women with the material world. In the climactic scene of the film, Zissou and crew watch the wondrous jaguar shark from inside their tiny, womb-like submarine. Asking whether the jaguar shark remembers him, Zissou places his hand on Jane's near-term belly, explicitly linking the life aquatic of the primordial deep to that of the evolutionary past and future of the species.[2] This scene reinforces the film's interest in nonbiological modes of kinship as Steve is not a father to either mother or child, but it also seems to reduplicate an understanding of the proximity between women and the life aquatic and their shared status as the environment or stable, ontological ground for human reproduction.

It is here that the film's attention to the ongoing recursive processes through which human subjects and social systems differentiate between a series of lifeworlds' insides and outsides becomes especially important to register. While Jane and the life aquatic with which she is clearly aligned might be assumed to continue to serve as a stable ground or backdrop to (masculine) human social life, the scene refuses to position the life aquatic or the species' reproductive time as a clear or stable ground for Zissou's nostalgic, patriarchal reproductive fantasies, as an end to his "deep search." In fact, there is no end to Zissou's or the human's "deep search" once the human is

understood as always already involved in material and cultural processes of evolution, a process of becoming without origin or end. Elena Past, in "Life Aquatic: Mediterranean Cinema and an Ethics of Underwater Existence," reads the underwater scene similarly as marking a shift in Zissou's mode of relating to nonhuman animals and material worlds. She suggests this undersea immersion figures a space of possibility "beyond language" and the discursive reach of social systems' patriarchy, yet this reading reinstalls an opposition between human and material lifeworlds. Instead of figuring a space absolutely outside the social, the underwater scene is thoroughly and complexly coimplicated in a recursive, reciprocal process, as evidenced by the appearance of these nature-culture hybrids (the animated jaguar shark, Zissou and crew circumscribed within their submarine, and the future human within Jane's womb contained inside it). If we listen to the final track in the film, David Bowie's "Queen Bitch," whose lyrics chronicle one man's unrealized desire for another man who is about to pick up the cross-dressing "sister Flo," the film's inquiries into former and emergent understandings of human gender roles, sexualities, and their continual ungrounding over time become even more pronounced. In light of these ongoing, dynamic, desubstantialzing, material processes, we cannot easily decide who or what is the real "bitch" in such postmodern seascapes.[3]

The Life Aquatic's reconceptualization of human social systems and their self referential social and artistic forms, while thinking the human beyond humanism's oppositional terms, is, nonetheless, accompanied by a pervasive anxiety about this very destabilization of gender, race, sexuality, and the properly human. Chris Robé convincingly argues that Zissou's "entitled masculinity" is both put into crisis and nonetheless largely preserved (111). *The Life Aquatic* opens onto the possibility, even necessity, of abandoning the oppositional frame within which we think our relations to the material world and nonhuman animals and our gendered and racialized, heterosexist relations to other subjects, yet it remains reluctant or unable, as Zissou, to fully redescribe the human or to extricate it from the patriarchal white humanist legacies in which it remains enmeshed. At the level of its systems thinking, though, the film's exploration of these ongoing, reciprocal processes of "bringing forth a world" informing all of these coimplicated interrelations does suggest how we might self-reflexively observe such processes through its and our own filmic and other binoculars, lookouts, scale models, and observational lenses. Such scrutiny might afford more wholehearted pursuits of these openings in what might be perceived as stable, closed human social and subject forms to other ways of realizing their complex, selective interrelations to broader social and material worlds.

Set on an island, instead of a ship, *Moonrise Kingdom* continues Anderson's studies of society and its recursive, self-referential systems of reproduction

in microcosm. It is equally preoccupied with the processes through which its island community, once again notably circumscribed, negotiates these boundaries between human, nonhuman animals and their material environments. Importantly, the ongoing encroachments of the island community on their nonhuman inhabitants and material environments, as epitomized by the Khaki Scouts' domesticated relation to the "wild," are countered by the relentless challenge an unpredictable, comparatively fluid material environment poses to the social and its pretense to stability, as evidenced by the flood. The latter material forces, once again, appear to catalyze characters Suzy Bishop and Sam Shakusky's joint self-realization. At the film's end we remain hopeful that their idiosyncratic cross-identifications with ravens, a cat, a dog, the island's material topography, embedded history, and fantastic otherworldly heroines, coupled with their careful observation of their 1965 American social world, will allow them to extend the circumscribed, habituated confines of an orchestral array of rigid, gendered social forms—policeman, lawyers, social worker, switchboard operator, town librarian, scoutmaster, and Khaki Scouts—into new territory by quite literally re-marking the social's dynamic interrelations to the material world through which it unfolds.

Notes

1. Bruce Clarke provocatively suggests that narrative embedding may, in fact, serve as a way of reflecting on the actual recursive processes through which biological and social systems enframe and dynamically reproduce their boundaries, i.e., as "a textual analogue to systemic self-reference" (94) and system formation. It recommends, as does the film, the self-referential processes of differentiating inside from outside likely occur at levels well-beyond storytelling or human worldbuilding.
2. It is worth noting that evolutionary biologists are in agreement today that fish are humans' evolutionary ancestors.
3. There is a literal bitch, or female dog, featured in the film, though her status is fully ambiguous as Zissou names her "Cody," suggesting the thorough penetration of the natural world by informatic code, and she is three-legged as a result of a violent preadoption life with Filipino pirates, further troubling the usual binary understanding of this gendered term.

Works Cited

Bowie, David. "Queen Bitch." *The Life Aquatic with Steve Zissou—Original Soundtrack*. Hollywood Records, 2004. CD.
Browning, Mark. *Wes Anderson: Why His Movies Matter*. Santa Barbara, CA: Praeger, 2011. Print.

Chabon, Michael. "Wes Anderson's Worlds." *New York Review of Books Blog*. January 31, 2013. Web.

Clarke, Bruce. *Posthuman Metamorphosis: Narrative and Systems*. NY: Fordham University Press, 2008. Print.

Colatrella, Carol. "The Life Aquatic of Melville, Cousteau, and Zissou: Narrative at Sea." *Leviathan: A Journal of Melville Studies* 11.3 (2009): 79–90. Print.

Fantastic Mr. Fox, directed by Wes Anderson, written by Wes Anderson and Noah Baumbach, based on *Fantastic Mr. Fox* by Roald Dahl. November 25, 2009. Twentieth Century Fox, 2009. Film.

Grosz, Elizabeth. *Time Travels: Feminism, Nature, Power*. Durham, NC: Duke UP, 2005. Print.

The Life Aquatic with Steve Zissou, directed by Wes Anderson, written by Wes Anderson and Noah Baumbach. December 25, 2004. Touchstone Pictures, 2004. Film.

Luhmann, Niklas. *Social Systems*. Translated by John Bednarz Jr., with Dirk Baecker. Stanford, CA: Stanford UP, 1995. Print.

Maturana, Humberto and Francisco Varela. *The Tree of Knowledge: The Biological Roots of Human Understanding*, revised edition. Translated by Robert Paolucci. Boston: Shambhala Press, 1998. Print

McKibben, Bill. *The End of Nature*. New York: Random House, 2006. Print.

Melville, Herman. *Moby-Dick: or, The Whale*. New York: Penguin Classics, 1992. Print.

Moonrise Kingdom, directed by Wes Anderson, written by Wes Anderson and Roman Coppola. October 16, 2012. Universal Studios, 2012. Film.

Past, Elena. "Life Aquatic: Mediterranean Cinema and an Ethics of Underwater Existence."*Cinema Journal* 48.3 (2009): 52–65. Print.

Robé, Chris. "'Because I Hate Fathers, and I Never Wanted to Be One': Wes Anderson, Entitled Masculinity, and the 'Crisis' of the Patriarch." In *Millennial Masculinity: Men in Contemporary Cinema*, edited by Timothy Shary, 101–21. Detroit: Wayne State UP, 2013. Print.

Thrift, Nigel. "Remembering the Technological Unconscious by Foregrounding Knowledges of Position." In *Knowing Capitalism*, 212–26. London: Sage, 2005. Print.

Winters, Ben. "'It's All Really Happening': Sonic Shaping in the Films of Wes Anderson." In *Music, Sound and Filmmakers: Sonic Style in Cinema*, edited by James Wierzbicki, 45–60. New York: Routledge, 2012. Print.

Notes on Contributors

Joshua Gooch has published in *Cinema Journal, Wide Screen, Nineteenth-Century Contexts, LIT: Literature Interpretation Theory, Texas Studies in Literature and Language,* and *The Iowa Journal of Cultural Studies.* He is an assistant professor at D'Youville College in Buffalo, New York.

Lara Hrycaj is an Adjunct Instructor in Media Arts and Studies at Wayne State University and a Lecturer in Mass Communication at Hillsdale College. She recently earned her PhD at Wayne State University with her dissertation "What Is This Music?": Auteur Music in the Films of Wes Anderson. She has presented papers on Wes Anderson at several regional and national conferences, including the Musing and Moving Image Conference and the Society of Cinema and Media Studies Conference. She has provided a book review of *Film's Musical Moments* for *Scope.* In addition to teaching, Hrycaj is operations manager for WHFR-FM, Henry Ford Community College's noncommercial radio station serving the Dearborn-Detroit community.

Rachel Joseph is Assistant Professor of Theatre at Trinity University. She earned her PhD in Drama from Stanford University. She also has an MFA in Creative Writing and MA in Theatre Studies from the University of Arizona. Her current book project, *Screened Stages: Representations of Theatre within Cinema,* analyzes the relationship between reproducibility and theatricality as it occurs throughout the history of cinema. Her chapter "Chaplin's Presence" is in *Refocusing Chaplin* from Scarecrow Press. Her essays have been published in *Octopus: A Journal of Visual Studies* and *The Journal of American Drama and Theatre.* Two of her plays and a short story are forthcoming in the literary journals *Petrichor Machine, Scissors and Spackle,* and *Prime Number Magazine.*

Colleen Kennedy-Karpat is the author of *Rogues, Romance, and Exoticism in French Cinema of the 1930s* (Fairleigh Dickinson UP), winner of the Northeast Modern Language Association Book Award. She teaches film and media studies at Bilkent University in Ankara, Turkey.

NOTES ON CONTRIBUTORS

C. Ryan Knight teaches composition and literature at Randolph Community College in Asheboro, North Carolina.

Peter C. Kunze is a Lecturer in Writing and Critical Inquiry at the University at Albany, SUNY. His research interests include comedy, masculinity, and childhood across literature, film, and new media. His current research examines sincerity in contemporary American narratives and parallels between Australian and American cinemas.

James MacDowell is Assistant Professor in Film Studies at the University of Warwick and the author of *Happy Endings in Hollywood Cinema: Cliché, Convention and the Final Couple* (2013). He sits on the editorial board of *Movie: A Journal of Film Criticism* and is currently writing a monograph on irony in film for Palgrave MacMillan.

Jennifer O'Meara is a doctoral candidate in film studies at Trinity College Dublin, where her research focuses on verbal style in art cinema. Jennifer's writing has appeared, or is forthcoming, in *Verse, Voice and Vision: Poetry and the Cinema* (ed. Santos, 2013), *Cinema Journal*, *Literature/Film Quarterly*, and *Scope*.

Jen Hedler Phillis is a PhD candidate at the University of Illinois at Chicago. Her dissertation, "Lyric Histories," traces the appearance and disappearance of history in twentieth-century American poetry, arguing that the development of the historical in modernist and contemporary poetry mirrors economic developments both in the United States and Europe. She has presented work from her dissertation at the Marxist Literary Group Summer Institute and the New School for Social Research. She has also always wanted to be a Tenenbaum.

Nicole Richter is Associate Professor in, and Area Coordinator of, the Motion Pictures Program at Wright State University in Dayton, Ohio. Her work has been published in the *Journal of Bisexuality*, *Short Film Studies*, *Feminism at the Movies*, *Queer Love in Film and Television*, and *The Multimedia Encyclopedia of Women in Today's World*. She is on the Editorial Board for Short Film Studies and the Executive Committee on the Board of Trustees for Film Dayton. She teaches courses in philosophy and film, cinema and sexuality, authorship, animation, feminist film theory, and film history.

Steven Rybin is Assistant Professor of Film at Georgia Gwinnett College. He is the author of *Terrence Malick and the Thought of Film* (Lexington Books, 2011), *Michael Mann: Crime Auteur* (Scarecrow Press, 2013), and coeditor of *Lonely Places, Dangerous Ground: Nicholas Ray in American Cinema* (State University of New York Press, 2014). He is currently writing a book on the performance of courtship in classical Hollywood cinema.

NOTES ON CONTRIBUTORS 217

Jason Davids Scott teaches at Arizona State University; his areas of focus include film and theater history, performance studies, and popular culture. He has also taught at Stephen F. Austin State University in Texas and the University of California–Santa Barbara. Other published work includes essays on actors and acting in the early sound era, the career of Robert Downey Jr., and contributions to the *Cambridge Encyclopedia of Stage Actors and Acting*. He is a member of the board and film studies area chair for the Mid-Atlantic Popular and American Culture Association (MAPACA). Before returning to school to earn his graduate degrees, Scott worked in the film industry as an executive in the areas of public relations and feature-film development.

Laura Shackelford is Assistant Professor of English at the Rochester Institute of Technology. In *Tactics of the Human: Experimental Technics in American Fiction* (University of Michigan Press 2014), she examines literary experiments with early digital cultures of the 1990s as they comparatively retrace and speculate on the digital's transformative influence on prior understandings of the human, human social life, and human relations to material lifeworlds. The book explores the consequences of this apparent plasticity of the boundaries of the human, particularly for women, subaltern subjects, and others already considered liminally human. Current research extends these comparative media inquiries into dynamic subject-technology relations, or *technics*, focusing on electronic poetry as a minor mode of interface theory and a thick site for rethinking the relations between language and other multimodal signifying systems, code-based processes, digital technologies, and the affective orientations and intersubjectivities they unfold.

Kim Wilkins is a PhD candidate at the University of Sydney, Australia. Her work explores American eccentricity as a mode of contemporary American cinema that makes use of ironic expression, parody, and pastiche to express sincere anxieties.

Index

About Schmidt (2002), 130
Achenbach, Joel, 160
Ahluwalia, Waris, 131, 146
Aisenberg, Joseph, 14, 17, 110, 115, 120
Allen, Woody, 91
Anderson, Eric Chase, 72, 112, 136
Anderson, Paul Thomas, 154
apRoberts, Ruth, 196
Ariès, Philippe, 94

Back to the Future trilogy (1985–1990), 81
Badlands (1973), 181
The Bagthorpe Saga (1977–2001), 98
Balaban, Bob, 32, 60
Baldwin, Alec, 1, 32, 97
Baldwin, William, 115
Baschiera, Stefano, 19, 29, 84, 86, 91, 96, 166, 190
Baudrillard, Jean, 31
Baumbach, Noah, 4, 6, 103, 109–122
Beard, William, 162
Beaumont, Lady, 2
The Believer, 157
Bellamy, Ralph, 79
Bellow, Saul, 111, 121
Belmondo, Jean-Paul, 22
Benigni, Roberto, 17
Benjamin, Walter, 56
Bertolucci, Bernardo, 130
Beslon, Melchior, 22
Betts, Johnny, 122
Black, Jack, 112
Blanchett, Cate, 87, 93, 111, 129, 131, 134, 140, 155, 210

The Blue Lagoon (1980), 100
Bogdanovich, Peter, 91
Bonnie and Clyde (1967), 2, 181
Bordwell, David, 28
Borg, Björn, 85, 96
Boschi, Elena, 32, 115, 116, 122
Bottle Rocket (1994), 14, 15, 16, 17
Bottle Rocket (1996), 26, 29, 36, 42, 43–44, 47, 62, 83–84, 85, 86, 87, 92, 93, 96, 104, 109, 111, 114, 119, 125, 133, 135, 140, 155, 156, 162, 163, 181, 187, 191
Bourdieu, Pierre, 7, 174
Bowie, David, 7, 120, 140, 141, 142, 143, 144, 147–149, 208, 211
The Brady Bunch (1969–1974), 80
Brakhage, Stan, 80
Breathless (1960), 21
Brecht, Bertolt, 158
Breckinridge, Bunny, 135
Bridge to Terabithia (1977), 101
British Invasion, 35, 139
Britten, Benjamin, 2, 60, 92
Brody, Adrien, 26, 30, 47, 101
Brody, Richard, 103, 185
Broken Flowers (2005), 36, 136
Brooks, James L., 16
The Brothers Bloom (2008), 182
Browning, Mark, 1, 13, 14, 15, 17, 29, 68, 69, 97, 98, 99, 159, 203
Brütsch, Matthias, 13, 21, 23
Buckland, Warren, 4, 42, 105
Buñuel, Luis, 91, 130
Burnett, Frances Hodgson, 94
Burton, Tim, 135

Caan, James, 43, 83, 86, 190
Caddyshack (1980), 126, 136
Callahan, Liz, 61
Campbell, Joseph, 15
Cannes Film Festival, 4
Cardoso de Aguiar, Maria Luiza, 149
Carlson, Marvin, 82
Carlyle, Thomas, 191
Caruth, Cathy, 54–55
Cassavetes, John, 91, 187
Cassel, Seymour, 29, 34, 69, 86, 93, 139, 202
The Catcher in the Rye (1951), 2
Cavazos, Lumi, 43
Chabon, Michael, 52, 53, 54, 97, 103, 158, 166, 172, 201–202
Chabrol, Claude, 20
Chaffin, Donald, 99
Charlie and the Chocolate Factory (1964), 100
Charlie Bartlett (2007), 1
The Cherry Orchard, 173
Chion, Michel, 141, 143
Chitty Chitty Bang Bang (1968), 187
Christensen, Jerome, 3
Christmas in July (1940), 79
Citizen Kane (1941), 79
Clark, Beverly Lyon, 93, 105
Clarke, Bruce, 212
Clash of the Titans (1981), 99
Clooney, George, 3, 62, 72, 181, 190
Coats, Karen S., 94, 104, 105
Coffee and Cigarettes (1986), 14, 16
Coffee and Cigarettes (2003), 136
Colatrella, Carol, 82, 205
Colebrook, Claire, 166
Coleridge, Samuel Taylor, 2
Collins, Jim, 27, 35, 93, 105
Conner, Bruce, 80
Contempt (1963), 21
Coppola, Roman, 4, 118, 132
Coppola, Sofia, 7, 132, 136
Corliss, Richard, 3
Corman, Roger, 80
Cornell, Joseph, 53, 103, 158, 202
Corrigan, Timothy, 133, 149

Cousin Ben Troop Screening with Jason Schwartzman (2012), 14
Cousteau, Jacques, 2, 35, 82, 87, 93, 202, 204, 205
Cowie, Jefferson, 175
Cox, Brian, 32, 130
Crazy/Beautiful (2001), 36
Creation, 32
Cresswell, Helen, 98
Criterion Collection, 133, 135, 136, 148, 149, 187
Crouch, Ian, 6

Dafoe, Willem, 39, 73, 131, 134, 142, 204
Dahl, Roald, 93, 99–100, 102, 103, 111, 120
Dances with Wolves (1990), 105
Daniels, Jeff, 111, 120
Danny, the Champion of the World (1975), 102
The Darjeeling Limited (2007), 14, 15, 17, 22, 26, 29, 31, 33, 35, 36, 47, 85, 94, 125, 130, 131, 132, 155, 156, 157, 162, 164, 181, 183, 185, 187, 190, 192, 196
Davies, Sam, 26, 29, 31
Davy Crockett (1955), 87
Day for Night (1973), 111
Dazed and Confused (1993), 78
Dean, James, 85
Dean-Ruzicka, Rachel, 183
Delerue, Georges, 111
Deleuze, Gilles, 7, 182, 186, 189, 191
DeMille, Cecil B., 86
Dennis, Rob, 109, 110
The Descendants (2011), 130
Desplat, Alexandre, 4
Desplechin, Arnaud, 4, 92
Devo, 87
Disher, Christopher, 122
Diving for Sunken Treasure (1971), 82
Dogville (2003), 158
Dorey, Tom, 99, 100
Douchet, Jean, 20
Drake, Nick, 117

INDEX 221

Easy Rider (1969), 80
Ebert, Roger, 1, 82
Edberg, Stefan, 85
Edelstein, David, 39
Ed Wood (1994), 135
Eggers, Dave, 157, 160, 166
Eisenberg, Jesse, 111
Ektachrome, 25
Elsaesser, Thomas, 126, 136
The Empire Strike Back (1980), 81
E.T. the Extra-Terrestrial (1982), 80, 81
Eustache, Jean, 111
The Faces, 45

Fantastic Mr. Fox (2009), 3, 4, 48, 62, 72, 85, 91, 93, 94, 99–100, 102, 103, 109, 111, 112, 113, 114, 115, 116, 120, 121, 122, 155, 164, 165, 166, 181, 182, 185, 199
Faubourg Saint-Denis (2006), 14, 22
Felando, Cynthia, 13
Fernández, James W., 159
Field, Syd, 15
Field of Dreams (1989), 105
Fitzgerald, F. Scott, 92, 98, 104
Fleischer, Ruben, 136
Flynn, Richard, 94, 95, 105
Fowler, Shea, 43, 96, 155
Franny and Zooey (1961), 97
French New Wave, 20, 23, 111
Freud, Sigmund, 52, 53, 54, 55–56, 186, 189
From the Mixed-Up Files of Mrs. Basil E. Frankweiler (1967), 97
Frye, Northrop, 154

Gamble, Mason, 155
Garden State (2004), 1
Gare du Nord (1964), 14, 20
George, Jean Craighead, 98
Gerwig, Greta, 116
Ghostbusters films (1984, 1989), 33, 36, 126
Gilbey, Ryan, 126, 135
Gillespie, Craig, 154

Gilman, Jared, 6, 26, 48, 57, 60, 71, 100, 158, 185, 199
Giovannelli, Leonardo, 93, 142, 155
The Girl Can't Help It (1956), 79
Glover, Danny, 87, 95, 173
Godard, Jean-Luc, 14, 20, 21, 22, 91, 116, 158
Goldblum, Jeff, 70, 129, 140, 204
Gondry, Michel, 154
Gooch, Joshua, 13, 110, 111
Gorbman, Claudia, 116, 139, 140, 147
Gorfinkel, Elena, 155
Gorovaia, Irene, 97, 156
Gottschalk, Simon, 160
Govender, Dyalan, 82
The Graduate (1967), 82, 127
The Grand Budapest Hotel (2014), 1, 136
Grant, Cary, 79
The Great Gatsby (1925), 104
Greif, Mark, 157, 159, 162
Greenberg (2010), 6, 110, 111, 113, 114, 116, 117, 118, 119, 122
Grosz, Elizabeth, 208
Groundhog Dog (1992), 126, 127, 128, 135, 136
Gross, Terry, 94, 99
Guattari, Felix, 7, 182, 186, 189, 191
Gubar, Marah, 105
Gunning, Tom, 52, 56, 60

Hackman, Gene, 3, 26, 32, 69, 86, 95, 112, 135, 171, 190
Halberstam, Judith, 166
Hammond, Albert, 116
Hancock, Brannon M., 18, 111
Haraway, Donna J., 66
Hardy, Françoise, 116
Harold and Kumar Go to White Castle (2004), 136
Harris, Neil Patrick, 136
Harryhausen, Ray, 99
Harvey, David, 175, 176
Hawks, Howard, 36, 91
Hayward, Kara, 6, 26, 48, 60, 71, 100, 116, 185, 199
Hearst, William Randolph, 79

Hegel, Georg Wilhelm Friedrich, 182
Hemingway, Ernest, 92, 98
Herzog (1964), 111
Hess, Jared, 1, 154, 182
Higonnet, Anne, 159
Hill, Derek, 149
His Girl Friday (1940), 79
historical anachronism, 155
Hitchcock, Alfred, 91
Hockney, David, 92, 104
Hoffman, Dustin, 128
Holden, Andy, 160
Honeyman, Susan, 94
Hook (1991), 105
Hotel Chevalier (2007), 14, 15, 16, 17, 18, 19, 20, 21, 22, 23
Huber, Mary Taylor, 159
Humphrey, Hubert, 179
Hunt, Peter, 104
Hussein, Waris, 100
Huston, Anjelica, 3, 29, 41, 47, 69, 87, 95, 110, 131, 140, 171, 204
Hyden, Steven, 1

I Heart Huckabees (2004), 154
Irving, John, 82
It's Always Fair Weather (1955), 79
It's a Wonderful Life (1946), 79

Jacobs, Marc, 36
Jaeckle, Jeff, 120
Jarmusch, Jim, 7, 14, 16–17, 132, 136
Jasenovec, Nicholas, 154
Jason and the Argonauts (1963), 99
Jennings, Garth, 182
Johansson, Scarlett, 132
Johnson, Rian, 182
Jones, Davy, 80
Jones, Kent, 120
Jonze, Spike, 154
Jorge, Seu, 7, 131, 139–149, 208
July, Miranda, 154
Juno (2007), 1, 154, 182

Kael, Pauline, 3, 126
Kaplan, E. Ann, 56

Karan, Amara, 35
Karina, Anna, 22
Karloff, Boris, 80
Kaufman, Charlie, 154
Kelly, Christopher, 1
Kertzer, Adrienne, 99, 111, 122
Kicking and Screaming (1995), 109
Kidd, Kenneth, 105
Kidman, Nicole, 111
Kipen, David, 6, 109, 120, 121
Kipling, Rudyard, 94
Kirby, Lynne, 56
Kline, Owen, 112
Knoepflmacher, U. C., 104
Knoper, Randall, 30
Konigsburg, E. L., 97, 98, 103
Konstantinou, Lee, 160, 161, 166
Kotzwinkle, William, 80
Kredell, Brendan, 34, 84
Kreisel, Deanna K., 111
Kubrick, Stanley, 91, 130

LaBute, Neil, 155
Lacan, Jacques, 111, 181, 182, 189, 190
LaCapra, Dominick, 56
Lars and the Real Girl (2007), 154
Leiner, Danny, 136
Lennon, John, 34
Leigh, Jennifer Jason, 112
Leitch, Thomas, 102, 105
Lethem, Jonathan, 120
Leys, Ruth, 55
The Life Aquatic with Steve Zissou (2004), 1, 3, 7, 8, 25, 31, 32, 34, 39, 40, 47, 48, 62, 66, 69, 70, 74, 77, 82, 87, 93, 103, 109, 110, 111, 112, 113, 115, 116, 118, 120, 121, 125, 129, 131, 132, 134, 136, 139, 140, 141, 142, 143, 148, 149, 150, 155, 156, 157, 158, 181, 191, 199–212
The Limits of Control (2009), 132
Linklater, Richard, 78
Linney, Laura, 112
Lippy, Tod, 13
Loach, Ken, 91
Lorentzen, Christian, 156

Lost in Translation (2003), 36, 132
Louis Vuitton, 36
Lubitsch, Ernst, 91
Luhmann, Niklas, 206

MacDowell, James, 13, 27, 30, 77, 93, 120, 121, 122, 129–130, 158, 160, 165
MacNaughton, Robert, 80
Maddin, Guy, 162
Magic Town (1944), 79
The Magnificent Ambersons (1942), 34, 177
Malick, Terrence, 181
Malle, Louis, 35, 91, 111, 130
Margot at the Wedding (2007), 6, 110, 111, 112, 113, 114, 118, 119
Marshall, Colin, 188
Martel, K. C., 81
Matilda (1988), 100
Maturana, Humberto, 206
Maysles, Albert, 134, 136
Mayshark, Jesse Fox, 65, 73, 93, 96, 98, 155
Mazis, Glen A., 66
McCarey, Leo, 91
McCarthy, Todd, 26
McCole, Stephen, 130
McDormand, Frances, 3, 60, 71, 100
McGillis, Roderick, 105
McGovern, George, 179
McKibben, Bill, 204
McNelis, Tim, 32, 115, 116, 122
Meet the Parents (2000), 33
Melody (1971), 100
Melville, Herman, 82, 205
Melville, Jean-Pierre, 91
Mendel, Barry, 131
metamodernism, 27, 33–34
Meyerson, Jonah, 68, 85, 103, 155
Michelangelo, 97
The Midnight Coterie of Sinister Intruders (2013), 1
Mills, Mike, 154
The Miracle of Morgan's Creek (1944), 79

Moby-Dick (1851), 82, 87, 205
Montparnasse et Levallois (1965), 14, 20, 21, 22
Moonrise Kingdom (2012), 1, 4, 6, 8, 14, 26, 32, 33, 48, 49, 51, 52, 53, 57, 60–61, 62, 66, 70, 71, 74, 77, 85, 86, 87, 92, 93, 94, 95, 100–102, 103, 104, 116, 118, 128, 129, 132, 135, 136, 155, 158, 162, 164, 181, 185, 186, 188, 192, 196, 199, 211
Moonrise Kingdom Animated Short (2012), 14
The Mother and the Whore (1973), 111
Mothersbaugh, Mark, 4, 25, 87, 139, 140, 149, 150
Mr. Jealousy (1997), 110
Mr. Smith Goes to Washington (1939), 79
Murmur of the Heart (1971), 111
Murray, Bill, 3, 7, 25, 29, 31, 33, 36, 39, 41, 44, 45, 47, 58, 60, 62, 68, 69, 71, 73, 78, 86, 93, 100, 111, 125–136, 139, 156, 173, 179, 183, 184, 185, 190, 200
Murray, Noel, 1, 17
Musgrave, Robert, 16, 43, 83, 119
My Side of the Mountain (1959), 98

Nabokov, Vladimir, 53
The Naked Gun (1988), 36
Namath, Joe, 80
Napoleon Dynamite (2004), 1, 182
Nel, Philip, 105
Nelson, Max, 77
New Deal Democrats, 174
New Left, 174
Newmark, Kevin, 56
New Punk Cinema, 155
New Sincerity, 27, 35, 42, 93, 105, 121, 154, 160, 161, 183
Nichols, Mike, 82, 91, 127
Nico, 46, 47
Nikolajeva, Maria, 105
Nixon, Richard, 175, 176, 179
Nodelman, Perry, 104
Norton, Edward, 1, 48, 60, 100, 118

Nosferatu (1922), 80
Noye's Fludde, 60, 74, 158, 199

Oliver, Kelly, 66, 67
Olsen, Mark, 111, 154, 183
Ordinary Jack (1977), 98
Orgeron, Devin, 3, 13, 42, 49, 59, 65, 98, 122, 132, 133, 148, 149, 157, 165, 183, 187

Pais, Zane, 111
Pallana, Deepak, 130
Pallana, Kumar, 29, 130
Paltrow, Gwyneth, 31, 32, 33, 41, 45, 68, 87, 96, 110, 129, 156, 171, 181
Paper Heart (2009), 154
Paquin, Anna, 118
Paris, je t'aime (2006), 22
Paris vu par... (*Six in Paris*, 1965), 20, 22
Parker, Wes, 80
Past, Elena, 94, 211
Paterson, Katherine, 101
Payne, Alexander, 130
Paul, Lissa, 105
Peanuts, 102
Peberdy, Donna, 30, 32, 35, 36, 113, 128, 130, 136
Penn, Arthur, 2, 103, 181
Perkins, Claire, 34, 36, 166
Phelan, Peggy, 54
Pialat, Maurice, 91
Piechota, Carole Lyn, 110, 112, 115, 116, 117, 157
Pine, Larry, 61
Pink Floyd, 112
Phipps, Kevin, 1
Plantinga, Carl, 157
Playboy, 78
Poe, Edgar Allan, 101
Polanski, Roman, 130
Pomerance, Murray, 40, 41, 114, 115
Portman, Natalie, 14, 18, 19, 20, 21, 22, 23, 47
Poster, Randall, 4, 122

post-pop cinema, 93, 155
Powell, Michael, 91
Pressburger, Emeric, 91
Punch-Drunk Love (2002), 154
Pye, Douglas, 154, 158

Quick Change (1990), 127, 136
The Quiet Man (1952), 80
quirky, 7, 13, 27, 77, 78, 93, 130, 154–155, 156, 158, 159, 160, 161, 162, 166

Rabin, Nathan, 1
The Ramones, 32
Rankin/Bass Productions, 99
Raskin, Richard, 5, 13, 14, 15, 16, 18
Ray, Satyajit, 35, 91
The Razor's Edge (1984), 126
Rebel Without a Cause (1955), 85
Reitman, Ivan, 33
Reitman, Jason, 1, 154, 182
Renoir, Jean, 35, 91
Reynolds, Kimberley, 105
Riedel, David, 95
The River (1951), 35
Robé, Chris, 52–53, 58, 82–83, 87, 122, 136, 211
Robin Hood (1973), 102
Robinson, Anthony, 160
Rocky (1976), 34
Rohmer, Éric, 20, 111
Rolling Stones, 2, 46, 139, 140, 164
Rombes, Nicholas, 155
Rose, Charlie, 127, 133, 135
Rose, Jacqueline, 94, 104
Rosenmeyer, Grant, 68, 85, 103, 155
Roth, Philip, 111, 121
Rouch, Jean, 14, 20
The Royal Tenenbaums (2001), 1, 3, 4, 7, 19, 26, 28–29, 31, 32, 34, 41, 42, 45, 46, 47, 48, 62, 66, 68, 70, 71, 77, 82, 84, 93, 94, 95–98, 102, 103, 109, 110, 111, 112, 113, 114, 115, 116, 117, 129, 131, 134, 135, 136, 140, 155, 156, 158, 164, 171–180, 181, 191

Rushmore (1998), 3, 4, 6, 7, 26, 30, 32, 34, 36, 41, 42, 44, 45, 47, 48, 51, 52, 53, 57–60, 62, 65, 66, 78, 82, 83, 86, 87, 93, 96, 101, 103, 111, 112, 113, 114, 117, 119, 122, 125, 126, 127, 128, 129, 130, 131, 132, 135, 136, 140, 155, 162, 164, 172, 177, 178, 179, 181, 191
Russell, David O., 154
Rutherford, Camilla, 47, 155
Ryzik, Melena, 125

Sabo, Lee Weston, 157
Salinger, J. D., 34, 82, 92, 97, 98, 111
Saltz, Jerry, 160
Sampras, Pete, 85
Sarstedt, Peter, 20, 35
Sartor Resartus (1833), 191
Sartin, Hank, 99
Saturday Night Live (1975–), 1, 126
Schatz, Thomas, 3
Schivelbusch, Wolfgang, 56
Schreck, Max, 80
Schulz, Charles, 102
Schwartzman, Jason, 3, 6, 14, 18, 19, 20, 21, 22, 26, 29, 30, 44, 47, 51, 65, 72, 78, 93, 103, 111, 112, 127, 132, 179
Sconce, Jeffrey, 27, 30, 42, 93, 154, 155, 158, 159, 160, 166, 183
Scorsese, Martin, 91, 116
Scott, A. O., 1, 82
Scrooged (1988), 127, 128, 136
Seigworth, Gregory J., 160
Seitz, Matt Zoller, 3, 8, 140
Selick, Henry, 204
Serpico (1973), 44, 59, 78
The 7th Voyage of Sinbad (1958), 99
The Seven Year Itch (1955), 79
Shakar, Alex, 160
Shone, Tom, 135
Simon, Paul, 28
Singin' in the Rain (1952), 79, 86
Sloterdijk, Peter, 161

smart films, 27, 30, 42, 93, 121, 155, 158, 159, 160, 166, 183
Solondz, Todd, 155
Son of Rambow (2007), 182
Spielberg, Steven, 91
The Squid and the Whale (2005), 109, 110, 111, 112, 113, 114, 118, 119, 120, 122
Stam, Robert, 33
A Star is Born (1954), 79
Star Trek franchise, 81
Stewart, Susan, 54, 56, 62
Stiller, Ben, 28, 33, 45, 68, 85, 96, 113, 156, 173
The Sting (1973), 29
Stockhausen, Adam, 196
Stockwell, John, 36
Streep, Meryl, 3, 72, 155
Stripes (1981), 33, 126, 127, 128, 136
Sundance Film Festival, 16
Sunset Boulevard (1950), 86
Swann, Adam, 186
Swanson, Gloria, 86
Swinton, Tilda, 185

Tanaka, Sara, 45, 177
Tarantino, Quentin, 116
Targets (1968), 80
Tati, Jacques, 188
Taylor, Noah, 146, 149, 200
The Terror (1963), 80
Thomas, Deborah J., 125, 183
Thomas, Henry, 80
Thrift, Nigel, 201
Timmer, Nicoline, 160, 166
Tobias, Scott, 1
Tootsie (1982), 126, 127, 128
Trollope, Anthony, 196
Truffaut, François, 2, 91, 111, 130, 187
Turner, David Cross, 49, 96, 172, 179
Turturro, Amedeo, 97
Twain, Mark, 29
Twentieth Century (1934), 36

Twenty Thousand Leagues Under the Sea (1870), 82
Tykwer, Tom, 14, 22

Uexküll, Jakob von, 67
Urquhart, Kyle Ryan, 103

van den Akker, Robin, 27, 33–34, 160, 166
Varela, Francisco, 206
Ventura, Elbert, 1
Vermeulen, Timotheus, 27, 33–34, 160, 166
Verne, Jules, 82
Viguerie, Richard, 175
von Trier, Lars, 158

Wachtell, Jennifer, 68
Wallace, David Foster, 160, 161, 162
Wayne's World films (1992, 1993), 81
Weber, Samuel, 53
Weiner, Jonah, 1
Weisberg, Jacob, 104
Welles, Orson, 34, 79, 103, 130, 177
What About Bob? (1991), 127, 136
Who Framed Roger Rabbit? (1988), 81

Wilder, Thornton, 60
Williams, Olivia, 34, 44, 57–58, 65, 82, 111, 130, 177
Williams, Raymond, 160
Willis, Bruce, 60, 100, 190
Wilson, Andrew, 29, 43
Wilson, Luke, 16, 29, 41, 44, 45, 62, 68, 84, 85, 95, 112, 115, 156, 171, 191
Wilson, Owen, 2, 4, 16, 25, 26, 29, 33, 39, 41, 43, 44, 46, 47, 69, 70, 83, 93, 111, 119, 127, 129, 130, 131, 139, 156, 171, 178, 191, 202
Winters, Ben, 115, 116, 117, 202
Wolodarsky, Wallace, 72, 85
Wordsworth, William, 2
Wright, Steven, 17

Yellow Submarine (1968), 87
Yeoman, Robert, 4
The Young Person's Guide to the Orchestra, 60

Žižek, Slavoj, 7, 159, 161, 182, 190
Zombieland (2009), 136
Zoolander (2001), 33
Zucker, David, 36